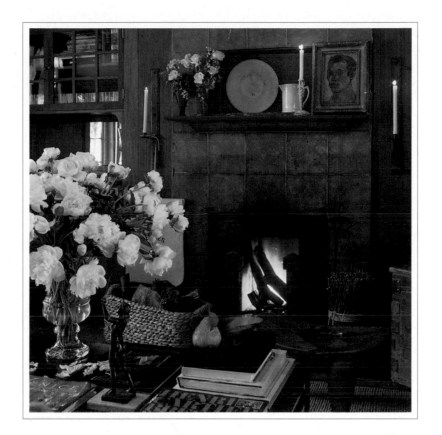

♦

SAN FRANCISCO
INTERIORS

♦

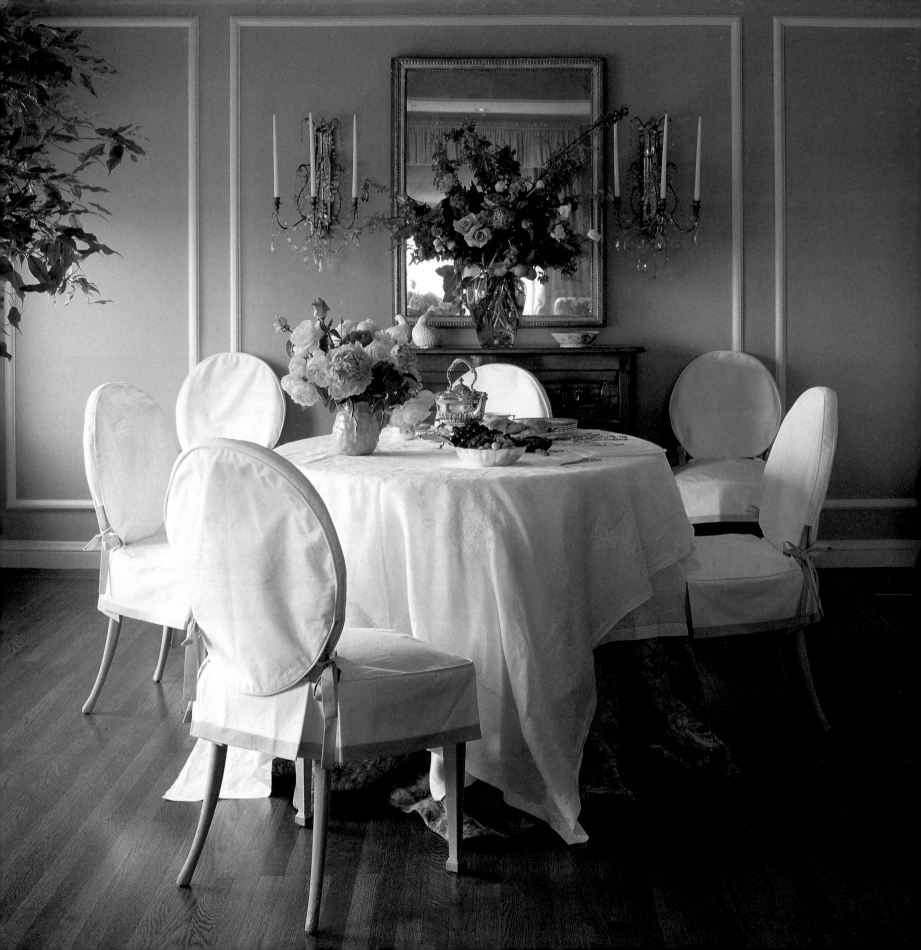

◆

SAN FRANCISCO
INTERIORS

◆

DIANE DORRANS SAEKS

PHOTOGRAPHY BY ALAN WEINTRAUB

◆

Foreword by Herb Caen

Introduction by Diane Dorrans Saeks

CHRONICLE BOOKS

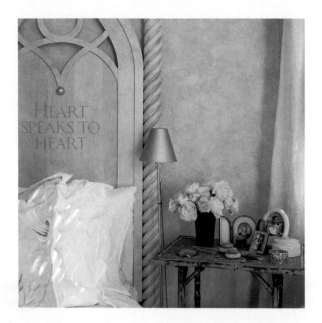

◆

Heartfelt carving on Arnelle and Roger Hase's headboard.

◆

Text copyright ©1995 by Diane Dorrans Saeks.
Photographs copyright ©1995 by Alan Weintraub.

Printed in Singapore.

Book and Cover Design:
Michael Manwaring & Elizabeth Ives Manwaring
The Office of Michael Manwaring

Library of Congress Cataloging-in-Publication Data available.

ISBN: 0-8118-0869-6

Distributed in Canada by Raincoast Books,
8680 Cambie Street
Vancouver, B.C., V6P 6M9

10 9 8 7 6 5 4 3 2 1

◆

Chronicle Books
275 Fifth Street
San Francisco, CA 94103

*Photo opposite title page: Ilene Sanford's Russian Hill dining room is set with alluring white linens
for an afternoon tea. New slipcovers on her dining chairs are as pretty as party dresses.*

◆

*Photo on page 1: Bursts of lush peonies and roses add luxury and beauty
to Stephen Brady's handsome, paneled study.*

ACKNOWLEDGMENTS

◆

For my son, Justin, with love always.

D.D.S.

For my father, my mother, Stephen, and Paul.

A.J.W.

◆

Working on this book has been a true pleasure. ◆ We would especially like to thank all of the designers and the own-ers of the remarkable houses and apartments presented on these pages for their enthusiasm. With perfect design pitch, they have gone to endless lengths to make these rooms look their best for the camera. Designers and homeowners and their teams have dashed to the San Francisco flower market at dawn to pluck garden roses and boughs of plums from the clutches of California's best florists. They have painted walls and reupholstered sofas, gilded chairs and waxed floors, stitched linens and trimmed draperies, searched for special paintings and antiques and triumphed. Designer Candra Scott, down to the wire, had her just-sewn, butter-yellow silk bedspread driven at breakneck speed from Los Angeles on Highway 5 to her house on Potrero Hill for the photo shoot. Busy Stephen Brady orchestrated speedy and talented teams to sew and hang new striped cottons on his guest room walls, perfect the garden, and gather the loosely arranged heirloom roses he loves. And then there were the designers who hastily completed rooms that had been in abeyance for months, and home owners who fine-tuned their collections, their books, their tabletops — and had their precious canines primped and clipped for their portraits. ◆ For years of professional encouragement, we send special bouquets to Dorothy Kalins, Donna Warner, Barbara Graustark, Newell Turner, Michael Lassell, Karen Saks, Susan Goldberger, Sarah Gray Miller, Terry Bissell, James Huntington, Wendy Silverstein, Cynthia Hochswender, Gail Steves, Tim Drew, and at the San Francisco Chronicle, Rosalie Muller Wright, Michael Bauer, Connie Ballard, and Barbara Hass. Deborah Geltman has been especially generous, thoughtful, and incisive. ◆ Friends and family all over the world have always been the greatest inspiration. ◆ For her wis-dom and love, Diane would like to give special acknowledgement to Dorothy Tanis Saeks. ◆ Warmest thanks, too, to Robert A. Harvey Q.S.O., Geraldine Paton, Mary Grant, Theadora Van Runkle, Michael Smith, Mish, and Erica Donaldson across the miles and over the years. ◆ At Chronicle Books, Jack Jensen, Nion McEvoy, Michael Carabetta, and Gretchen Scoble have been enthusiastic, helpful, and always open to new ideas. Charlotte Stone is a gracious, creative editor and splendid organizer. ◆ Graphic designers Michael Manwaring and Elizabeth Ives Manwaring, of the Office of Michael Manwaring, have created thrilling, fresh, and elegant pages. The words have room to breathe and the photographs are pre-sented with grace and style. ◆ Terry Ryan and her trusty, sharp Blackwings, the third time around, is a perceptive, sensi-tive, and good-humored editor. ◆ Thanks to Kevin and Suzanne Duggan and Paul Mason at Iris Photographic; Brian Condon, Wendy Gallacher and Lynn Fulk at New Lab SF; Heidi Grassley, Asa de Matteo, Scott Calzaretta, and Robert Rudelic. ◆ To all the friends in San Francisco — thanks for caffe lattes, inspiration, afternoon meetings at Zuni Cafe, hikes, sculling, mulberries and cookies at Chez Panisse Café, coffee at South Park Cafe, lunches at Boulevard, chats at Café Fanny, and sunny meetings at the Waterfront Cafe on Schoonmaker Point Marina. Love and kisses. ◆ For G.R.D., love forever, and thank you for the PowerBook from Heaven.

DIANE DORRANS SAEKS ◆ ALAN WEINTRAUB

San Francisco

Contents

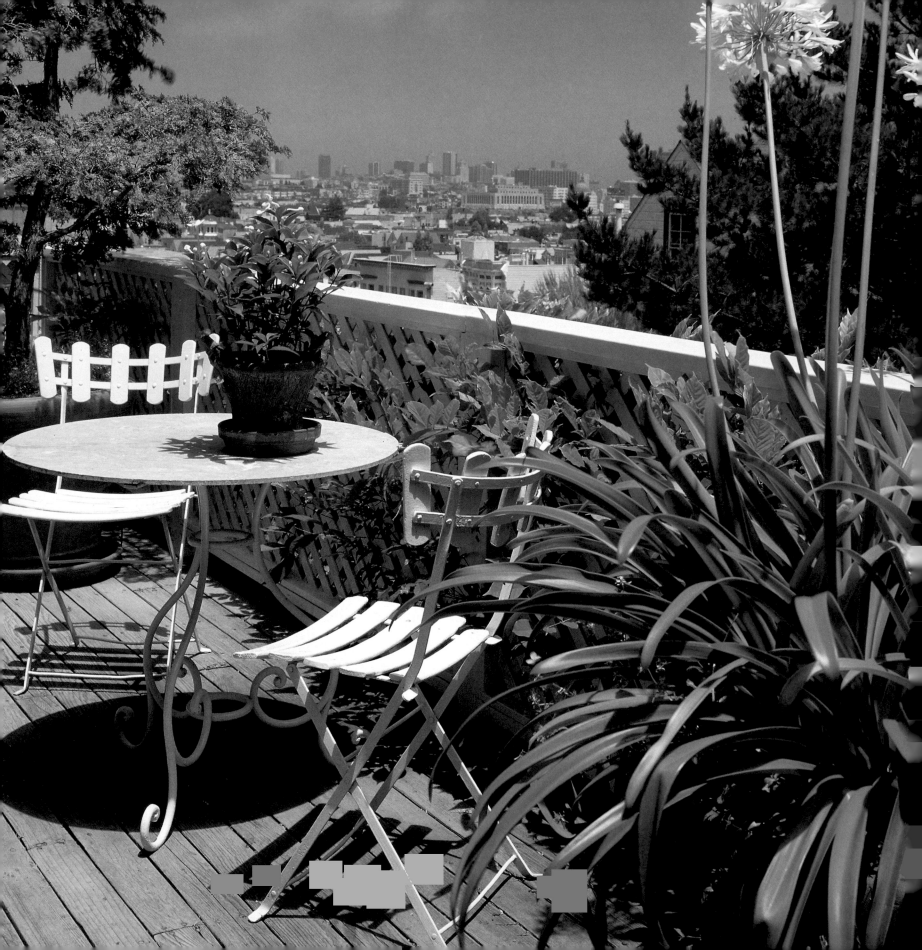

FOREWORD

◆

By Herb Caen

SAN FRANCISCO, THE MAGNIFICENT AND MELANCHOLY. HER MOODS CHANGE WITH THE WEATHER, ONE MINUTE BRIGHT AND SUNNY, THE NEXT COOL AND BREEZY. SUDDEN PATCHES OF FOG MAKE HER SEEM THOUGHTFUL, WHICH SHE SELDOM IS. GIDDY PRETTY CITY WITH SALT IN HER HAIR, A BIT TRYING IN BROAD DAYLIGHT, MUCH MORE GLAMOROUS AT NIGHT, WITH RHINESTONES AND ZIRCONS GLITTERING IN HER EMPTY HEAD, AND HERE AND THERE A GENUINE PEARL TEARDROP. TERRACE UPON TERRACE, THE HILLS DROP DOWN TO THE FAKE MEDITERRANEAN MARINA. OUT IN THE BAY, ANGEL ISLAND AND THE DEVIL'S ISLE OF ALCATRAZ FACE EACH OTHER ACROSS TREACHEROUS WATER. THE LONG OIL TANKERS MOVE IN AND OUT, CARRYING OUR DESTINY, OUR DREAMS OF MOBILITY. SHIPS OF MYSTERY. ◆ NEW NATIVE SAN FRANCISCANS ARE BORN EVERY DAY AND A FEW NATIVE SAN FRANCISCANS DIE EVERY DAY AND GO TO HEAVEN, WHICH, IF THEY ARE LUCKY, RESEMBLES THE PENTHOUSE OF SOME SPLENDID APARTMENT HOUSE, PERHAPS 2500 STEINER. ◆ SOME OF THE GREATEST ARCHITECTS IN SAN FRANCISCO'S HISTORY ARE UNKNOWN OR FORGOTTEN, BUT THEY CREATED THE FACE OF THE CITY THAT BECAME UNIVERSALLY LOVED — BAY WINDOWS OPENING TO THE MIDDAY SUN; WOODEN HOUSES CLINGING PERILOUSLY AND MIRACULOUSLY TO STEEP HILLSIDES; ENDEARING EXCESSES OF VICTORIANA AND EDWARDIANA IN STOOPS, STEPS, SCROLLWORK; ADORNMENTS OF EVERY KIND IN A PROFUSION OF STYLES THAT CAME FROM THE HEART, NOT A SCHOOL. ◆ WILLIS POLK FORMALIZED THE ELEGANT SAN FRANCISCO TOWNHOUSE, GRACIOUS AND SPACIOUS. ARTHUR BROWN PUT HIS BEAUX ARTS STAMP ON CITY HALL AND THE OPERA HOUSE. THE SKYLINE ROSE NATURALLY AND WITH DIGNITY FROM THE HILLS — NOT BY PLAN OR UKASE BUT BY SIMPLE GOOD TASTE AND MANNERS.

*Viewed from antiques dealer Ed Hardy's
deck, San Francisco glows in the afternoon sun
like a mirage.*

I have lived in San Francisco for 15 years, and for all of that time I have been writing about interior design, designers, fashion, furniture design, and architecture. ♦ I arrived in San Francisco from the East Coast (and before that, Europe, and a few years before, the Mediterranean, and before that, Asia and Australia). ♦ I grew up in New Zealand, reading *Harper's Bazaar* and *Vogue* when Diana Vreeland was the style queen. Style and chic and pizazz were the great ideals. ♦ I vowed, as I lay with my books in grassy meadows far from civilization, that I would quickly complete my studies and set off to live in New York, where I would reside at 1 West 67th Street. I did have an apartment there for one blissful summer, but, in fact, I now find I much prefer California, and in particular, San Francisco, and most particularly, Pacific Avenue. Maybe it's the clear white light. Perhaps it's the salt-infused air that blows in from the Pacific. I didn't read about this wide and handsome avenue in the glossies of my girlhood that arrived by ship months out of date. I discovered the City on a chance trip to the coast, and have never left. ♦ In the years I have lived in San Francisco, I have visited and viewed hundreds, perhaps a thousand or more, houses, apartments, lofts, decorator showcase rooms, studios, houseboats, cottages, aeries, flats, attics, villas, weekend houses, mansions, retreats, ateliers, seaside cabins, architects' and designers' offices, and construction sites in search of the best interior design and architecture. As a design writer and editor, I quickly discovered that San Francisco interiors are not at all the mind-bending, cart-wheeling experimental salons that the City's free-thinking reputation might suggest. La vie bohème is a faded memory. Hard-hitting design has not been embraced by the City. Change comes slowly, but that does not mean rooms are all stodgy and staid or pompous and conventional. ♦ Rather, the best interiors in the City — most of them completed by the confident hand of a professional — exist for the pleasure and comfort of the owners. They are as personal as a fingerprint and patterned to perfection with paintings, sculpture, and quirky collections to quicken the pulse. Trophies from travels, and signs of life fill the walls and the halls. Children's drawings, wedding gifts, family heirlooms, and even instant antiques and an invented past give the rooms poetry and magic. ♦ Today, interior design should not be judged solely on the provenance of the antiques, the high quality of the rare silk vel-

The romantic pure-white interiors of Leo and Marlys Keoshian's house were compelling when San Francisco interior designer John Dickinson first planned them in 1968.

Today, the confident simplicity and timelessness of the original scheme demonstrate clearly Dickinson's prescience and his secure grasp of classic design.

vet and taffeta, the elaborate gilded frames of the paintings, or the intimidation factor of its furnishings. The exquisite can have great allure but it's not the only form of perfection. ♦ Rather, I look beyond costly fabrics and furniture with perhaps a history to find intriguing proportions, comfort, beautiful light, a sense of interesting lives lived there. I note the stacks and stacks of well-read books, a cat snoozing on a silk pillow, or a corgi napping on the velvet-upholstered Directoire-style chair. A good room also needs fresh and natural flowers, some humor or a light touch, and beautiful textures and surfaces. Children are welcome there. ♦ Good taste is not a quality I admire particularly in interior design. Show me a room where everything is "perfect" and I head for the door. Nothing is dared. Nothing is achieved. It's so safe, so textbook trite, and altogether too obvious. Follow the good taste route and the result is invariably a room that lacks vitality, charm, and character. It looks like display rather than home. ♦ Good design should delight and surprise the senses and provide comfort and respite for the body and the mind. ♦ Theme design has no place in this book. Design-by-the-numbers is of no interest. ♦ San Francisco designer John Dickinson, who was a mentor, used to wear pressed Gap chinos with his Huntsman bespoke jackets and cashmere cable sweaters. He appreciated the contrast of refined chairs and recherché antiques with "airport art" and junk shop finds. ♦ "Good design is not all deluxe," he used to say. "Tacky things with grand things, mundane things with rather grand things! Nice design has no vitality at all. If you want a lot of zip, vulgarity is hard to beat." French designer Andrée Putman, a friend of Dickinson's and an inspiration to me, loves "courageous contrasts" in interior design. "True elegance," she once told me, "can derive from an insolent pirouette. Unexpected choices sometimes result in a house that is sublime." ♦ So San Francisco, too, is all over the design map. There is no one decorating style that represents all of the City. A handsome house on Russian Hill is very San Francisco. So, too, are an art-filled salon in Pacific Heights, a studio South of Market, and a writer's Victorian on Telegraph Hill. ♦ Within the pages of this book, I take you on an inspiring visit behind the walls of San Francisco. ♦ May you use these pages to dream and imagine and plan great things. I have always used books as guide books and maps to the unknown — and look where it got me. San Francisco.

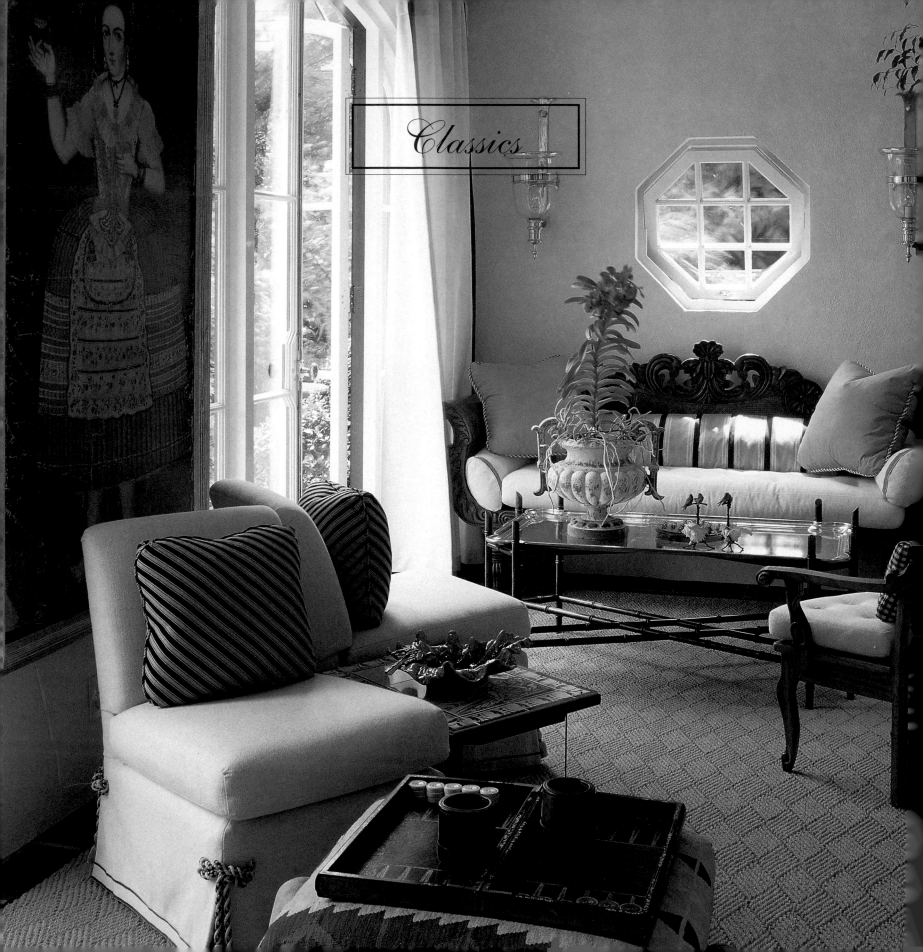

Classics

*I*t's time to admit that San Francisco is a bit of a decorating impostor. The City, standing shakily on the edge of the continent, seems like a place for experimentation, outrageousness, trendsetting, and kicking over the traces. A town that embraces new ideas and freethinking would seem to be just the place for experimental design and avant-garde creations. ♦ In fact, it's classic, traditional style that's hidden behind most ivy-clad brick walls, magnolia trees, and Victorian fretwork fripperies. San Franciscans may embrace cutting-edge art and freethinking literature, but when they sit down at the dining table or entertain guests in their orderly living rooms, the chairs and sofas that soothe their way are likely to be perfectly proportioned, classic, quite beautiful, and at heart reassuringly traditional. ♦ Oh, sometimes there's a twist. A flea-market-find chair (suitably restyled in chic new Gustavian guise) stands beside a neoclassical gilded table. A Charles and Ray Eames storage unit, all modern metal and proletarian plywood, stands foursquare in a luxurious bedroom. A challenging painting glares from a splendidly plastered wall. ♦ There are acknowledged masters of classic design, such as Anthony Hail, John Dickinson, and Michael Vincent — all with design careers that span a lifetime. Their mastery and control of their medium are clear. Orlando Diaz-Azcuy, too, is single-minded, rigorous, and a perfectionist. Paul Wiseman and Scott Lamb achieve refined, refreshing rooms. ♦ These are rooms in which timeless design is the goal, and classicism is the ideal. There is nothing trendy within these houses, but they are alive and inviting. Each room will evolve and there is every reason to imagine that they will change somewhat, and will give pleasure for many more years.

Kaye and Richard Heafey's loggia was the newest room to be completed. It was created in place of an
exterior patio. Beneath the octagonal window stands a nineteenth-century Portuguese caned-seat rosewood settee.
The brass tray-topped table on a metal, bamboo-form stand is a bold presence beside a pair of
slipper chairs in natural canvas.

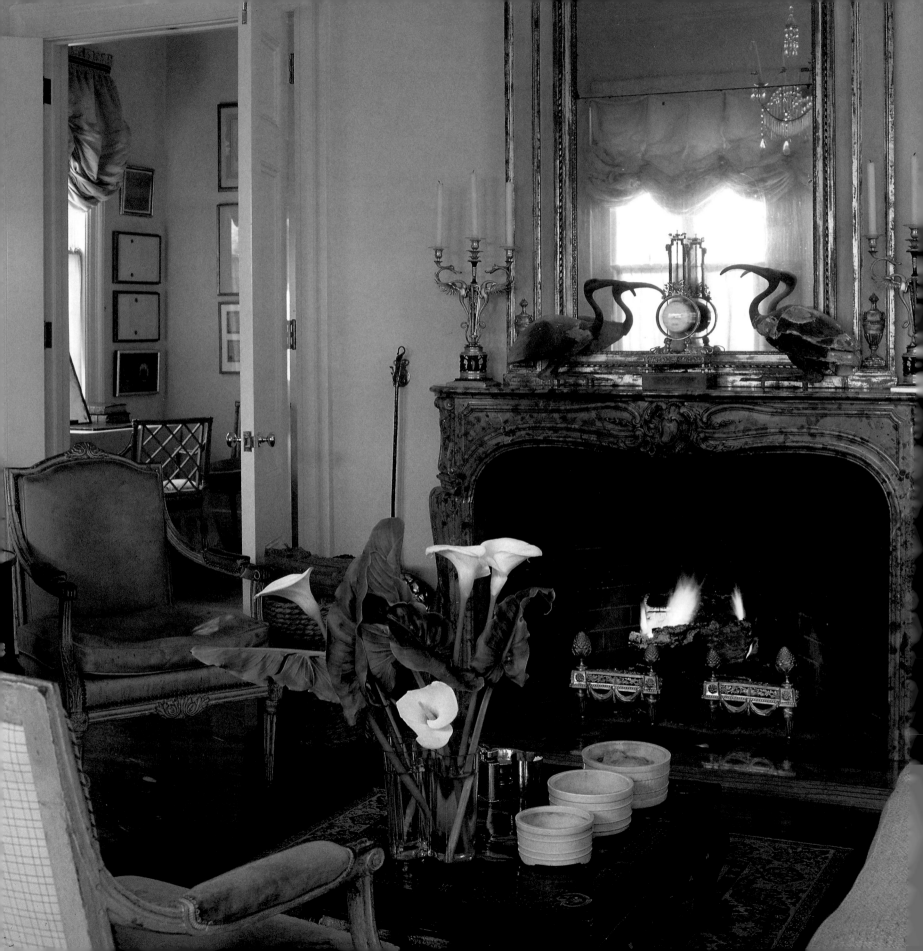

INTERIOR DESIGNER ANTHONY HAIL'S MONDAY-NIGHT BRIDGE CLUB IS AN EXTREMELY FORTUNATE GROUP. NOT ONLY ARE THE LOYAL MEMBERS – WHO HAVE BEEN MEETING FOR 25 YEARS – VERY GREGARIOUS TYPES, BUT THIS RUSSIAN HILL HOUSE AFFORDS THE MOST CONGENIAL, HOSPITABLE SETTING FOR CONVERSATION, TUTORIALS, AND GAMES. THE LIVING ROOM IS FORMAL AND HUSHED, YET EXTREMELY INVITING. ♦ FOR THE COMFORT AND DELIGHT OF HIS GUESTS, HAIL HAS ARRANGED THREE SEATING GROUPS, CAREFULLY MODULATED LIGHTING, AND DOWN-FILLED SOFAS UPHOLSTERED IN RAW SILK. FRAMED ARCHITECTURAL DRAWINGS AND PORTRAITS HANG ON THE CREAM WALLS. RARE LEATHER-BOUND BOOKS AND ART MONOGRAPHS COLLECTED OVER A LIFETIME ARE LINED UP IN A PAIR OF IMPOSING BOOKCASES. ♦ ON TABLETOPS IN THE LIVING ROOM, HAIL HAS ARRANGED ANTIQUE, CARVED-JADE ANIMALS, ROMAN BRONZE REPTILES, HIS COLLECTION OF *BLANC DE CHINE* URNS AND VASES, AND OTHER INTRIGUING OBJECTS THAT INVITE CLOSER INSPECTION. ♦ COLORS OF HIS ISFAHAN RUGS, THE FRENCH SILK VELVET AND LEATHER UPHOLSTERY, AND CREAM SILK TWILL DRAPERIES ARE MUTED AND DIFFUSED, WITH A PALED-DOWN LOOK THAT SUGGESTS CENTURIES IN THE NORDIC SUN. ♦ "THIS HOUSE IS AN ODE TO LATE-EIGHTEENTH-CENTURY SCANDINAVIA," SAID HAIL, WHO IS CONSIDERED THE DEAN OF SAN FRANCISCO DESIGNERS. "I WAS BORN IN TENNESSEE, BUT I GREW UP IN DENMARK, AND I WAS ENORMOUSLY INFLUENCED BY ITS ARCHITECTURE, ANTIQUES, COLOR PALETTE, AND DÉCOR. THE BLUES AND YELLOWS AND CREAM COLORS HERE ARE VERY SCANDINAVIAN." ♦ THE HOUSE, DESIGNED BY SAN SIMEON ARCHITECT JULIA MORGAN IN 1916, WAS EXTENSIVELY RENOVATED AFTER HAIL AND HIS PARTNER, CHARLES POSEY, PURCHASED IT TEN YEARS AGO. THEY OPENED UP TWO ENFILADES THAT RUN THE DEPTH OF THE HOUSE.

Quality control: The living room of Anthony Hail and his business partner, Charles Posey, is a perfectly ordered salon, with beautifully proportioned chairs and tables and comfort at every turn. The designer's classical training (he studied architecture at Harvard under Walter Gropius) is evident in every detail. The carefully planned interior architecture sets off his less-is-more choices of fabrics and color. The door at left leads through a study to his bedroom.

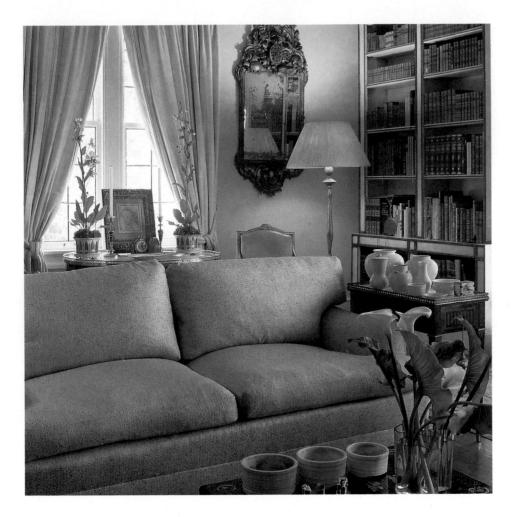

The design historian: Hail was a classicist long before it became fashionable. Here, he brings together a raw-silk-twill-upholstered sofa, Chinese porcelains, a Ming lacquered table with mother-of-pearl inlays, and a pair of elaborate eighteenth-century French gilded mirrors. The bookcases, carefully antiqued, are of a pair Hail had custom-crafted to replace handsome Georgian cabinets.

♦

On the table in hand-painted porcelain cache pots is a pair of rare blue Himalayan poppies.

Hail never displays a piece of porcelain or a jade sculpture merely for effect or to fill up a tabletop. Rather, he brings together objects that relate to each other, to build up a theme or a narrative of art history. ♦ At one side of the fireplace in the living room stands an inlaid-marble Swedish table topped with a graceful seventeenth-century Venetian bronze horse, a pair of Sung-period jade *kongs*, and Chinese carved-jade bowls and boxes. ♦ Beside a sofa, a Swedish table by the noted *ébeniste* Haupt, from the period of Gustav III, is topped with *blanc de chine* urns, Japanese white vases, and white porcelain cachepots of different periods. ♦ On a Parian marble-topped Louis XVI table, Hail has gathered a Roman marble Bacchus, a bronze snake, a Roman marble panther, and a bronze medallion of Thomas Jefferson's *amour*, Mrs. Maria Cosway. ♦ It is significant that there is neither one stick of modern furniture nor a simple contemporary painting or sculpture in the house. ♦ The closing years of the eighteenth century hold the most allure for the designer. To his eye, the architecture and decorative arts of that time maintain unrivaled degrees of refinement, sophistication, and simplicity. "Late Louis XVI" is Hail's own definition of his taste. ♦ Still, he avoids any slide into lugubrious nostalgia. Merely parroting his favored period is not the goal. Rather, Hail aims for rooms that are graceful, graphic, fresh, and animated.

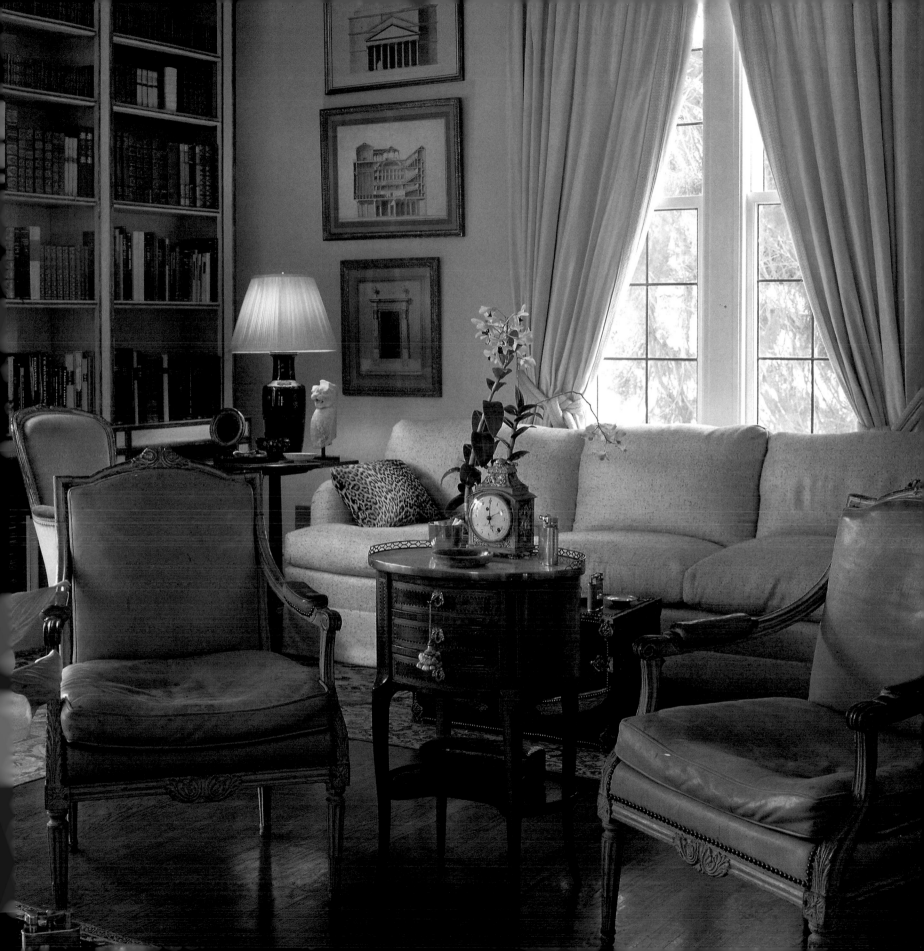

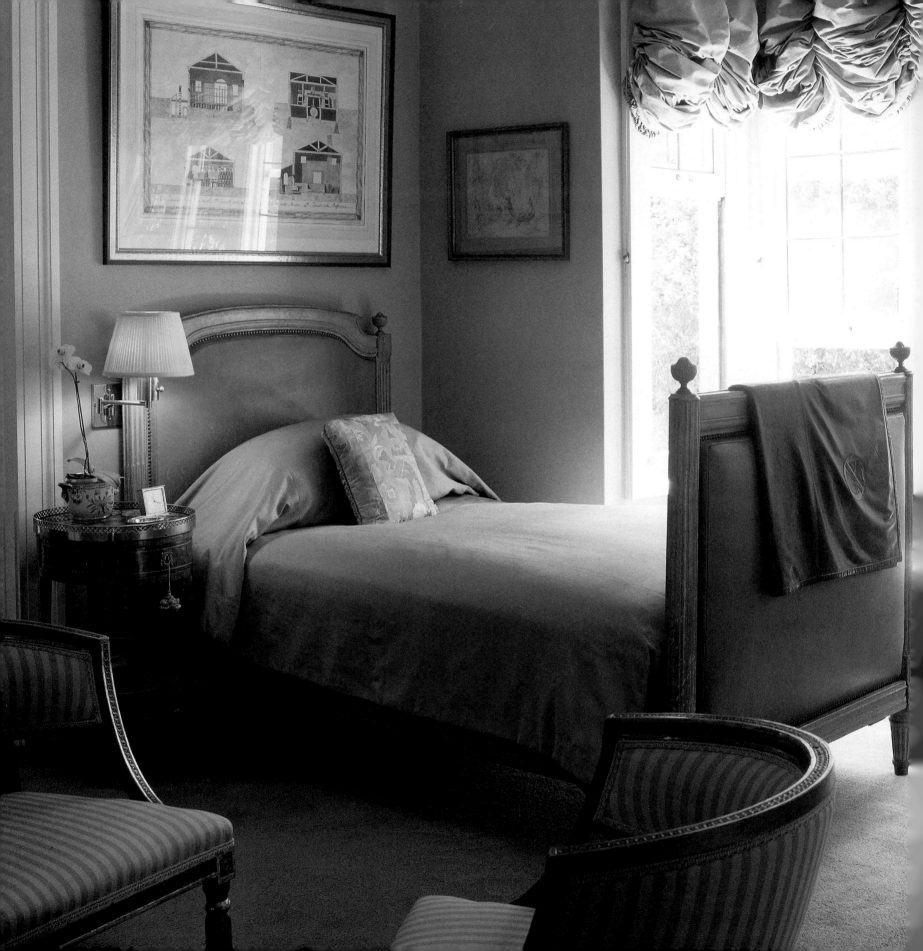

Tony Hail is a great admirer of Thomas Jefferson, and he took the blue/gray color of his guest room walls from the hue on the dining room walls at Monticello. ◆ Hail's Harvard thesis was on Thomas Jefferson's architecture. He refers to Monticello as "that haven of aristocratic largess." Aware of its classic inspirations, Hail set off for Europe immediately after his Virginia sojourn to revisit Denmark and Sweden. He studied once more the Gustavian rooms of his childhood, and every detail — from the linens and mattress ticking to the elegant furniture — left an indelible impression. ◆ He went on to London, Paris, and Rome and ended up staying in Europe for six or seven years. It was in Paris, he said, where he caught "the incurable disease of *grande luxe*." ◆ Anthony Hail made the move to San Francisco in 1955, and he soon found his place, and a devoted following, in the design world. ◆ "When I first arrived, no one had ever heard of Gustav III, neoclassical Russian, or Scandinavian antiques. Copies of French furniture, lots of Louis, and heavy Queen Anne were the rage," he recalled. "In fact, the light in San Francisco is a lot like the light in Denmark. It's cool, and it's very intense. That's why Scandinavian decor works so well here."

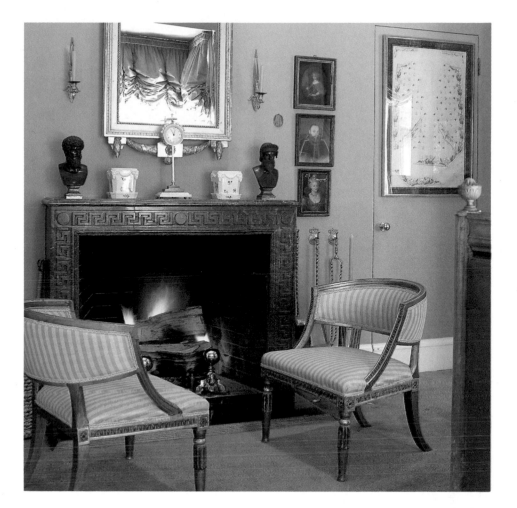

Scandinavian light: The walls of the guest bedroom are painted the color of the North Atlantic Ocean at the outset of a storm. Their blue/gray tone mutes the light admitted through the large leaded windows that overlook the garden. The rather chaste leather-upholstered bed (in the style of Louis XVI) is accompanied by a handsome pair of gilded Gustavian chairs in the Greek mode. All of Hail's newly installed eighteenth-century fireplace mantels are unique: this one, incised with a Greek key motif, is rare French Rouge Royale marble. On the walls, Hail shows framed architectural drawings, portraits, and an antique embroidered vest.

"Every antique in my bedroom is either Danish, French, or Russian," said Hail. "I chose pieces that were rather architectural and understated. The last thing I'd want in my bedroom are antiques or colors that are flamboyant or over-the-top." ♦ Hail's room, where he takes breakfast on a tray every morning, invites lingering. Colors are neutral and encourage repose. One wall, bisected by a bay window, is covered floor-to-ceiling with bookshelves. There Hail keeps arcane leather-bound volumes on art, architecture, and antiques — some in French, others in Danish, Russian, and Swedish — along with signed first editions of biographies and autobiographies. ♦ "I use all my books every day for reference, for inspiration, and entertainment," he says. ♦ Hail's favorite armchair, down-filled and upholstered with faded, garnet-colored silk velvet, is attended by convenient tables for his telephone, his newspapers, books, and photograph albums.

Anthony Hail's bedroom, which faces south, is a paradigm of comfort, restfulness, and understated decorating. Hail chose a heavy French striped-silk fabric in muted ivory/taupe/vanilla for his bedcover and for the padded and upholstered walls, the better to present his Louis XVI bed and his lifetime collection of architectural drawings and paintings. A pair of rare Danish commodes (circa 1790) stands beside his bed. The pair of mirror-black lamps was a gift from New York designer and longtime friend, Billy Baldwin.

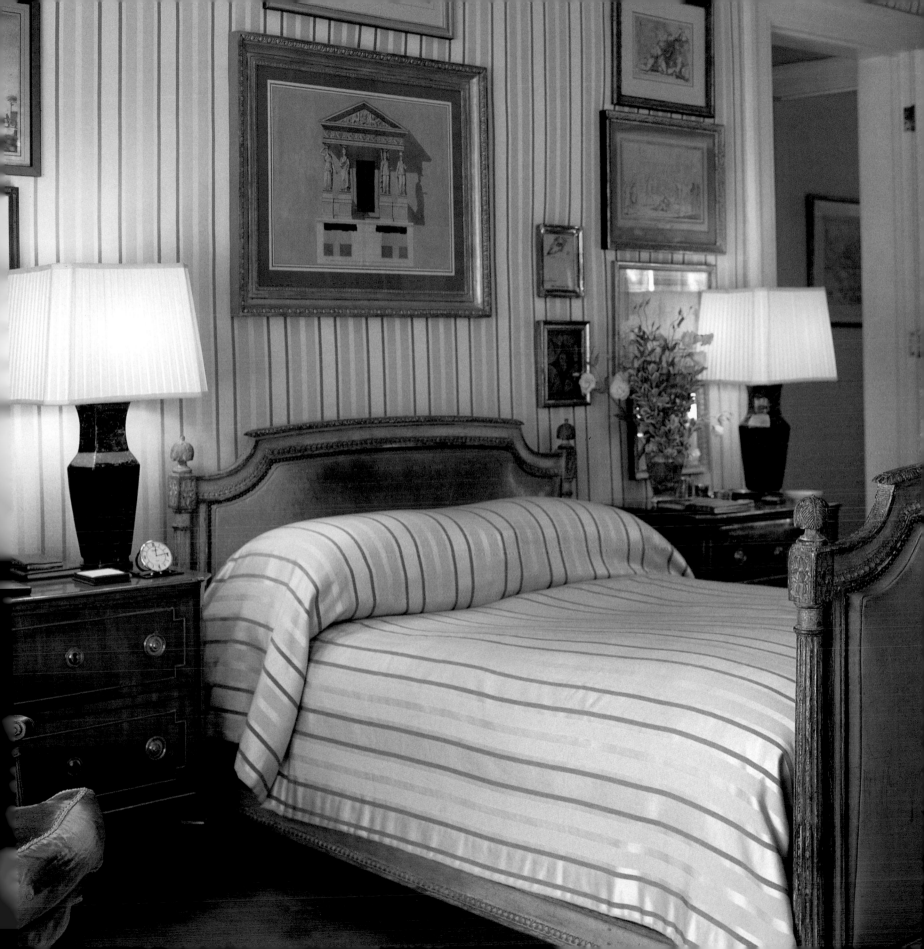

Timelessness is one of the most admired qualities in design today – and one of the most challenging to finesse. Avoiding trendiness, eschewing fads and fashions, and still giving a room freshness, individuality, and life is as tricky and ultimately rewarding as walking a tightrope. Designing a room for the ages is a noble effort, and only time can tell if it was truly successful. ◆ In 1970, Dr. Leo Keoshian commissioned San Francisco interior designer John Dickinson to design new interiors for his Spanish-style house, built on a quiet street in Palo Alto in the twenties by architecture professor Clarence Tantau. ◆ "I was really excited with John's designs the minute he presented them, but I had no idea they would last so long and give me such pleasure for 25 years," said Dr. Keoshian, a plastic surgeon who specializes in hands. A Bugattist, he is the president of the American Bugatti Club. ◆ "John would come in and sketch, make notes, and present his ideas for dining chairs or the steel window frame," recalled Dr. Keoshian. "His plan from the beginning was to keep the rooms very precise, quite understated." ◆ "Every day, these rooms give us such pleasure," added his wife, Marlys Keoshian. "There is nothing we would add or take away. The rooms work. They look wonderful in the afternoons when the light pours in, and they have a serene mood at night." ◆ The rooms have staying power, too, because the comfort-minded decor has a solid foundation. ◆ In the living room and dining room, a custom-made V'Soske wool carpet in a Mondrianesque pattern of subtle gray, ivory, and beige outlines the formal arrangement of chairs, banquettes, and tables. ◆ The simple, crisp plan had such

Classic white: The Keoshians' world, as designed by John Dickinson. The simple furniture – banquettes and chairs upholstered in natural canvas with Naugahyde legs – shows the designer's superb sense of proportion and understated comfort. The painted fiberglass-and-plaster sculpture is an early Manuel Neri.

Steel frames emphasize the symmetry of the windows here and in the dining room. Roman shades are heavy canvas. A dark-stained ceiling molding gives the room contour.

Palo Alto summers are hot and (mostly) fog free. Airy Mediterranean-inspired interior architecture is especially apt. John Dickinson's wisdom: keep the interiors crisp, cool, and calm.

authority that the rooms did not fall apart with the later addition of framed photography, an art deco clock, and Dr. Keoshian's noted collection of hand sculptures, plus stacks of books. ♦ "I never put my stamp on a room with styling," said Dickinson. "I don't plump pillows a certain way or fluff up the curtains. Then design becomes so ephemeral. Basic construction of a room should be where good design comes from — otherwise, it is not really style." ♦ Several tones of white were Dickinson's choice for the rooms' color. ♦ "The reason I prefer white in all its shades is that it does not draw attention to itself and you never tire of it," said the designer. "I can't use strong color with conviction because it draws attention away from line, proportion, and shape, precisely those qualities I admire in design. Anyway, I prefer not to base a room design on color or pattern. It's too obvious." ♦ John Dickinson always wanted to bring freshness and freedom to his work, but he was well aware that in design there is a fine line between originality and full-tilt eccentricity. ♦ The dining room is a simple room with no clutter, no color but tones of white, and pure, spare, soothing space. ♦ Entered through an elegant arched door, the room has four symmetrical windows with steel frames, a large white-lacquered table lined with bleached-oak, six bleached oak chairs with cotton canvas pillows, and a pair of marble consoles. ♦ With no color or texture to divert the critical eye, a monochromatic scheme must be perfect in every detail. Dickinson believed color was a cop-out.

Purity of line and precision of purpose: John Dickinson's reductive design for the white-on-white dining room includes a lacquered table and six beautifully delineated oak chairs, their subtle back curves and outlines influenced by Jean-Michel Frank. The chairs are solid, carved oak, and their splendid and substantial weight (moving them can be a two-person operation) is an important facet of their character.

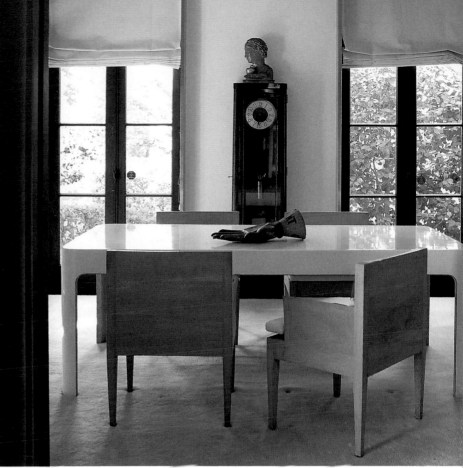

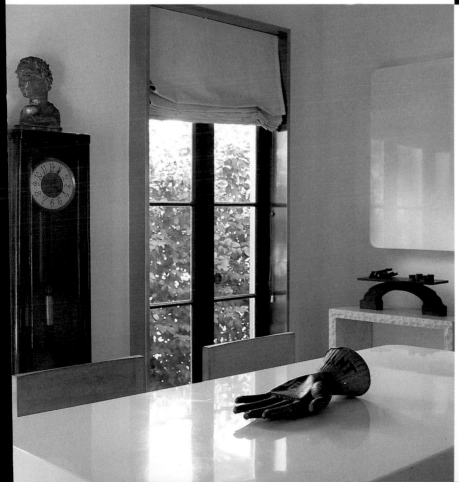

Windows, framed in stainless steel, have simple mid-weight natural canvas Roman shades. Dickinson found curtains "tiresome" and knew that in this rigorously pared-down room they would ruin his exact lines. Dickinson added dimension to the room and height to the windows by making the steel frame one foot higher than the top of the window and used the shades to cover the discrepancy. The antique French metal hand on the table is from Dr. Keoshian's extensive hand sculpture collection.

Instead, he attended to surfaces, edges, finishes, textures, and infinite tonalities of white so that his clients enjoyed luxury in craftsmanship and had the pleasure of his technical virtuosity. ♦ At one end of the room are a pair of console tables crafted with a "chipped" outer edge, as if they had been hewn in a quarry. An iron sculpture is by David Anderson. ♦ It was for the Keoshian house that John Dickinson first began experimenting with furniture with animal feet. The Keoshians' hand-carved wooden bed, with its swooping head and graceful lines, stands foursquare on feet that closely resemble lion paws. ♦ "The Regency or Egyptian influence was not in my mind at all when I first designed chairs and tables and a bed with animal feet," remarked Dickinson, who died in 1982. "Not at all. I was after something quite fetishy. I wanted a concept that would be very surprising. The mock primitive thing, the artificially primitive leg and foot idea is quite marvelous and had not been explored at all." ♦ Dickinson deliberately kept the carving and proportions somewhat artless. ♦ "Designers have usually taken something primitive and then refined it beyond recognition and that way you usually end up with something rather banal," he noted. "If you go the other way, as I did, you usually achieve a design that is very peculiar-looking but quite memorable." ♦ For the bedcover, Dickinson chose simple, box-stitched cotton. ♦ "You don't have to make a big production of everything in a room," noted the designer. "Draperies and bedcovers can be made in a very humble fabric but they must be made in the most Balenciaga way. Muslin curtains or simple, cotton-covered pillows can be the prettiest things in the world if they are sewn beautifully." ♦ John Dickinson did not put originality on a pedestal. Logic and function were the primary design goals of his 40-year career in design. In his opinion, proportion and good sense had to be satisfied before he could take liberties with design or head off for some artful exploration. ♦ The Keoshian house shows John Dickinson's logic and playfulness in action. Twenty-five years after he first started work on the house, it is possible to grant his design another virtue — timelessness.

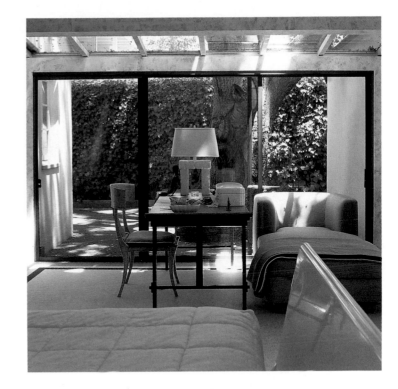

Greek themes: Curves of the metallic gray chair were influenced by the traditional Greek Klismos chair. Dickinson also designed the campaign desk and had it lacquered a subtle garnet color. The chaise longue, upholstered in gray wool, is soothed with a wool-lined throw. "Stonehenge" carved lamps were Dickinson's designs.

♦

The Keoshians' bed was hand-carved and given a glossy coat of white lacquer. The wood end tables and lamp were carved and painted to look like ancient stone. The two-tone gray carpet is outlined with a border of off-white and garnet.

John Dickinson's designs stand the test of time because he paid attention to every detail. His skill and daring and his experienced eye are especially evident in the Keoshians' bathroom design. ♦ The bathroom (carved out of a former bedroom) and the bedroom were redesigned in the mid-seventies and have been superbly maintained by the Keoshians. Remarkably, after 20 years the design still looks innovative, bold and uncompromising. Not one aspect of it looks tired or passé — certainly not the bath, the large-scale, brass-handled, white-lacquered cabinets, shades painted to match the walls, the wool draperies lined with white chintz, or the faux plaster walls. ♦ A steel tub, which stands in the center of this solacing room, is a perfect example of John Dickinson's use of somewhat utilitarian materials. He was able to make steel, plaster, industrial wool carpet, and white-lacquered surfaces seem utterly luxurious and desirable. ♦ The plumbing was carefully thought through. Hot water runs through pipes under the bath and through the towel rack to warm the metal. There is no water spout, simply a round outlet for the water to exit with considerable pressure. ♦ "It was important that the water should pour out with some authority," noted Dickinson. Tap handles in brass were made to look like gold nuggets.

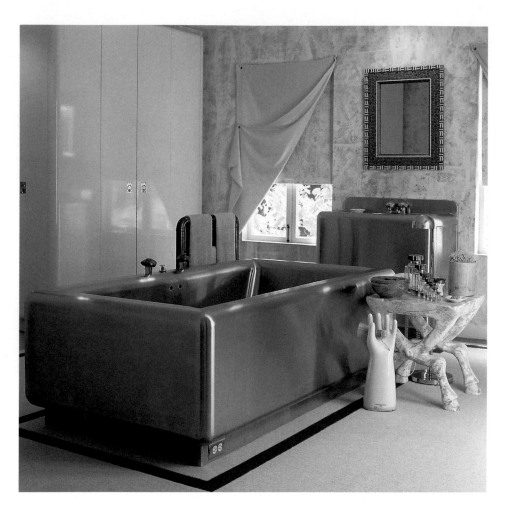

The renovated and redesigned bathroom, with its alluring steel bath and balanced proportions, is one of John Dickinson's most innovative designs. Perfectly symmetrical windows with wool-and-white-chintz, tent-flap draperies held back by grommets, a steel console hand basin, and a mirror with a hand-carved frame add to its pleasing alignment. Part of the appeal, too, is the juxtaposition of materials: wool carpet with steel; bronze with plaster; smooth, white lacquer cabinets with "distressed plaster" walls handpainted by Carol Lansdown. Beyond the closets and dressing area is a shower.

♦

To perfect the curves of the three-foot by seven-foot bath, Dickinson first had his metal craftsman create a sample corner. Welded immaculately and then given a silken polish, the seamless steel feels sensuous and luxurious. The animal-legged plaster table was an early Dickinson design, and is no longer produced.

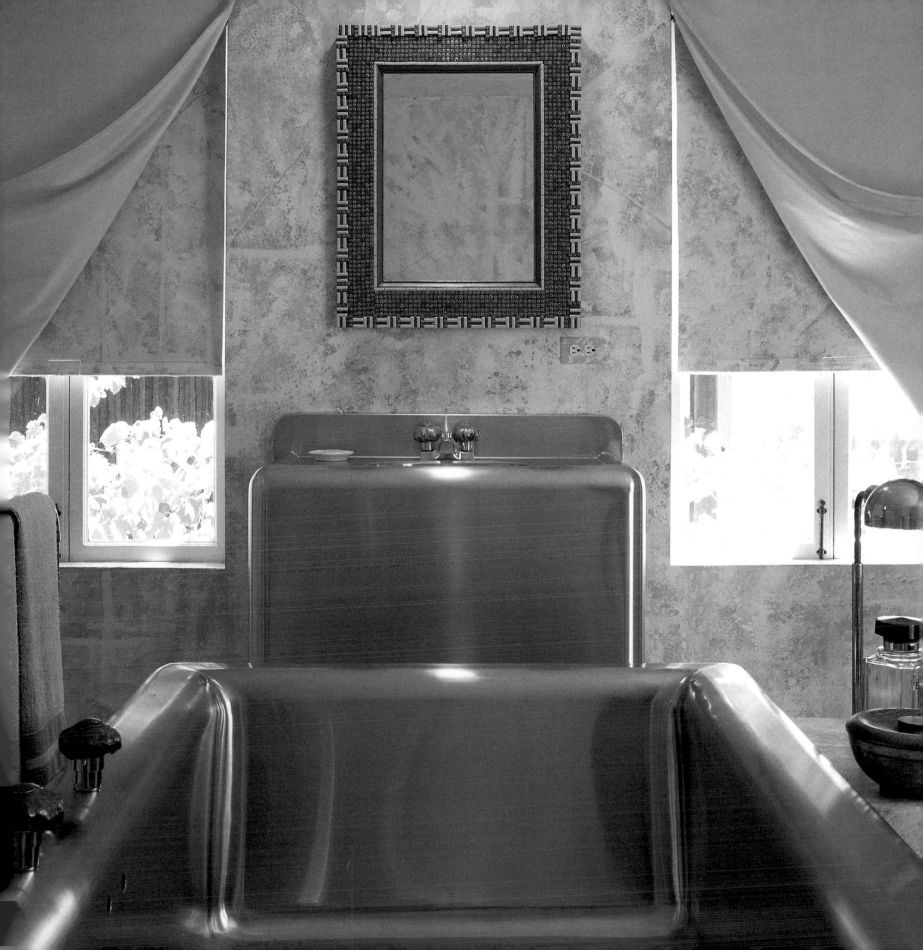

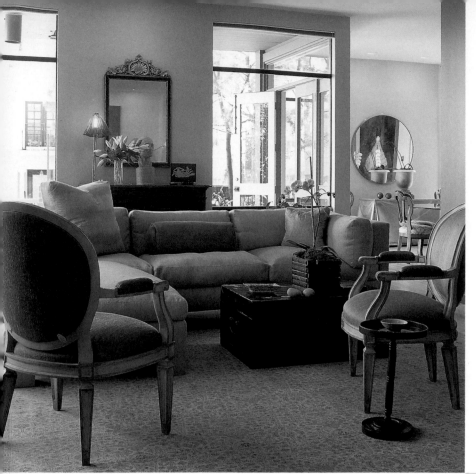

An Italian gilt-wood mirror, Kevin Walz's copper-

mesh-shaded steel lamp, and Japanese lacquer boxes

make a timeless composition atop an

Italian walnut chest.

◆

The silk-upholstered sofa with over-scale pillows

addresses the room and the art rather than the views

from corner windows. Custom paint colors were

designed by Donald Kaufman.

In the dining room, a brass-framed mirror hangs

above John Dickinson's signed, brass-banded,

galvanized metal table.

◆

Eight Italian fruitwood chairs upholstered with a

silvered taupe Fortuny fabric surround the

oxblood-red-lacquered dining table.

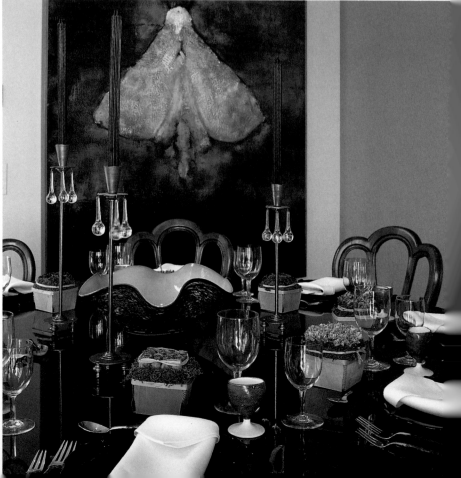

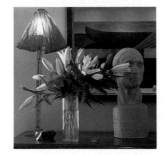

UNDERSTATEMENT IN DESIGN IS ALWAYS A CHALLENGE. ◆ WITHOUT FROUFROU, PATTERN, OR CLUT-
TER TO DISTRACT THE EYE, EACH ELEMENT IS EVIDENT AND EVERY DETAIL COUNTS. RIGOROUS EDITING
AND A SUAVE COLOR SCHEME MAKE THIS RUSSIAN HILL RETREAT THE PERFECT STAGE FOR SCULPTURE
AND PAINTINGS AND FOR GATHERINGS OF FAMILY AND FRIENDS. ◆ THE COSMOPOLITAN OWNERS DECIDED
FROM THE START TO KEEP THEIR DECOR UNPRETENTIOUS, CRISP, AND — ABOVE ALL — MODERN. SPARE,
WELL-PROPORTIONED ARCHITECTURE ALLOWED THEM TO TAKE THEIR OWN DIRECTION. ◆ WORKING WITH
SAN FRANCISCO INTERIOR DESIGNER SCOTT LAMB AND WITH NEW YORK PAINT DESIGNERS DON
KAUFMAN AND TAFFY DAHL, THE COUPLE PLANNED A MUTED COLOR SCHEME INSPIRED BY A REMARKABLE
NINETEENTH-CENTURY WOOL AND SILK AGRA RUG OF PALEST TAUPE, KHAKI, RASPBERRY, AND CREAM. ◆
SAND-COLORED, SLUBBED RAW SILK BY RANDOLPH & HEIN COVERS THE LARGE-SCALE, HIGH-BACKED BAN-
QUETTE AND TWO PAIRS OF LOUIS XVI-STYLE ARMCHAIRS IN THE 20-FOOT BY 32-FOOT LIVING ROOM. A
CHINESE LACQUERED PIGSKIN TRUNK AND A GILDED, CINNABAR-LACQUERED PEDESTAL TABLE ADD SUBTLE
PATTERN AND TONAL SHIFTS. ◆ THE PRECISION OF THE FURNITURE PLACEMENT PAYS OFF IN THE PLEAS-
ING GEOMETRY OF THE ROOMSCAPE, WHICH REVEAL THE FLAT'S GRACE NOTES. ◆ STRINGS OF PAPER
LANTERNS ARE LOOPED OVER A CLASSIC MURANO GLASS URN. AN ALBERTO GIACOMETTI ANATOMICAL
DRAWING IS PERCHED ON A METAL TABLE. SCULPTURE AND PAINTINGS BY STUDENTS (AND NOTED
CALIFORNIA ARTISTS) ARE CAREFULLY PLACED IN EACH ROOM. ◆ THE OWNERS AND DESIGNER WANTED
TO ACHIEVE A THOUGHTFUL, VERSATILE DESIGN THAT COULD ACCOMMODATE NEW PAINTINGS AND
SCULPTURE. WHAT THEY HAVE ALSO CRAFTED ARE ROOMS THAT WILL STAND THE TEST OF TIME.

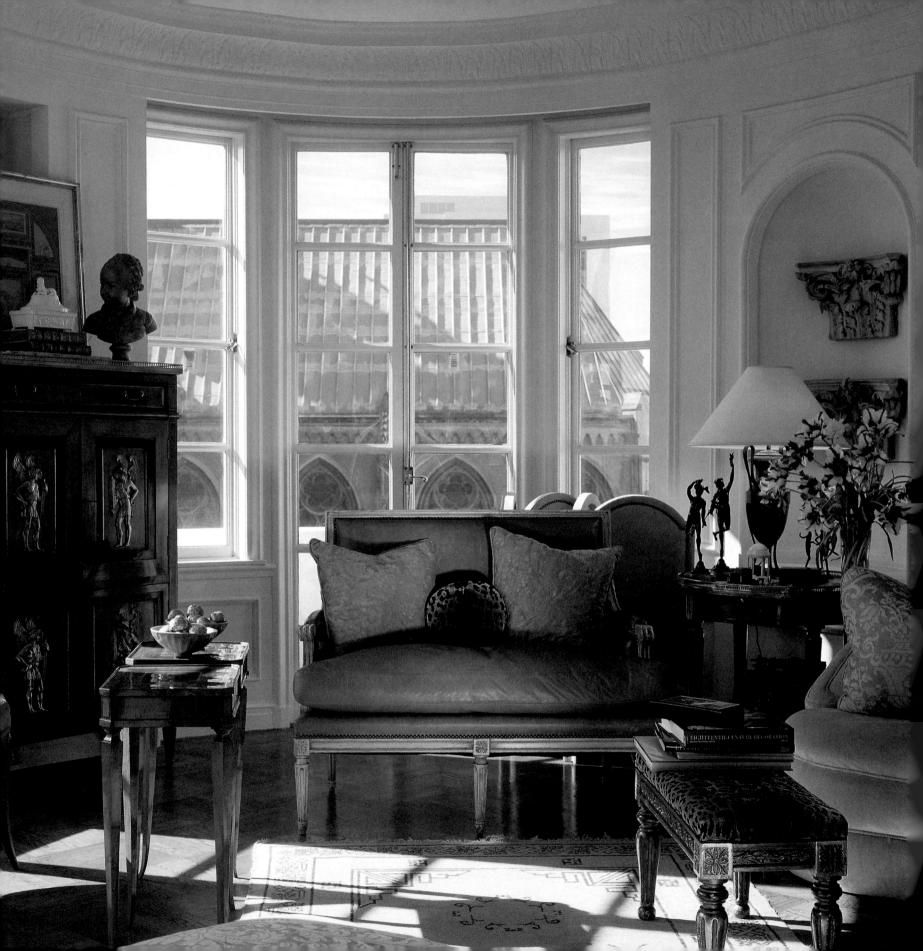

RUSSIAN HILL
PAUL WISEMAN'S APARTMENT

A T THE TOP OF A PARTICULARLY STEEP SLOPE ON NOB HILL STANDS ONE OF THE PRETTIEST AND MOST DISTINCTIVE BUILDINGS IN SAN FRANCISCO. BUILT IN THE EARLY 1920s IN THE FRENCH BEAUX ARTS STYLE, ITS CURVY BALCONIES AND ELABORATE, ORNAMENTAL METALWORK ARE A BIT OVER-THE-TOP. ON A CLEAR DAY, IT CAN LOOK RATHER LIKE A WEDDING CAKE, ALL SENTIMENTAL SCROLLS AND UNABASHED NOSTALGIA. IT'S THE PERFECT ANTIDOTE TO SAN FRANCISCO'S VICTORIANA. ♦ SUCCESSIONS OF STYLISH SAN FRANCISCANS HAVE LIVED THERE OVER THE DECADES. THE SYCAMORE-SHADED STREET IS WITHIN WALKING DISTANCE OF RESTAURANTS AND CLUBS AND, OF COURSE, OTHER CHIC CHUMS' APARTMENTS AND HOUSES. ♦ WHEN INTERIOR DESIGNER PAUL WISEMAN MOVED HERE IN 1988, HE WAS PARTICULARLY DRAWN TO THE OVAL LIVING ROOM. THE APARTMENT, WHICH MEASURES A NEAT 1,000 SQUARE FEET, IS JUST THE RIGHT SIZE FOR AN IN-DEMAND DESIGNER WHO IS OFTEN FLYING OFF TO MEET CLIENTS IN MONTANA, HAWAII, CHICAGO, LONDON, AND NEW YORK. ♦ WISEMAN HAS A PARTICULAR PENCHANT FOR THE POST *ANCIEN REGIME* DIRECTOIRE PERIOD, AND MOST OF HIS FURNITURE AND OBJECTS ARE IN THAT NEOCLASSICAL MODE. ♦ IN THE WANING YEARS OF THE EIGHTEENTH CENTURY, THERE WAS STILL AFFECTION FOR LOUIS XVI'S VANISHED WORLD, BUT PARISIAN FURNITURE MAKERS, ARTISTS LIKE DAVID, AND FRENCH AND ITALIAN CRAFTSMEN EMBRACED AN IDEALIZED VIEW OF ANCIENT GREECE AND ROME. BONAPARTE HAD YET TO CONQUER EGYPT, MONEY WAS TIGHT, AND POMP WAS NOT IN STYLE. DESIGN WAS

Harmony with history: Stately gothic Grace Cathedral looms large just outside Paul Wiseman's living room windows. He likes to join his guests at the windows and view landmarks like Coit Tower, the Pacific Union Club, the Fairmont Hotel, Alcatraz, and the Bay. Alluring, too, are Wiseman's Empire walnut secretary with brass appliqués of mythological warriors and an Italian neoclassical painted settee whose curves mimic the lines of the oval room.

♦

Golden glow: Wiseman had the walls glazed a very subtle, tone-on-tone, buttery-yellow color. The work was executed by Evans & Brown. Since no one can see into the windows of the 20-foot-long room, and the views are nonstop, the designer left them bare. The rug is a Samarkand.

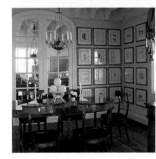

Design is clearly Wiseman's vocation and avocation. The dining room walls are a gallery for his collection of framed, hand-tinted engravings of French furniture designs, published by J. Taylor, London, England, in 1805. The designer mounted a pair of antique faux bois doors on the wall, and added mirrors to bring in light and increase the apparent size of the small room. Six neoclassical Italian fruitwood chairs surround an Italian fruitwood dining table. The English neoclassical tole-and-brass chandelier is not electrified.

somewhat chaste, all perfect proportions and pleasing symmetry. ♦ "I wanted the rooms to have a feeling of antiquity without exactly mimicking the post–Louis XVI decades," said Wiseman. "Nothing is shiny. The paint is crackled, the brass is dull, the metals are misty, the tole is rusted. The fabrics are a bit faded. Nothing is too perfect. There's a sense of decay and age and use, and I like that." ♦ Wiseman's criteria for furniture selection are strict. "It has to be beautiful, and then it has to be the right proportion, and it has to work both in a decorative and a practical sense," he said. ♦ Wiseman moved into the apartment in 1988 with just his bed, a Samarkand rug, his handsome secretaire, and the Italian bench. ♦ "I wanted to let the rooms evolve. I had everything I needed, so I was in no hurry," he said. "It's the opposite of instant decorating. Start with what you love and slowly find other pieces that are appropriate. You have interests, a life, and your rooms should reflect that honestly." ♦ Wiseman, who grew up in an 1860s Victorian in the Sacramento Delta, said he is happy with the way his apartment looks now. ♦ "I often meditate on the floor of the living room first thing in the morning," he said. "The sun angles in, and the room is all shimmery and bright. I'm at the highest point of the hill, so I can see out, but no one can see in. It's private and perfect." ♦ Later he will take his breakfast out on the fire escape overlooking Chinatown and the Bay. ♦ "Up here on Nob Hill, I always have a sense of the weather changing, the surrounding architecture, and the movement of ships and ferries and fog on the water," Wiseman said. "My apartment and the cityscapes outside are a miniature world of San Francisco."

Restrained color: Colorful Dutch tulips are in marked contrast to Wiseman's muted color scheme. On the French game table, he has arranged an English tole lamp, his collection of antique tortoiseshell objects, and Roman-style bronzes on ochre marble bases. In the niche, a pair of nineteenth-century painted Corinthian capitals.

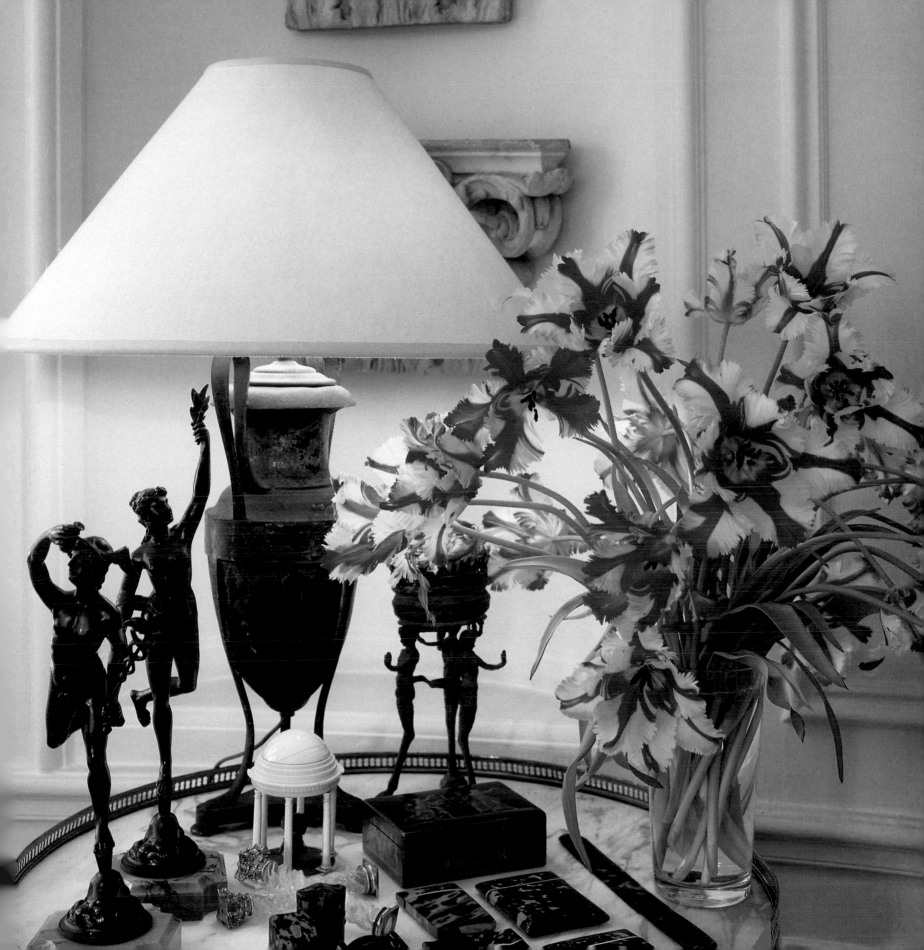

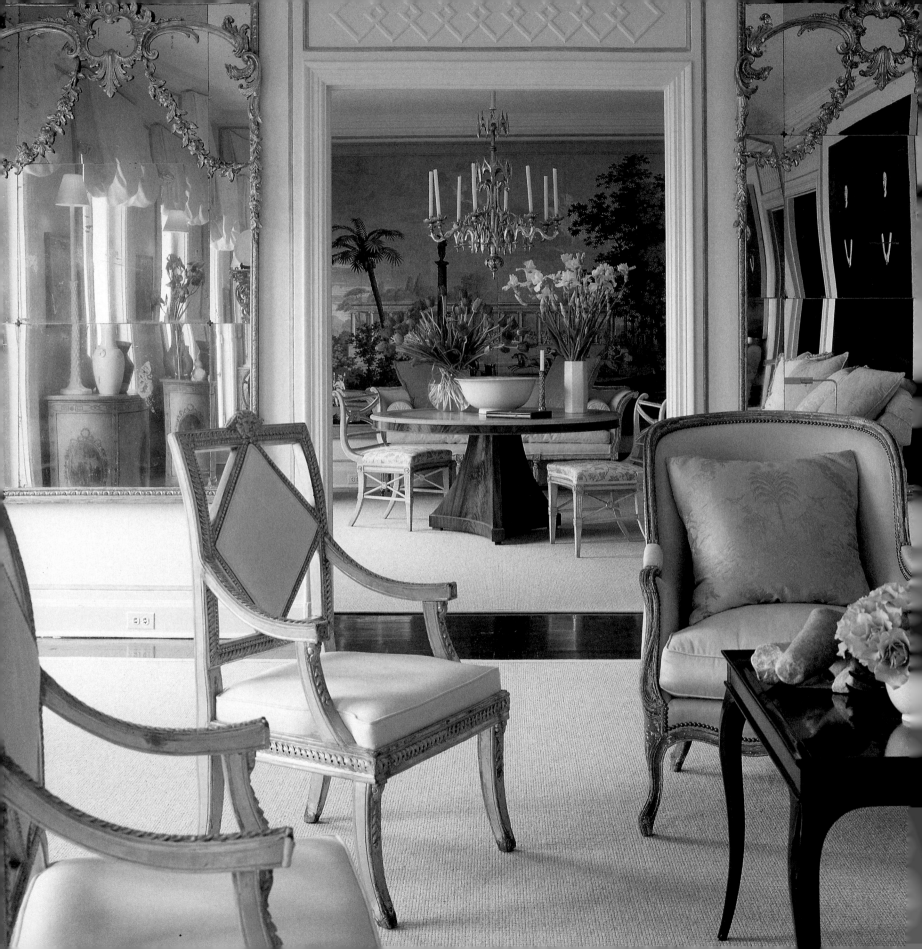

IN HIS DISTINGUISHED THREE-DECADE CAREER, CUBAN-BORN ORLANDO DIAZ-AZCUY HAS DESIGNED EVERYTHING FROM OFFICE CHAIRS, FABRICS, DESK ACCESSORIES, ELEVATOR CALL BUTTONS, TABLES, OFFICES, UMBRELLA STANDS, AND STORES TO INTERIORS FOR ELEGANT CITY APARTMENTS, COASTAL RETREATS, AND GRACIOUS COUNTRY HOUSES. HE HAS EARNED DEGREES IN LANDSCAPE ARCHITECTURE, ARCHITECTURE, AND CITY PLANNING. ♦ WHEN HE SET UP HIS OWN SAN FRANCISCO FIRM, ORLANDO DIAZ-AZCUY DESIGNS, SEVEN YEARS AGO, MANY WHO HAD OBSERVED HIS SLEEK COMMERCIAL DESIGNS FOR GENSLER & ASSOCIATES IMAGINED THAT THE SIGNATURE STYLE OF HIS COMMISSIONS WOULD BE SIMILARLY RIGOROUS, PARED-DOWN, AND CLEAN-LINED. ♦ IN FACT, DIAZ-AZCUY'S WORK IS RICHLY DETAILED, REFERENTIAL, AND RATHER ROMANTIC. DIAZ-AZCUY SAYS HE IS A CLASSICIST AT HEART, CHOOSING A RATIONAL APPROACH RATHER THAN MAJOR DESIGN STATEMENTS. HE'S NEVER BEEN A DESIGN EVANGELIST, PREFERRING TO OFFER CLIENTS LOW-KEY, COMFORTABLE, AND TIMELESS DESIGNS. HE DOES NOT BELIEVE IN FOISTING HIS EGO ON HIS WORK. IT'S A CANNY APPROACH, OF COURSE. MOST CLIENTS – COMMERCIAL OR RESIDENTIAL – ARE NOT LOOKING FOR DRAMA, FAST-DATING TRENDY DESIGN, OR CONTROVERSY. ♦ "A LOT OF PEOPLE THOUGHT THAT WHEN I OPENED MY OWN DESIGN STUDIO I WOULD SET OUT TO SHOCK," HE SAID. "NO, THAT'S NOT ME. SHOCK HAS BEEN A METHOD FOR THOSE WHO HAD TO ESTABLISH THEMSELVES IN 24 HOURS. THAT'S FINE. BUT EVEN THEY EVENTUALLY DO THEIR LEAST-SHOCKING AND MOST-LASTING WORK. IF I HAVE A SIGNATURE AT ALL, IT'S THE RICHNESS OF MY MATERIALS AND FINISHES, BUT THE LOOK IS ONE OF SIMPLICITY," SAID THE DESIGNER. "MY WORK HAS ALWAYS BEEN VERY CAREFULLY CONSIDERED, BUT I CAN'T PRODUCE A ROOM OR PIECE OF FURNITURE THAT DOESN'T HAVE

Restraint is the key: In the living room, which has expansive views over the Bay, Diaz-Azcuy's attention to detail is evident in every trim, group of Ming porcelain, and down-filled pillow. Behind the gray cotton damask pillows on his custom-designed Marco sofa, he hides tasseled Chinese silk sachets of Agraria potpourri, which subtly scent the room. The pair of gilded eighteenth-century neoclassical Neapolitan chairs is upholstered in simple white linen.

some emotional content. The mechanical parts must work, and I want to feel excitement and experience some poetry." ♦ In Diaz-Azcuy's commercial work, he sought to humanize offices and commercial spaces. He saw the possibilities of luxury and charm, introducing Chinese screens and antiques, along with pretty colors, to institutional interiors. ♦ "It was shocking for people, at first, to see Fortuny fabrics in commercial interiors. In the eighties, I'd put gilt mirrors in lobbies, give a desk a *faux marbre* finish, and use pink and pastels when they were still considered 'sissy' colors. Now, of course, pink is a cliché, but I still like to soften a serious room with rich fabric or fine detailing," he said. ♦ Never a proponent of art-for-its-own-sake, Diaz-Azcuy's designs tend to show his appreciation for the history of design, without getting stuck in the past. Clean lines, smooth silhouettes, and comfort — along with a shake of extravagance and exaggeration — are his trademarks. ♦ "Simplicity and humility are the design qualities I admire most," he said. "Low-key, understated design is the basis of my designs and doesn't have to be boring, especially when it's done with a twist. With the background meticulously planned, a room then needs a sense of humor, luxury." ♦ Diaz-Azcuy also likes to seduce the eye with antiques of surpassing beauty — introduced into his rooms with a certain gravity and great confidence. ♦ When he moved into his City apartment in 1982, Orlando Diaz-Azcuy took a carefully measured approach to designing the rooms. "I have very strong respect for traditional architecture and furniture," said Diaz-Azcuy. "Rather than gut the apartment to make it look contemporary, I wanted to maintain the classic 1913 beaux arts interiors. These rooms have great merit. Everyone who has lived in this building has appreciated it and maintained it." ♦ He decided to take his time, and only 11 years later was he satisfied with the completed rooms. "I looked in Paris, London, New York, and San Francisco and bought only antiques I love," said the designer. "Pieces in my house have value and style, but I didn't want anything pretentious." ♦ In the living room and hallway, he juxtaposed French, Italian, and Chinese antiques with contemporary art. "I don't like rooms that are a painstaking, historical recreation of a period," he said. "Contrast and counterpoint in design always appeal to me. It's much more interesting to upholster an elaborate chair with plain white linen or place a rather severe contemporary painting above a sofa with a baroque damask pattern." ♦ He was fortunate, too, to discover a rare pair of Louis XVI trumeau mirrors, fresh from a Paris auction, at a San Francisco antiques dealer's. Beautifully detailed — and weighty — they are supported on the walls by steel brackets. ♦ Diaz-Azcuy said that over the years he has appreciated the setting of the building, in a garden on one of the few flat blocks on Russian Hill. ♦ "It's like a house rather than an apartment," the designer said. "The proportions of the rooms are gracious, and all are very light. At night I can watch the lights flickering on Alcatraz or see ships sail beneath the Bay Bridge."

Diaz-Azcuy gave his rather sedate dining room snap and crackle with armfuls of flowers, fresh from his country house in Freestone, Sonoma County. The vases stand on a neoclassical dining table with a sienna faux marbre top by Dennis King. The custom-framed nineteenth-century grisaille wallpaper panels from a mansion near Versailles depict Greek festivals and athletic games. The eighteenth-century white-and-gold, Swedish neoclassical chairs, upholstered in vintage Fortuny fabric, were from Ed Hardy Antiques.

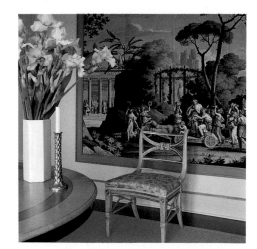

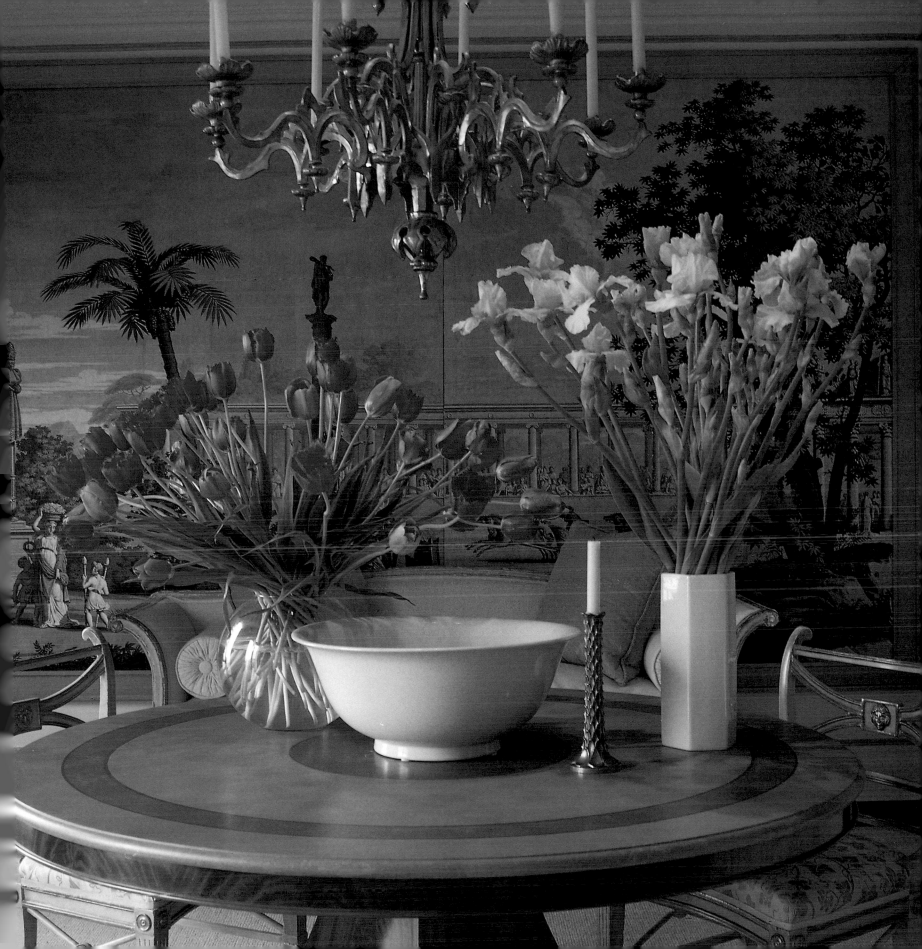

In Diaz-Azcuy's cool and calm bedroom, his George II gilded side chairs blaze like candles on a birthday cake. The bedspread and bed head are upholstered in silks and linens from Henry Calvin. A handsome, rare George II chest-on-chest stands against the wall facing the bed, all the better for the designer to admire it from beneath his white linen sheets.

Clearly, Diaz-Azcuy frowns on clutter. His bedroom is orderly, monochromatic, and deliberately devoid of distraction. Few signs of the twentieth century intrude upon the timeless mood. Appropriately, this room overlooks a neatly groomed garden, so the green view, too, is soothing. ◆ All day Diaz-Azcuy is surrounded by drawings, pattern, hubbub, and minutely measured decisions, so he has created for himself the perfect refuge from a design-mad world. With simple linen draperies to keep out sound and light, bare ebonized hardwood floors, tufted bed head and walls upholstered in beige linen, the room is at once monastic and utterly luxurious in its simple pleasures. ◆ Diaz-Azcuy's love of fine finishing is evident here, too. ◆ Full-length linen draperies are edged with a cordon of tone-on-tone, beige Fortuny fabric. His linen bed skirt is box-pleated so that the fabric will sit flat but not appear skimpy. Ornate gilded chairs were newly upholstered in a practical, modern, cream wool fabric that Diaz-Azcuy designed for HBF, which sells textiles primarily for commercial use. ◆ The designer is particularly partial to grisaille, a painting or printing technique that builds up dynamic effect using only a range of gray tones and off-white. On his bedroom walls, he has placed three eighteenth-century French grisaille panels depicting seasons, which were originally made as overdoors for a mansion near Versailles. Working in grays and ivory, the artist has nonetheless attained a three-dimensional relief effect. In certain lights, the framed panels look like highly detailed carved marble.

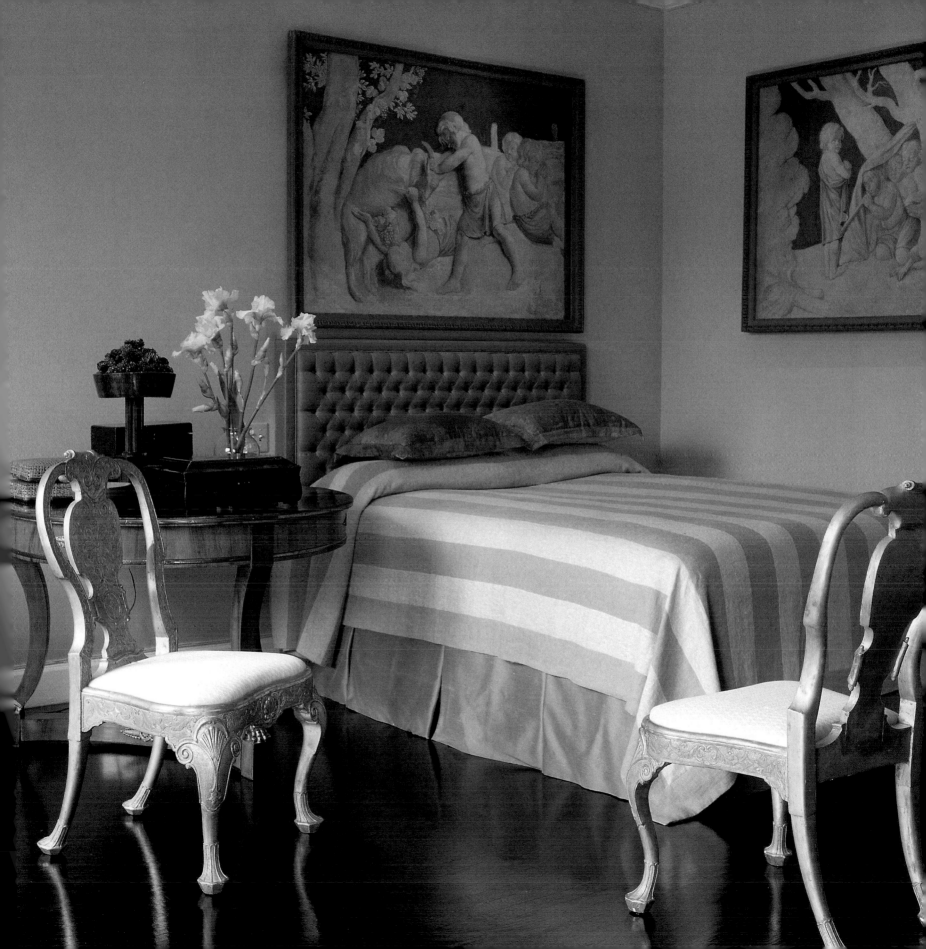

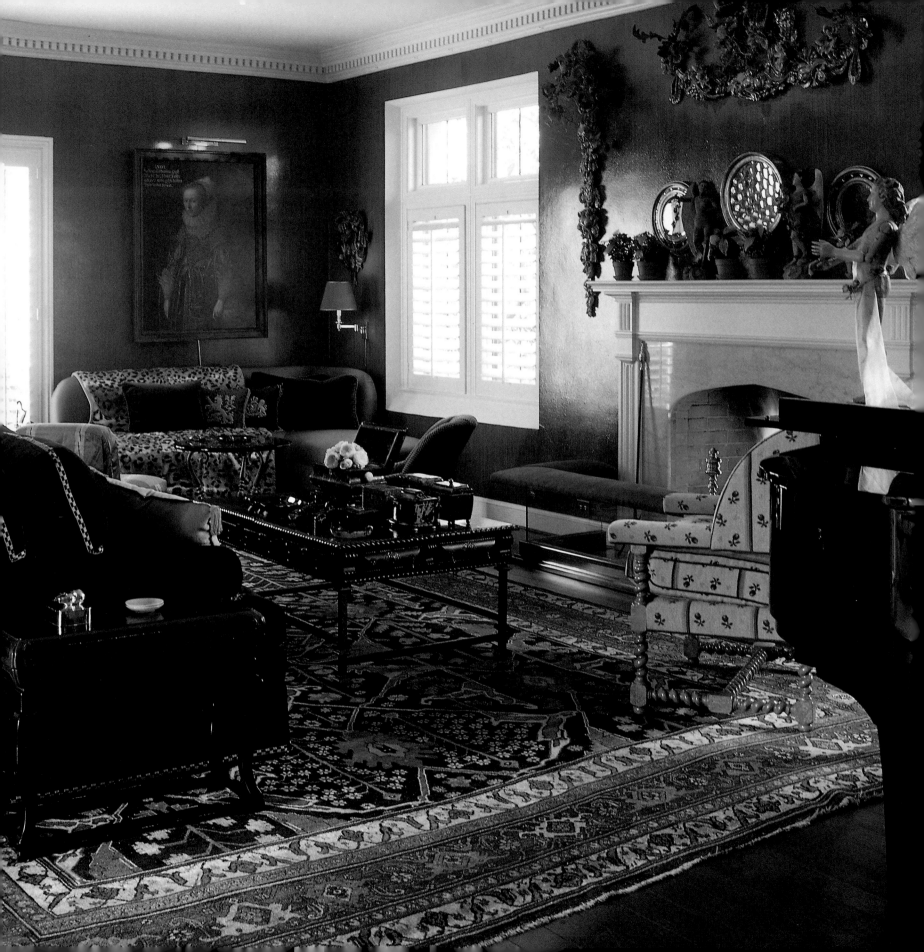

RICHARD AND KAYE HEAFEY'S GLAMOROUS HOUSE HIGH IN THE OAKLAND HILLS, DESIGNED BY MICHAEL VINCENT, IS PERFECT PROOF THAT DECORATORS DO THEIR BEST WORK FOR BRIGHT, DECISIVE, OPEN-MINDED, AND IMAGINATIVE CLIENTS. ALL THREE SAW THE SIX-YEAR RENOVATION AND REDESIGN OF THE HOUSE AS A COLLABORATIVE EFFORT. THE HEAFEYS ENCOURAGED VINCENT, AND THEIR DECORATOR PULLED OUT ALL THE STOPS. ♦ THE DECOR OF EACH ROOM IN THE HEAFEYS' 1935 HOUSE IS INVENTIVE, COMFORTABLE, AND HIGHLY INDIVIDUAL – THE OPPOSITE OF SUPERFICIAL, FAST, FORMULA DESIGN. THE FURNISHINGS ARE ELEGANT AND ROMANTIC, YET STILL PRACTICAL FOR A FAMILY WITH THREE CHILDREN AND FAMILY PETS. EACH CHAIR, CHANDELIER, CONSOLE TABLE, AND CARPET WAS HAND-PICKED OR CUSTOM-MADE TO GIVE MAXIMUM PLEASURE. ♦ "KAYE AND RICHARD GET THE VERY BEST OUT OF ME," SAID BERKELEY-BASED VINCENT, WHOSE INTERNATIONAL DESIGN CAREER SPANS MORE THAN 40 YEARS. "THEY ARE ALWAYS OPEN TO NEW IDEAS AND VERY WILLING TO EMBARK ON SOMEWHAT COMPLEX PROJECTS, SUCH AS ADDING A LOGGIA OR GLAZING THE WALLS OF THE LIVING ROOM. KAYE IS ALWAYS REMARKABLY DIRECT ABOUT WHAT SHE WANTS, CLEAR IN HER VISION FOR THE HOUSE, AND WILLING TO CONSIDER SLIGHTLY 'ODD' COLORS AND OUTRÉ ANTIQUES." ♦ VINCENT NOTED THAT HIS MOST SUCCESSFUL ROOMS RESULT WHEN A CLIENT DOES NOT TRY TO DILUTE OR SAVAGE HIS DESIGN. THE HEAFEYS ALWAYS SAW THE BIG PICTURE, SUPPORTED HIS VISION, AND NEVER NIGGLED ABOUT PETTY DETAILS LIKE PILLOW TRIM OR A LAMPSHADE. THEY WERE ALSO DECISIVE IN THEIR CHOICES AND NEVER DITHERED, HE SAID. INDECISION CAN BE THE DEATH OF DESIGN. ♦ THE HEAFEYS PURCHASED THEIR HOUSE IN 1977. IN 1988, THEY COMMISSIONED MICHAEL VINCENT. ♦ "I LIKED MICHAEL'S DESIGN CONCEPT OF 'SANTA

Rich flavors: Interior designer Michael Vincent is a master at mood-setting with unusual colors. There's nothing insouciant here. Vincent selected a delicious aubergine/raspberry glaze for the living room walls, and luxe black silk velvet with gold braid trim for the roll-arm sofa. The large silk rug, friendly to bare feet, is an antique Persian Bijar with tree-of-life patterns. In the late afternoon, sun streaks into the room through white-painted plantation shutters. For evening gatherings, the Heafeys dim the lights and light candles.

Well-positioned: Kaye Heafey's collection of antique English tortoiseshell tea caddies and musical instruments found in England and Canada are displayed on the coffee table. In one box: a sweetly scented bouquet of creamy-pink heirloom roses. The foliated, scroll-arm brass wall sconces in the dining room have silver shades with giddy, ruby-beaded trim from Tail of the Yak.

On the stone-topped, eighteenth-century Italian neoclassical console table, Kaye Heafey stands an antique French boulle liquor case with Baccarat glasses and decanters. Flowers arranged by Carrie Glenn.

Barbara in the Forties' — a cosmopolitan mix of furnishings with rather Mediterranean architecture — from the beginning and never wished to lose the impact of his overall plan," said Kaye, who recently initiated a Sonoma County business growing special flowers like clematis for the flower trade. Her husband is a noted attorney. ♦ "Michael read what we wanted perfectly," said Kaye. "He knew we like to entertain, but we wanted our children to feel welcome in every room. Once he presented a plan and outlined a specific idea, we never deviated. If he thought a large, black-velvet-upholstered sofa was right for the living room, he would dream up a final flourish of checkered trim on the pillows. If we couldn't find just the right table or bookcase, he would custom-design one for us. It was his idea to make a coffee table for the living room from a Georgian-style mahogany library tabletop set on new, custom-made metal legs." ♦ Vincent, for his part, was so inspired by his clients that he obsessed about every detail. ♦ "Michael is so knowledgeable about fabrics and colors, and we benefited from his years of experience. He found a French woven wool in mauve with gold bee motifs for our headboard and luscious raspberries-and-cream silk velvet for the dining room chairs," said Kaye. "Our rooms have a certain formality, but there's a feeling that we or our dogs and cat could put our feet up on the sofa. The children love the house and can't bear the thought that we might one day sell it. That's not going to happen for a long time." ♦ After living in their house for ten years, the Heafeys knew exactly what they wanted in the redesign. They liked rooms with a certain formality, and furniture with grace and presence, but they did not want the rooms to feel stuffy or too grand for the children. ♦ "Michael would always suggest the mood of a room first," said Kaye. "He would decide that the loggia would be Portuguese/Indian and then create the look with a Portuguese rosewood settee, an ebonized and rather Indian-looking mirror, an eighteenth-century portrait of a Portuguese grandee from the Cuzco school, and lion heads on the

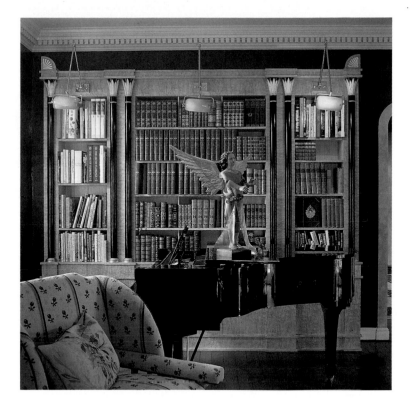

A carved and polychromed Central American wood angel from Tail of the Yak stands on the Yamaha piano. The burlwood bookcase was custom-made by Aaron Crespi.

stone console. He's expert at building up a feeling. It's rather like building a stage set, but the result is not at all artificial. This is a house that really works." ♦ For the Heafeys' drop-dead-glamorous bedroom, Vincent set the tone with an Aubusson rug, a tufted headboard inspired by Syrie Maugham, and a remarkable, palest lavender, gilded leather-topped desk with Lucite ball feet, inspired by a table by Jean-Michel Frank. Full silk *cloqué* draperies in pale ecru soothe a wall of windows. Vincent designed a pair of bedside tables as a pair of leather-bound, ultra-elegant thirties traveling trunks, complete with shelves and handles. ♦ "Throughout the year, the house feels very comfortable," said Kaye. "It was the first house on the block and got the pick of sites for beautiful day-long light." ♦ From every window, there are views of the garden where rhododendrons, lilies, and wisteria paint Renoiresque scenes in spring. The Heafeys keep a kitchen garden and a small herb garden. Three canaries live in an Eric Lansdown—designed octagonal birdcage, complete with a copper cupola. ♦ "Michael's plan for the dining room was for the colors and fabrics and the French chandelier to look marvelous in candlelight," said Kaye, who loves to set a formal table. "We liked the Clarence House art deco fabric he chose for the draperies because dashes of gold give it a certain glamor but it's not obvious. The black- and burgundy-etched taupe fabric is subtle and I can't imagine ever tiring of it." ♦ The Heafeys are especially pleased with a gilt-framed, eighteenth-century Peruvian painting from the Cuzco school of the Madonna and angels, which is shown to advantage on the moss-green-glazed dining room walls.

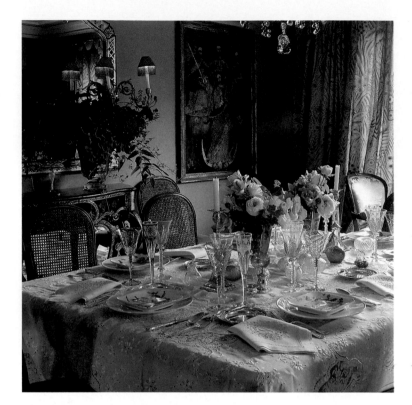

Kaye Heafey sets her dining table with an antique, embroidered-linen tablecloth, antique linen napkins embroidered with a cartouche, festive Venetian glasses and Tiffany's "Audubon" sterling silver. Caned Louis XV side chairs have silk-velvet-upholstered seats. Flowers by Carrie Glenn.

♦

Heirloom roses arranged in crystal vases give the Heafeys' table great allure. Best of all, collections of Italian crystal fruit, Murano flutes, antique silver, and neoclassic crystal-and-silver candlesticks make this a joyful and memorable setting.

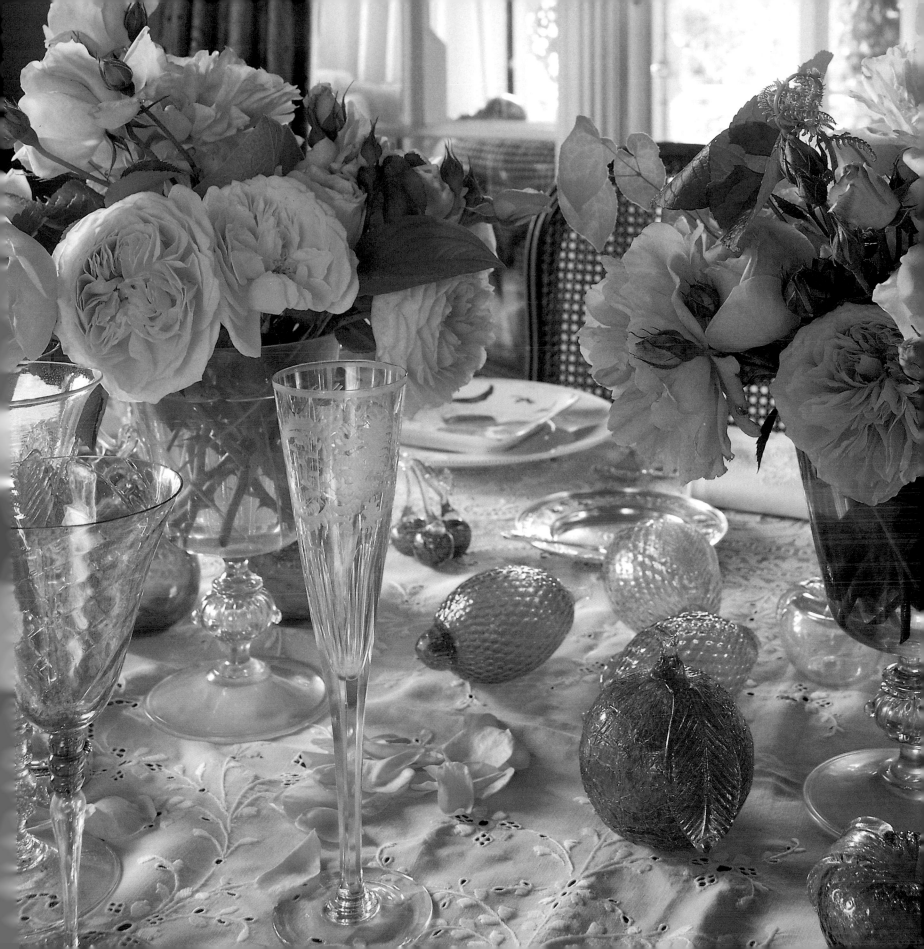

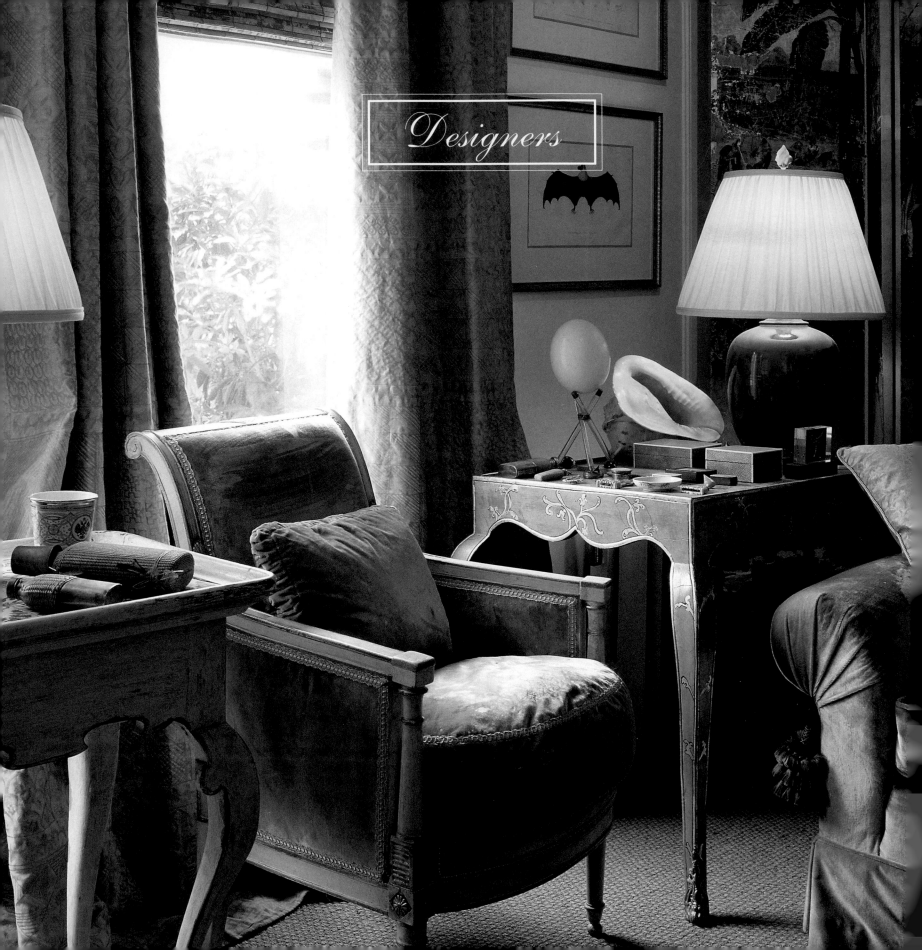

In decades past, San Francisco interior designers were benign design despots. Daunting style arbiters and erudite educators, they ruled unchallenged and left quaking amateurs in the dust. The decorators' ideal was to impose good taste on the client — whether it was desired or not. And so the very finest rooms in San Francisco were decorated from crown molding to sconce to baseboard and from ottoman to console table by great talents such as Michael Taylor and John Dickinson. Alas, the masters have flown to decorator heaven. Years have gone by. Times have changed. ♦ Even designers as grand as Anthony Hail are no longer dictators. Instead, they interpret the zeitgeist, defer (sometimes) to their clients, and recognize that over-the-top decorating is as dead as the dodo. ♦ The best San Francisco designers today are individualists. Rejecting theme design, bombastic decor, checkbook decorating, and overly elaborate finishes and fabrics, they opt instead for appropriateness, originality, even comfort. ♦ No one style dominates. Rooms may be spare and understated or rich with texture and historical allusions. Or they may be as loose as a summer day, all sunshine, transparent colors, and delights for the eye. Best of all is the house or apartment with a masterly mix of furniture and collections. Each room has genuine charm. The decor is as personal as a portrait. Decorating has come a long way.

The Directoire chair, left, is upholstered in silk velvet. Beneath a pair of Thomas Bennett's beloved bat prints, he shows conchological specimens on a gilded, cerulean blue, cabriole-leg table, a copy by Camparo of a Louis XVI occasional table he had admired.

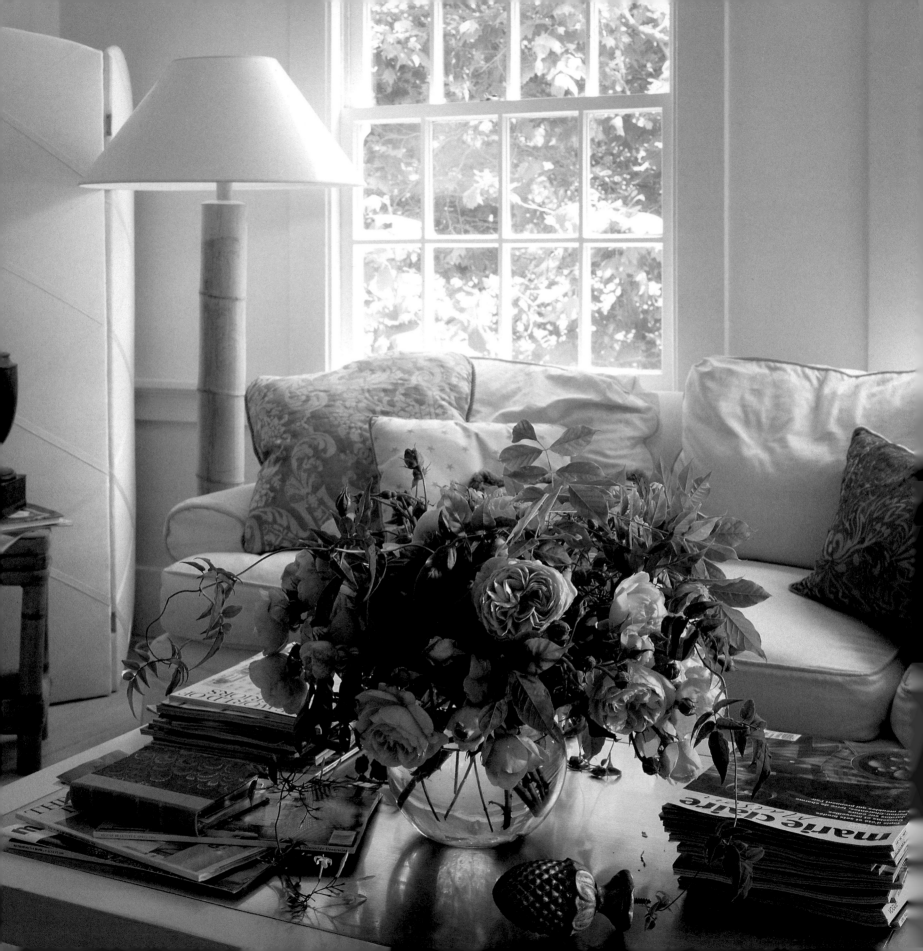

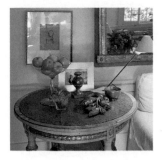

Ⅰ N THE 17 YEARS HE HAS LIVED IN HIS BERKELEY APARTMENT, INTERIOR DESIGNER STEPHEN SHUBEL HAS CHANGED THE DECOR AT LEAST 25 TIMES. "I LIKE EXPERIMENTING WITH ROOMS, AND I GET BORED WITH THE ARRANGEMENT OF MY OWN ROOMS AFTER THEY'RE SET UP. DESIGN, FOR ME, IS AN ONGOING INQUIRY, NOT SOMETHING CAST IN STONE," ADMITTED THE DESIGNER, WHOSE SIGNATURE STYLE IS FRESH AND AIRY, NEVER POMPOUS OR TRENDY. "FOCUSING ON MY OWN APARTMENT, I CAN WORK OUT IDEAS, CHECK ON PAINT COLORS, LIVE WITH MY CONCEPTS, AND SEE THEIR EFFECTS. I ALSO WANT TO GET MY IDEAS OUT INTO THE WORLD." ♦ EVERY FEW MONTHS, IN HARMONY WITH THE SEASONS, A NEW PALED-DOWN PAINT COLOR TINTS HIS WALLS. ♦ "LIVING IN CALIFORNIA, EVERYTHING IS IN FLUX ANYWAY," NOTED SHUBEL. "CALIFORNIA'S ONLY TRADITION IS CHANGE. MY URGE TO KEEP MOVING FITS RIGHT IN." ♦ SHUBEL'S IMPETUS TO REFASHION HIS APARTMENT IS FUELED BY HIS FREQUENT TRIPS TO EUROPE. "I SET OFF TO PARIS OR L'ISLE-SUR-LA-SORGUE AND COME HOME WITH MANY NEW IDEAS TO TEST — PLUS FUR-NITURE AND BOXES OF FLEA-MARKET FINDS," HE SAID. "OUT GO MOST OF THE OLD ACCESSORIES. EVERY ROOM GETS A NEW LOOK." ♦ THE KEY FACTORS THAT ALLOW SHUBEL TO PERFORM HIS DECORATING LEG-ERDEMAIN ARE THE SUBTLE SHADES-OF-WHITE OR CREAM-PAINTED WALLS OF HIS LIVING ROOM AND DIN-ING ROOM, AND THE BEAUTIFULLY CALIBRATED EDWARDIAN ARCHITECTURE OF THIS 1919 BUILDING. HE HAS A NEUTRAL CANVAS, AND HE MAKES THE MOST OF IT. FORTUNATELY, WOODY BIGGS, HIS ROOMMATE, IS NOT SHOCKED BY THE ROOMS' MOOD SWINGS. THE APARTMENT, HIGH IN THE BERKELEY HILLS, HAS DAY-LONG SUN ON THREE SIDES. SHUBEL DOES NOT SEE HIS WINDOWS AS A DESIGN OPPORTUNITY. RATHER HE LEAVES THEM BARE, THE BETTER TO EMBRACE THE LIGHT THAT BOUNCES OFF THE BAY.

The one constant in Shubel's changing roomscape is the easygoing sofa. The silver-leaf-topped "Paris" table is by
Donghia. A Louis XVI chair upholstered in linen damask completes the scene. One virtuoso piece can
make a room. Here, a painted and gilded antique Swedish table with a green marble top is topped with a slim-line
adjustable lamp and an architectural fragment. On the wall hang drawings of chairs by a Parisian decorator.
Shubel's obsession: stacks of design books.

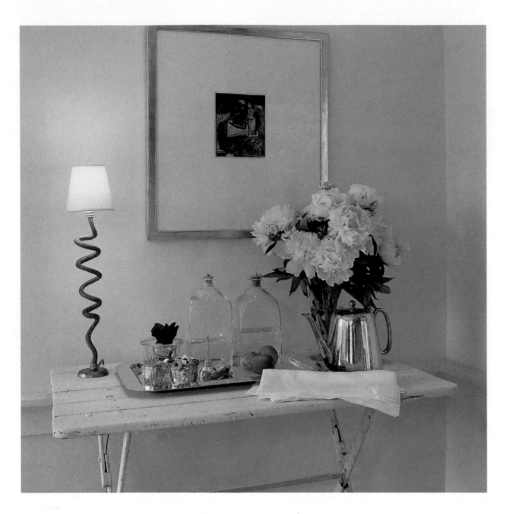

Shubel's classic custom-made sofa in the living room has been reupholstered four times and Shubel keeps three plain, woven slipcovers at hand, like changes of clothing. ♦ "I never use pattern in my apartment because it calls attention to itself and upstages everything," noted the designer. "I also find pattern very distracting. It gets in the way of furniture and destroys the line." ♦ Instead, Shubel likes simple, honest fabrics like cotton sailcloth, white linen, cotton twill, and natural canvas. He is particularly intrigued by the juxtaposition of these unpretentious textiles with elaborate gilded antiques and elegant Fortuny pillows corded in a rather ornate fashion. ♦ "Using plain fabrics gives me much more latitude to improvise and move everything around spontaneously," Shubel said. "In all my 25 years of decorating I have never tired of good, basic cottons. I'd rather spend my decorating budget on an unusual antique or good books than on delicate fabrics that are going to wear out."

A bar table can be a simple affair — and still look fetching. Best of all, this folding metal can do duty in other rooms.

♦

On the dining table, the white cotton twill cloth is fringed with heavy (and costly) bullion fringe. Antique silver and heirloom roses make a sparkling combination. A terra-cotta bust of Corneille surveys the scene. The chandelier is from RH.

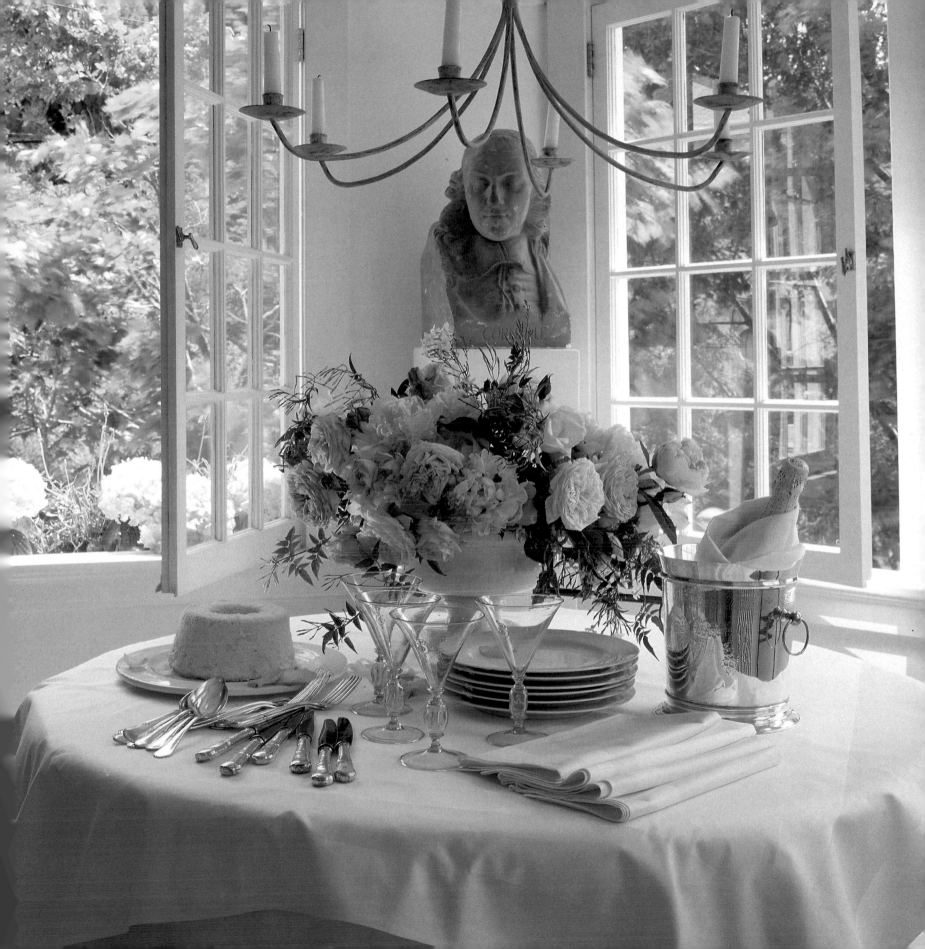

Design inspiration comes in many ways. That's one reason why Stephen Shubel and his friend — Chez Panisse Café maître d' Woody Biggs — set off for Europe each fall. ♦ Twelve years ago, exploring northern Italy, Shubel and Biggs disembarked from a rickety ferry and discovered the romantically faded Hotel Florence in Bellagio overlooking Lake Como. ♦ Local lore (whispered by the manager) recounts that Puccini himself dashed off several operas at the hotel and its halls still echo with the ghosts of Dante, George Sand, Stendhal, Nietzsche, and Flaubert. ♦ It was the distinctive, slightly faded green color of the walls in his room and the some-what chipped, antique gold-leafed furnishings that lingered in Biggs' memory, long after he had returned to his sunny apartment high in the Berkeley Hills. ♦ "I had never encountered a green quite like it. Time had given the green a soft, soothing quality, and it was not at all overpowering. The gilding seemed to throw off sparks. I knew I'd have a room with those colors some day," recalled Biggs, an accomplished painter. ♦ A few months ago, Biggs asked Shubel to refurbish his bedroom suite. Above all, he wanted his walls to be painted the same verdant tone as the romantic room at the Hotel Florence. ♦ Shubel achieved great style in the small room with his confident mix of elaborate and simple furnishings. A rich, silk-velvet, leopard-spot pillow cozies up to a relaxed cotton slipcover on a club chair. The corner chair, a flea-market find repainted black, contrasts with a rococo Venetian gilt stool. Heirloom roses in a crystal vase stand on an antique Belgian school desk. Biggs' tablescape includes a gilded plaster lamp designed by Shubel.

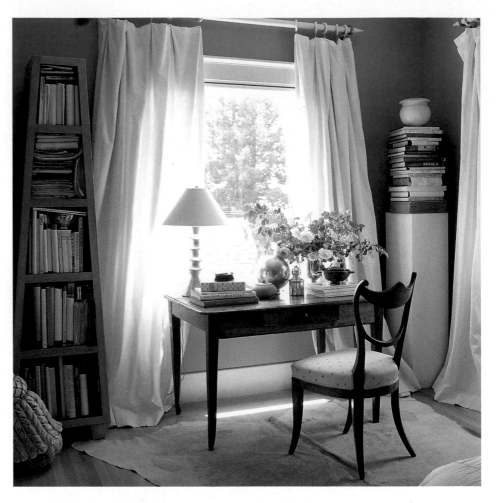

Woody Biggs and Stephen Shubel created a studious, sun-struck mise-en-scène with a handsome old desk, a Shubel-designed lamp, books, Crayola crayons, and armfuls of flowers.

♦

Sophie takes center stage on Biggs' white-cotton duvet. On the wall, framed drawings and prints purchased from "bouquinistes" along the Parisian quais.

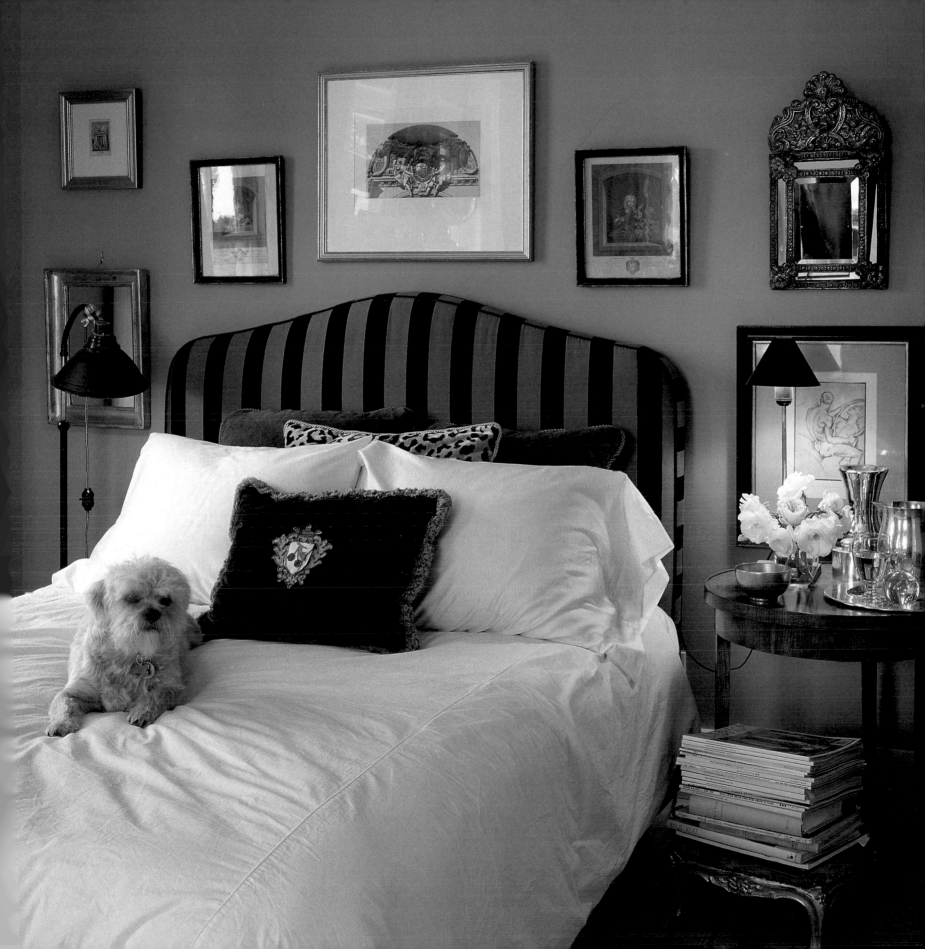

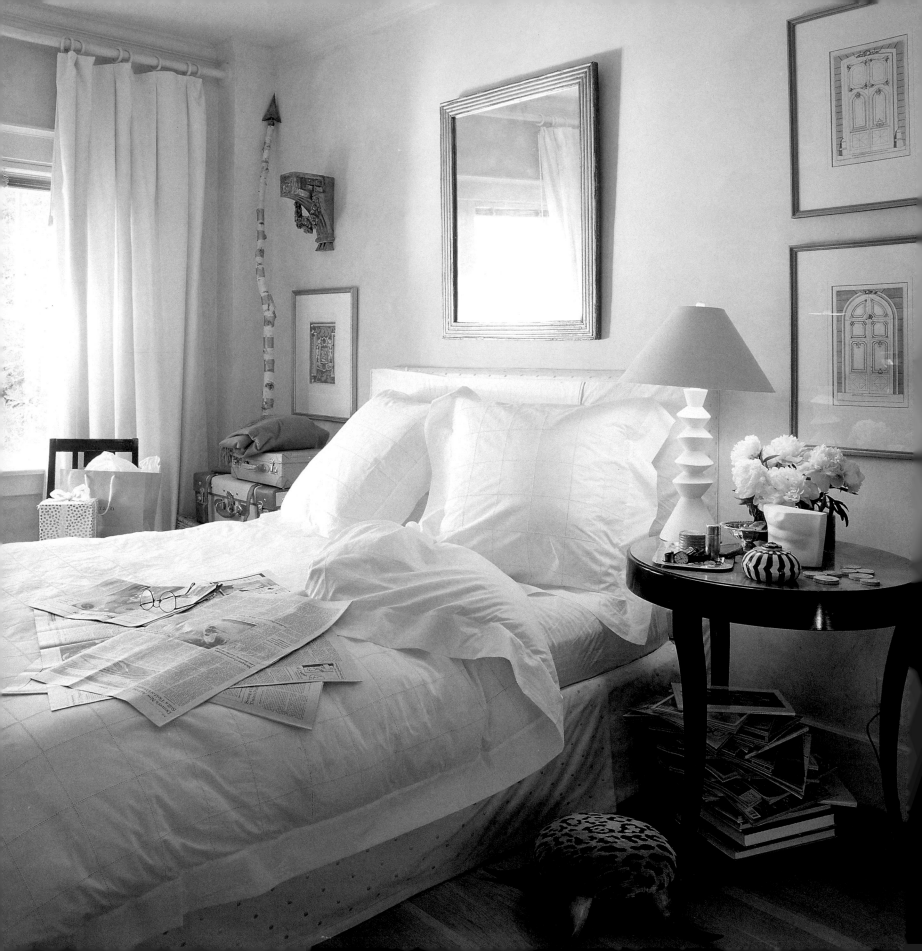

"After years of white paint, Woody's green walls were a wonderful surprise," said Shubel. "I seldom use bright colors. When I do, I balance them with neutrals and dashes of white so that the effect is not strident." ♦ The corner bedroom, whose windows overlook a sea of sycamore, has simple, white-cotton draperies that hang from white rods with fluted finials. The fabric was cut long so that the curtains pool on the floor and give the impression of billowing in the breeze. ♦ Shubel spent months trying to find a match of the Hotel Florence signature striped cotton for the headboard. Finally, he found a Swiss cotton with the right somber tones, a superb counterpoint to the green walls and white linens. ♦ For inspiration for the color scheme of his own bedroom, Shubel looked to the walls of Venice and chose sun-struck ochre. ♦ "I ragged them myself to give them texture and a sort of ancient, mottled look," recalled Shubel. "When I tried to paint the walls, the paint looked flat. I simply diluted the paint and rubbed it on the walls with handfuls of rags." ♦ His headboard was upholstered with white sailcloth embroidered with egg-yolk-yellow silk polka dots. White cotton buttons punctuate the front of the slipcover. ♦ "I have eight slipcovers for the headboard, all with matching skirts," said Shubel. "The most dramatic are in black-and-white stripes. Another set is in scarlet silk damask. Another variation I love is pure white linen." ♦ Of course, changing the headboard also means changing the styles of his sheets. For Shubel, who embraces change, that may also mean rethinking the color of his walls. Another metamorphosis is about to begin.

Gold and white are constants in Shubel's design. On his mantel he gathered gilt Italian frames, candlesticks, prints, and momentoes from Parisian flea markets.

♦

Paled-down ochre walls in Shubel's bedroom glow in the afternoon sun. The designer eschews pattern, preferring to let the carefully chosen shapes and outlines of his furnishing create their own interest. A collection of slipcovers is always at the ready to give his room a new attitude.

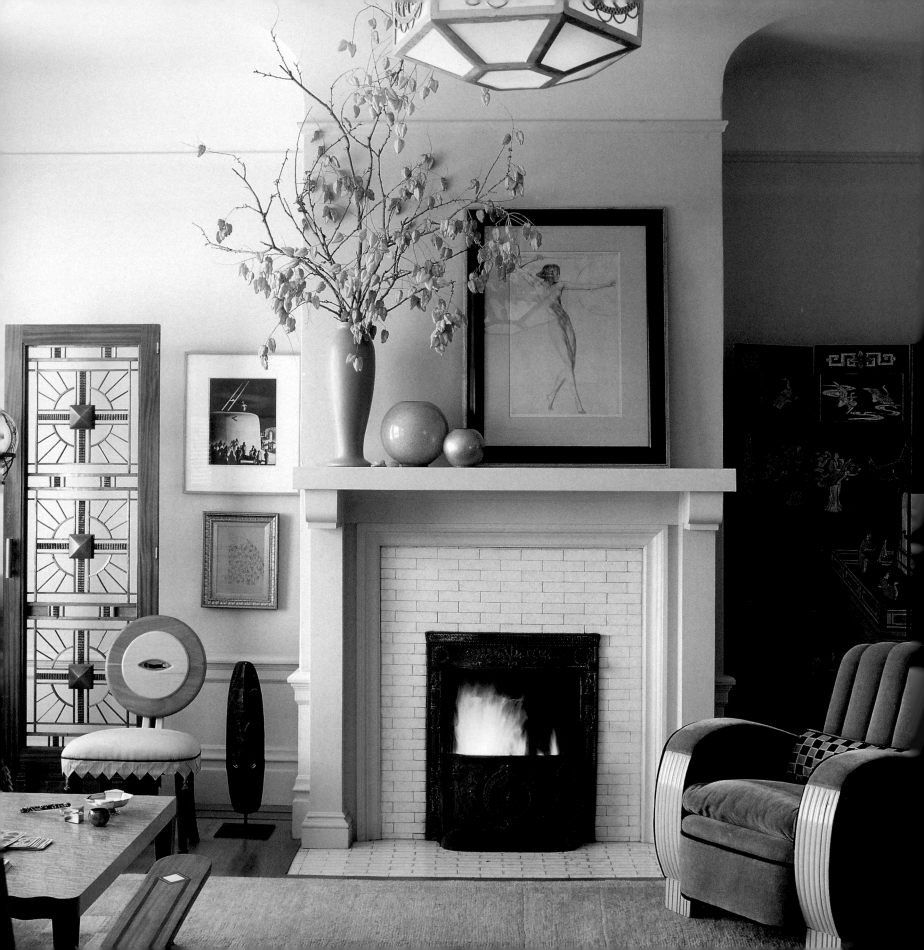

SAN FRANCISCO INTERIOR DESIGNER ARNELLE KASE ADMITS SHE MAY INITIALLY HAVE BEEN INTIMI-
DATED BY THE SEDATE PROPORTIONS OF THE TURN-OF-THE-CENTURY ROOMS IN HER IMPOSING BUENA
VISTA HOUSE. FOR THE LONGEST TIME, SHE WOULD WALK INTO THE FORMAL FRONT PARLOR, WITH ITS
CENTERED MANTEL, TRADITIONAL POCKET DOORS, AND BAY WINDOW, AND FEEL NO DESIGN TWINGE AND
NOT ONE WHIT OF INSPIRATION. FINALLY, SHE DECIDED THAT A CONFIDENT INJECTION OF DESIGN IRREV-
ERENCE WOULD TURN THE TABLES ON THE HOUSE AND GIVE THE ROOMS THE KIND OF CHARACTER SHE
COULD LIVE WITH. ♦ THE HOUSE WHERE SHE LIVES WITH HER HUSBAND, ROGER, AND DAUGHTER, JESSICA,
HAD BEGUN LIFE SHAKILY IN 1906 AS A RESIDENCE FOR TWO UNMARRIED SISTERS. IT WAS COMPLETED
SLOWLY AS THE NECESSARY MATERIALS GRADUALLY BECAME AVAILABLE FOLLOWING THE GREAT
EARTHQUAKE. ♦ "PUTTING MY STAMP ON THE FORMAL SYMMETRY OF THESE ROOMS, AND MAKING THE
OLD-FASHIONED CONFIGURATION WORK FOR TODAY WAS A CHALLENGE. WE WEREN'T PLANNING ANY
MAJOR REMODELING, EXCEPT FOR THE KITCHEN," SAID KASE, WHO WORKS IN A WIDE VARIETY OF STYLES
FOR CLIENTS AS AN ASSOCIATE WITH BARBARA SCAVULLO DESIGN. ♦ ARNELLE AND HER BUSINESS EXECU-
TIVE HUSBAND HAD FIRST RENTED THE HOUSE IN 1971 WHEN THEY WERE "IMPECUNIOUS HIPPIES," SHE
SAID. THEY EVENTUALLY PURCHASED IT TEN YEARS AGO. ♦ SLOWLY AND THOUGHTFULLY OVER THE LAST
EIGHT YEARS, ARNELLE BEGAN TO COLLECT FRENCH AND AMERICAN FURNITURE, CHINESE CARPETS,
EASTERN EUROPEAN ART GLASS, AND DRAWINGS SHE LOVED. ♦ "I FOUND THE ART DECO SOFA AND ARM-
CHAIRS AT A FLEA MARKET IN LOS ANGELES AND REALIZED THAT THEIR SIZE AND PERSONALITY WOULD
HOLD TOGETHER THE LIVING ROOM," KASE SAID.

The original cast-iron, coal-burning fireplace is surrounded by the family's collections —

mohair-upholstered art deco chairs, vivid thirties art glass, and

Arnelle's new "Button" chair.

Visits to country flea markets, City garage sales, and auction houses all over California have unearthed the treasures of Arnelle Kase's well-displayed burgeoning collections. She prefers pieces that have a sense of humor and come with a convoluted history. ♦ "Everything in these rooms has had a previous life with another family. The French door grille that I use as a piece of sculpture beside the fireplace was once in a house in Paris. The Chinese plaster heads in the foyer were thirties paint-by-number craft projects. Things with a bit of history are much more interesting than shiny, new pieces. But of course, it takes longer to find them and bring them all together," admitted the designer, who also designed a new coffee table and whimsical, silk-upholstered side chair for the room. ♦ Kase's focus on finding telling objects has paid off. ♦ "Now I really appreciate the formality of the original rooms. Their great advantage is that I can make impromptu changes, move pieces in and out, and the scheme doesn't fall apart. It can be like a theater backdrop with furniture changing for the seasons," she said. ♦ "Originally, I thought that as a designer I had to tolerate the Victorian layout, but I've grown to love and respect the house. We've come a long way together."

Brightly colored French, Eastern European and Italian glass collections are as delicious and cheerful as fruit-flavored lollies.

Musical notes: Kase designed the dining room/

music room in the somewhat somber, serious spirit

of the original Edwardian design — with a

few surprises. In the bow window overlooking the

garden, she hung cotton canvas draperies

hand-painted with classical motifs.

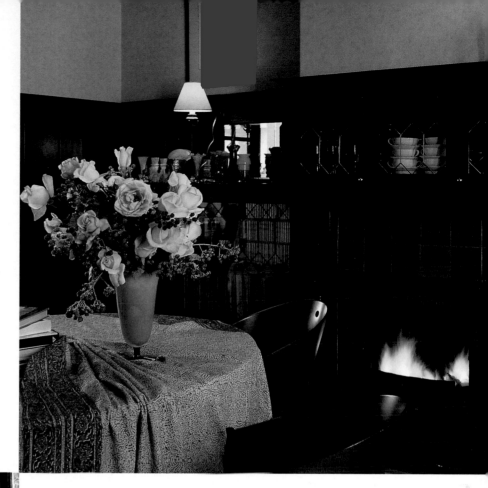

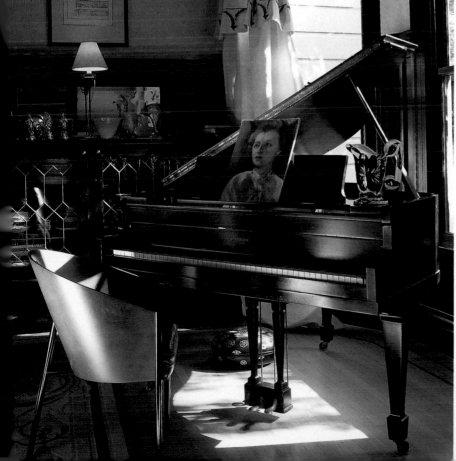

The table, draped with an antique Kashmiri

hand-blocked paisley shawl, is encircled

by Philippe Starck-designed Café Costes chairs.

French art glass and mercury glass pieces

are displayed on the original china cabinets.

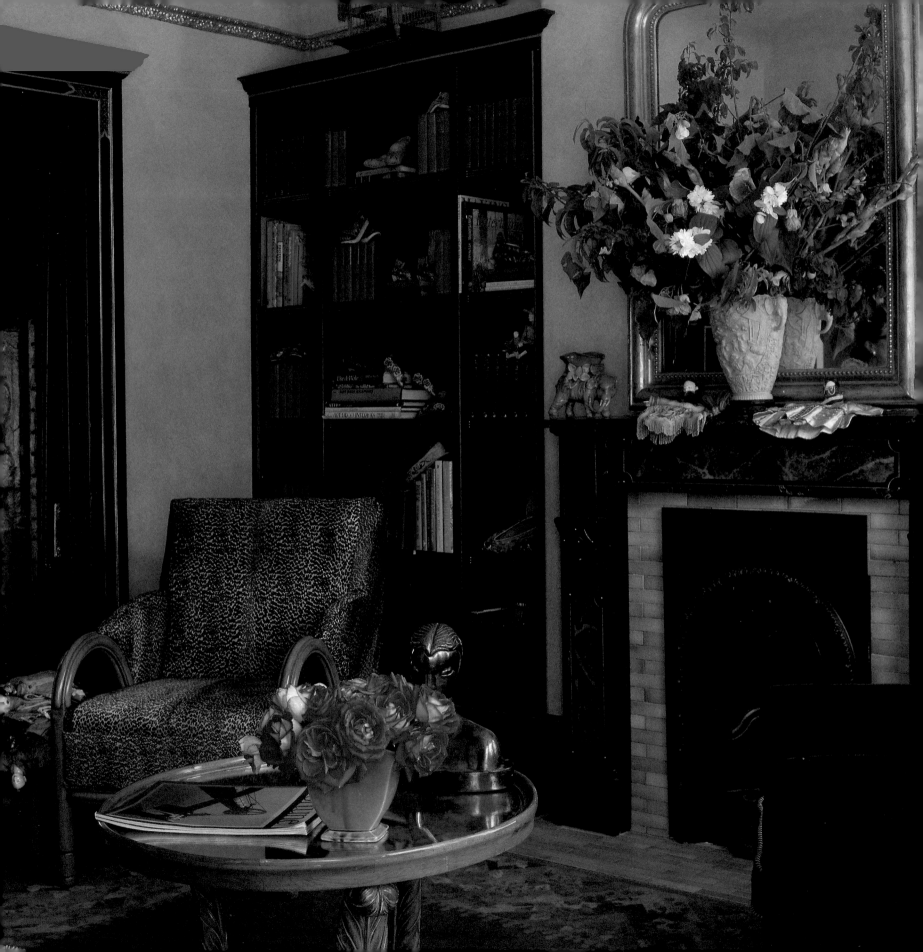

THE BEST REMODELS START WITH A PROMISING BUT DOWN-IN-THE-DUMPS HOUSE – AND CAREFULLY TURN SO-SO INTO SPECTACULAR. THE SENSITIVELY REVISED MODEL LOOKS A LOT LIKE THE ORIGINAL HOUSE – BUT A MORE FUNCTIONAL VERSION OF IT, COMPLETE WITH NEW PLUMBING, A LOGICAL FLOOR PLAN, SPACIOUS CLOSETS, AND RESTORED STYLE. ♦ SAN FRANCISCO INTERIOR DESIGNER CANDRA SCOTT BOUGHT HER POTRERO HILL HOUSE FOR ITS BEAUTIFULLY PROPORTIONED ROOMS AND SUNNY OUTLOOK. A HEAVY-HANDED REMODEL, COMPLETE WITH INAPPROPRIATE BLACK METAL WINDOW FRAMES, HAD STRIPPED IT OF ITS EDWARDIAN STYLE. SHE SAW ITS POTENTIAL. EVEN A LACKLUSTER KITCHEN AND A DRAB CONCRETE "FRONT GARDEN" DID NOT DETER HER. ♦ TODAY, VISITORS TO CANDRA SCOTT'S CREAM AND WHITE EDWARDIAN HOUSE ON POTRERO HILL STEP INSIDE A NEAT PICKET FENCE AND WALK PAST FRAGRANT ROSES AND HOLLYHOCKS AS HIGH AS AN ELEPHANT'S EYE TO THE FRONT DOOR. BEAUTIFULLY DETAILED WOOD-FRAME WINDOWS LOOK OUT ONTO THE GARDEN. ♦ "IT'S SO IRONIC," SAID SCOTT, AN INTERIOR DESIGNER WHO SPECIALIZES IN THE RESTORATION OF HISTORIC HOTELS. "EVERYONE THINKS THE HOUSE HAS ALWAYS LOOKED THIS WAY – THAT I JUST GAVE IT A FRESH COAT OF PAINT. THEY DON'T KNOW HOW STARK IT WAS BEFORE, AND THEY CAN'T GUESS AT ALL THE WORK." ♦ WHEN SCOTT PUR-CHASED THE 1907 HOUSE, SHE DISCOVERED THAT IT HAD ALWAYS BELONGED TO THE SAME ITALIAN FAMILY. ♦ "THE HOUSE WAS SOLID AND HAD BEEN 'FIXED UP' OVER THE YEARS, BUT POORLY," SAID SCOTT. "ALL THE ORIGINAL CHARACTER HAD GONE. THE 'MODERNIZING' WAS BRUTAL. I HAD A MUCH MORE ROMANTIC VISION OF THE WAY THE HOUSE SHOULD LOOK." ♦ SHE LIKED THE ROOMS' GENEROUS PROPOR-TIONS AND THE CITY VIEWS FROM THE BACK OF THE HOUSE, AND PLANNED NO STRUCTURAL CHANGES.

Candra Scott's talent for historically correct restoration is evident in every room of her Potrero Hill house. In the sitting room, she replaced a plain fireplace and mantel with a more romantic, painted model. She likes to decorate the mantel with a flourish of flowers and branches collected by the armful from her garden.

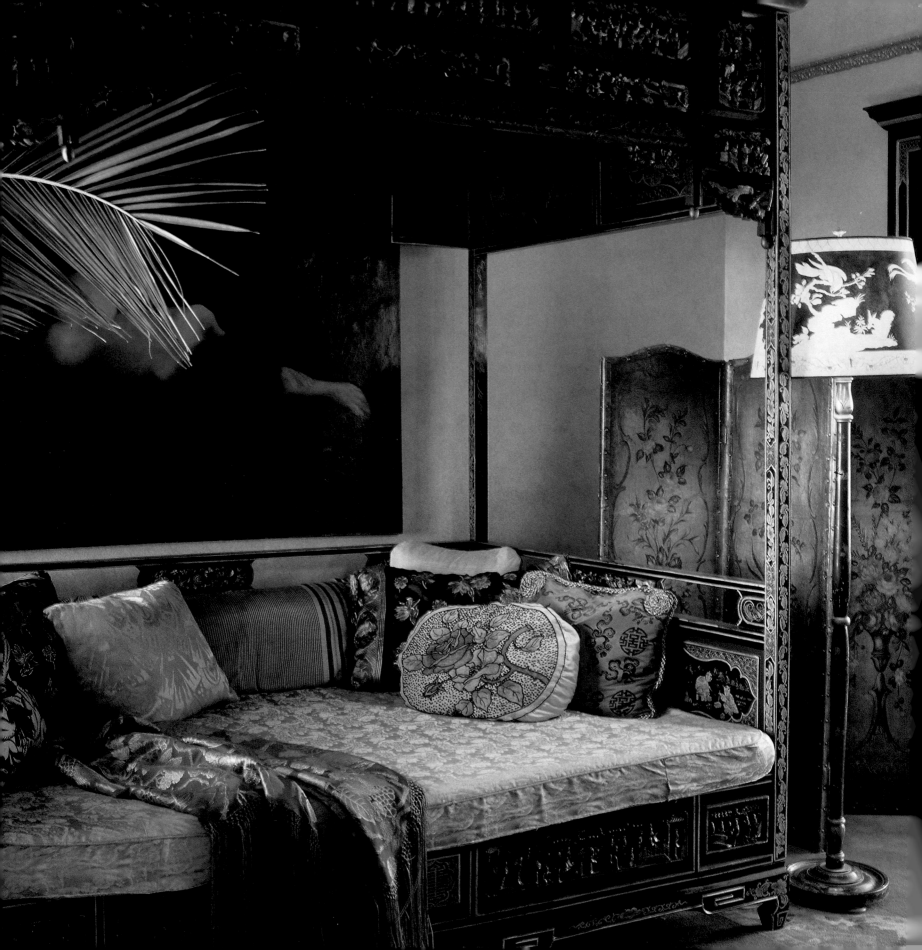

"It was great, basic Edwardian architecture, but I wanted to emphasize and enhance its character," said Scott, who designed the evocative interiors of San Francisco's Majestic and Regis hotels. ♦ She replaced grim aluminum-framed window frames with arched wooden frames, following the lines of the old front door. A large window box with Edwardian detailing was built beneath her upstairs bedroom window and planted with petunias. ♦ Scott imagined a Chinese/deco living room and parlor with a sumptuous color scheme, but nothing too sweet. ♦ She found an elaborate, hand-carved and gilded, black-lacquer four-poster Chinese wedding bed at a local antique dealer's and installed it in the parlor. A vintage, gold Chinese silk-brocade coverlet and braid-trimmed pillows make it a comfortable corner for reading or conversation. The bed and her collection of thirties Chinese carpets in jangled colors such as amber and plum with apple green and apricot inspired the house's highly detailed color scheme. ♦ Plum-colored Axminster carpets with geometric bands of magenta, mustard, and celadon look as if they might have been planned by a worldly former owner, and seem original to the house. A grand antique fireplace with a hand-carved mantel and green marble insets replaced the former plain fireplace. Walls were painted a pale, textured terra-cotta. ♦ "In keeping with period style, I had all the doors, door frames, and windows painted matte black," said Scott. Artist Tom Soltesz added traditional gold banding with delicate chinoiserie patterns on the corners. ♦ Scott installed a wall of closets with mirrored doors in a former hollow beneath the eaves of her bedroom. "They make my room look so much bigger and provide storage in what was just wasted space," said Scott. She gave the beveled doors a period look with vintage glass door handles. ♦ In the living room, fat deco chairs covered in black mohair, and a deep, down-filled Edwardian-style sofa upholstered in moss green, invite guests to stay and perhaps dream of time travel to the turn of the century. ♦ "Now the house lends itself to entertaining," said Scott. "I make strawberry lemonade with lemons from my own trees. We sit in the living room. It was once just bare bones, and now it feels like a room that has gathered its own history. This house takes me away from today to a past era. I love it. It inspires my creativity."

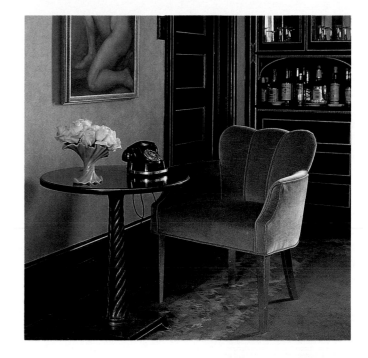

Scott dressed her Chinese lacquered rosewood bed with a drift of silk brocade and vintage embroidered pillows. She had the lamp and shade custom-made for the room. To add to the period glamor, she created a thirties vignette with an old telephone (working) and a reupholstered deco chair.

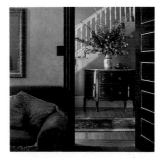

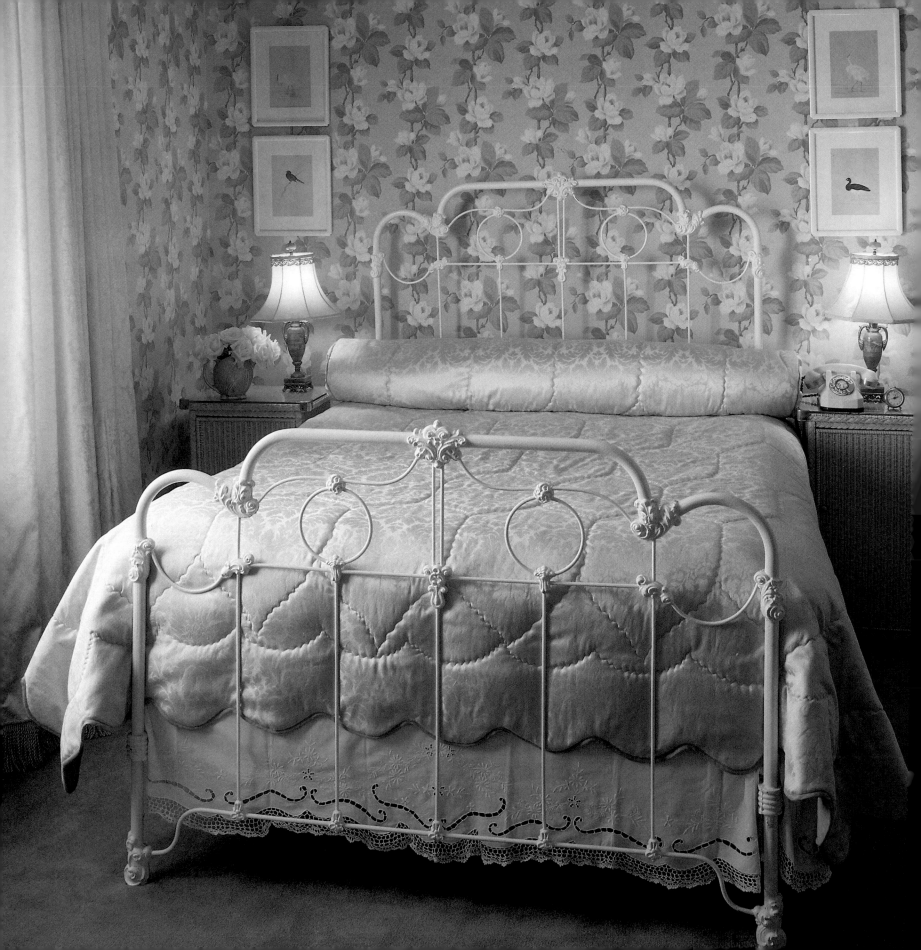

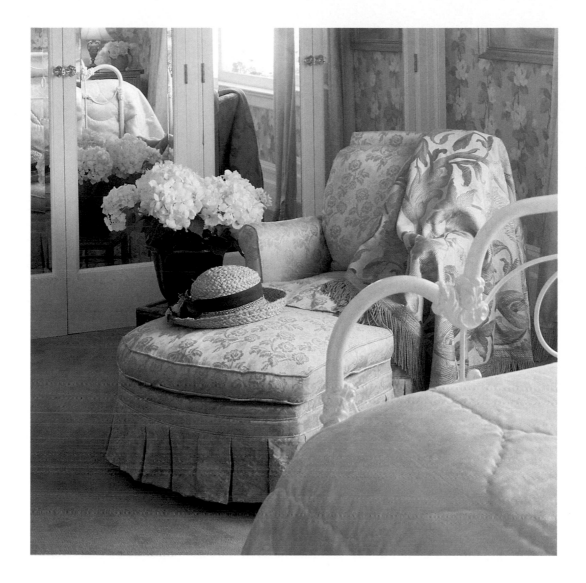

For her bedroom, Scott went in search of vintage wallpapers and accessories to create a rather nostalgic and peaceful retreat. To soothe the bed and give it a little Hollywood glamor, she found a movie-star-handsome silk brocade and had it made in Los Angeles into a retro trapunto bedspread. An armchair and ottoman, with hats and flowers for period effect, invite reading and quiet contemplation.

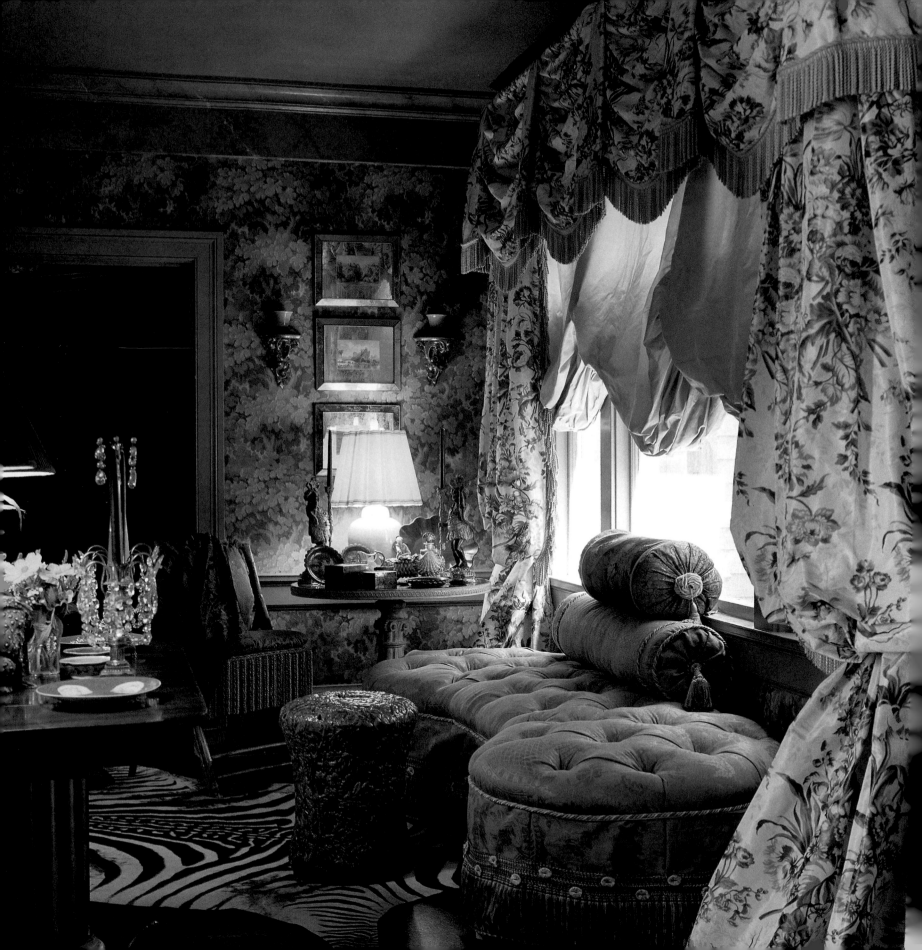

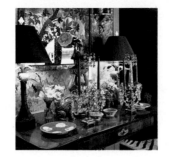

Decorator Diane Chapman has a marvelous sense of luxury. She can turn even an ordinary hallway in her house into a luscious, theatrical salon. ♦ "In the 22 years I've lived in this house, I've gone through an all-white 'California' period, and then my 'chintz and Chippendale' era," said the designer, who also has her own accessories collection. "Now my work is much more international. I love a combination of French- and Italian-style furniture with Regency influences and oriental accessories." ♦ Chapman likes formal, richly colored rooms with lots of comfort. ♦ "My taste in fabrics is changing, too," she said. "I love Italian silk damasks, French silks, and cut velvets, all trimmed with beautifully handcrafted fringes and tassels to emphasize the curves of a sofa or to outline draperies." ♦ In every corner and on every surface of her hallway/salon, there are beautiful things to please the eye. Walls are covered in textured "tapestry" wallpaper. Elaborate gilded sconces present rose-pink Chinese porcelain bowls and cloisonné urns. Tasseled silk draperies are vivid with woven bouquets. ♦ On a round table beneath a trio of framed paintings, Chapman has gathered her "red collection." Antique lacquer plates, tortoiseshell boxes, painted pitchers, perfume bottles, ceramic scallop shells, and lacquer candlesticks are all in rich tones of coral and Chinese red. Beside the table is a tortoiseshell bamboo folding chair, dressed by the designer with silk damask pillows, a paisley throw, and long tricolored silk fringe. ♦ "It's hard to imagine that this was just a hall that we used to rush through on our way to more interesting rooms," said Chapman. "Now we take tea here in the afternoons. When the sun goes down, I lower the balloon shades and the room glows. I hate to leave."

Grace and favor: Brunschwig & Fils silk draperies as elaborate as ball gowns dress the hall window. Chapman designed the curved, Regency-style, tufted damask banquette trimmed with green and gold fringe with pink rosettes. To further soothe her guests: a pair of tasseled silk damask bolsters.

♦

Regency dandy: On a lustrous, Swedish, Regency-style, column-based table, Chapman poses Italian ceramic frogs, a ceramic monkey on a leopard silk pillow, Regency crystal girandoles, Chinese plates, and a pair of palm-leaf tole lamps. An English reverse painting on glass hangs on the wall, covered with French tapestry-print wallpaper.

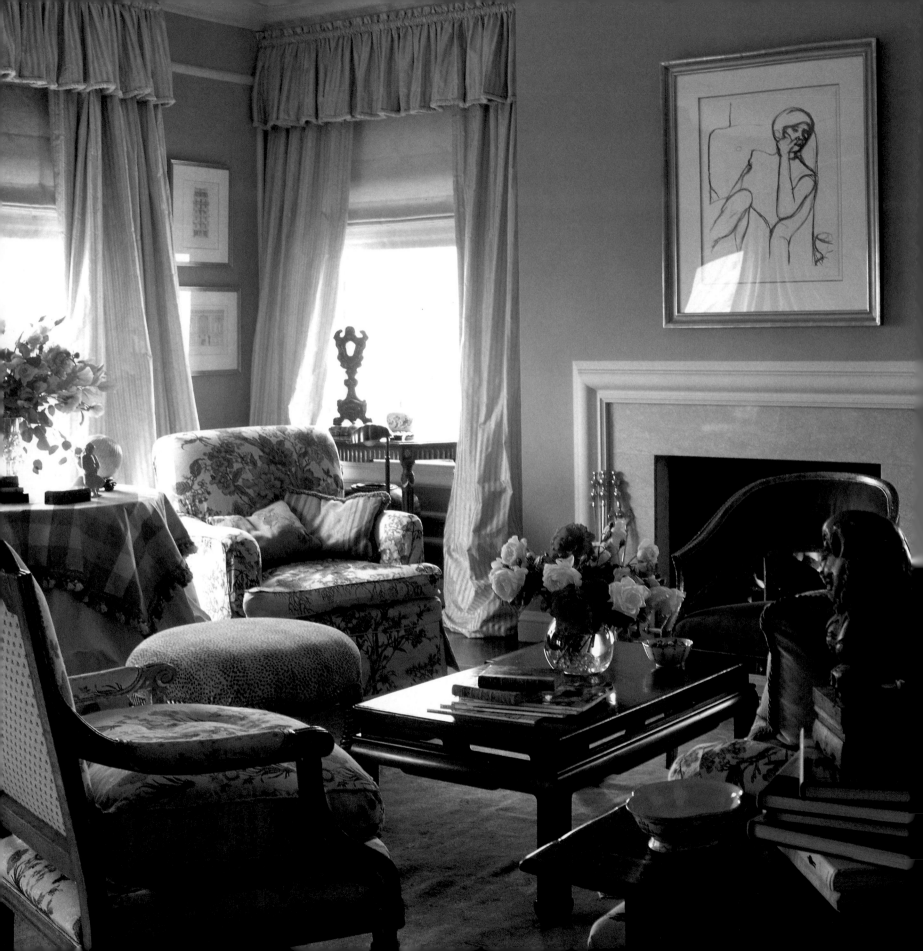

IN THE VERY MATERIAL WORLD OF INTERIOR DECORATING, DESIGNER ILENE SANFORD IS KNOWN AS A PROFESSIONAL WHO CHOOSES AND USES FABRICS DEFTLY AND CONFIDENTLY. DECADES OF EXPERIENCE EYEING AND TOUCHING TEXTILES HAVE GIVEN HER A GREAT LOVE AND APPRECIATION OF BEAUTIFUL FABRICS. PERHAPS THAT IS WHY IN HER OWN RUSSIAN HILL APARTMENT, THE FABRIC COMBINATIONS AND FINISHING SEEMS SO EFFORTLESS, SO APT. WHILE SHE MAY USE AS MANY AS 13 OR 14 FABRICS IN A LARGE LIVING ROOM FOR A CLIENT, NOTHING HERE IS EXCESSIVE OR SHOWY. ♦ "FOR MY OWN APARTMENT, I WANTED THE FABRICS TO BE INTERESTING BUT LOW-KEY," SAID SANFORD. "IT WAS NOT ABOUT MAKING A DESIGN STATEMENT." ♦ ILENE AND HER HUSBAND, LARRY, AN ATTORNEY, FIRST VIEWED THE APARTMENT IN A HANDSOME BUILDING ALONG HYDE STREET IN 1985. "WE HAD BEEN LIVING IN A HOUSE IN PRESIDIO HEIGHTS. OUR TWO CHILDREN HAD GONE OFF TO COLLEGE, AND WE WERE LOOKING FOR AN APARTMENT FOR JUST THE TWO OF US AND THE OCCASIONAL GUEST," SAID SANFORD ♦ THEIR FIRST SIGHT OF THE HIGHLY TOUTED APARTMENT WAS NOT AUSPICIOUS. "THE KITCHEN, CIRCA 1933, HAD NEVER BEEN RENOVATED," RECALLED ILENE. "THERE WERE HULKING PSEUDO-SPANISH LIGHT FIXTURES, RATHER LOW ARCHWAYS BETWEEN THE ROOMS, WORN LINOLEUM ON THE KITCHEN FLOOR, NO CLOSETS. OUR FIRST THOUGHT WAS THAT IT WAS SIMPLY GHASTLY." ♦ LATER, OBJECTIVELY, THE COUPLE REALIZED THAT THE LARGE, HILLTOP, THREE-BEDROOM APARTMENT HAD DAY-LONG LIGHT AND EXTRAORDINARY VIEWS OVER PACIFIC HEIGHTS TO THE PRESIDIO AND THE GOLDEN GATE BRIDGE. THE BAY LAY BENEATH THEIR GAZE, WITH SAUSALITO AND THE MARIN HEADLANDS IN THE BLUE YONDER. ♦ THE SANFORDS DECIDED TO BUY

Sweet and tart: For her corner living room, decorator Ilene Sanford chose pretty, paled-down peach and beige, offset with gold. Sanford likes colors with substance and fabrics with texture. The sofa wears summer slipcovers of floral-printed English linen. In winter, its upholstery is sensuous, oyster silk velvet. A hint of acid green in the Oushak rug suggested the tart, green silk velvet upholstery for her curvy, Swedish neoclassical gilt chair. The coffee table is Chinese cinnabar lacquer. From west- and east-facing bay windows of their urbane apartment, the Sanfords can view both the Golden Gate Bridge (dramatic at sunset) and the Bay Bridge (lit up like a birthday cake at night).

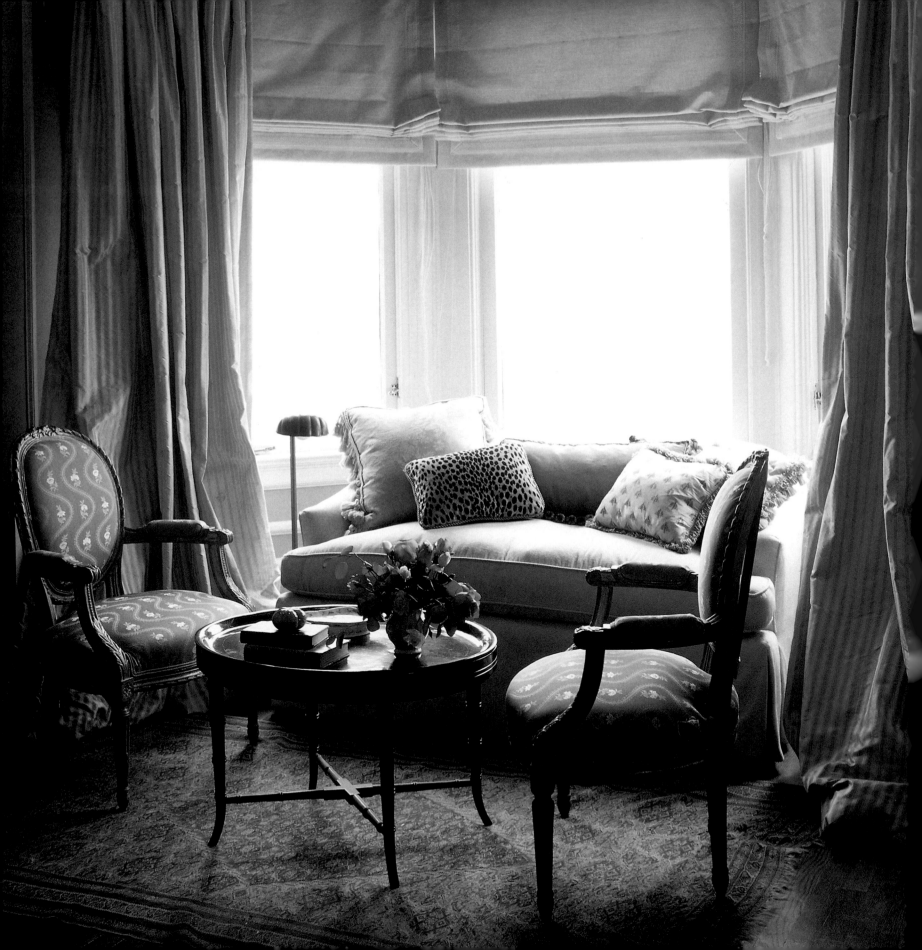

the apartment – and to go through a no-holds-barred renovation to make it their own. They spent six months remodeling, taking the kitchen and bathrooms down to the studs, building in new closets, opening up the small-scale arches, adding bookcases, redesigning and simplifying the fireplace, and removing all traces of faux Spanish flourishes that had imbued the rooms with faded glamor. ♦ Sanford had the hardwood floors repaired and stained rich, dark walnut. New crown moldings gave the rooms more finish. She replaced double-hung windows with single-pane windows for better view framing. ♦ "We wanted the rooms to feel more expansive," said Sanford." It was imperative to get the architecture right so that the apartment would feel livable and comfortable. This is a marvelous location, and the style had to be updated, smoothed, and perfected." ♦ "I don't consider myself a trendsetter in design," said Sanford. "I never do anything dramatic or over-scale, but rather look for balance, classical proportions, and timeless comfort." ♦ Moving cautiously, she said, she has never regretted any design. Her work does not date, and she can fine-tune it and change with the seasons so that she is never bored. ♦ "I think a house should be quiet, not jarring or showbiz," said Sanford. "I like to be able to sit in a room and then notice the fine details rather than having them hit you in the face." ♦ For her living room, she arranged two seating groups. In the bay window alcove, she set a small sofa upholstered in taupe silk ottoman fabric. Leopard silk velvet and peach silk taffeta pillows add color. A pair of gilded French chairs and a black *papier mâché* tray table complete the ensemble. ♦ Before the fireplace, she angled an English roll arm, down-filled sofa upholstered in beige silk velvet. A collection of slipcovers gives it a new look each season. ♦ "The sofa, Swedish chair, and bergère chair make a good conversation group when I have a dinner party, and you can always pull up another chair," said the decorator. "It's an eight-foot sofa, so it can seat three." ♦ She chose a Scalamandre peach-and-cream-striped silk taffeta lined in peach for her living room draperies. ♦ The dining room walls were given a pistachio green glaze by Lazslo Petrick. Moldings are forthright white. ♦ "I wanted a color with punch," said Sanford. "To get the color just so, we mixed and mixed and then toned the green down. It's strong but it's not overpowering, and I've never tired of it. Sometimes an unusual color makes the perfect background. It stops everything from sailing off on its own." ♦ Sanford admits to the possibility of design adjustments. "I'm sure over the years I'll change the fabrics and pillows and give the rooms a new look," said Sanford. "When you get the room right and it functions well, you don't have to make continual improvements. You can simply entertain yourself with new finds."

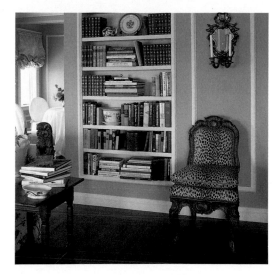

♦

Ilene and Larry Sanford's apartment is ideal for entertaining. Whether it's just one friend or client for afternoon tea, or rooms full of chums to celebrate a birthday or the first day of spring, these spacious, open rooms are extremely welcoming. In one corner of the living room, beside a bay window, Ilene has arranged a sofa and a pair of Louis XVI–style chairs. The singular leopard-patterned chair placed against one wall beside bookshelves invites reading or a moment of reflection.

♦

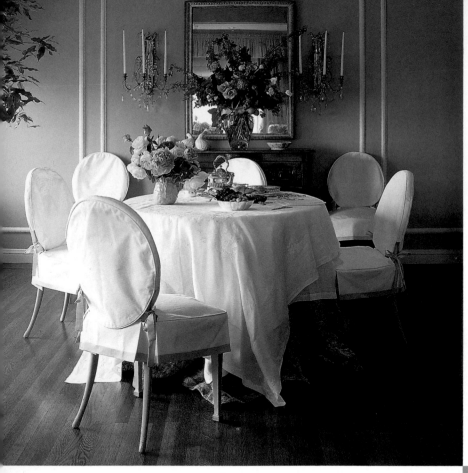

On the occasion of a summer afternoon tea, she

arranged great armfuls of Balenciaga-pink garden roses,

double peonies, and greengage branches in a

crystal vase on an eighteenth-century French fruitwood

buffet. An antique gilt-framed mirror doubles

her efforts. Beneath her vintage embroidered white-

linen cloth, an extra-full vintage tapestry cloth

gives the table party airs.

Double identity: For her dining chairs,

Ilene Sanford fashioned starched white-sailcloth slipcovers

as pretty and beguiling as summer dresses.

They're piped in sunflower-yellow chintz. Beneath their

cotton skirts, the chairs are upholstered in tapestry,

which is perfect for winter.

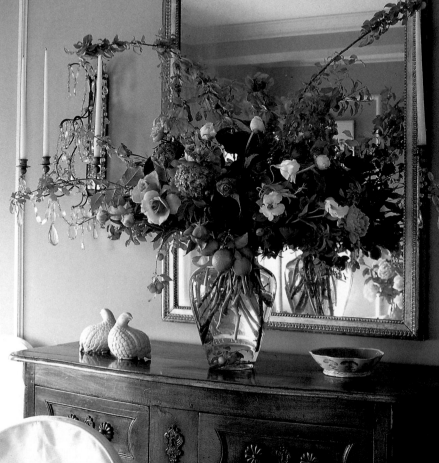

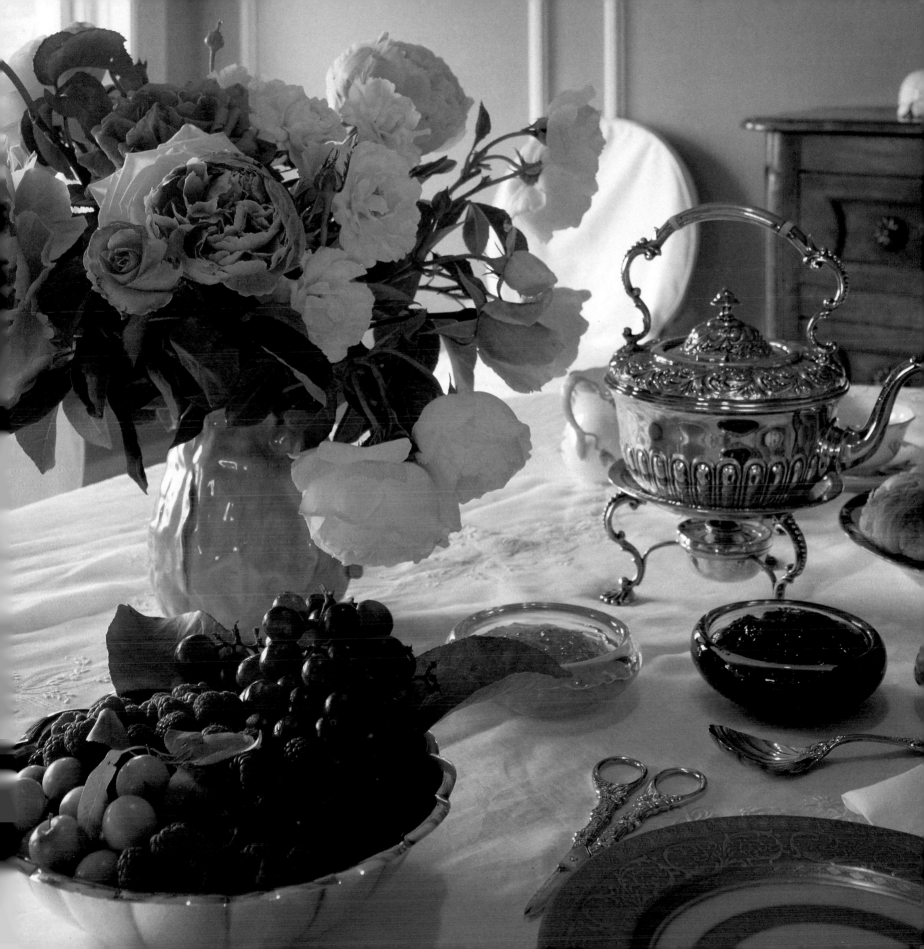

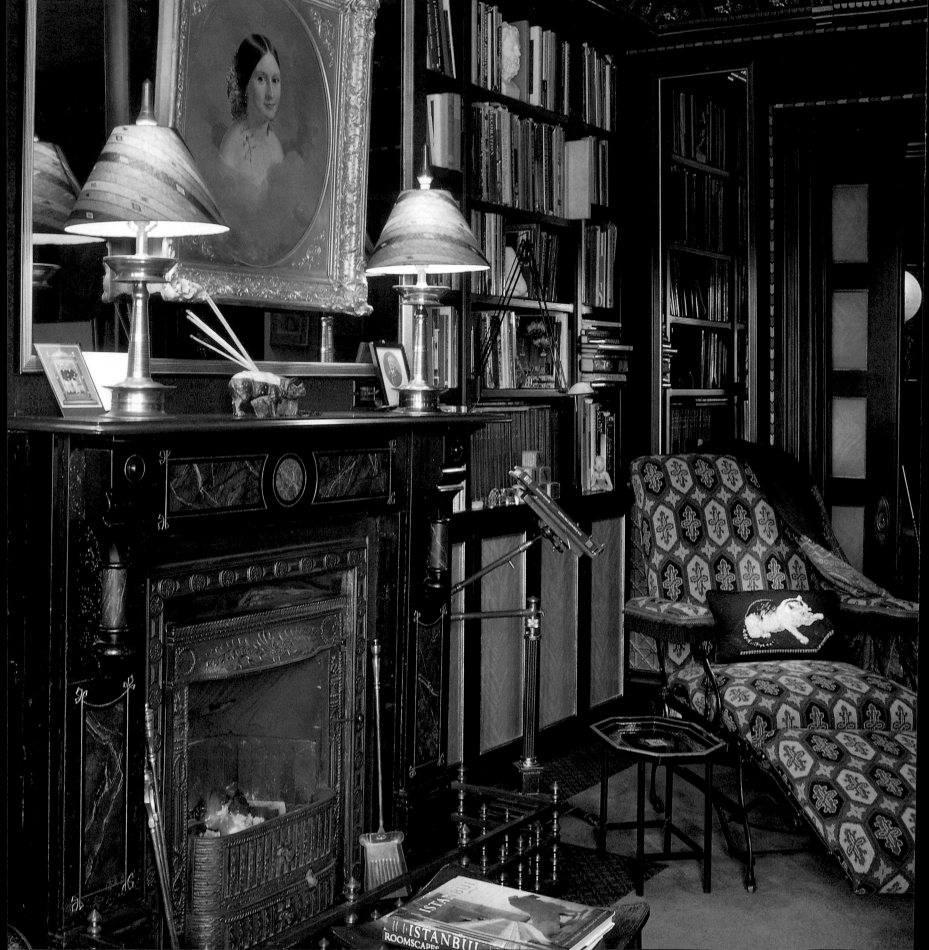

WHEN INTERIOR DESIGNER MICHAEL VINCENT DISCOVERED HIS FLAT ABOVE AN ANTIQUE SHOP IN BERKELEY FIVE YEARS AGO, ITS INDIFFERENTLY RENOVATED ROOMS OFFERED LITTLE IN THE WAY OF DESIGN INSPIRATION. THEY WERE SPACIOUS AND SUNNY, BUT FREE OF ARCHITECTURAL DETAIL OR CHARM. ♦ UNDETERRED, VINCENT DESIGNED A HANDSOME WALL OF BOOKSHELVES FOR THE LIVING ROOM AND BEGAN EXTENSIVE REPAIRS AND REMODELING. AT A NEIGHBORHOOD FURNITURE STORE, HE CHANCED UPON A TURN-OF-THE-CENTURY TILT-TOP DESK IN THE EASTLAKE STYLE, ALL CHAMFERED ANGLES, FRETWORK ORNAMENTATION, HAND-PAINTED GILT STRIPES, AND ECCENTRIC DETAILING. WITH EXTRAORDINARY ATTENTION TO DETAIL AND AUTHENTICITY, THE INTERIOR DESIGNER DECIDED TO PAY HOMAGE TO VICTORIAN TASTEMAKER CHARLES LOCKE EASTLAKE. ♦ "WHEN I FELL IN LOVE WITH THAT EASTLAKE DESK, MY FATE WAS SET. THEN I HAD TO HAVE CHAMFERED EDGES AND GILDED STRIPES ON THE BOOK SHELVES. BRASS FIREPLACE FENDERS, ANTIQUE FIRE IRONS, A BLACK "FAUX MARBRE" MANTEL, EASTLAKE CHAIRS, ELABORATE BRADBURY & BRADBURY WALLPAPERS AND AN EASTLAKE-STYLE CORNICE SOON FOLLOWED," SAID VINCENT, WHO OFTEN WORKS IN A MORE CONTEMPORARY MODE. ♦ MATTE BLACK, LAVENDER, AND DARK TURQUOISE ACCENTED WITH GOLD LEAF WERE THE COLORS HE CHOSE FOR THE LIVING ROOM. THE WALLS ARE COVERED IN BLACK SILK MOIRÉ WALLPAPER. ♦ "I LOVE TO WORK WITH COLORS AND FINISHES OTHER PEOPLE CONSIDER A BIT 'OFF,'" NOTED VINCENT, WHO WAS BORN IN

Michael Vincent's living room is just 13 feet by 18 feet, yet it has all the comforts of a gentleman's study.
A Boer War officer's folding chair, with pigskin suede cushions, is pulled up beside the hearth. Vincent's vast
library of books, a pair of contemporary flexible Italian reading lamps, and statuary from Bali and
Central America enliven the setting. Bookshelves built by Petaluma cabinetmaker Aaron Crespi.
Painted finishes by Norman Rizzi.

♦

A gilt-framed painting of Echo Lake, New Hampshire (circa 1866) hangs on the mirrored wall
above an ornate, gilt-edged, Eastlake-style table. "This is an extremely small room, so the bronzed mirrors are an
important part of the scheme," said Vincent. The walnut burl desk and silk-upholstered chairs are
also in the restrained Eastlake style.

Yorkshire and served with the Royal Air Force in Karachi, Pakistan. "These colors seem a bit sixties, but happen to be very authentically Victorian." ♦ In his passion for authenticity, Vincent left no surface untouched. New pressed-tin wainscot (discovered in a catalogue) was "aged" with a hand-applied coppery patina finish, and the mantel (rescued from a salvage yard) was given panels of rich red marble. ♦ "There can be a tendency, doing Victorian rooms, for the 'bordello' look to creep in," noted Michael Vincent. "Instead of ornate silk draperies in the living room and dining room, I have black, fire-screen-chain "draperies" and black-painted shutters, which add texture but are almost invisible. Instead of frilly lamps, I have articulated, low-voltage, Italian reading lights." ♦ To prevent the highly detailed room from look-ing sentimental or stilted, the designer added some mod-ern light fixtures. These are period rooms with Bose speakers and concealed ceiling lighting. ♦ Vincent noted that while the look is rich and embellished, he obtained the maximum look with budget-conscious design, cunning, and sleight of hand for a "song." ♦ "Friends visit and assume that I've simply revived some of the original woodwork and the fireplace. Absolutely everything here is new. Some pieces were serendipitous finds. I discovered a pair of Eastlake-style chairs for $15 in Petaluma," he said. ♦ Even the weightier furniture he brought in to add cre-dence to the rooms — the six-drawer desk, parlor chairs, another Eastlake-style table — were not all expensive. ♦ "Now that the apartment is finished, I'm not going to change the 'bones,' because the rooms work so well for entertaining. Sculptures and collections will come and go. Anything that stays longer than six months becomes bor-ing and static, and rooms like these must have life," Vincent said.

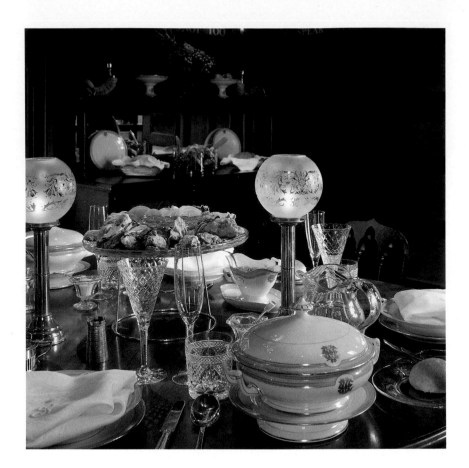

♦

In the dining room, the designer's table is surrounded by Gothic revival chairs. Vincent restored the fine Victorian chandelier.

♦

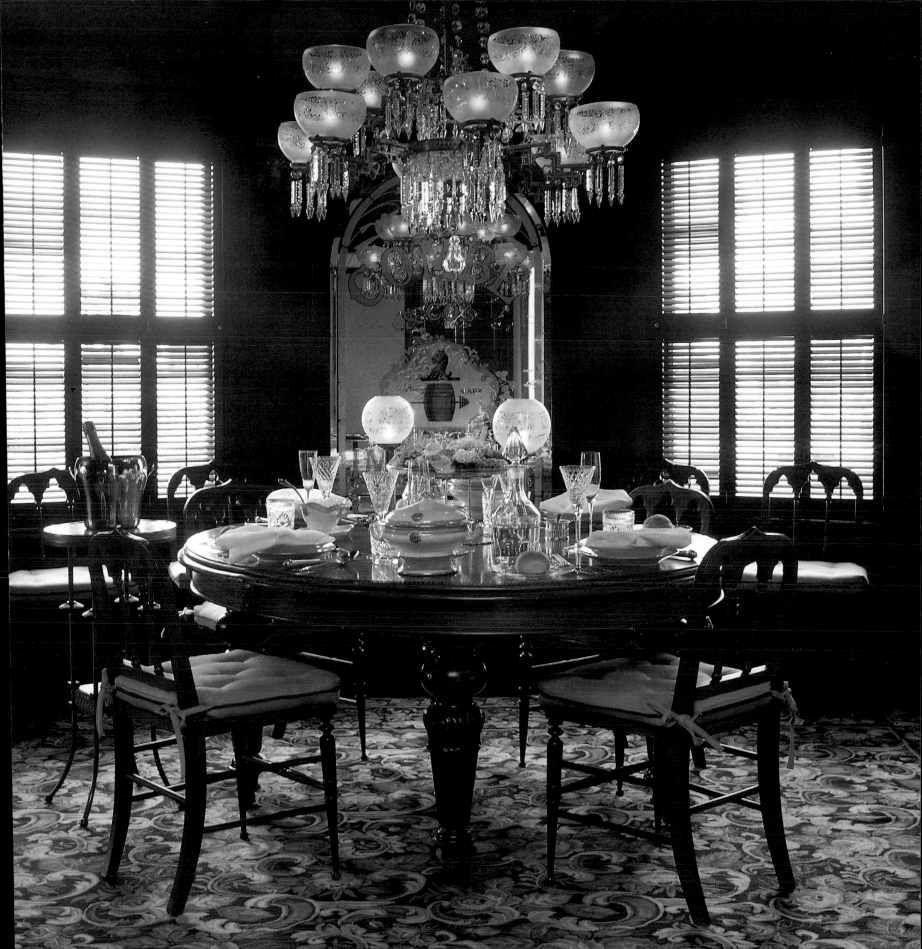

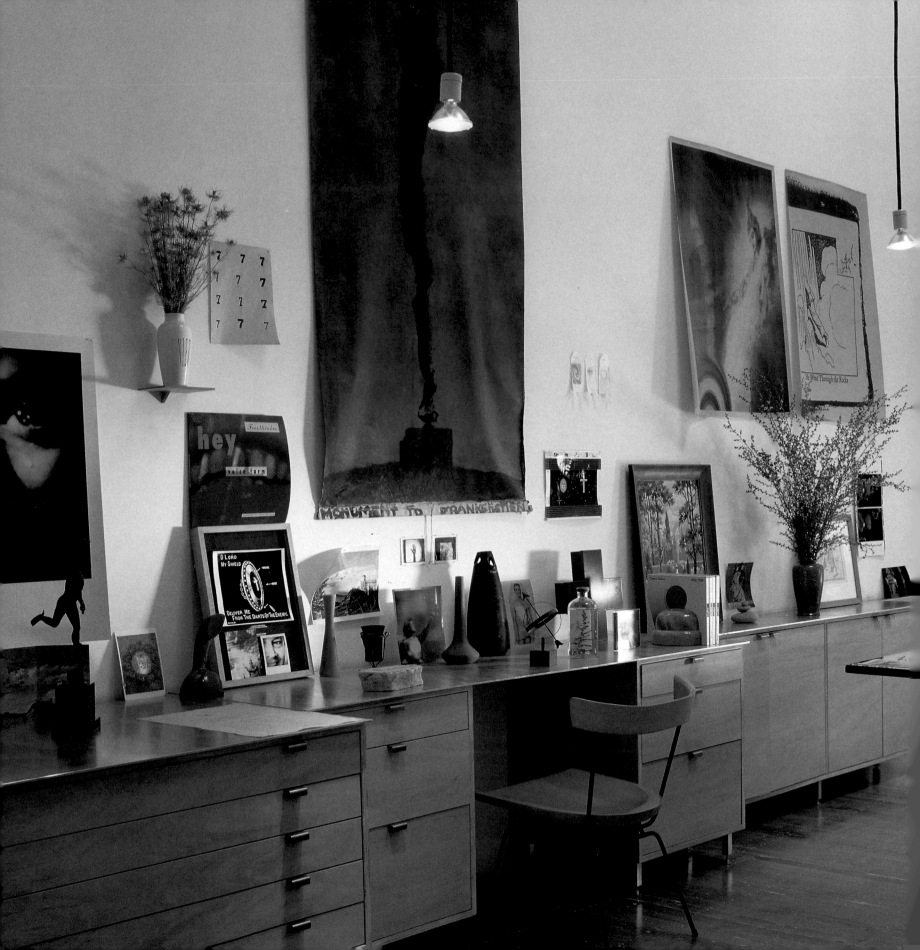

Graphic designer tom bonauro is internationally admired for the highly original and powerful imagery and videos he creates for clients like MTV, record companies, rock groups, fashion designers, theater groups, and book publishers. At home in san francisco, too, he chooses his icons with care and displays them with affection. Tableaux he creates for his own pleasure and inspiration on the tables, walls, and shelves in his potrero hill loft are object lessons in cryptic editing. ♦ "I see my studio as a laboratory, as a place to try out ideas and live with my new designs," said bonauro, who worked with bruce tomb and john randolph of the interim office of architecture on the design, sculptural glass-topped desk, lighting, and furniture for his loft. ♦ Bonauro is known (and emulated) for both very charming, whimsical works on paper and for his more confrontational, in-your-face work on behalf of social causes. He recently gave a highly praised multimedia presentation. Its theme: "Can man survive the media?" ♦ "This 'research' I do with objects and printed materials affects my eye and my thinking. Imagery drifts into my conscious-ness, and I begin to free it from the entrapment of our culture," said the designer. ♦ He finds three-dimensional sculptures and "objets trouvés" important inspiration in his work. A trip to paris or the sausalito flea market may uncover new ideas, out-there drawings to manipulate. He may photograph his own bronze statue of messenger mercury and use it in a

In Tom Bonauro's loft, arcane objects are chosen as nonverbal messengers and for the multitude of connections and loose-jointed affiliations they may suggest. Each is open to individual interpretation. Above the flat file, Ian Hamilton Finlay's red and white manifesto, "Don't Cast Your Revolution Before Swine."
Among his clients: the Margaret Jenkins Dance Company, MAC, Swatch Watch, record companies, M & Co, the Design Industry Foundation for AIDS, Sundance Institute, the Lesbian and Gay Film Festival, and Joseph Schmidt chocolates. A montage of appropriated images and objets trouvés on and in Bonauro's desk. His new fascination with old tools and "ancient" bones will doubtless find its way into his graphic design work.

promotional mailer. Or he can commandeer a sentimental paint-by-number religious portrait and give it new meaning and vitality by juxtaposing it with an expletive. ◆ The enigmatic appeals to Bonauro. His graphic studio collages range from sweet and altruistic views of the cosmos and optimism concerning the human condition to cynical street-smart artist-as-outsider calls for action that address today's concerns head-on. ◆ Under Bonauro's sure eye, objects transcend their often-mundane genre. A pair of 1916 photo-offset "Weather" instructional photos may be juxtaposed with Bonauro's graceful hero, Mercury. ◆ As continuing food and provocation for his eyes, Bonauro's desk-top details and wall-mounted gallery include fifties vases and postcards, a photocopy portrait-on-newsprint of a rose, paint-by-number books, and pieces of his own work that are symmetrically aligned with fabric designs, vintage tools, maquettes, an ink bottle, and a Tibor Kalman clock. ◆ Light pours into the live/work loft, turning the Tomb-and-Randolph-designed lighting system of loopy wires into airy sculpture. Cabinets and the trestle desk provide storage and work space. ◆ The combined power of the objects in Tom Bonauro's multilayered montages transfigures the individual images he chooses and their surface subject matter. His desk and furnishings become the stages for presentation, as well as superbly designed pieces in their own right. ◆ A wooden mallet on an oddly proportioned stand becomes a commentary on work, industrialization, the power of tools, respect for craft. ◆ An archetypal wooden wheel or a rusty old pitch fork inspire free-association, a search for meaning. A New Guinea mask gazes heavenward. Mercury takes off on a new mission. ◆ With the same vision that he applies to his work, Bonauro has transformed his white-walled, hard-edged industrial loft and its upstairs sleeping balcony into a meditative private gallery, a place where his ideas can take wing.

Tom Bonauro's tablescapes of found objects, stones, vintage images, and beautiful relics from the natural world form a dreamy still life. Every surface in Bonauro's loft is arranged as carefully and deliberately as his own graphic works. Every carving, handtool, vase, postcard, clock, paint-by-numbers book, as placed by the designer, invites inspection and introspection.

◆

A storage sculpture custom-made for Bonauro's studio is at once an allusive art piece and a beautifully practical cabinet. It was crafted by his longtime friend and collaborator, Philip Agee, and has the same direct-yet-abstract quality with which Bonauro infuses his art.

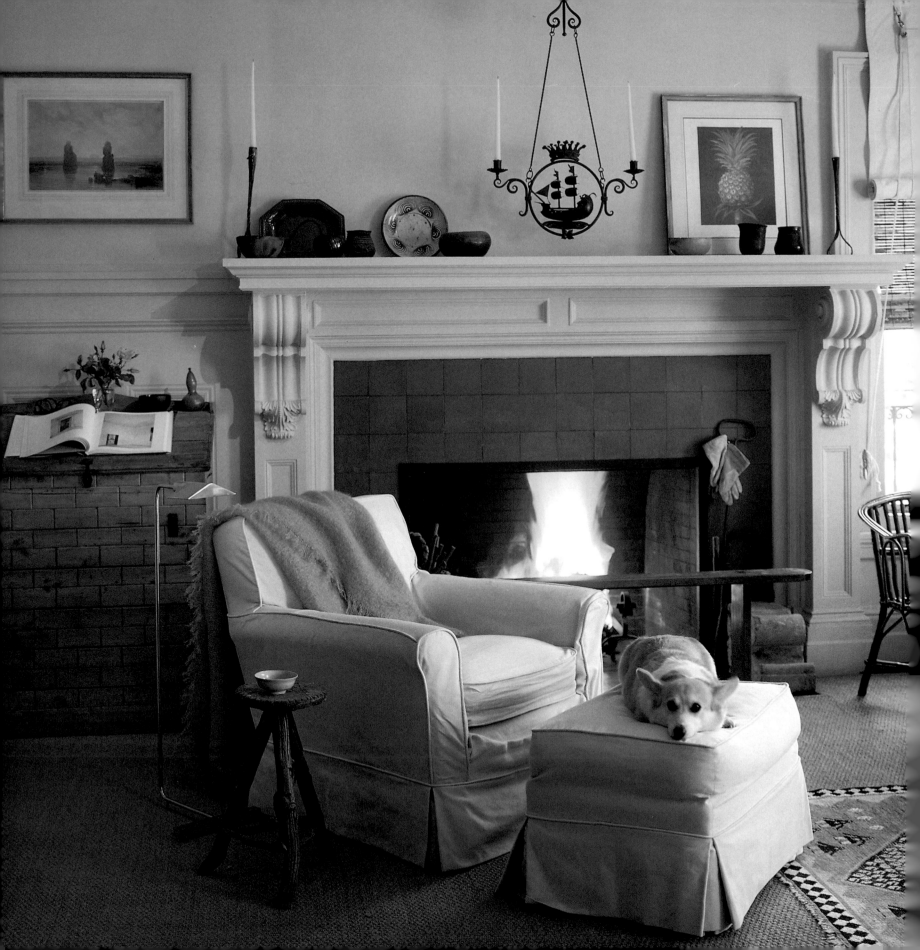

EXPERIENCED INTERIOR DESIGNERS CAN ALWAYS RISE GRACEFULLY TO A CHALLENGE. ♦ NOTED SAN FRANCISCO INTERIOR DESIGNER MICHAEL TEDRICK, ORIGINALLY FROM KENTUCKY, RECENTLY MOVED INTO A HANDSOME ONE-BEDROOM APARTMENT IN A FORMER EMBASSY (CIRCA 1890) IN PACIFIC HEIGHTS. IT HAS A GRAND OVERSCALED FIREPLACE, GLORIOUS AFTERNOON LIGHT, A QUIET DISPOSITION. THE CHALLENGE: ITS DIMENSION IS JUST 400 SQUARE FEET. ♦ "CAREFULLY PLANNED, A SMALL ONE-BEDROOM APARTMENT CAN BE TREMENDOUSLY COMFORTABLE, WELCOMING, AND VERSATILE," SAID TEDRICK, WHO IS A PARTNER WITH DESIGNER TOM BENNETT. "CONFIDENTLY EXECUTED, SMALL ROOMS CAN HAVE CHARM, PERSONALITY, AND MEMORABLE CHARACTER. THE KEY," HE SAID, "IS EDITING OF EVERY PIECE OF FURNI-TURE AND EACH OBJECT." HE PARTICULARLY RELISHED THE CAREFUL PLANNING A STUDIO APARTMENT IMPOSES. ♦ TEDRICK BOTH WORKS AND ENTERTAINS IN THE ELEGANT APARTMENT ACCOMPANIED BY HIS SWEET-TEMPERED CORGI, WALLIS. "WITH ONE LARGE ROOM, EVERYTHING IS VISIBLE AND OBVIOUS," SAID TEDRICK, "EVERY PIECE OF FURNITURE, EACH LAMP AND TABLE HAS TO BE CONSIDERED VERY CAREFULLY. CORRECT PROPORTIONS AND PLACEMENT ARE CRUCIAL." ♦ THE DESIGNER PAINTED WALLS AND MOLDINGS A RICH MATTE IVORY FOR A PLEASING, NEUTRAL BACKGROUND. "FOR ME, A MUTED PAINT COLOR GIVES THE MOST CHOICES IN DECORATING," TEDRICK SAID. "MY VISION OF THE ROOM IS THAT MY PAINTINGS, MY COLLECTIONS OF SHELLS, MINERALS, AND AMERICAN INDIAN ARTIFACTS WILL BE AT HOME. THIS IS VERY PERSONAL, NOT AT ALL A DESIGN STATEMENT." ♦ ON ONE SIDE OF THE ROOM HE SET A SIMPLE, UNDERSTATED SOFA AND ARMCHAIR, BOTH UPHOLSTERED IN PEARLESCENT, OYSTER-GRAY SILK VELVET. TO COMPLETE THE GROUPING, HE CHOSE A FRENCH ANTIQUE LEATHER WING CHAIR. ♦ "EVEN IN A SMALL SITTING ROOM, YOU SHOULD HAVE A SOFA LONG ENOUGH TO LIE ON," HE SAID. "BIGGER FURNITURE IS MORE VERSATILE. AND IT STRETCHES OUT THE ROOM" ♦ THE COFFEE TABLE, LACQUERED A BEAUTIFUL OXBLOOD RED, IS ONE OF THE FEW HINTS OF COLOR IN THE ROOM. ♦ ON THE WIDE MANTEL ARE A LIFE-TIME COLLECTION OF INDIAN POTS. ♦ IN ONE CORNER OF THE LIVING ROOM, TEDRICK HAS SET A BISTRO TABLE ACCOMPANIED BY A PAIR OF RATTAN ARMCHAIRS. "A SMALL TABLE CAN EASILY SEAT FOUR PEOPLE," TEDRICK SAID. "I BRING IN AN EXTRA PAIR OF FOLDING CANE CHAIRS. WITH CANDLES FLICKER-ING IN EVERY CORNER, THE ROOM FEELS VERY SPACIOUS."

Michael Tedrick's City apartment is compact in size, big on style. His choice: muted colors, well-ordered collections, and elegant, comfortable furnishings. Collections of a lifetime — minerals, sculpture, crafts, books, and ceramics — are carefully arranged on the mantel, tables, and a bookshelf.

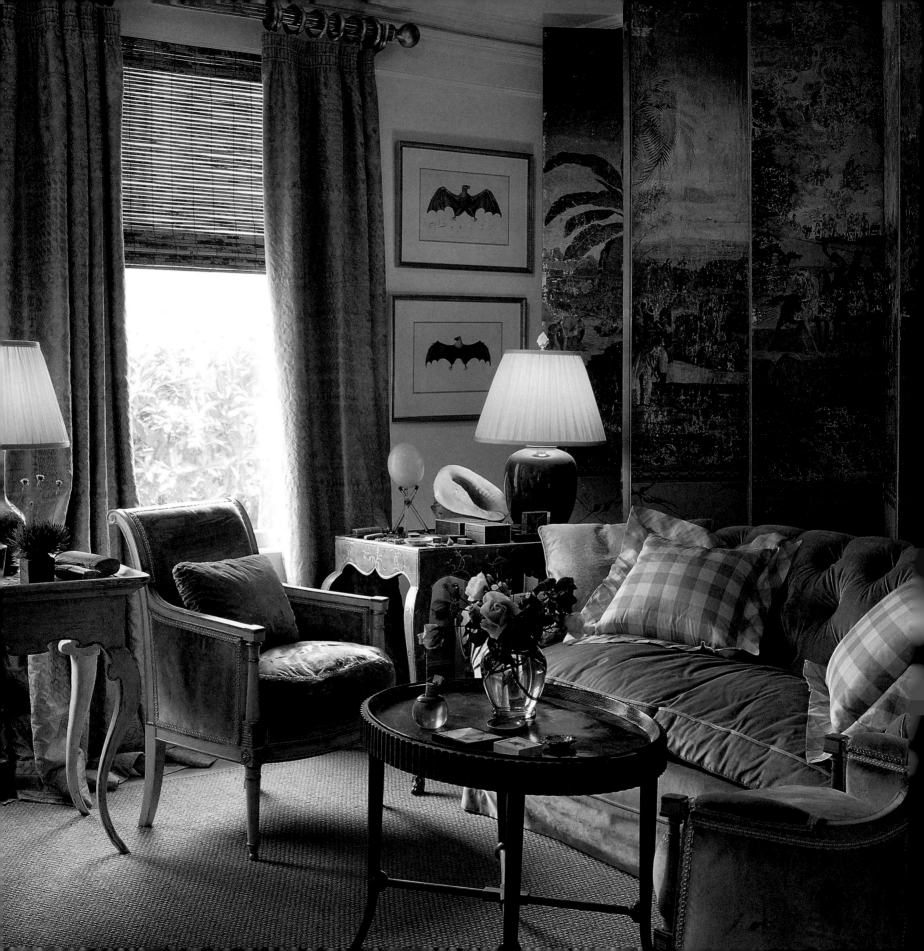

INTERIOR DESIGNER THOMAS BENNETT MAY DREAM IN TECHNICOLOR FOR HIS CLIENTS, BUT FOR HIS OWN APARTMENT HE PREFERS A SUBDUED, ALMOST MONOCHROMATIC COLOR PALETTE. BENNETT AND HIS CORGI, MEMPHIS, HAVE LIVED IN THESE GENTLEMAN'S CLUB-STYLE ROOMS FOR JUST TWO YEARS, YET THE TIME-MUTED, OLD-WORLD TONES OF HIS FABRICS AND GLAZED WALLS LOOK AS IF THEY HAD RESIDED THERE IN GREAT COMFORT FOR MANY YEARS. ♦ REJECTING THE SHOCK OF THE HUE, BENNETT SELECTED COLORS OF GREAT SUBTLETY TO GIVE HIS QUIET CORNER APARTMENT ITS CHARM AND GRACE. THE MORNING SUN GLANCING THROUGH HIS TORTOISESHELL BAMBOO SHADES SEEMS TO FADE-OUT THE FABRICS FURTHER. ♦ BENNETT SELECTED LUXURIOUS FRENCH SILK VELVET IN A MUTED TONE THAT SEEMS TO CHANGE FROM CELADON TO MONTANA SAGE TO SLATE BLUE DURING THE COURSE OF A DAY. FOR THE YOUNG DESIGNER, THIS SENSUAL AND COSTLY FABRIC IS A LIFETIME PROPOSITION. BENNETT SAVORS THE IDIOSYNCRATIC WAY HIS SLEEK SILK WEARS, WITH IMPRINTS AND SHADING SUGGESTING YEARS OF COMFORTABLE CONVERSATIONS AND DAY-TO-DAY LIFE. HE USED IT TO UPHOLSTER THE ENGLISH SOFA IN HIS SITTING ROOM, FOR HIS COLLECTION OF EIGHTEENTH- AND NINETEENTH-CENTURY FRENCH CHAIRS, AND FOR THE TAILORED COVERLET OF AN ANTIQUE FRENCH DAYBED. ♦ "I LOVE THESE HARD-TO-PIN-DOWN SOFT COLORS IN MY APARTMENT BECAUSE THEY RECALL THE NORTHERN LIGHT OF SCANDINAVIA AND THE ANTIQUE FABRICS OF HISTORIC ROOMS I'VE VISITED AND ADMIRED IN PARIS AND STOCKHOLM," SAID BENNETT. "GRAY/BLUE, TAUPE, PALE AMBER, CELADON, AND IVORY ARE VERY HARMONIOUS. THEY'RE NOT MODERN LOOK-AT-ME COLORS. I FIND THEM VERY RESTFUL AND PLEASING." ♦ THE APARTMENT WALLS

Point of view: To give dimension and texture to his sunlit sitting room, Tom Bennett posed his papier peint screen, which depicts a Napoleonic battle, behind the tufted, silk-velvet sofa. His eighteenth-century tole tray table depicts the port of Bordeaux. The floor is covered in simple sisal. Bennett's corgi, Memphis, has the run of the apartment.

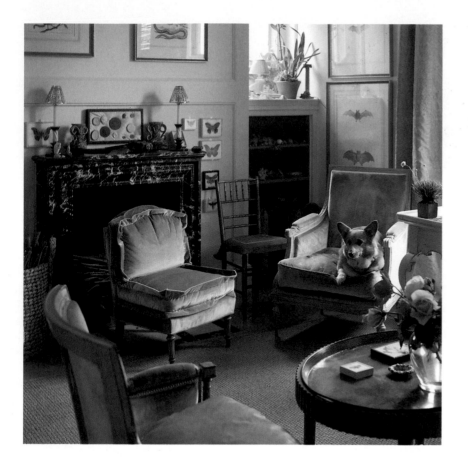

Tonalities: Fortuny's "Ashanti" print draperies in a paled down marmelade color cast a golden light into the sitting room. Bennett chose mutable celadon/slate-blue silk velvet for his collection of eighteenth- and nineteenth-century chairs. The Directoire mantel from Charles Gaylord's Powell Street antique gallery is of black and white marble.

◆

Natural history: In the dining room/study, a Louis XVI paintedbeechwood daybed is covered with a silk-velvet coverlet and topped with Fortuny pillows. On the wall are a lifetime's collection of butterflies (specimens from the 1920s), a drawing of an ibis, an old sun-bleached lobster that looks like intricate blanc de chine porcelain, and a sketch of a boa constrictor. The Parisian chaise de malade, upholstered in taupe leather, has an articulated wing back.

were striéd and glazed the color of clover honey. Bennett's lined and interlined cotton draperies, which hang from plain wooden rods, were made of Fortuny's "Ashanti" fabric printed with African motifs in amber and ivory dyes. ◆ "I like to contrast colors just as nature combines them. Harmony is important to me," said Bennett. Flanged silk pillows checked in amber and stone and a coral silk velvet pillow seem to glow against the slate-colored silk upholstery. ◆ Bennett's apartment is a memoir written with objects and furniture. It has the confident air of a very elegant natural history professor's study complete with obscure volumes, conchological prints, fishing lures, shagreen boxes on tables, and bat prints hovering on the walls. Every butterfly and drawing tells his story. ◆ "I've always been interested in nature, and I like to surround myself with mineral specimens, rare shells, flowers, and artifacts," said Bennett. ◆ He comes by his young fogey habits honestly. He has always admired the great explorations and expeditions of the late eighteenth century and the Victorian era. As a child he read about intrepid voyagers and scientists tramping through Africa and the antipodes and then returning with curious specimens, plants, and elaborate drawings of strange creatures to thrill academicians. ◆ "I have a voracious appetite for collecting," said Bennett. "The walls and tabletops are almost full, but that won't stop me. I'm now hanging new prints in the hallway." ◆ Above all, Bennett wanted his apartment to be very comfortable, not stuffy. ◆ "I never set out to design historically correct decor," he said. "I've mixed substantial nineteenth-century chairs with more delicate Directoire chairs. Men find Directoire chairs a bit petite. I love to visit museums, but I don't want to live in one."

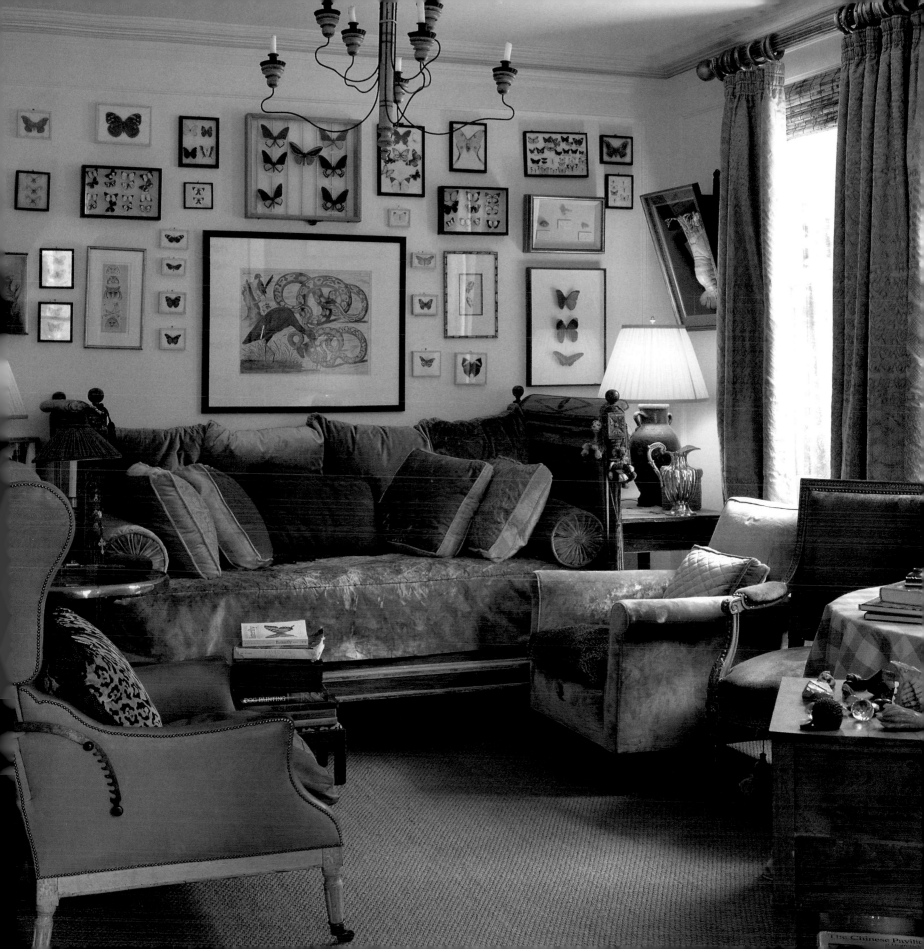

Collectors

*T*rash or treasure? ♦ To truly passionate collectors, provenance and price and pedigree are of little importance. Their eyes are open to a neoclassical chair, an old fragment of architecture, a vintage paint-by-numbers graphic, an exquisite Biedermeier chair, a powerful portrait, a forties French chair, or a smiling Mexican carnival head wherever they may find them. ♦ Rummaging through a Paris flea market, haunting a grand Jackson Square or Design Center antiques gallery, perhaps even enjoying a little midnight dumpster diving, they challenge cherished design assumptions and throw caution to the winds. With one treasure in hand, they determine to double their pleasure with a second, and thus a collection is begun. ♦ San Francisco is an enticing center for collectors. There are auctions, weekend flea markets, gallery shows and shops, and — for the truly imaginative — sidewalk sales and cheerful charity stores. Interior designers have long recognized the wonders of down-and-dirty junk shops where Frank-esque tables or Gustavian-style chairs and maybe an original Nelson, John Dickinson plaster table, Aalto, Bertoia, or Eames await discovery.

The Textures of her life: Obiko owner Sandra Sakata has a great eye for handcrafted textiles and baskets.
Here in her Russian Hill studio she has arranged Indonesian baskets, African Kuba cloths, and mud cloths.
Their striking geometries demonstrate folk art's remarkable border-crossing affinities.

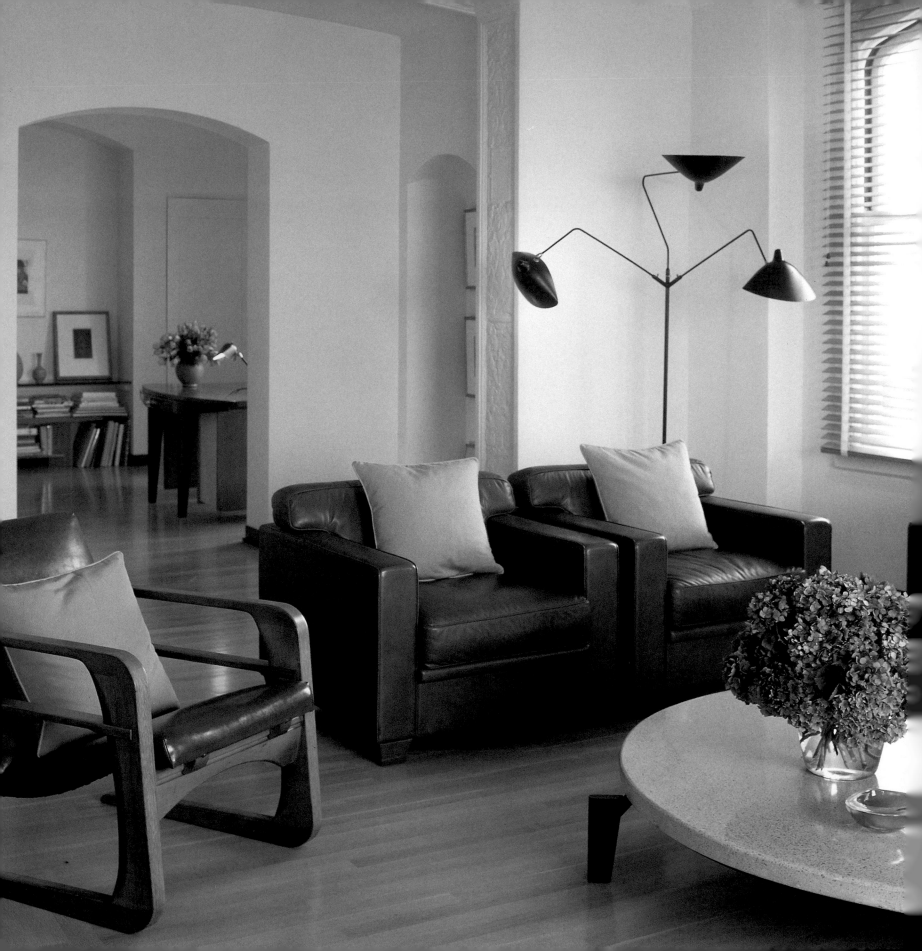

Esprit owner Susie Tompkins was born and raised in San Francisco. She remembers when, for women, wearing white gloves downtown was de rigueur. She recalls the dizzy days of the summer of love, and can name with great fondness restaurants, soda fountains, and shops that have long since closed. She spent summers in Bolinas, where she now owns a house, and later lived in a handsome house on Russian Hill designed by Willis Polk. ♦ Curious, cheerful, and direct, Tompkins, mother of Summer and Quincy (and now a grandmother), is reinventing her life. After living for most of her 50-plus years in "other people's houses," Tompkins has a city home of her own. The 12th floor of a Pacific Heights apartment building built in the twenties, it's dubbed "The Cloud Club" by her chums. ♦ A passionate learner, Tompkins's conversation topics range from hiking in Alaska to fifties design, conservation, her Jack Russell terrier, Gracie, low-maintenance clothing, Alice Waters's cooking, summer at a chateau in France, or an evocative new Dorothea Lange photograph. ♦ "I've always expressed myself through my work. My business and private interests collide," said Tompkins. "I admire the timeless chic of forties clothing, so my Susie Tompkins collection inevitably shows some of that influence. I collect forties and fifties French furniture, so I have Jean Prouvé "Présidence" desks in my study at home and in my office. I included a pair of his chairs in my living room and at work," said Tompkins. ♦ "I never studied design or business. I didn't even really complete high school, always learning as I went along. When you haven't been indoctrinated with the 'right' way to do

Movable seats: In Tompkins's top-of-the-town living room, a functional, non-precious aesthetic perfectly
suits her pragmatism. California industrial designer Kem Weber's wood and vinyl "Airline" chair (1934) throws
a curve. Her brown leather sofa and chairs are Jean-Michel Frank designs, in re-editions
from Andrée Putman's ECART.

Susie Tompkins's collections of 20th-century furnishings include this remarkable "Presidence" desk and chair, both designed by Jean Prouvé. His machine-age designs are now highly collectable. Tompkins's informally posed photographs invite closer inspection.

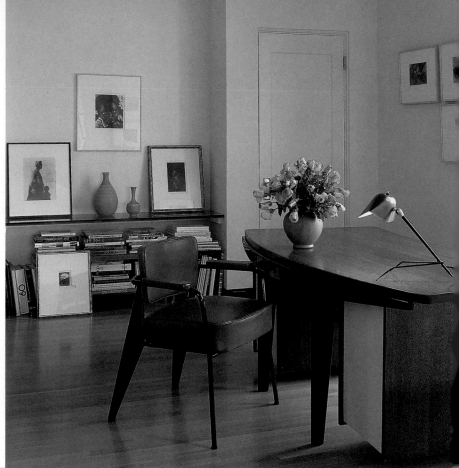

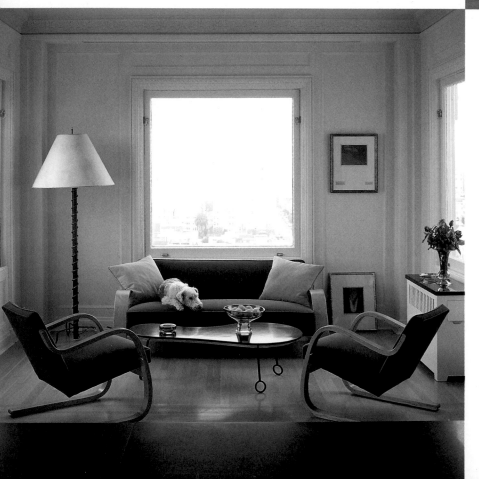

Curvy designs by Alvar Aalto animate the breakfast room. From this perch on the top floor of a landmark Pacific Heights building Tompkins, her family, and friends can look east along Pacific Avenue to the Bay Bridge and Berkeley. To the north she can see over the blue bay to Belvedere and Sausalito and the upper reaches of Richardson Bay.

something, you're less inhibited by dogma," she said. Not knowing what orthodoxy might dictate, she feels free to combine vintage American photographs; swap-meet finds; Venini glass; mass-produced, oak-and-steel Jean Prouvé "Visitor" chairs; and refined, brown leather Jean-Michel Frank sofas and chairs in her living room. ♦ As owner of the 24-year-old San Francisco-based clothing company Esprit (co-founded with her former husband, Doug), Tompkins has a platform for her social activism. She said she is very aware that times have changed mightily since the early eighties, when No Detail Is Too Small was Esprit's motto, and the company's teams of international designers spent millions of dollars developing award-winning new packaging, superstores, lavish catalogues, and clothing. Then image was everything. Today, substance must back up style. ♦ Now instead of obsessing about buttons or T-shirt logos, Tompkins may take Gracie down to the Ferry Plaza for the Saturday morning farmer's market, fly to Paris for inspiration, or meet Los Angeles furniture designer Roy McMakin. Sunday, Tompkins may be in San Francisco's Tenderloin for her weekly spiritual uplift at Rev. Cecil Williams's Glide Memorial United Methodist Church. ♦ "I've always been a very Northern California person. I really appreciate the beauty that surrounds us here. That's why I'm very interested in conservation. We can't let all this natural beauty be destroyed because we don't care," she said. ♦ Tompkins found her sky-high aerie four years ago. Guided by Gregory Turpan, she stripped the light-filled rooms bare of moldings, overwrought sconces, and froufrou plaster detailing, and painted all the walls white. She lightened the floors and now leaves

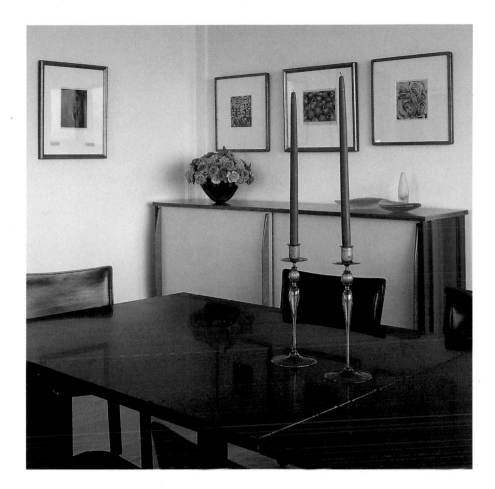

♦

Shapes of the past: In the dining room, brightly colored roses in a vintage Italian vase from De Vera pay tribute to a quartet of Tina Modotti prints hanging above a Jean Prouvé painted steel cabinet. "The rooms are deliberately spare and open-ended so that I can add to and move my collections," said Tompkins. She's now considering changing the techie, black-granite-topped dining table for a neoclassical design by T. H. Robsjohn-Gibbings. Black leather "Cab" chairs by Mario Bellini.

♦

them bare. ◆ "When I moved here, I wanted to start a new way of life — pared down, simpler. I wanted to find furniture in shapes I'd never seen before. This was a way of discovering myself," she said, sitting in a curvy, vintage Alvar Aalto birch chair in her breakfast room. From her window, she can see over some of the most handsome houses in Pacific Heights — as far as the distant gray Bay Bridge and the hills of the East Bay. ◆ "First, I found the round table by Jean Prouvé in New York. I loved the no-nonsense, unpretentious materials," she recalled. She later added lighting by Jean Royer and furniture by Charlotte Perriand (an associate of Le Corbusier) to her collection. The apartment is also a gallery for collections of fine photography, tramp art, Scandinavian glass, and folk art. A quartet of Tina Modotti's twenties photographs hang on the dining room walls above a Jean Prouvé oak-and-metal cabinet. A Prouvé desk and chair furnish the study. ◆ Encouraged by beau Dan Miller, Tompkins is collecting photography by women photographers like Imogen Cunningham, Consuelo Kanaga, Laura Gilpin, Dorothea Lange, Maria Cosindas, and Tina Modotti (a special favorite), along with works by Edward Weston, Minor White, and Edward Steichen. ◆ "I want to stay inspired and keep my spirit shining," said Tompkins, glancing up from a new acquisition awaiting framing. It is a poetic Modotti print of telegraph wires against a Mexican sky. "Today, you have to find out where the action is and be flexible."

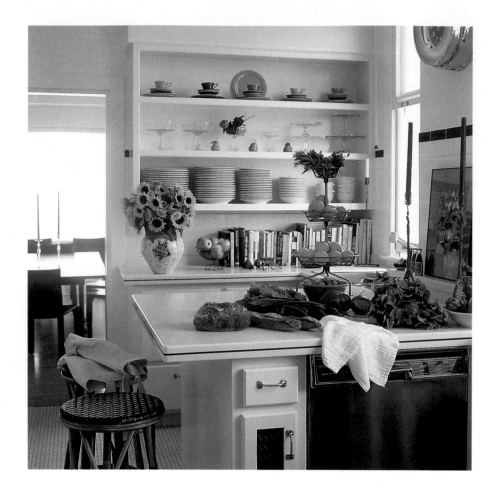

◆

Most of the year, Tompkins can leave windows open as she prepares salads, with vegetables and baguettes fresh from the Ferry Plaza farmer's market. Her penchant for collecting green objects is legendary among her friends: On the shelves of her kitchen, she displays Depression glass, a pique-assiette vase depicting a Jack Russell terrier, and a lifetime's collection of olive, emerald, veridian, sage, and pea-green plates and glasses.

◆

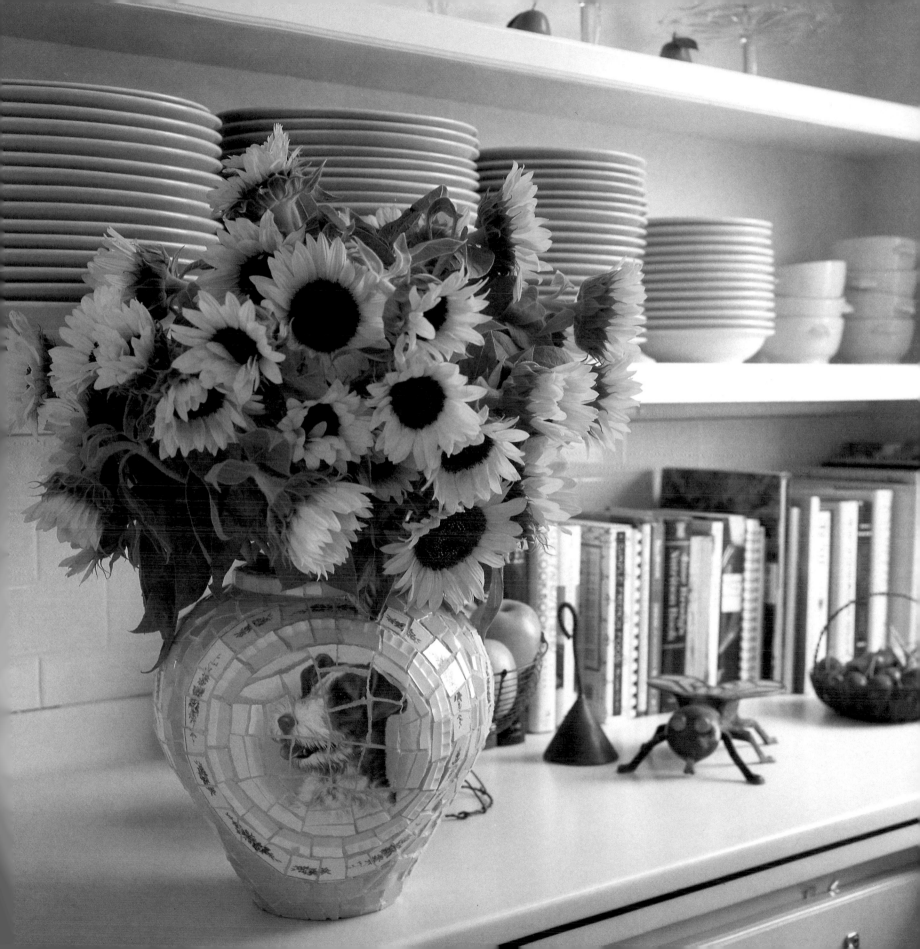

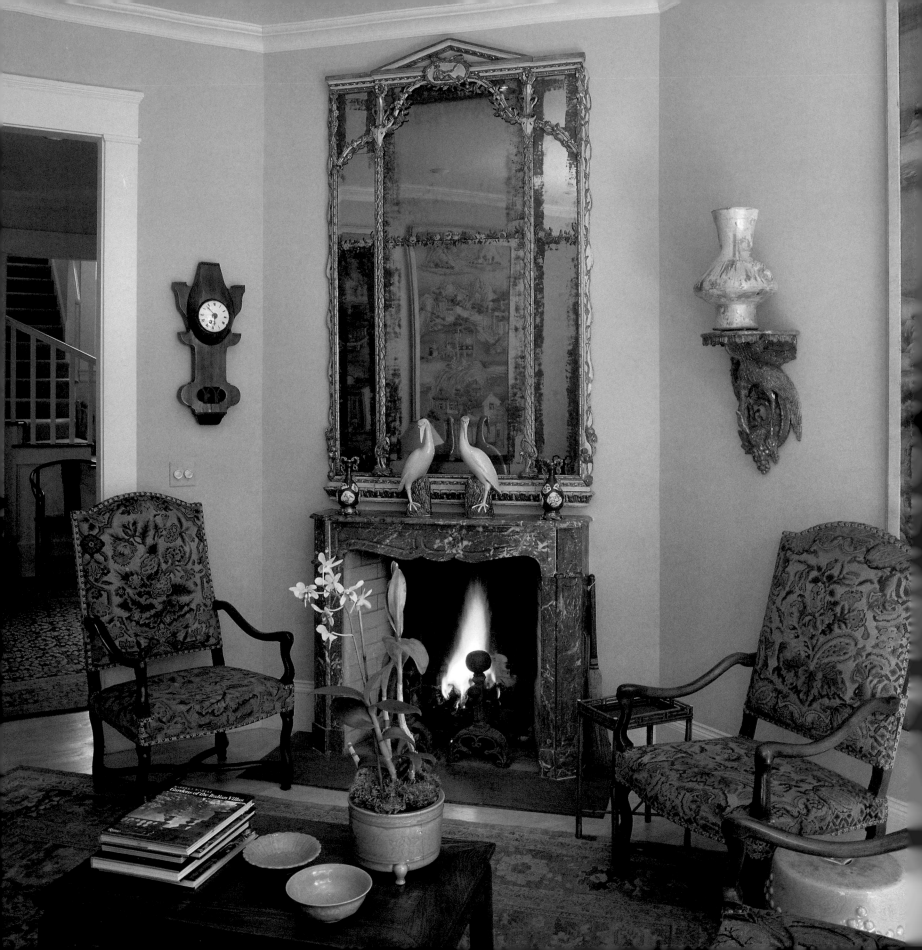

FOR 19 YEARS AND IN SEVERAL LOCATIONS AROUND THE CITY, SAN FRANCISCO ANTIQUES DEALER ED HARDY HAS BEEN FULFILLING THE AESTHETIC DESIRES AND COMPULSIONS OF CONNOISSEURS, DECORA-TORS, AND MUSEUMS FROM FAR AND WIDE. HIS GALLERY, ED HARDY/SAN FRANCISCO, HAS NOW COME TO REST IN THE SHOWPLACE SQUARE AREA. THE ELEGANT CONTENTS OF HIS SKY-LIT, PALLADIAN-INSPIRED SHOWROOM ATTRACT CLIENTS SUCH AS BILL BLASS, WHO MAY SPEND HOURS IN REVERIE AMONG THE EUROPEAN ANTIQUES AND DECORATIVE ARTS, ANTIQUE GARDEN ORNAMENTS, AND A NEW LINE OF REPRODUCTIONS. ♦ AT HOME, THE ERUDITE MICHIGAN-BORN HARDY IS FREE TO PLEASE HIS OWN TASTES, WHICH HOVER IN THE DIRECTION OF SCHOLARLY AND RATHER SOBER ORIENTAL WORKS. STUDIED SIM-PLICITY IS NOT HARDY'S ONLY LOVE, HOWEVER. HE MAY TAKE A DETOUR FROM A MING DYNASTY ROSE-WOOD CHUANG CHUANG (SLEEPING BED) AND APPRECIATE THE CONTRAST OF FANCIFUL HAND-PAINTED PIEDMONTESE CHAIRS WITH COLORFUL STRIPED UPHOLSTERY, TAKE A WHIRL WITH A ROMANTIC PARCEL-GILT MIRROR REPLETE WITH FLORAL DECORATION, OR SAVOR THE ENDURING APPEAL OF A QUARTET OF BOLD-SCALE LOUIS XIV FAUTEUILS. ♦ HIS CREAM-WALLED RESIDENCE, A RENOVATED QUEEN ANNE VICTORIAN BUILT IN 1891, OFFERS A SIMPLY STATED BACKGROUND FOR THOUGHTFUL PLACEMENT OF ALL OF HIS ANTIQUES, WHATEVER THEIR STYLE OR PROVENANCE. ♦ "I LOVED THIS PLACE FROM THE MOMENT I FIRST SAW IT IN 1981," RECALLED HARDY. "I WALKED INTO THE ENTRY HALL AND SAW A LARGE, OPEN, WELCOMING SPACE AND DECIDED TO BUY THE HOUSE." ♦ HARDY SOON DISCOVERED THAT HIS NEW RESI-DENCE, ON A VERDANT HILLSIDE ABOVE THE CASTRO DISTRICT, WAS HARDLY A GEM. ITS PREVIOUS OWNER, AN ECCENTRIC BOOK DEALER, WAS CONTENT TO LIVE WITH BUCKETS PLACED STRATEGICALLY AROUND THE HOUSE TO CATCH RAIN DRIPS RATHER THAN REPAIR THE ROOF. CATS ROAMED THE ROOMS, SLEEPING AMONG BOOK STACKS. DREARY TONGUE-IN-GROOVE WAINSCOTTING AND SMALL, DATED, CLOSED-

Antiques dealer Ed Hardy has used a confident mix of furnishings in his City house. Handsome, very sculptural Louis XIV walnut fauteuils with period needlepoint (and perfect posture) stand in front of a Louis Philippe Rouge Royale marble chimneypiece (circa 1850). The Piedmontese neoclassical, parcel-gilt wall mirror is ornamented with whimsical floral polychrome motifs. A pair of cream-glazed Chinese porcelain egrets stands on the mantel.

off rooms gave the house a lugubrious air. The garden, now redesigned by Stephen Suzman into an elegant oasis with a cupola'd gazebo, was piled with rusted junk. ♦ "I decided to simplify and edit the details of the house but keep the essence of its Queen Anne Victorian style," said Hardy, who supervised the remodel. "Victorian building-style ideas generally came from builders' books rather than an architect, so proportions and embellishments were completely arbitrary and often awkward. I had to remove an oddly placed eyelet window, take out a strange band of stucco on the exterior, and remove some of the more strident Victorian features. I wanted the interiors and exterior to have a refined, understated look." ♦ Over three years, Hardy patiently restored the house and lower garden. He built a new terra-cotta-paved kitchen, installed all new plumbing, added central heating and insulation, repaired the roof, even built a new foundation. Today the architecture, moldings, and proportions and finishes of the rooms look appropriate to Queen Anne, not aggressively modern. New plastered walls were painted a sunny cream. Woodwork is all white. ♦ "In every design decision, I tried to keep the spirit of the house because I respected what was inherent to the classic style," said Hardy. He kept one Victorian conceit, a quirky tower that is accessible only through a window in his bedroom. ♦ Renovation was arduous. Choosing his furnishings was a pleasure. Hardy had his collection of antiques waiting in the wings. ♦ "I've been very fortunate to work with antiquarians like Carl Yeakel in Laguna Beach, and to have befriended Gep Durenburger in San Juan Capistrano. They have opened up whole new horizons in the art and antiques worlds," said Hardy, who headed up the Oriental works of art department at Sotheby's in Los Angeles for four years. ♦ Hardy has also been the recipient of his share of good fortune. ♦

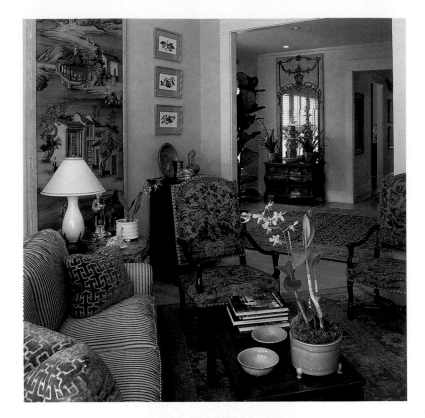

Hardy's complete renovation of his house included removing doors and opening the sitting room up to the foyer. Among objects that reflect his wide-ranging interests are a Chinese porcelain figure, a Chinese Kwantung glazed stoneware vase used as a lamp base, three hand-painted Chinese wallpaper panels (circa 1760), three Chinese pith paper paintings, a Persian dragon-form ewer, and a gilt-copper lion's paw on a Ming chest. The Louis XIV fauteuil with needlepoint upholstery is one of a quartet.

"Finding extraordinary antiques often takes years of detective work and patience, but I do have occasional windfalls," he said. "One day a woman from Chicago wandered into my shop and asked me if I would sell for her a handpainted, three-panel, mid-eighteenth-century Chinese screen formerly in a David Adler house in Lake Forest. In loving detail, the screens depict a romantic view of daily life, costumes, architecture, and landscapes of the mid-eighteenth century. It was very unusual, very appealing to me. It now hangs on the wall of my living room." ♦ Hardy is partial to the surpassingly simple and modest lines of Ming furniture in a beautifully grained, honey-colored rosewood that is now extinct. Still, he can also appreciate the rococo giddiness of a Piedmontese parcel-gilt mirror painted with bouquets of roses, or a set of neoclassical northern Italian shield-back dining chairs, circa 1780, which formerly belonged to actor David Niven. ♦ "In California, we don't have such rigid rules or reverence for strict period rooms," said Hardy. "I want to show and enjoy my antiques, but I don't want my house to look like a museum. Juxtaposing embellished French and Italian pieces with more soulful and simple Japanese and Chinese pieces emphasizes their beauty, their spirit, and their eccentricity." ♦ In the spacious hallway that first drew him to the house, he has posed a Chinese iridescent-glazed tomb tower on an ornate Régence walnut *bombé* commode. ♦ In his upstairs landing, Hardy has grouped a collection of blue and white Chinese and Japanese porcelains on top of a carved gilt-wood, Italian baroque console table, circa 1700, probably from Florence. Above them hangs a watercolor of insects and flowers of the Canton school, circa 1820. ♦ "If I change anything, it will be small refinements," noted Hardy. "I'm very happy with the mix of things I have now. I've owned the Ming furniture for 15 or 20 years, and I never tire of it."

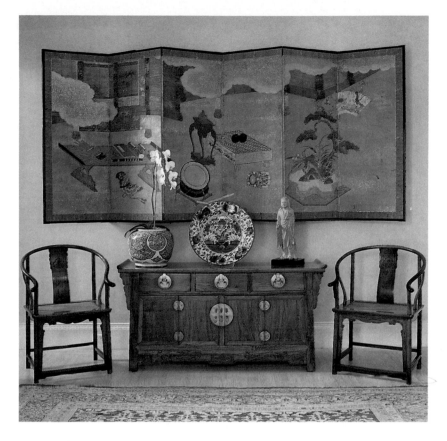

♦

In the foyer, a six-panel Japanese screen portraying a scholar's studio hangs above a seventeenth-century Chinese huanghuali altar coffer. A pair of seventeenth-century Chinese huanghuali horseshoe-back armchairs complete the rather understated, scholarly ensemble. Huanghuali, a revered type of decorative rosewood that was sold by the ounce, became extinct in the eighteenth century.

♦

JEAN AND CHUCK THOMPSON HAVE BEEN COLLECTING THE COLORFUL ARTS AND CRAFTS OF MEXICO FOR THE PAST 30 YEARS. SEVERAL TIMES A YEAR, THEY HEAD SOUTH TO VISIT OAXACA, TAXCO, PUERTO VALLARTA, OR MEXICO CITY, AND TO FIND OFF-THE-CHARTED-TRACK VILLAGES, POTTERIES, GALLERIES, AND STUDIOS. THEIR COLLECTIONS ENLIVEN THEIR APARTMENT, FILLING THE NORTH-FACING ROOMS WITH SUNSHINE, FIESTA COLORS, AND ECHOES OF LONG-AGO ENCOUNTERS. ◆ "WE LOVE THE WILD COLORS, THE FULL-TILT HUMOR, AND THE GREAT VITALITY OF HANDCRAFTED DECORATIVE MEXICAN ART," SAID JEAN, PARTNER WITH BARBARA BELLOLI IN FIORIDELLA, ONE OF SAN FRANCISCO'S TOP FLOWER SHOPS. "WHILE THERE ARE SOME SCULPTURES OR PAINTINGS THAT ARE SET OUT IN DISPLAYS, WE LIKE TO USE OUR COLLECTIONS, NOT JUST LOOK AT THEM. NOTHING PLEASES US MORE THAN TO SET THE TABLE WITH MEXICAN MAJOLICA PLATES AND TO SURPRISE OUR GUESTS WITH FAVORITE VASES FILLED WITH FLOWERS OR GREEN-GLAZED BOWLS PILED WITH FRESH TOMATOES OR MANGOES." ◆ JEAN, HER HUSBAND, CHUCK, A MARKETING EXECUTIVE, AND THEIR SON, SCOT, LOVE TO CREATE NEW ARRANGEMENTS AND COMBINATIONS OF MEXICAN GLASSWARE, PAPIER-MÂCHÉ MASKS, PAINTINGS BY UNTUTORED ARTISTS, AND THE OCCASIONAL HAND-CARVED CHAIR OR TABLE. THE COUPLE ALWAYS GIVE THEIR ROOMS THEIR OWN SPIN. THEY KEEP THEIR FURNISHING CLASSIC TO GIVE THEM FLEXIBILITY WITH DISPLAYS. ◆ FOR THE THOMPSONS, MEXICAN DECORATIONS HAVE BECOME THEIR OWN TRADITION FOR THANKSGIVING OR CHRISTMAS. "AS IT HAPPENS, OUR FAVORITE MEXICAN SCULPTURES, CERAMICS, TIN CRAFTS, AND PAINTINGS ARE GREEN, RED, AND PINK, PERFECT COLORS FOR FESTIVE OCCASIONS," SAID JEAN, WHO HAS BEEN STUDYING MEXICAN CRAFTS FOR MORE THAN 20 YEARS. SHE AND CHUCK AND BARBARA TRAVEL INTO THE HEART OF MEXICO, CLAMBERING ABOARD LOCAL BUSES IN HOPES OF FINDING TINWARE, POTTERY AND CARVED FIGURES, AND ONE-OF-A-KIND TREASURES THAT NEVER TURN UP IN CITY GALLERIES.

The Thompsons particularly love the all-out, joyful colors of Mexican folk arts. Garden roses in sweet-Mexican-candy pink stand among collections of ceramics, hand-blown glass, silver, tinware, and eccentric hand-built houses and animals. A paper-mâché head, originally made for a carnival figure, makes a witty sculpture in the Thompson's living room. Collections of Mexican ceramics, paintings, and handmade glass change with the seasons.

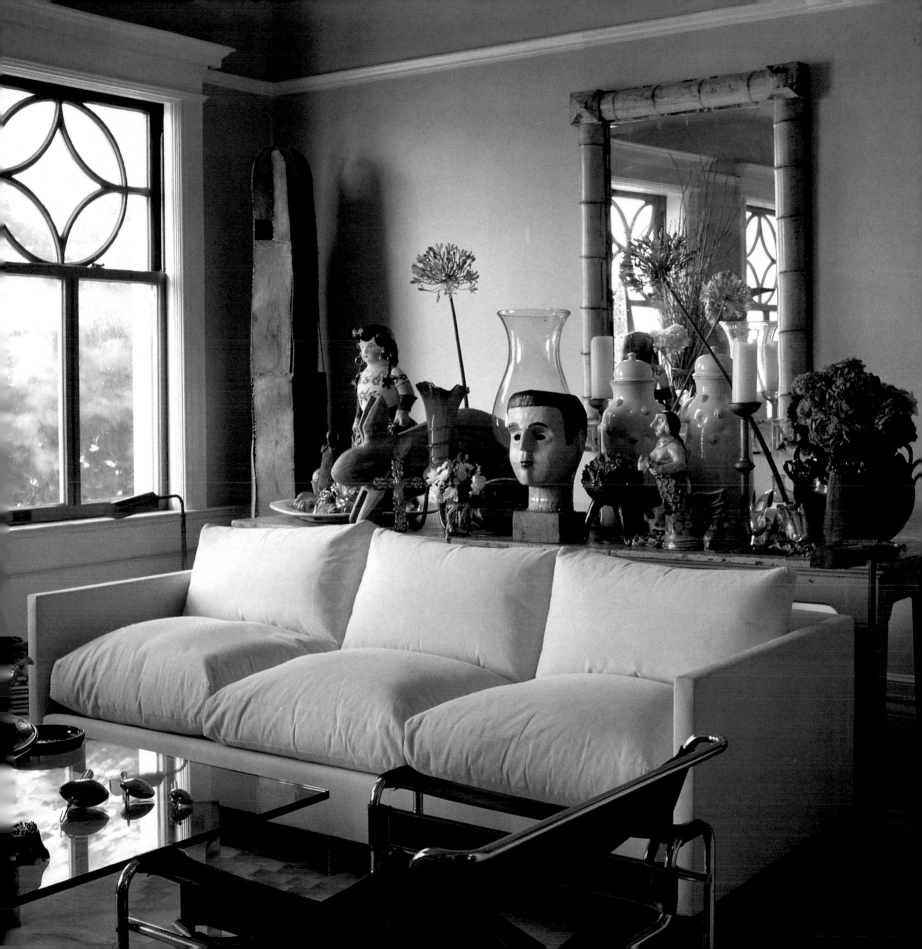

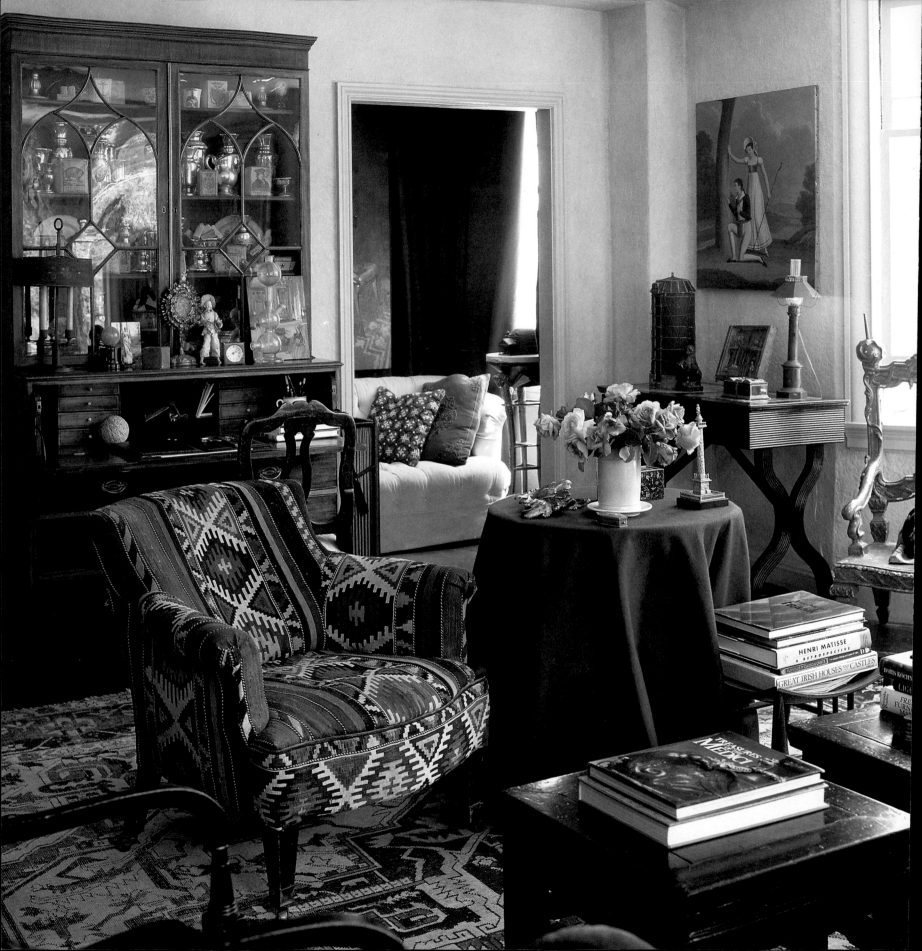

IT'S NO SURPRISE THAT THE APARTMENT OF DESIGNER/ANTIQUES DEALER CONOR FENNESSY HAS ITS LYRICAL, WITTY SIDE. HE WAS BORN IN DUBLIN AND HAS SPENT A GREAT DEAL OF TIME IN THE IRISH COUNTRYSIDE, SO HE APPRECIATES LIGHTNESS IN DECOR AND A TOUCH OF HUMOR IN HIS COLLECTIONS. THAT MIGHT EXPLAIN, TOO, WHY HE HAS A CERTAIN FONDNESS FOR OBJECTS OF FADED GRANDEUR AND ANTIQUES OF THE GEORGIAN PERIOD. DUBLIN IS, AFTER ALL, A SHABBY, GENTEEL GEORGIAN CITY. ◆ "I LOOK FOR A SENSE OF EASE AND COMFORT IN MY OWN ROOMS AND THE PATINA OF AGE IN MY ANTIQUES," SAID FENNESSY. "I HAVE A CERTAIN LACK OF REGARD FOR DESIGN CONVENTIONS. EVERYTHING DOESN'T HAVE TO MATCH. ANTIQUES APPEAL TO ME MORE WHEN THEY SHOW SIGNS OF USE. I'M MORE INTERESTED IN CREATING A RELAXED ATMOSPHERE THAN MAKING FORMAL OR PRETENTIOUS DECOR." ◆ JUST TWO BLOCKS FROM LOMBARD STREET (THE CROOKEDEST STREET IN THE WORLD), FENNESSY'S APARTMENT BUILDING WAS COMPLETED IN 1928 AND DISPLAYS THE HAND-FINISHED PLASTER WALLS, ARCHWAYS, COVED CEILINGS, VAST BAY WINDOWS, AND RATHER THEATRICAL CALIFORNIA COLONIAL-STYLE HARDWARE OF THE PERIOD. ◆ WHEN FENNESSY FIRST MOVED THERE 13 YEARS AGO, HE MADE NO ATTEMPT TO CREATE A FAUX PERIOD SETTING. RATHER, HE MOVED IN WITH A LIFETIME'S COLLECTION OF UNCOMMON EPHEMERA, SMALL TREASURES, AND BEAUTIFUL ANTIQUES AND SET UP HOME. HIS IS THE KIND OF COLLECTING IMPULSE THAT TRANSCENDS MERE ACQUISITIVENESS. HE WANTS TO LEARN, BE ENTERTAINED, BE DELIGHTED AND AMBUSHED BY THE ANTIQUES HE FINDS. ◆ "MY ROOMS ARE ALSO MY ATELIER. I LEARN A LOT ABOUT HOW A PIECE WORKS AND CONTRASTS IN THE ROOM WHEN I KEEP IT HERE A FEW MONTHS," FENNESSY SAID. "I CAN OBSERVE ITS PROPORTIONS AND SEE HOW IT

Context and content: In Conor Fennessy's living room, a handsome English Georgian mahogany secretary,

circa 1790, is used to house his collections of nineteenth-century mercury glass, antique Swedish tobacco blocks

wrapped in paper, French cartonnage, Roman oil lamps, and the inevitable clutter of an inveterate collector.

Fennessy has shaped a cozy, put-your-feet-up atmosphere with his capacious kilim-upholstered club chair, a kilim

rug, Chinese rosewood tables, eccentric antiques, a baize-covered table, and stacks of art books.

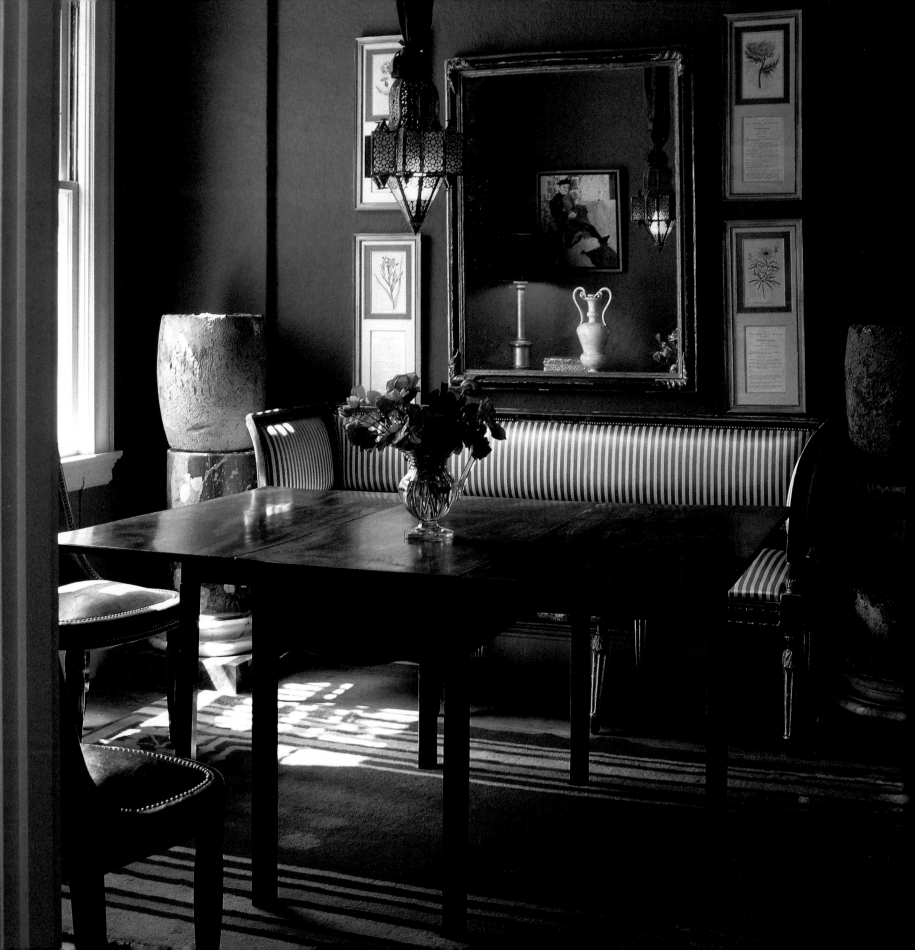

functions. Like most dealers, I also move favorites in and out. Paintings, prints, collections, chairs, and chests of drawers or mirrors may be moved from room to room, or I may sell them." ♦ Fennessy does have some favorites. ♦ "I'm drawn to French and Irish and English neoclassical design and Venetian rococo because they're a meld of periods and sensibilities," noted Fennessy. "It's a juxtaposition of disparate qualities that creates life in a room." ♦ "I love having a formal dining room," said Fennessy. "When I take breakfast there, I can spread my newspapers all over the table. The table can seat eight comfortably, or the leaves can be folded down so that it can serve as a buffet. ♦ "In decorating the room, I followed my taste for contrast and chiaroscuro. The white faience urn, mercury-glass column lamp, and antique mirror stand out boldly against the crimson walls," said Fennessy. "I find the richness of the red walls very comforting and luxurious. I can linger there for hours." ♦ His eye is drawn to strange proportions, craftsmanship, and elegance. A bit of mystery intrigues him more than glitz and flash. In his living room, he displays an eighteenth-century Venetian cardinal's gondola chair, a Ming chest with faded orange-red lacquer, a small Swedish gilt-wood gueridon, circa 1810, topped with an architectural model of the Parthenon. ♦ Colors, too, are engagingly eccentric. His tufted, silk-velvet sofa is in a toned-down mossy green. He chose fragments of a kilim for pillows because he loved their washed-out, ashy blue and dusty rose hues. ♦ "As a designer and dealer, I've been exposed to so many wonderful fabrics and antiques," Fennessy said, not at all world-weary. "I never get tired of colors that are enigmatic or antiques that are a bit inscrutable. Just when I think I understand them, I move them to another room and some new quality reveals itself. I fall in love all over again."

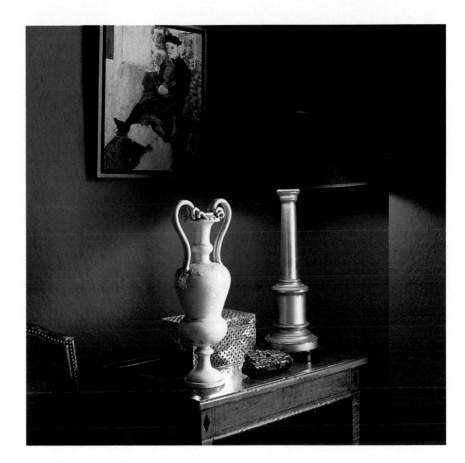

Walls painted rich, ruby red bestow great distinction upon the dining room. The neoclassical Italian settee, circa 1818, is upholstered in chic silk twill in ivory and crimson. The English mahogany gate-leg dining table, circa 1790, is lit by an exotic Moroccan brass lantern. Fennessy stands a pair of foundry urns on scagliola pedestals.

♦

On a Swedish tea table, Fennessy placed an elegant late-eighteenth-century Italian faience urn. The oil painting is by Eleanor Dickinson.

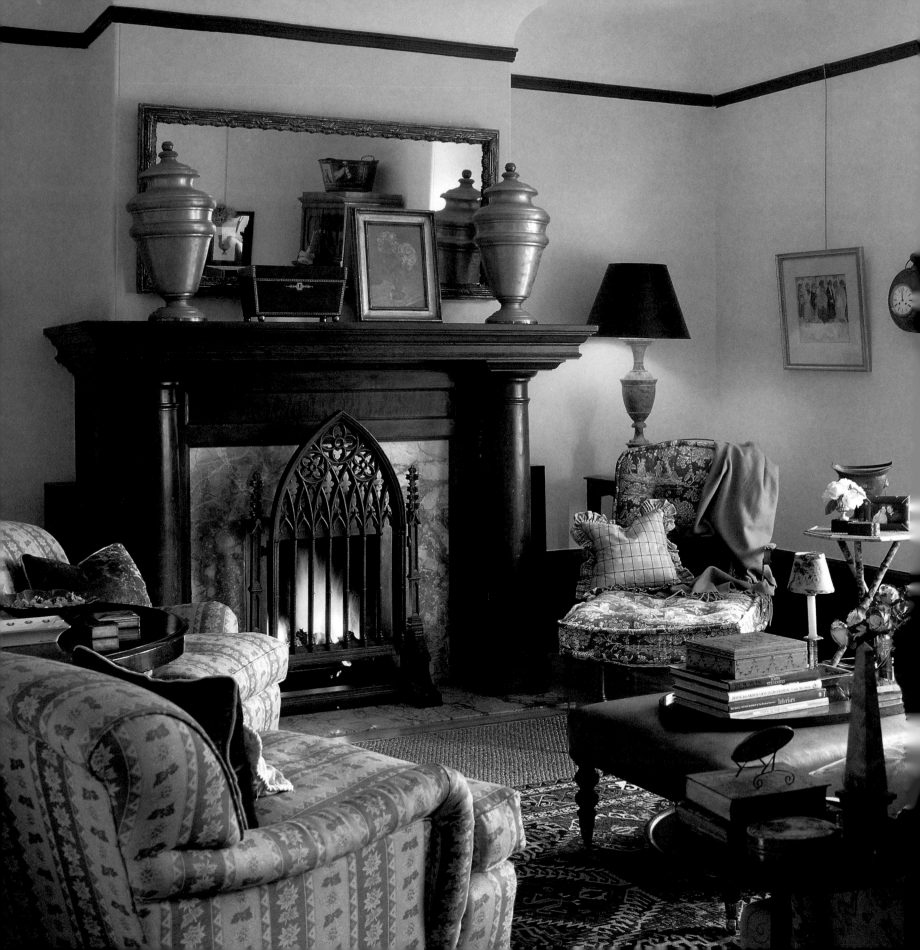

MOST PEOPLE BELIEVE THAT TRAVEL BROADENS THE MIND. SAN FRANCISCANS PATRICK WADE AND DAVID DEMATTEI BELIEVE THAT AN EQUALLY LOFTY PURPOSE FOR WORLDLY EXPLORATION IS TO DISCOVER ANTIQUES, FOLK CRAFTS, AND VINTAGE TREASURES OF OTHER CULTURES. THEIR DAUNTLESS TRAVELS HAVE RESULTED IN FINELY HONED COLLECTIONS, ALL PRESENTED IN THE ROOMS OF THEIR HOUSE WITH TOUR DE FORCE DISPLAYS. ♦ CRACK-OF-DAWN TRAIPSING ALONG LONDON'S PORTOBELLO ROAD, WILD GOOSE CHASES IN SEARCH OF FUSTY ANTIQUE STORES IN THE WILDS OF NEW MEXICO, AND SUNDAY SWEEPS THROUGH OBSCURE FLEA MARKETS ALONG THE STONE CANYONS OF MANHATTAN OR MOODY PARIS QUAIS ARE ALL ON THE ITINERARY FOR THE TWO FRIENDS. ♦ LIKE FEARLESS VICTORIAN TRAVELERS VENTURING OUT INTO REMOTE CORNERS OF THE WORLD TO FIND SIGNS OF CIVILIZATION, WADE AND DEMATTEI SPEND THEIR TIME DISCOVERING THE TELLING OBJET D'ART, THE METAPHORIC BRONZE FIGURE, THE DUST-LADEN URN, THE NEGLECTED RUG OR FOXED PHOTOGRAPH, OR BLACKENED SILVER VASE OF IMPECCABLE PROVENANCE. MANY A PAPER-WRAPPED PRINT OR PITCHER HAS BEEN HAND-CARRIED HOME, ALL THE BETTER TO APPRECIATE EVOCATIVE SHAPES, CAREFUL CRAFT, AND THE PATINA OF AGE. ♦ WADE AND DEMATTEI, BOTH EXECUTIVES, HAVE CHOSEN TO LIVE IN THE PERFECT SETTING TO HOUSE THESE TREASURES. POLISHED TABLETOPS, PRISTINE SHELVES, ANTIQUE HANDCRAFTED BENCHES, AND CARVED MANTELS MAKE PERFECT LANDING PLACES FOR SILVER BOXES, BOOKS, ALABASTER URNS, ETCHINGS, FRAMED HISTORIC PHOTOGRAPHS, RICHLY TEXTURED KILIMS, CARVINGS BY UNTUTORED ARTISTS, AND NORTH AFRICAN CERAMICS. ♦ "COLLECTING IS OUR HOBBY. WE PREFER OLDER PIECES, OBSCURE OBJECTS, NOTHING CLICHÉD," SAID WADE, AN EXPERT IN FINESS-ING SHIPMENTS OF ODD-SHAPED AND FRAGILE MERCHANDISE.

Welcome home: The pale-ochre-tinted walls (which rev up to a golden sunflower yellow in the late afternoon sun) are picture-perfect for the Merchant-Ivoryesque palette of the sitting room. Bennison cotton prints on the chairs, down-filled pillows, a sisal-covered floor, ancient-madder velvets, antique Kashmiri throws, and dark-stained woods give a sense of timeless ease. The French metal garden chaise longue, dug up in East Hampton, is pillowed with toile de Jouy and soothed with a cashmere throw by Hermès. Traditional club chairs on casters are by George Smith. Flowers by Patty Wilkerson of Seaflower.

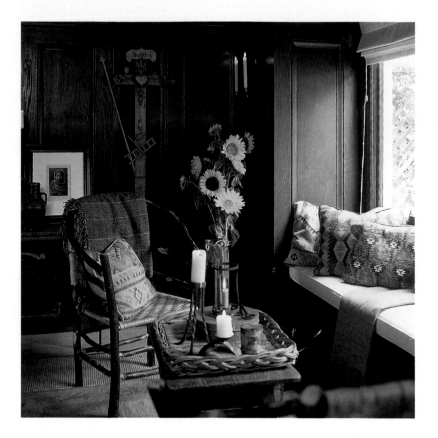

Shades of the Southwest: Passionate and curious collectors,
Wade and DeMattei first buy, then find a home for, their flea-market
and antique arcade loot. Cosmopolitan collections lit by the
bay windows of the dining room include an ever-changing display of
Moroccan urns, kilim rugs, handwoven pillows, Edward Curtis
photographs, a hand-carved cross from New Mexico,
and a pair of traditional handcrafted chairs from the Ozarks. The
window overlooks a garden that is fragrant with old roses and
jasmine for most of the year. Out there, too, on a sheltered stone
terrace among the delphiniums and peonies, thoughts of travel
and beautiful objects from distant lands can take flight.

When Wade and DeMattei moved into the beautifully proportioned house two years ago, it had already been thoughtfully renovated. Layers of paint and the ad-hoc renovations of 80 years had been cleared, and the rooms returned to their original purity of purpose. ♦ DeMattei was taken by the high ceilings and gracious proportions of the rooms, the confident outlines of mahogany moldings, arched windows, and handsome mantels, and a floor plan that worked. ♦ Impatient to complete the interior decor, they called on their friend, Gap vice president of visual merchandising and store display, Stephen Brady, to help furnish the rooms. Together they created the canvas for the design, painting the walls antique white or cream and covering floors with practical, self-effacing sisal. ♦ "The scale of the rooms demanded larger furniture and bold shapes. Small objects would just get lost here," said Brady, a passionate designer and knowledgeable collector himself. He was able to offer objectivity and sympathetic fine-tuning. ♦ "It's important to anchor each scheme with good, comfortable chairs and sofas, and to surround them with useful tables so that the room feels settled, well organized. Then with larger, permanent pieces in place you have the structure for improvisation and display," said Brady. ♦ For the paneled dining room, Wade, DeMattei, and Brady custom-designed in Santa Fe a nine-foot-long table of old mesquite and surrounded it with rush-seated English chairs. ♦ "I like the mix of massive and refined that we have with the large-scale rugged wooden table and fine-lined chairs. It gives the room vitality because it's not obvious," noted Brady. Bringing together furniture from different periods and continents and adding Edward Curtis prints, Moroccan pottery, a Windsor bench, vintage Turkish carpets, and country crafts enlivens the room. ♦ Friends like to linger around the table after dinner, in the glow of dozens of beeswax candles perched along the mantel and poised in the graceful chandelier. ♦ In the flickering penumbra, the present seems to disappear. It could be 1905, still.

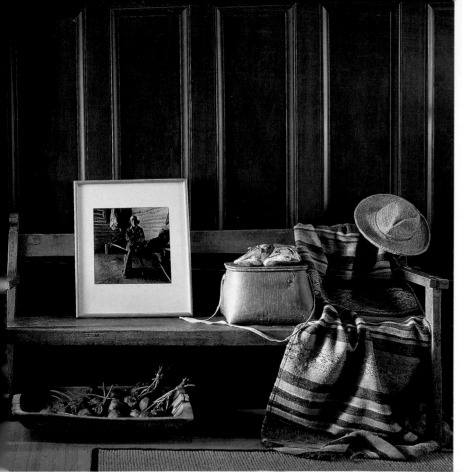

The art of this passionate pair is to make their
vignettes look artless; they're in fact carefully
and thoughtfully planned. On an old
Santa Fe bench they gathered a striped serape,
a handwoven hat, an old gathering basket,
and a contemporary photograph.
Nothing stays static: a Southwest sojourn, new
beauties will pique interest.

The brilliance of Dave and Patrick's
arrangements is in their variety, their unexpected
textures, and their idiosyncratic juxtaposition.
Right, a Morroccan vase and Curtis photographs
make a balanced composition with flowers
in a handcrafted tole vase. Still, the group is
mutable: seasonal flowers can change
the look instantly.

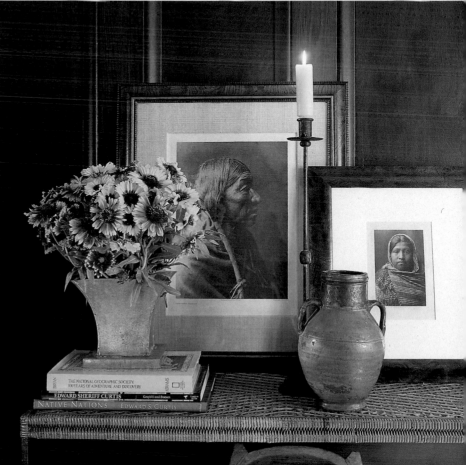

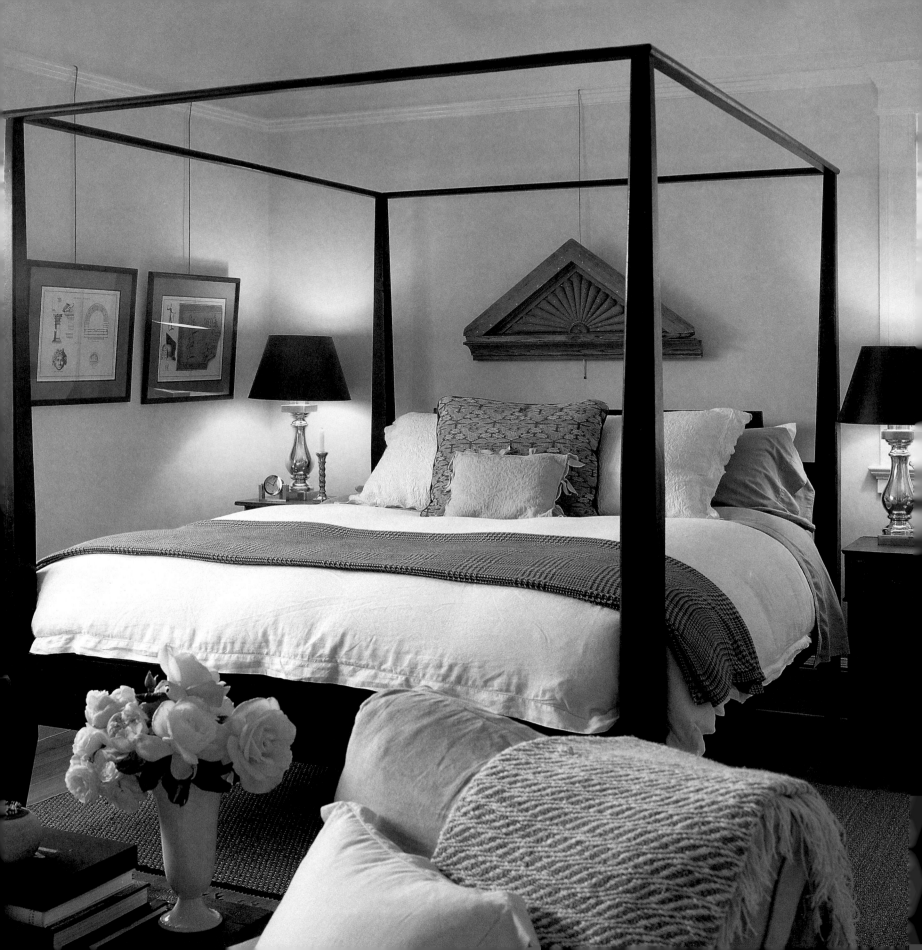

"I've learned a lot working on the house with Stephen. We have similar tastes and sensibilities, and it's tremendously helpful that he can offer us his professional expertise along with friendly encouragement," said Wade, who would often telephone his chum from Paris or Arizona with news of a special find. ♦ "As you explore print shops, art galleries, museums, Paris markets, and London antique stalls, your taste evolves and focuses. We've tired of some of our earlier collections, and previous favorites have come and gone already," said Wade. ♦ "Putting together a room so that it is cohesive and pleasing is all about careful editing and placement," Brady added. "Rooms should never look jumbled or fussy. Each piece should be beautifully presented so that you can really appreciate it." ♦ Inevitably Wade or DeMattei will return from a holiday trip to Florida or Paris, or a weekend in the Southwest with more acquisitions that turn into collections. Already, one corner of their bedroom mantel is a thicket of old and new silver candlesticks, and a bedroom wall is a gallery of contemporary and vintage black-and-white photos and prints. Trophies from a Pasadena swap meet gleam on a mahogany tray. ♦ "It has always been our goal to turn the house back to the way it should have been kept. We never wanted the decor to look 'decorated' or predictable or period. Flea-market stuff mixed with more serious things makes some arrangements look a little off. Odd proportions are much more intriguing than safe and expected combinations," mused Wade. "The rooms are at a point where they don't speak of today, but rather of a time 70 or 80 years ago. I sometimes imagine the very proper Edwardian family who built this house returning for a visit," said Wade. "I think they would feel at home."

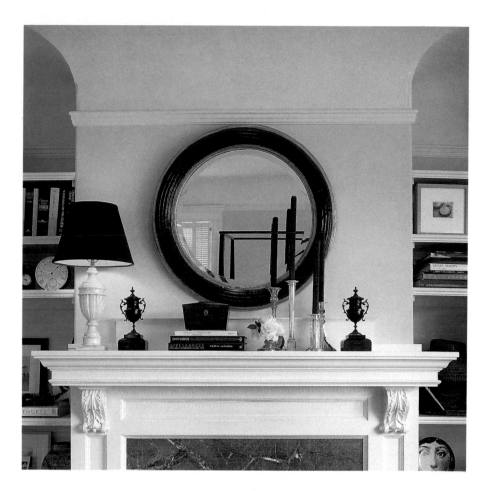

♦

Sweet repose: For a change of pace, the owners turned down the color volume of the upstairs bedroom to pale ivory and taupe and increased the comfort level. Down-filled armchairs by Shabby Chic have guaranteed-to-wrinkle slipcovers in pale natural linen, with cashmere throws at hand. The beautifully delineated custom-made Shaker-style four-poster is painted dark blue/green. Tone-on-tone bed linens by Ralph Lauren. The well-edited collections here are all about pleasing shapes, smoothed-down texture, and soothing color. The result: a respite for the design-dazzled eye and the travel-weary body.

♦

Quiet corners: Informal rooms in Wade and DeMattei's house are as carefully thought-through as the more formal rooms downstairs. In the study/television room, they have provided easygoing sofas and chairs and perching places for magazines and books (and feet). Terra-cotta pots of agapanthus and daisies on the balcony outside the window seem to bring the garden indoors.

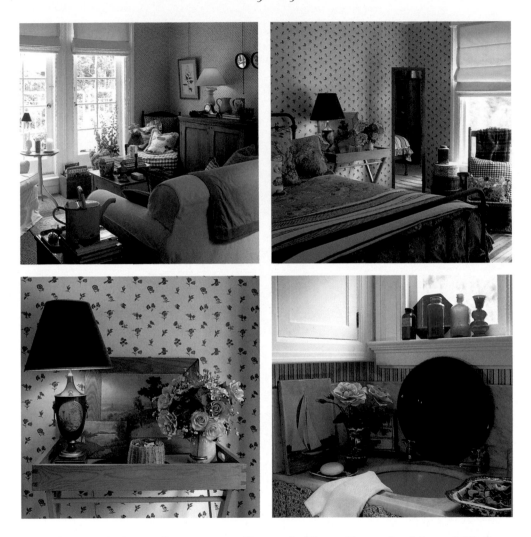

In the guest bedroom, flower-sprig wallpaper by Pierre Deux, hand-loomed Madras cottons and floral prints by Ralph Lauren, and colorful flowers by Patty Wilkerson create a welcoming mood. An indigo glass collection (from flea markets far and wide) is displayed in the diminutive guest bathroom.

SAN FRANCISCO BOUTIQUE OWNER SANDRA SAKATA'S LIFELONG SEARCH HAS ALWAYS BEEN FOR HARMONY, NEVER CULTURE CLASH. ◆ THE WORDLY ART AND CRAFT COLLECTIONS SHE DISPLAYS IN HER RUSSIAN HILL STUDIO CELEBRATE THE TIMELESS AFFINITIES OF FAR-FLUNG CULTURES AND THE BEAUTY OF OBJECTS CRAFTED BY HAND. ◆ CHOSEN BY HER EDUCATED AND CONFIDENT EYE, VILLAGE-CRAFTED TEXTILES, HAND-CARVED FURNITURE, AND ANTIQUE SCULPTURES FROM AFRICA, OCEANIA, AND JAPAN COEXIST HAPPILY, EACH A TRIBUTE TO THE HONEST CRAFTSMANSHIP OF ITS MAKER. ◆ "I FIND THAT HANDMADE TEXTILES AND FURNITURE HAVE A VITALITY AND POWER THAT MACHINE-MADE THINGS CAN NEVER DEMONSTRATE," SAID SAKATA, OWNER OF OBIKO, THE INTERNATIONALLY ACCLAIMED SUTTER STREET STORE THAT SPECIALIZES IN ELEGANT, ONE-OF-A-KIND GARMENTS AND JEWELRY. ◆ IN SAKATA'S STUDIO, ANTIQUE AFRICAN FABRICS, JAPANESE TANSU CHESTS, PHILIPPINE BASKETS, CONTEMPORARY HANDWROUGHT AMERICAN JEWELRY, WEIGHTY ART BOOKS, RARE YORUBA SCULPTURES, NOGUCHI LAMPS, AND FRAMED PORTRAITS OF KENYAN TRIBESPEOPLE ARE DISPLAYED IN CAREFULLY CURATED TABLEAUX. ◆ "I LIKE TO SURROUND MYSELF WITH BEAUTIFUL OBJECTS THAT SHOW THE HAND AND SPIRIT OF THEIR MAKERS," SHE SAID. "WHEN I FIND AN UNUSUAL CARVING OR A BEAUTIFULLY WORKED TEXTILE FROM ANOTHER CULTURE, MY HEART RACES. I HAVE TO KNOW THEIR STORY, SIGNIFICANCE, AND TRADITION. THE MORE I LEARN ABOUT THE MEANING OF CENTURIES-OLD CRAFTS AND SEE THEIR SINCERITY AND INTEGRITY, THE MORE I WANT TO HAVE THEM IN MY LIFE." ◆ IN HER SUNNY DOMAIN, WITH ITS

Craft caravan: Among Sandra Sakata's far-reaching collections: a stool from Burkina Faso, a Japanese step tansu, Mali textiles, and lamps by Noguchi. The subdued gray, ivory, and tan colors of her sun-faded pattern-on-pattern textiles and the burnished antique woods emphasize the singular beauty of the materials and their individual artistry.

◆

Sakata has been collecting antique boxes and baskets for decades. Since each object in her small studio must be both beautiful and functional, they, in turn, display jewelry and miniature carvings.

panoramic views of the Bay, a large custom-made ebonized sofa is upholstered and bolstered in cream and gray Mali mudcloths and Cola cloths. Sakata turned them inside out to mute the hand-applied patterns. ♦ A beautifully detailed ten-legged West African stool stands beside a low Japanese table topped with books and hand-carved Japanese platters. Intricate Kuba textiles from Zaire in austere wooden frames look like contemporary abstract paintings. ♦ Two pairs of Yoruba carved-mahogany Ibeji twins dressed in amulets and beaded cloaks stand on Japanese hinoki wood *tansu* chests. ♦ "This setting is very conducive to working," Sakata said. "I meet my designers here, initiate projects, study antiques, and meditate. The essential innocence and sophistication of these sculptures and fabrics encourages my creativity." ♦ The studio is small, so Sakata installed a wall mirror behind the sofa to reflect the view and to double the apparent size of the room. ♦ Kenyan portraits by Dana Gluckstein, woven raffia cloths, Japanese baskets, temple gongs, beaded necklaces, and vivid flowers delight the eye at every turn. ♦ Sakata has not always found such joy in ancient craft traditions. ♦ "Growing up, I wanted to be very American," recalled Sakata. "I wasn't interested in my Japanese heritage at all. I never saw the serenity in a Buddha's face." ♦ All that changed 20 years ago when Sakata, who was born in Watsonville, California, moved to San Francisco to study painting at California College of Arts and Crafts. One Sunday, she visited the Avery Brundage Collection at the Asian Art Museum. ♦ "I saw so much aliveness and beauty there among the Japanese art. I felt at peace," Sakata said. "I immediately decided I must know more about my own heritage and about the traditional arts and crafts and design of Asia." ♦ In the course of her art studies, Sakata decided that she was not an artist. "I knew I couldn't make a living from my paintings," said Sakata. "But I came to understand what an awesome, humbling experience creating art really is." ♦ The refinement and originality of Sakata's interiors would not be surprising to someone who has followed her career in San Francisco over the last 20 years. She has always been crafting rooms of mystery and power — in her own apartments, as well as in her boutique.

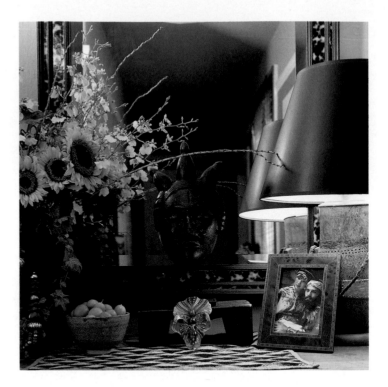

On a Japanese chest: A rare Nigerian Ibibio mask is reflected in a faux tortoiseshell-framed mirror from Gump's.

♦

Saharan dreams: Sandra Sakata asked her longtime friend, jewelry designer Lee Brooks, to paint the walls of her dining room and kitchen with African motifs. In a book on traditional African wall paintings, he found his inspiration for the lively geometric patterns of terra-cotta and gray he applied to the cabinet doors and walls.

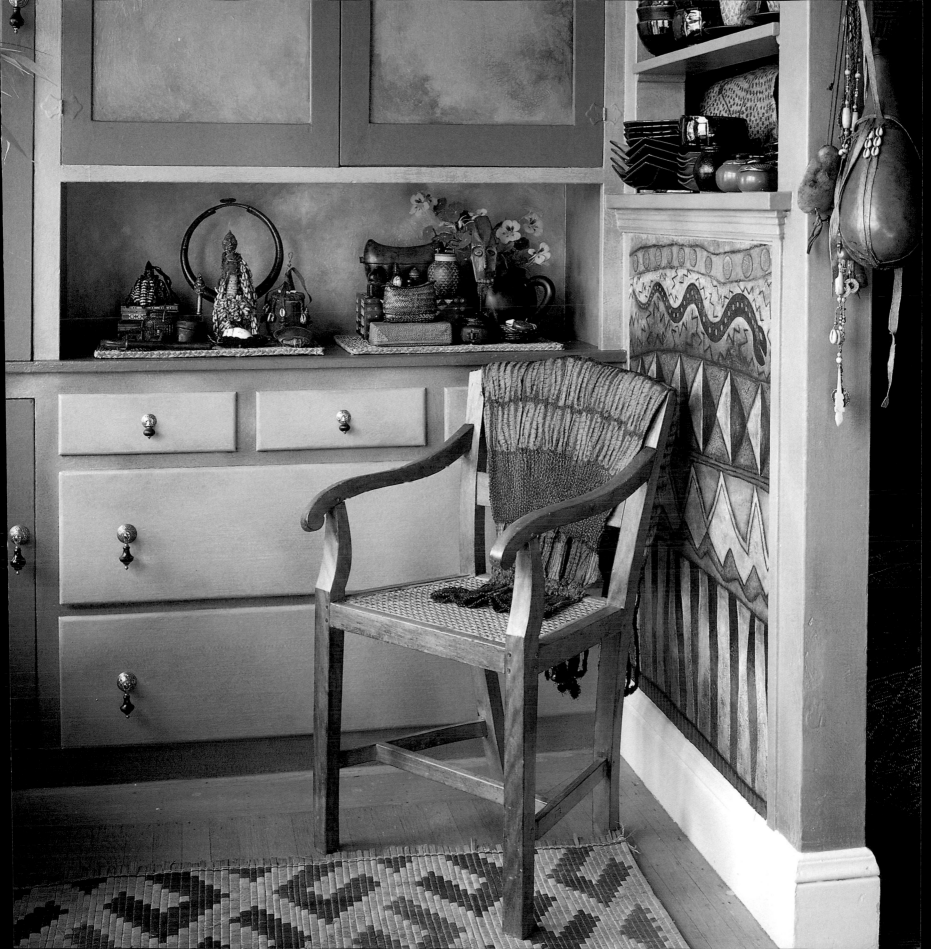

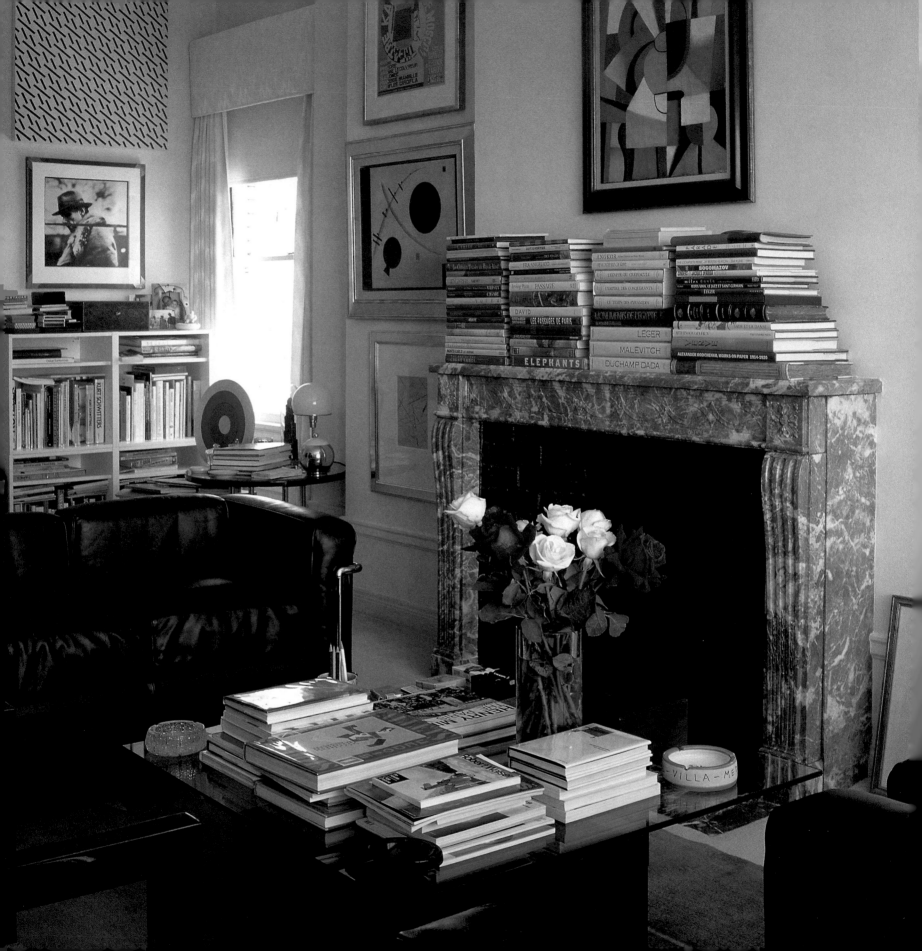

Geneva-born art dealer Martin Muller has been an admired and successful figure on the San Francisco art scene since he opened his gallery, Modernism, in 1976. ♦ The gallery, which specializes in works of the early-twentieth-century vanguard movements and contemporary European and American artists, first drew art thrill-seekers to the then rather louche streets south of Market to feast on artists like the Russian avant-gardists El Lissitzky, Casimir Malevich, Alexander Rodchenko, and Liubov Popova. Today in an elegant Market Street building, Modernism is noted for its hotly followed international stable of artists, as well as for its longevity. ♦ One reason for the success of the gallery is the dedication of Martin Muller to finding and encouraging new artists, as well as creating provocative group shows on such topics as the culture of the martini and a recent tribute to the Moscow and Paris work of the Znadevich brothers. ♦ Muller has taken the same focus, clarity, and rather scholarly approach to his own apartment, in a grand 70-year-old building on Nob Hill. There, too, five rooms are host to a very precise, personal, and occasionally animated collection of Russian avant-garde paintings, contemporary California painters, and shelves, tabletops, mantels, and desks piled with art books and monographs. ♦ "When I moved in, I simply painted the walls white and covered the floor in fog-colored carpet to make the thirties interiors look rather more modernist," said Muller, who lives

On the wall above the antique French marble mantel, Muller arranged his rather remarkable Russian avant-garde paintings, simply and elegantly framed. Stacked in his favor: A small selection from Muller's collection of 10,000 art and design books, in clear, neat jackets, is arranged fastidiously like conceptual sculpture on the mantel.

♦

Muller's black-leather-and-chrome armchairs and sofa are classics designed by Le Corbusier and Charlotte Perriand. The glass-topped table beneath stacks of new art catalogues and books was designed for the original Modernism gallery.

alone. "I wanted to bring together very disparate contemporary art, sculptures, and objects from the twenties and thirties to the eighties, so it was important for coherence that the apartment would be a blank canvas." ◆ A certain tranquility and order were important. In the few evenings when Muller is at home, he likes to read and play the piano, so comfort and purity of composition were givens, too. ◆ "I read in the living room, so I placed there non-representational paintings that would not be particularly stimulating," he explained. "It's fine for a painting to be exciting in the dining room." ◆ Since Muller keeps a pied-à-terre in Geneva and often travels to Paris, Zurich, Moscow, and St. Petersburg, this apartment serves as his home base and as emotional nourishment. Here he keeps most of his collection of more than 10,000 books, including volumes of Dostoyevski that he bought when he was 16. ◆ Life here is not all calme and luxe. Nor is his world hermetic. From the apartment windows, Muller is offered up some of the juiciest, historic cityscapes of San Francisco. His simple Joseph Beuys sculpture in the window is in intriguing juxtaposition with the grand, yet rather inscrutable Pacific Union Club across the street. A tongue-in-cheek Philip Agee bulls-eye chair contrasts with the gracious, yet somewhat stodgy Brocklebank apartments on the opposite corner. In December, Muller hardly needs holiday decorations. The nearby Fairmont Hotel, with its wing-flapping banners, gaudy flags, and Christmas-season trees lit like Catherine Wheels, gives his

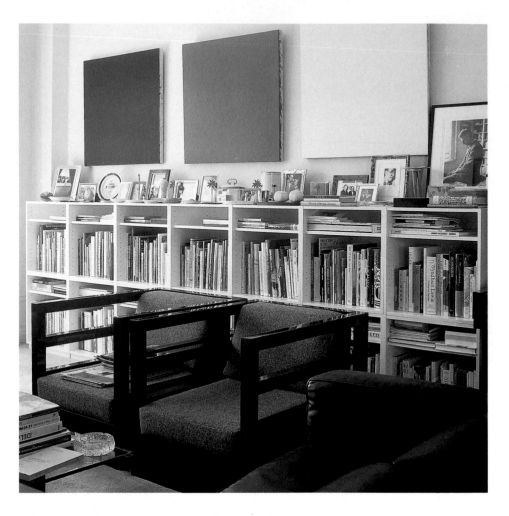

In front of Muller's modernist white bookshelves stand a pair of black-lacquered, gray-tweed-upholstered chairs, designed for the first Modernism gallery and subsequently seconded to Muller's City apartment. Along the top of the shelves, the erudite Muller displays a Bauhaus ceramic lunchbox, ceramics by the founding suprematist, Malevich, and amateur and pro portraits of artists, family, and friends. On the wall three unframed oils from the Automatic Painting series by James Hayward. Muller noted that White (1978) was painted over a period of more than a year. "This is truly art for art's sake. There are many layers and dabs of paint, and there's nothing remotely figurative or narrative or decorative or pretty about it. I have great admiration for Hayward," said Muller.

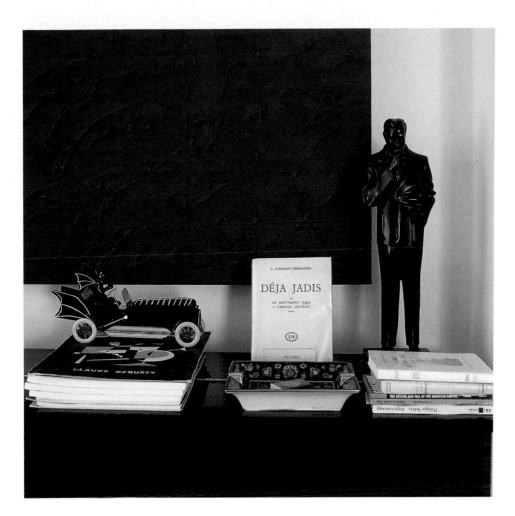

monochromatic rooms instant festivity. ◆ Swiss-born Martin Muller collects art of the century for himself the old-fashioned way — passionately, very selectively, and in depth. His great love is the Russian pioneers of abstraction, those lively suprematists, constructivists, and futurists and cubofuturists whose fomenting theories, improvisations, and creativity still have a profound effect on typography, painting, poetry, and graphic design. But he'll speak as eloquently and fervently about his favorite contemporary California painters and gallery artists. ◆ His entryway, filled with new acquisitions, is one of his favorite rooms of the apartment. ◆ "When I return from a long trip or a long day, it's always comforting and reassuring to see the Ed Ruscha painting, *So*, or my Gottfried Helnwein photograph, *Entrance to Paradise*, or a graphic work by Malevich. I zero in on a few books, explore some of the new catalogues just in from Paris or Zurich. For a few seconds, I'm transfixed on those artists, those ideas, those art theories. The concerns of the day disappear." ◆ Each book is kept in a clear protective jacket. "A beautiful book in perfect condition is as important and meaningful to me, as an object, as the content of the book," said Muller. Speaking (and reading) French, Italian, German, and Russian gives him even more latitude for his book collecting.

"The paintings I have in my apartment are an important part of my life. Looking at them, walking past them, I get the same feelings of transcendence as when I read a great novel. Some of them are a bit unsettling and that's important, too. I wouldn't sell any of them. I might trade up to a better or newer piece by the same artist, but I would never sell," said Muller. ♦ He never tires of his Mark Stock paintings, his John Registers, palm trees by Mel Ramos, books by Charles Bukowski and John Fante. ♦ "The best paintings stimulate me intellectually and have emotional depth," said Muller. "It's an addictive combination. Occasionally, I wonder whether I control my collection or if perhaps the collection controls me." ♦ Muller has his rituals. Food is not one of them. "I have a very pleasant dining room, but this apartment is not a place where I eat," said Muller, who takes breakfast at a cafe in North Beach. "I'm a bachelor, so I read, I rest, I dress — that's all."

In the dining room, the glass-topped table by San Francisco artist Peter Gutkin contrasts with the curvy Thonet chairs and a Jerry Kearns acrylic on canvas, Road to Casablanca, 1985. The table serves perfectly as a perch for books and flowers. Dinner parties are few and far between, said the gregarious Muller, who prefers to meet friends in restaurants like Bix in Jackson Square.

♦

Muller keeps many of his books and paintings in the foyer, which feels like a shrine to art and books. In the archway an acrylic on canvas, the enigmatic, graceful So (1990) by Los Angeles artist Ed Ruscha.

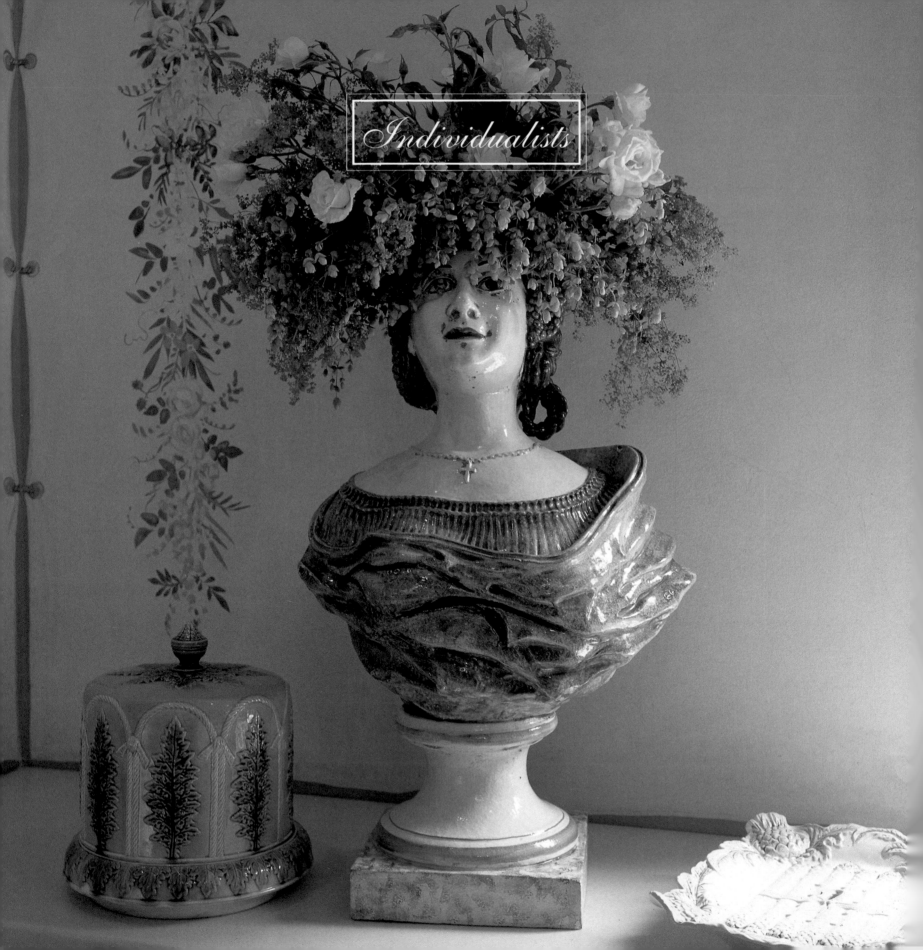

I have great admiration for those who follow their heart in matters of style. Rejecting design clichés and refusing to be stifled by rules and regulations, they break free and thus open our eyes to new possibilities, new delights, and fresh inspiration. ♦ Admittedly, individualists in San Francisco do not have to fear social ostracism or censure. Their friends welcome wit in decor, admire obsessive collecting, and appreciate eclecticism, charm, spontaneity, and change. ♦ Best of all, San Francisco's building stock ranges wide from the obvious Victorian houses to crisp modernist apartments, stately mansions, and glamorous twenties Spanish-style flats to brick-walled lofts and Bay-view houses with pocket-sized gardens. ♦ In the following pages, the owners and designers not only invented the decor, they also painted walls to resemble Pompeii and Moorish Spain, gave junk-shop chairs new vibes, and rewrote the history of their houses. A house on Telegraph Hill chases away its ghosts, and a fearless writer gazes out over the city he loves, that loves him back.

One wonderful attribute of Ryann Abeel's handsome faience bust is that the top of the head is actually a
vase for flowers. Depending on the season, this smiling Italian beauty can be wearing heirloom roses (as she is here)
or masses of Casa Blanca lilies, even trailing scented jasmine with a sunburst of greenery.
On this same dining room buffet, Abeel displays Reine de Saba cakes or delicately colored majolica plates
of white asparagus or Babcock peaches.

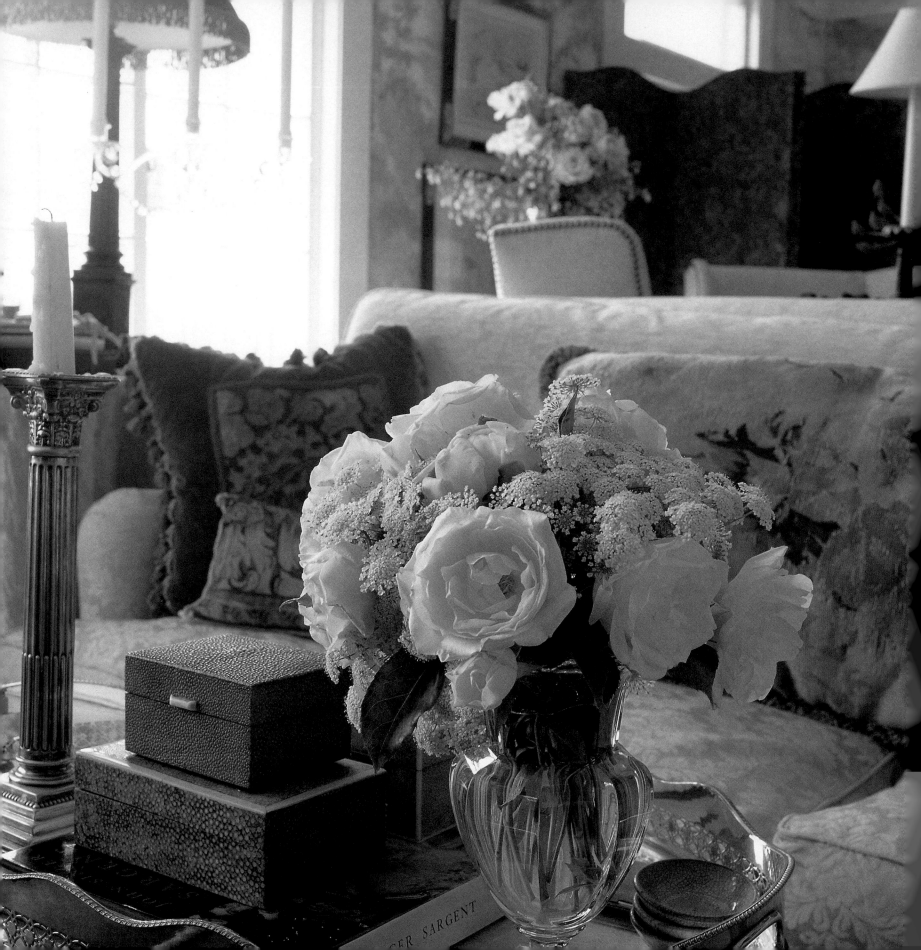

STEPHEN BRADY'S TWO DECADES OF EXPERIENCE IN STORE DESIGN AND VISUAL MERCHANDISING GIVE HIM A DISTINCT ADVANTAGE WHEN IT COMES TO DESIGNING ROOMS FOR HIS OWN CITY FLAT. DAILY EXPOSURE TO DESIGN HAS TAUGHT HIM WHAT HE LOVES AND APPRECIATES IN COLORS, FABRICS, TEXTURES, STYLES, FURNISHINGS, AND ANTIQUES. HE KNOWS HOW TO INDULGE AND SEDUCE THE EYE AND HOW TO CREATE INTERIORS THAT ARE BOTH BEAUTIFUL AND PRACTICAL. ◆ WORKING FOR FASHION STORES LIKE BRITCHES OF GEORGETOWN, FOR COMPANIES SUCH AS CALVIN KLEIN AND POLO/RALPH LAUREN, AND NOW AS SENIOR VICE-PRESIDENT OF VISUAL MERCHANDISING AND STORE DESIGN FOR THE GAP AND BANANA REPUBLIC, BRADY HAS BECOME A MASTER AT CREATING INSTANT TABLEAUX, STYLISH VIGNETTES, AND WHOLE WORLDS OF MEANING WITH WELL-CHOSEN FURNISHINGS AND ALLUSIVE SURFACES – AT WORK AND AT HOME. ◆ IN HIS CITY FLAT, BRADY FASHIONS ROOMS FOR HIS OWN PLEASURE AND COMFORT, BEYOND EPHEMERAL DISPLAY. THERE HE IS AT TURNS DECISIVE AND PLAYFUL, RESPECTING THE FORMAL NATURE OF HIS ROOMS, BUT LOOSENING THEM UP SO THAT THEY'RE NOT STUFFY OR TOO SERIOUS. ◆ "I LIKE GOOD INTERIOR ARCHITECTURE, AND I PREFER CLASSIC LINES TO MY FURNITURE, BUT THE LOGIC AND PRECISION HAVE TO BE BALANCED BY PAINTINGS AND OBJECTS WITH A CERTAIN ECCEN-

Return to the past: Stripping back layers of white paint and old wallpaper from the living room walls to prepare for repainting, Stephen Brady unearthed an unexpected gift — wonderfully moody, villa-esque, mottled-green-and-gray plaster. With its random colorations and abstract patterns, it looked like an enchanted landscape. That was exactly the poetic wall finish he wanted for this quietly opulent room. Brady had artist Skip Price sand and wax the walls to "perfect" the ancient look. The ceiling, windows, and trim were painted creamy white, as a crisp frame for the smudgy walls.

◆

Light touch: The Ralph Lauren sofa is upholstered in pale-cream silk damask. Pillows are old Aubusson and tapestry fragments. The silver tray table holds shagreen boxes and silver candlesticks. Collections include a bronze column lamp and heirloom silver. Flowers by Patty Wilkerson.

tricity," said Brady, who first rented, then recently purchased, the 1920s house. "It's important in bringing everything together that there's room for design spontaneity." ♦ Brady's forte at home is creating a basic framework of beautifully proportioned sofas and chairs and making sure that the rooms are full of places where he and his friends can sit, sprawl, read, rest, and gather. Tables of different scales are placed at hand, ready for lamps, candlesticks, and vases of garden flowers, along with newspapers, magazines, teacups, and wine glasses. ♦ The hospitable Brady likes to delight the senses of his guests. Down-filled armchairs and a damask-covered sofa are oases of comfort. Tables in the living room are arranged with stacked shagreen boxes, bronze sculptures, antique silver candlesticks, and favorite old books with gilded (and frayed) bindings. Subtle potpourri (a natural blend of roses and jasmine) scents the air. The windows stay open most of the year, and the fragrances of his lavender and wisteria waft in from the garden. ♦ Brady is particularly fond of centifolia roses, Casablanca lilies, Queen Anne's lace and lilies of the valley. Patty Wilkerson fills vases and lets the flowers arrange themselves in a loose, rather offhand manner. Like Brady's rooms, they never look stiff, over worked, or trendy. ♦ Beginning the remodel of his paneled study, Stephen Brady made another discovery. Beneath a hard-edged, black marble and dark-stained mahogany fireplace that he had always found heavy-handed, he found the original fireplace, the terra-cotta tiles and hand-hewn redwood mantel all perfectly intact. On recessed tiles, partially hidden, he found the pencil signature, "John Bonehill, 1928, Woodland, Middlesex, England." ♦ "I had always loved this paneled room but the old marble fireplace was so wrong for its cozy, Arts and Crafts style," said Brady.

♦

A study in easygoing charm and comfort: Stephen Brady is especially adept at remaining faithful to a room's inherent character and emphasizing its individuality. In his cozy paneled study, it was simply a matter of unearthing the original terra-cotta tile fireplace beneath a horrid black marble mantel that had been imposed on it in the seventies in the name of "modernization." Taking his design cues from the handmade tiles and redwood mantel, Brady added a new steel table, antique hand-carved African stools, framed black-and-white photographs, an old ironstone pitcher, and copper candlesticks. The 1932 portrait of Donald Forbes is by William Littlefield.

♦

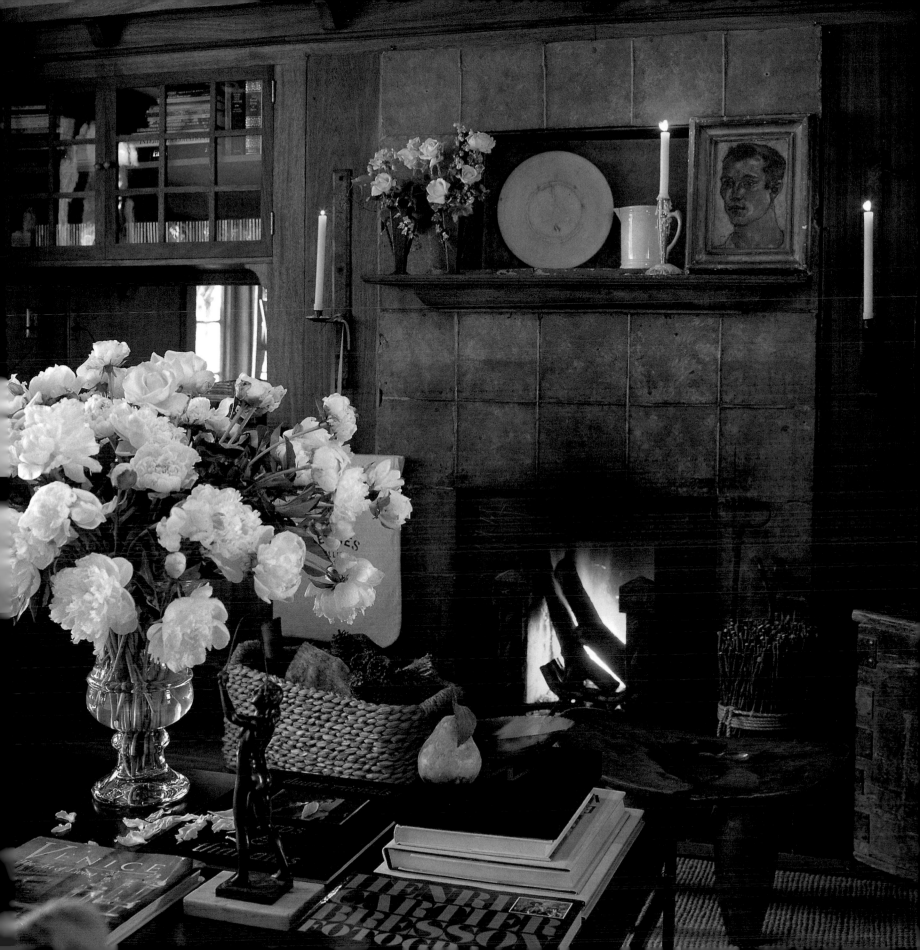

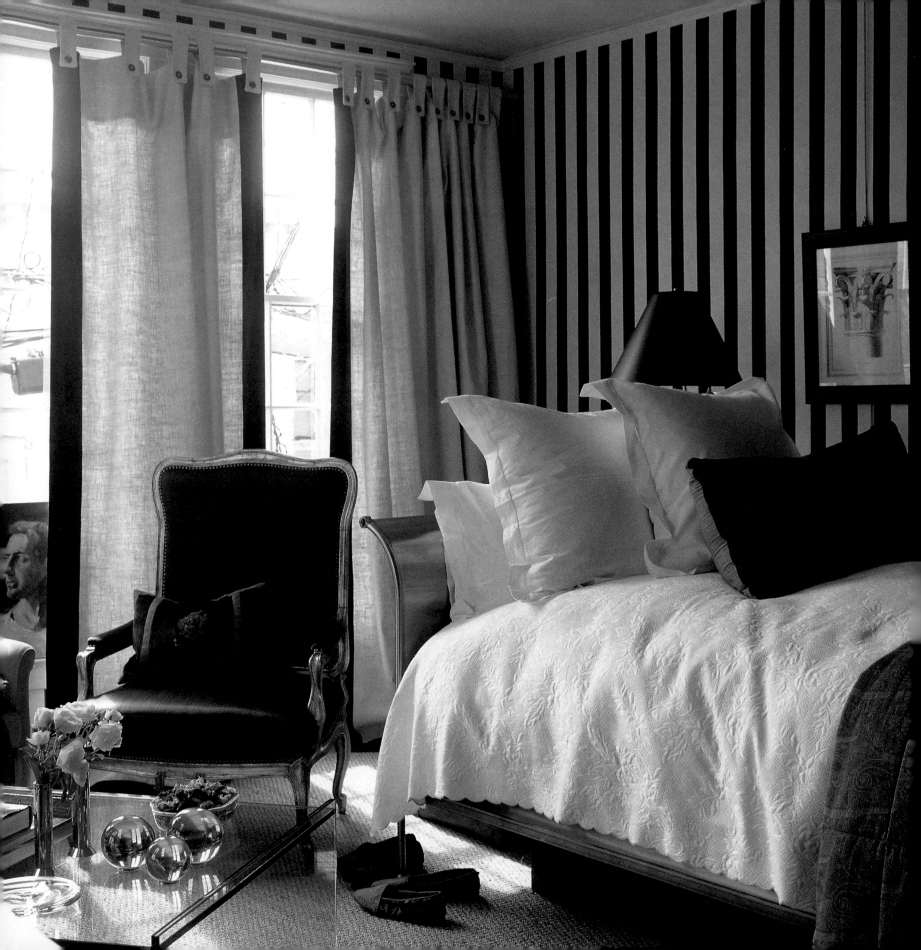

"With the terra-cotta fireplace spruced up and the mantel stripped down to raw redwood, the room now looks its best," he said. A taupe linen sofa, leather armchairs, and a pair of rattan chairs with fat, striped cushions are arranged in a somewhat relaxed manner around the fire. Brady designed a new metal-based coffee table with an oxidized, rolled steel top. ◆ In the study, as in other rooms, Brady likes to create contrasts of materials, shapes, and provenance. The new steel coffee table is topped with an elegant crystal urn vase filled with armfuls of pink-and-cream peonies. Hanging beside the rather rustic fireplace is a Hermès sellier bag in canvas and leather. An old painted chair from a Santa Fe flea market stands beside an artist's easel, on which stand fine photographs found in London. Piles of old books and the newest must-read magazines are stacked on tables and on the sisal-covered floor. ◆ As a tenant, Brady was happy with the existing white-walled bedroom. As the new owner, he wanted much more. ◆ For his bedroom, Brady chose a classic wide-striped Cowtan & Tout wallpaper in ivory and ebony. The two-inch stripes add instant architectural lines to the square room. Woodwork and trim are painted white. ◆ "I like the contrast of the raw-steel queen-sized bed with luxurious, oversized linens," said Brady, who finds the room a welcome sight when he returns from business travel. ◆ He dressed the bed with a king-size white *matelasse* cover, an Etro cashmere paisley throw, an oversized, hand-dyed silk-velvet pillow, and white linen sheets and pillows. ◆ Ebony-framed prints were found in Paris and Florence. ◆ "The bed stays against the wall, and the Biedermeier-style secretaire stays where it is, but I like to change the other objects in the room every few months," noted Brady. "If I don't move things around, change the arrangements, and bring in new favorites, I start to take everything for granted. Rooms should delight the eye, entertain a little. They have to be kept lively and fresh — otherwise, you just don't notice what's there."

◆

Sunstruck stripes: Brady's curvy steel Shannon bed has not a chance to feel hard-edge, with its luxurious Italian damask linen sheets, matelasse coverlet, paisley throw, and Venetian velvet pillows, all from Sue Fisher King. Black-and-white-striped wallpaper gives the formerly all-white walls dimension and drama. Sun streams into the room from early morning, so Brady covered the windows with full, interlined, tabbed linen draperies bordered in black. A gilt chair from Jasper Byron is upholstered in traditional black horsehair.

Stephen Brady's secretaire is a stage for his collections.

◆

Brady's guest room, inspired by holidays in the Caribbean, is a sea of stripes. ♦ "My inspiration came from idealized tropical islands and relaxed summer houses," said Brady.. "I love shades of blue in a room. Classic blues, not sentimental blues, feel so refreshing." ♦ Brady bought a versatile Polo/Ralph Lauren duvet cover, sheets, and pillows in shades of cobalt, cerulean, navy, indigo, white, and cream for the whitewashed sleigh bed. Pillows for the bed, which affords a cozy nest for weekend reading, include a mix of monogrammed navy canvas piped in white and a pair of striped cotton bolsters. A blue-and-tan-striped cotton throw is essential on foggy afternoons. ♦ "I open the windows overlooking the garden and the bed feels like a hammock at a summer house," said Brady, who revved up the style with a white linen upholstered chair, a vintage metal bistro table, an antique French mirror, and indigo glass bowls and vases.

A room of a different stripe: Livability and comfort are as important to Brady as eye-pleasing colors and smooth-to-the-touch textures. For an instant change of pace from the formerly all-white room, Brady hung blue-and-white-striped Ralph Lauren cotton draperies on the walls. The fabric muffles sound and makes the room feel like a tent on a tropical island. The bed is soothed with a baker's dozen pillows, blankets, and a light cotton throw. Shells, coral, wicker chairs, sisal mats, and rattan tables enhance its Caribbean air.

♦

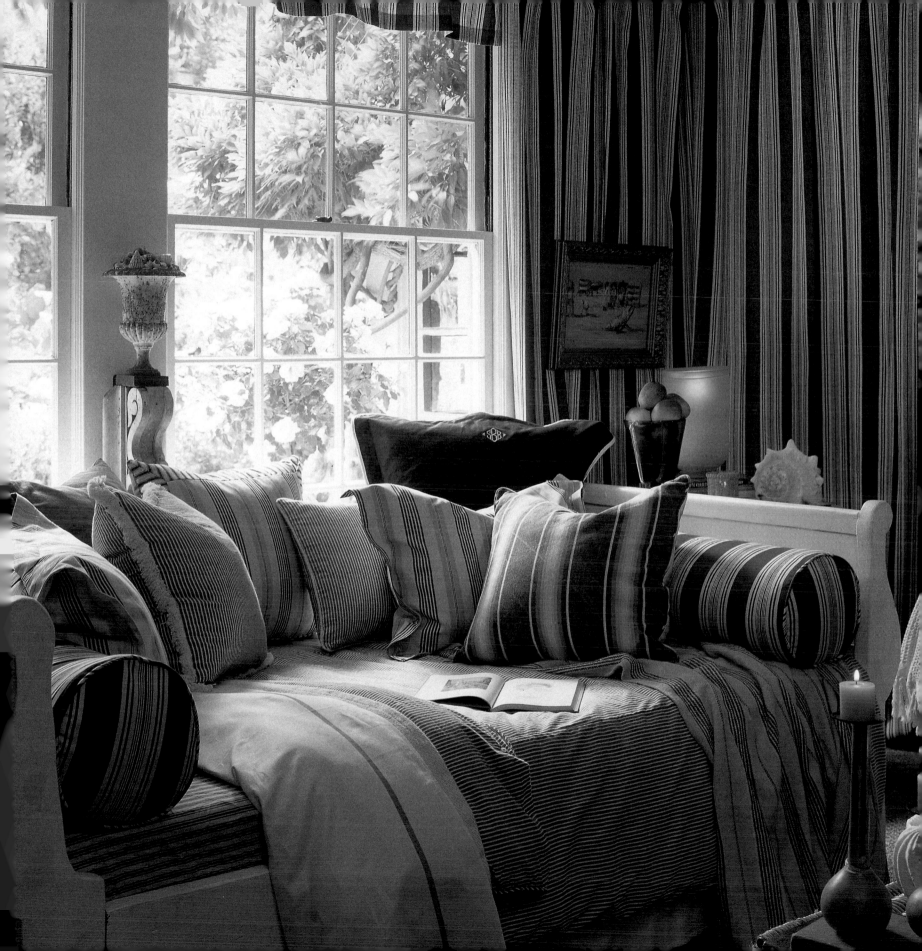

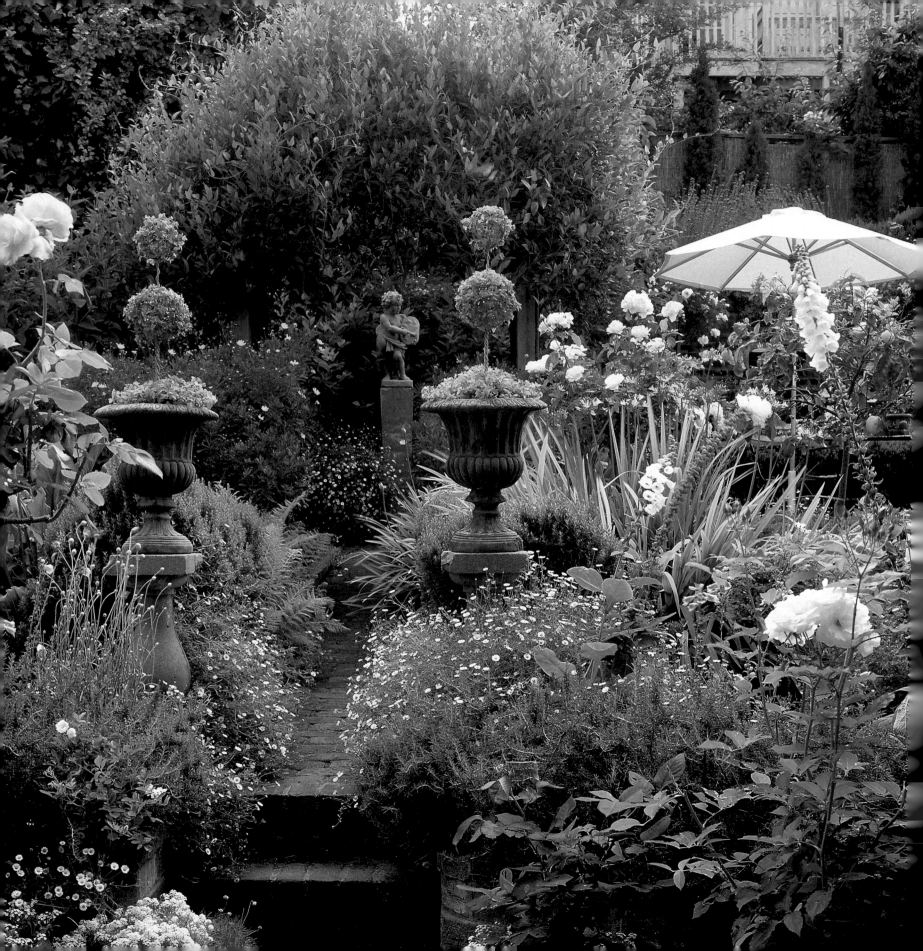

The secret of Stephen Brady's garden's year-round beauty is classic structure and a flourish of flowers. ♦ All summer long, Nigel, Stephen Brady's frisky black Scottish terrier, loves to spend his day in the garden chasing butterflies. Hordes of the flighty creatures gather in this fragrant City domain to feast on delicious 'Iceberg' and 'White Delight' roses, blue delphiniums and foxgloves, bursts of agapanthus, verbena, Iceland poppies, and jasmine. Butterflies are especially fond of 'Provence' lavender that spills over the mossy paths and scents Brady's terrace. ♦ This garden splendor is new for pet and owner. When Brady took over the well-planned 40' x 60' garden of box-edged terraces and neat brick paths four years ago, it was clipped to a fare-thee-well and quite bare. Tidy paths and skimpy borders did not invite evening musing or weekend wandering. ♦ Working with his friend Patty Wilkerson, Brady immediately banished the manicured look and brought in mature lavender bushes, and planted erigeron and ferns along pathways. He willed the wilting agapanthus and boxed-in box back to life. ♦ "I'm an Anglophile, so I like my garden to be overgrown," said Brady, who, after dusk, lights candles among his ivy topiaries. "I change the garden from year to year to keep it interesting. I prefer white flowers for their pristine beauty, but last year I was passionate about the vibrant colors of poppies and ranunculus. This year I love the tall 'spires' of campanulas and delphiniums and standard roses." ♦ Brady designs for scale, subtle color, and texture, almost like decorating a room. "Having the structure in place gives me flexibility to plant new bulbs and shrubs and to 'furnish' paths with pots of roses and herbs," he said. ♦ Brady likes to plant mature plants and flowers for instant gratification. In the spring, there are always his favorite daffodils and lilies of the valley. Pretty flowering weeds are welcome. ♦ He placed antique stone urns with tall ivy topiaries to take the eye skyward. Brick paths are now crowded with large and small terracotta pots of French roses, alyssum and mint, along with antique architectural fragments, and quirky, vintage French water pitchers found at a Paris flea market. ♦ Overgrown, said Brady, does not mean low-maintenance. "Every day I deadhead, trim, and clip," he said. "Romantic gardens still need infinite attention."

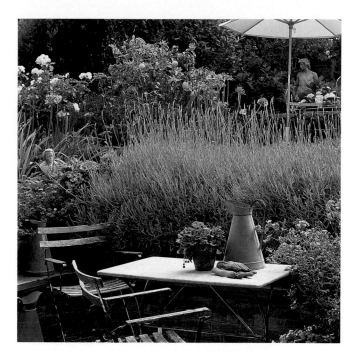

Green thoughts: Working with his friend Patty Wilkerson, garden designer/florist of Seaflower in Stinson Beach, Stephen Brady has turned his hillside garden into a private paradise. It is all carefully planned so that it seems natural and innocent of design. Sheltered from strong winds, lavender, heirloom roses, jasmine, wisteria, and garden herbs scent the air and attract butterflies.

♦

Clipped topiaries and English stone statuary give shape and focus to the box-hedged parterres. Lush spills of vines and flowers soften the silhouette. An antique, marble-topped French bistro table, found in New York, serves equally to accommodate alfresco luncheons or to secure his gardening equipment. Galvanized tin pitchers were found in the Napa Valley at a St. Helena antique shop.

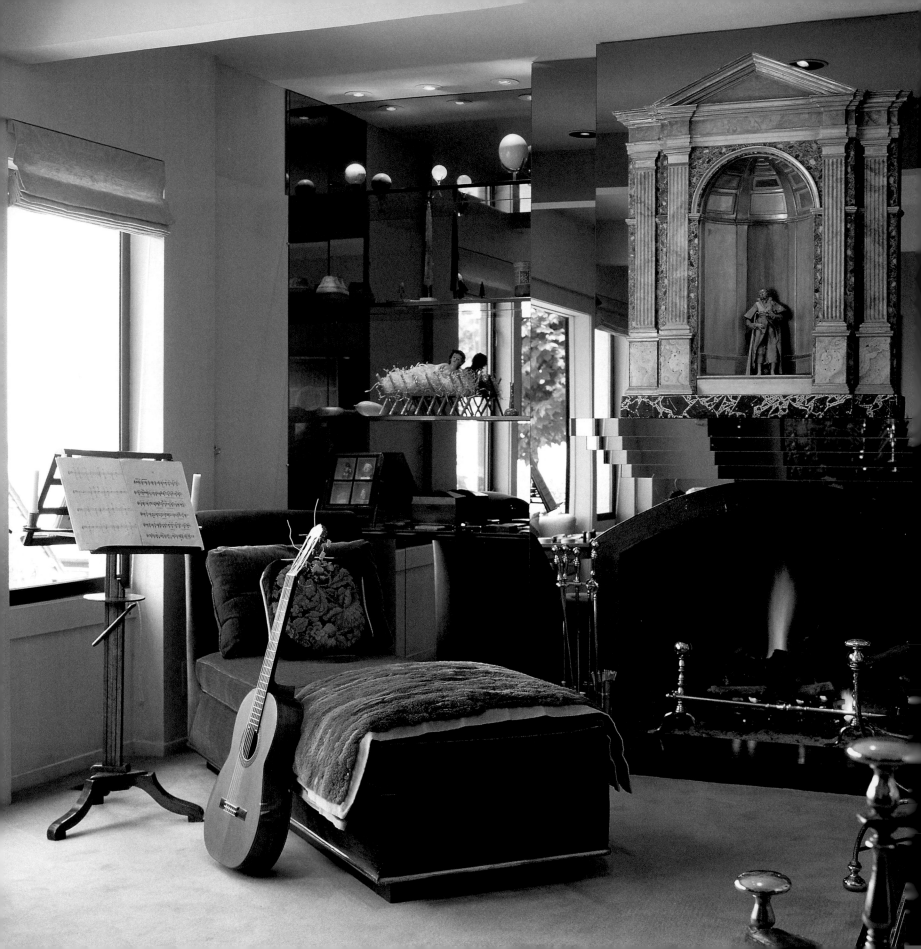

RYANN AND BILL ABEEL ARE AMONG THE MOST IMAGINATIVE AND ENTHUSIASTIC HOSTS IN SAN FRANCISCO. THEIR ELEGANT AUTUMN COCKTAIL PARTIES, LIGHTHEARTED SPRING GARDEN PARTIES, DASHING WINTER GAME DINNERS FOR MEN ONLY, AND TALKY LUNCHEONS-FOR-NO-REASON-AT-ALL, ARE SUPERBLY ORGANIZED, LIVELY, AND HIGHLY ORIGINAL. ♦ EVERY SPRING, THE ABEELS INVITE FRIENDS TO A FORMAL DINNER TO CELEBRATE THE LAVISH FLOWERING OF THE PAMPERED, WISTERIA WHOSE ANCIENT GNARLED VINES CIRCLE THE BACK OF THEIR TALL, NARROW HOUSE. DRIFTS OF PALE AMETHYST-COLORED BLOSSOMS DRAPE WINDOWS AND TURN THE DINING ROOM AND UPSTAIRS BEDROOM INTO FLORAL BOWERS. ♦ IN EARLY SUMMER, WHEN THEIR PINK AND WHITE HEIRLOOM ROSES ARE AT THEIR BEST, HAND WRITTEN INVITATIONS GO OUT FOR A SATURDAY LUNCHEON, AND THE FAMILY'S CHUMS SAVOR THE GARDEN IN ALL ITS GLORY. MUSICIANS PLAY ON THE STONE TERRACE AS GREEK AND ITALIAN DISHES ARE ENJOYED BY THE CITY'S JUDGES, NOVELISTS, DESIGNERS, DANCERS, RARE BOOK DEALERS, PUBLISHERS, ATTORNEYS, AND PSYCHIATRISTS, ALONG WITH YOUNG FRIENDS OF THE COUPLE'S DAUGHTER, LOUISE. ♦ "WE HARDLY NEED AN EXCUSE TO GATHER OUR FRIENDS AROUND US," SAID RYANN, WHO LOVES TO THROW IMPROMPTU BIRTHDAY PARTIES – WHEN SHE'S NOT SCULLING IN SAUSALITO OR SCOUTING FOR ANTIQUES. ♦ THE ABEELS' HOUSE, PERCHED ON A HILLSIDE, IS IDEAL FOR FÊTES AND QUIET GATHERINGS. EACH ROOM OFFERS VISUAL DELIGHTS AND A SENSE OF WELCOME. THE COUPLE HAS SPENT THE PAST 18 YEARS WHIPPING IT INTO SHAPE. ♦ WHEN WE FIRST MOVED HERE, EVERYTHING WAS DIMINUTIVE," RECALLED RYANN. "I USED TO THINK THAT TWO GNOMES HAD LIVED HERE." ♦ THEY RAISED THE CEILINGS

The Abeels' collections mirrored in the fireplace wall include Greco-Roman figures from Apuleia, antique snuff boxes, a Roman spear, an eighteenth-century planetaire, malachite boxes, and a hand-painted Greek terra-cotta platter. Smoked glass was chosen to mute the reflection and daylight glare. Above the fireplace is an eighteenth-century Italian reliquary niche with a crèche figure. The couple worked with designer Michael Vincent to find classic wool and silk upholstery fabrics. Walls are glazed in a pale golden amber tone, which is particularly beautiful and cheerful on a foggy summer day.

on the top floor, spruced up the kitchen, and extended the terrace, but did not plan major renovations. "I think we would have ruined the house if we'd done too much," said Bill, a noted board-sailing aficionado. ♦ In the living room, they painted the walls parchment with a golden strié pattern. ♦ "We started with a chaise and sofa designed by Michael Vincent. We had them upholstered in wool fabrics, so that they feel delicious when you sit on them. We brought in our grand piano and built in a small bar, added new chairs and collections, so the room has changed a little over 18 years," said Bill. ♦ "Colors there are all a little 'off' to give the room character and individuality," said Ryann. The wool carpet is Atlantic Ocean gray/green, the sofa is beige/taupe, and the cushy chaise longue is pale aubergine silk velvet. One armchair is upholstered in celadon silk. ♦ Guests love to sit on the windowseat and watch twilight over the Bay. ♦ The decor of the Abeels' dining room was very carefully planned and executed. After painting walls a natural canvas color, Ami Magill decorated them with garlands of flowers and swags of fabric to make the room look like an elaborate outdoor tent. Inspiration came from an early eighteenth-century room in northern Italy. The furniture — just an antique table, a carved-mahogany buffet, and caned chairs — was kept very simple and versatile. ♦ "This room is very flexible," noted Ryann. "I can put extra leaves in the table so that it can easily seat 12. If more guests are expected, I'll set up two or three small tables in the dining room or in front of the fire in the living room." ♦ In the spring, they take up the antique Oriental carpets in the dining room and leave the bleached hardwood floors bare. Down come the smocked silk draperies so that they can see the wisteria, the cosmos, and the roses in the garden outside.

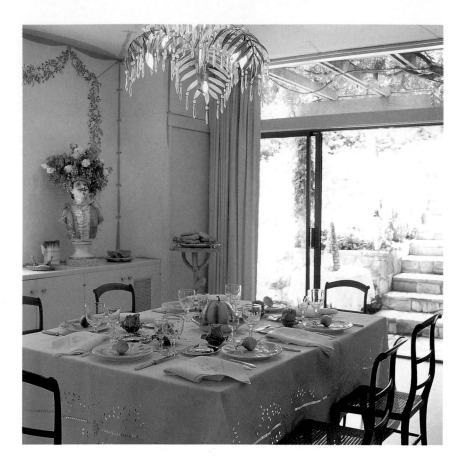

For a summer dinner party, the Abeels fashioned a setting surrounded by the season's bounty. The table is set with an heirloom tablecloth, French faience cabbages, family silver, eighteenth-century Dutch crystal from Bill's family, and large monogrammed napkins.

♦

Cane-seated chairs are French, originally designed for orchestra musicians.

"For a luncheon for my women friends, I'll set my prettiest table linens and silver and fill silver vases with 'Cecile Brunner' pink roses," said Ryann. She fills crystal vases with lilies of the valley and forget-me-nots and sets them beside place cards. ◆ "We love living in the heart of the City," said Bill. "This house is a wonderful refuge. It's very private, but we're close to the farmers' markets, to Swan's Oyster Depot, to the superb bakeries of North Beach, and just five minutes from Crissy Field, where I go board sailing." ◆ Ryann noted that the City is full of talented artists, craftspeople, and possible outdoor adventures. ◆ "In many ways, San Francisco is like a small town, where everything wonderful is very accessible," said Ryann. ◆ "With just a ten-minute drive, I can be out in Richardson Bay in my scull heading for Raccoon Straits. On the way home, I can pick up exquisite pastries or rich coffee on Union Street. The Opera House and the Symphony Hall and all the best restaurants are just a few minutes away. Living here is the best of all worlds."

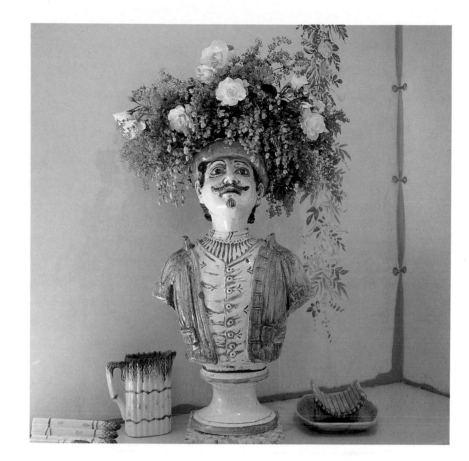

A witty, Italian, hand-painted bust was discovered in Italy. Ryann gave him a green and white "hat" of Iceberg roses and Queen Anne's lace.

◆

Hand-sewn antique lace, heirloom crystal and silver, and Ryann's perfectionism set a glorious table.

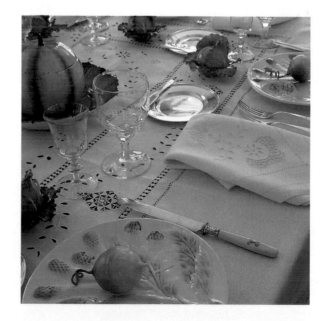

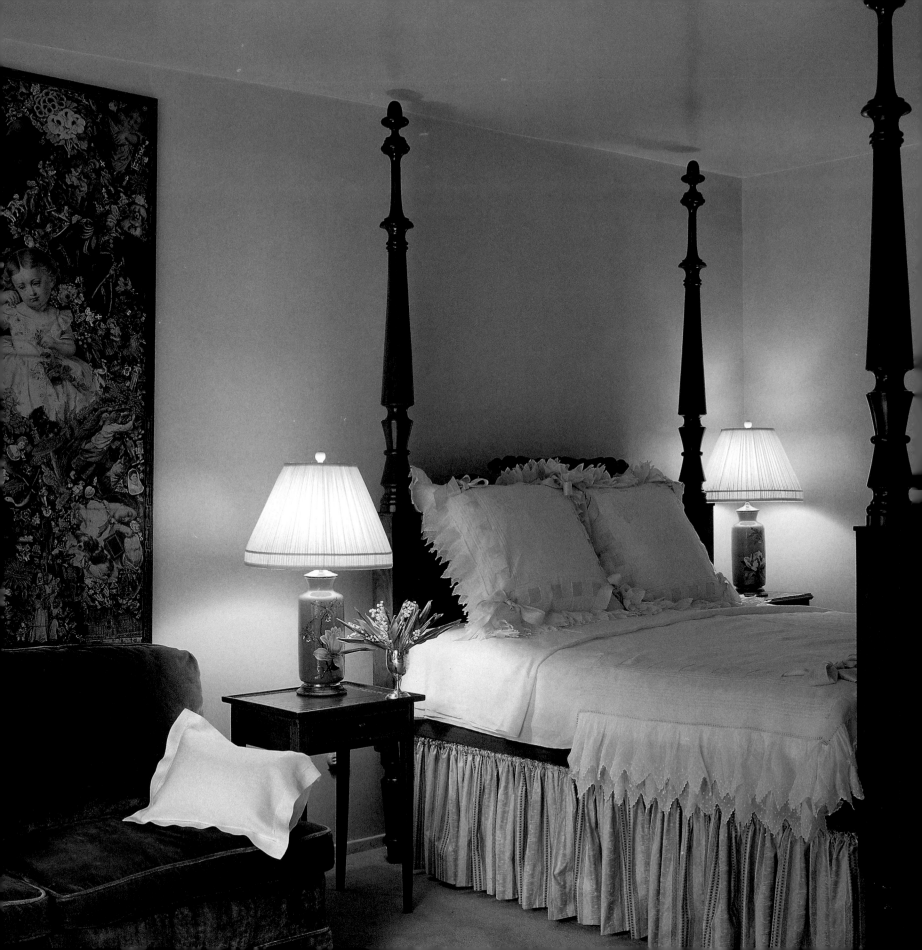

Old-fashioned comfort: The Abeels' mahogany four-poster was Bill's Texan grandfather's. Originally purchased in Rome, New York, the bed came to San Francisco via Waco, Texas. It is dressed with Ryann's collection of heirloom hand-embroidered linens.

Beyond the lush leaves of wisteria lies the terraced garden. Ami Magill painted Bill Abeel's grandmother's carved chair with grape motifs. The Biedermeier table, adorned with garden flowers, has a Victorian cutwork cloth.

"The garden and terrace are very private and sheltered, so they're like rooms for us," Ryann Abeel said. "We take breakfast out there in the sunshine and often sit in the upper garden to enjoy drinks in the evening." ◆ Every spring, Bill surprises Ryann with different bulbs. One year it was tall pink tulips and white hyacinths, another April it was a host of golden daffodils. Later in the summer, curved beds are vibrant with cosmos. ◆ "The garden's just the right size for a city house," noted Bill. "The stone terraces make it easy to maintain, and it's not so large that it requires a team of gardeners to keep it in order." ◆ Perhaps best of all, in a city where it feels like spring year-round, the flourishing and fading of lilies, roses, and wisteria speak eloquently of seasons and reasons to rejoice.

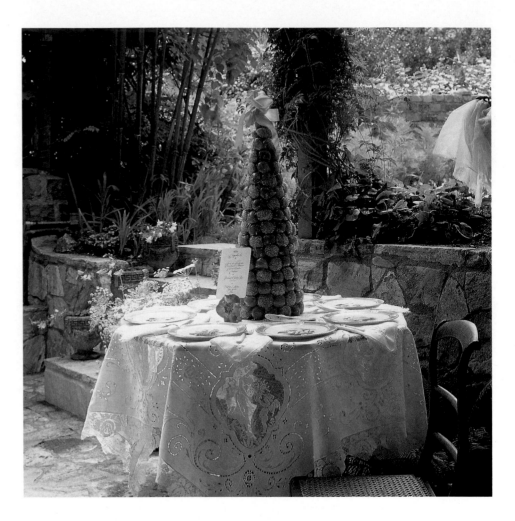

Festive for a summer luncheon party, the Abeel's lawn was given a monogram of pale pink roses by Claudia and Peter Schwartz. The garden seems to go on forever because of the "borrowed landscape" from neighboring properties. Linens on the table are all Victorian. The cork vase filled with pink heirloom roses is from Paxton Gate. French plates with pink borders are hand-painted with festoons of flowers.

◆

The towering croquembouche, set on a table on the terrace, is a family favorite and a delight for guests.

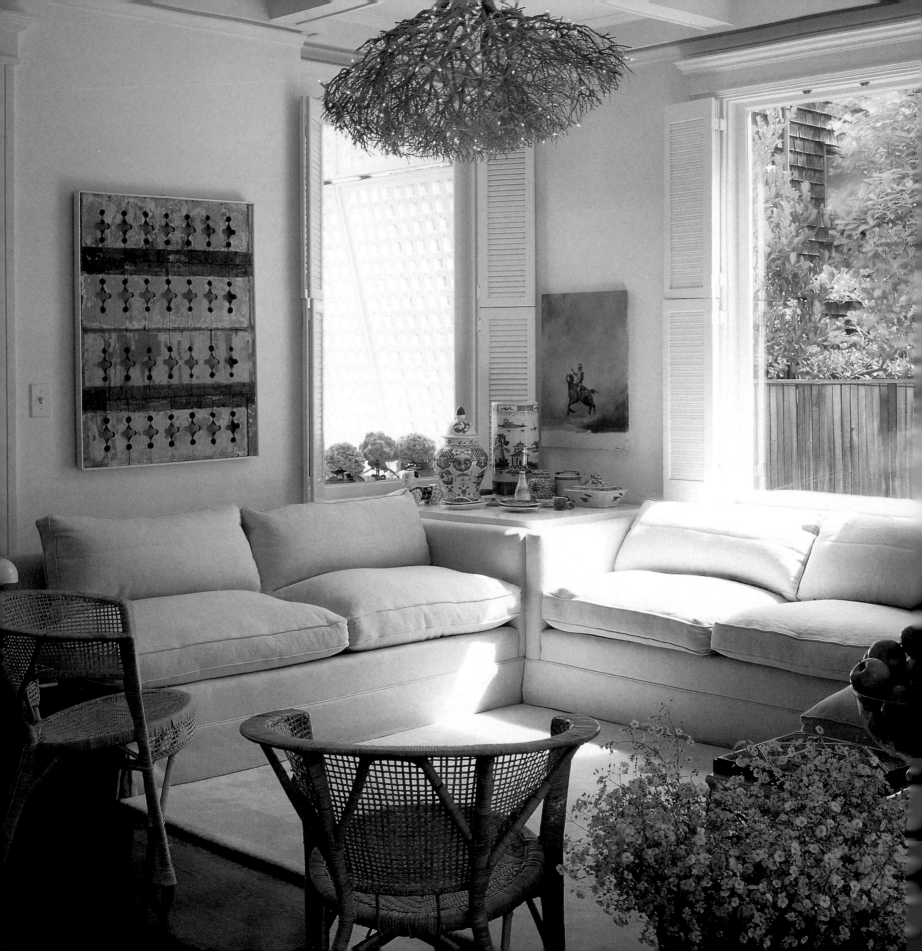

TELEGRAPH HILL
TERRENCE O'FLAHERTY & LYNN HICKERSON'S HOUSE

FOR 36 YEARS, TERRENCE O'FLAHERTY WAS THE TELEVISION CRITIC OF THE *SAN FRANCISCO CHRONICLE*. WRESTLING WITH O'FLAHERTY'S MUSCULAR PROSE WAS A COMPULSIVE MORNING PLEASURE FOR GENERATIONS OF NORTHERN CALIFORNIA READERS. ALONG THE WAY, THOSE OPINIONATED COLUMNS NOT ONLY AROUSED THE POPULACE AND ELUCIDATED THE AGE OF TELEVISION, THEY ALSO ENABLED O'FLAHERTY TO PURCHASE HIS LIGHT-FILLED HOUSE ON TELEGRAPH HILL. ♦ "MY AFTER-HOURS ADVENTURES IN REMODELING BEGAN IN THOSE SWEET DAYS OF THE EARLY FIFTIES WHEN A COPY BOY ON THE CHRONICLE COULD AFFORD TO BUY A HOUSE IN THE CITY," O'FLAHERTY REMINISCED. "THOSE WERE THE YEARS WHEN MICHAEL TAYLOR WAS WORKING AT KASPER'S FURNITURE STORE AND JOHN AND ELINOR MCGUIRE WERE EXPERIMENTING WITH RAWHIDE TO BIND THEIR RATTAN FURNITURE. ARCHITECTS CHARLES PORTER AND BOB STEINWEDELL WERE WORKING OUT OF THEIR PENTHOUSE APARTMENT ON TOP OF JULIUS' CASTLE. RICH PEOPLE SHOPPED FOR ANTIQUES AT MARSH'S AND GUMP'S AND VIRGINIA FRIZZELL OR MRS. ASHLEY, WHILE THE REST OF US RAIDED STORES LIKE THE HANG KOW TASSEL COMPANY FOR INEXPENSIVE TREASURES WRAPPED IN DUSTY CHINESE NEWSPAPER ON FORGOTTEN SHELVES IN THE BASEMENT." ♦ O'FLAHERTY RECALLED BUYING HIS KITCHEN SUPPLIES AT WHOLESALE PRICES FROM THOMAS CARA IN NORTH BEACH, AND BOOKS FROM THE ARGONAUT BOOKSTORE ON KEARNY STREET. ♦ O'FLAHERTY'S HOUSE, WHICH HE SHARES WITH BOOK PUBLISHER LYNN HICKERSON, WAS ORIGINALLY BUILT IN 1919 FOR AN ITALIAN FAMILY, AND STILL HAD A HUGE WINE VAT IN THE BASEMENT WHEN HE BOUGHT IT. ♦ "ONE SURPRISE, NOT MENTIONED BY THE

Plain vanilla: O'Flaherty's living room is an object lesson in tranquil, self-assured design. The former critic, who is now busy writing screenplays and books, prefers plain-vanilla paint for the walls and coffered ceiling of his living room. The house, he said, is decorated with 16 different shades of white. Sofas and chairs designed by Charles Pfister and made by Randolph & Hein were upholstered with Henry Calvin linen in simple cream/white. The ivory/white wool carpet was custom-made by V'soske.

♦

On corner tables, he displays his lifelong collections of blue-and-white china.

INDIVIDUALISTS

former owners, was the ghost of a sea captain whose old house on the hill had burned down and made way for my house," said O'Flaherty. "He was angry with me for many years until I built a cupola. Since then, we have been the best of friends. My neighbors say they often see him sitting up there on quiet evenings scanning the horizon for the ghost ships of his youth." ♦ Over the years, as he had the funds, O'Flaherty opened up the interior of the two-story house to make it more spacious. He added a circular stairway. Small rooms made way for a large living room, a mirrored dining room, and a sunny kitchen. Bedrooms with views from Pacifica to the Farallones are upstairs. ♦ "My main decorative source was the ever-bountiful back lot of the Cleveland Wrecking Company," said O'Flaherty, who grew up in Los Angeles. The curbstones of Chinatown after midnight were another gold mine, where large, glazed ginger jars and jardinieres could be found among wicker baskets that still smelled of tea shipped from Hong Kong and Canton. ♦ In his dining room, O'Flaherty put a gloss on tradition, painting an antique mahogany table with white automotive paint and hanging gleaming old pub mirrors on the walls. The dark-stained hardwood floor is waxed to a high shine. ♦ "I found the mahogany-framed mirrors in London in the sixties at Trad's in Portobello Road," remembered O'Flaherty. "They were salvaged from bars that were being torn down. I loved the look of them and bought a pair for $75. The dealers shipped them back for $75." ♦ O'Flaherty's rigorous editing is especially evident in this room with its spare white-painted Parsons tables, bare floor, and unadorned table. ♦ "I prefer to keep the decor consistent and unpretentious. This way, friends feel at home. In a white-on-white color scheme, everyone looks their best," said O'Flaherty. "I don't want anything disturbing the guests — except other guests." ♦ O'Flaherty found the Thonet chairs 20 years ago at a mortuary that was being demolished. They were painted pea green. He paid $3 each for 16 chairs and promptly had them lacquered gleaming white.

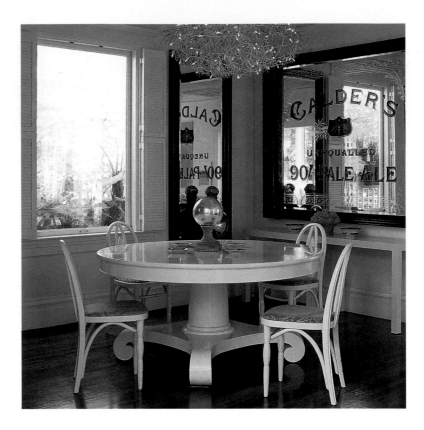

♦

White is right: O'Flaherty polished off the decor of the dining room, which overlooks a fern-filled garden, with just a few confident moves. Vintage London pub mirrors reflect white Parsons tables, a glossy white-painted Honduras mahogany table, and Thonet chairs. The "chandelier" was improvised from a dried boxwood bush entwined with strings of white party lights.

♦

O'Flaherty's south-facing kitchen, which overlooks a walled garden, was designed and renovated in collaboration with Charles Pfister. Here O'Flaherty, an enthusiastic host, prepares pot roast, pasta, crème brûlée, and anything with potatoes, "God's gift to the Irish." ◆ "We chose white here, too, because it is an absolute classic," said O'Flaherty. "To hell with fashions in decorating! I like my own collections and unfussy decor whether they're à la mode or not." ◆ The narrow kitchen was extended across the back of the house. ◆ "For years I cursed the tenacious Algerian ivy vines growing outside the window because they prevented me from enlarging the kitchen," recalled O'Flaherty. "Finally, I realized that they are a decorative window covering. In winter, I clip back the leaves, and the bare, twisted vines are very sculptural. In summer, I let the vines grow and trail, and they keep out the bright sun very effectively." ◆ O'Flaherty's hard-working kitchen now includes four large green-veined Arabasciatto marble counters with ogee edges, four aligned burners, bronze handles and faucets, and easily accessible wall shelves for storage. There, O'Flaherty displays collections of U.S. Navy–issue ironstone with distinctive blue anchors, antique bottles of house-made pear brandy, pear preserves, vintage saloon trays, duck decoys, Mexican glasses, Cost Plus white porcelain dinnerware, and fine crystal. ◆ "I was brainwashed in the Navy about "spit and polish" but that's not really why everything here is very orderly," said O'Flaherty. "It's just quicker and more efficient to have plates or knives or bottles at hand, where they should be." ◆ O'Flaherty's whimsical art direction is evident in every corner. On one counter, he presents glass soda fountain jars full of ruffled paper cupcake holders and fresh eggs. On the preparation counter, he arranges bottles and jars of olives, olive oil, and vinegars. ◆ "I've always used white dinnerware," he said. "It shows off food best. I couldn't imagine serving on fancy plates." ◆ Beneath the linen-upholstered banquette, O'Flaherty keeps all of his household linens. For lunch or dinner for two or three, he can pull a table and chairs up to the banquette and chat with his guests as they sip an aperitif and he prepares omelettes or salads.

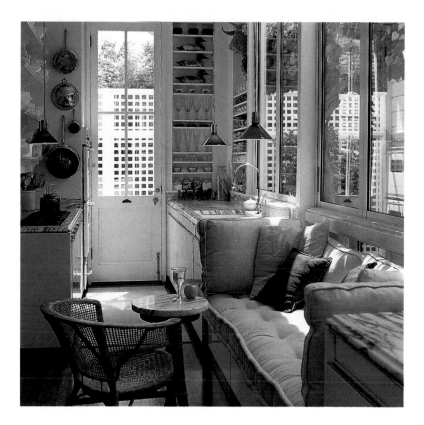

◆

Spit and polish: Sunshine floods into O'Flaherty's 26-foot by 7-foot kitchen for most of the day. In keeping with the classic style, O'Flaherty kept lighting simple and practical. Windows overlook a walled garden where O'Flaherty and Hickerson nurture espaliered pear trees.

◆

The sunny kitchen overlooks a quiet, walled garden. The writer likes to put up his own

flavored oils, pear brandies, pickles, and vinegars, which he displays in handsome

bottles on the marble counter and often gives to friends.

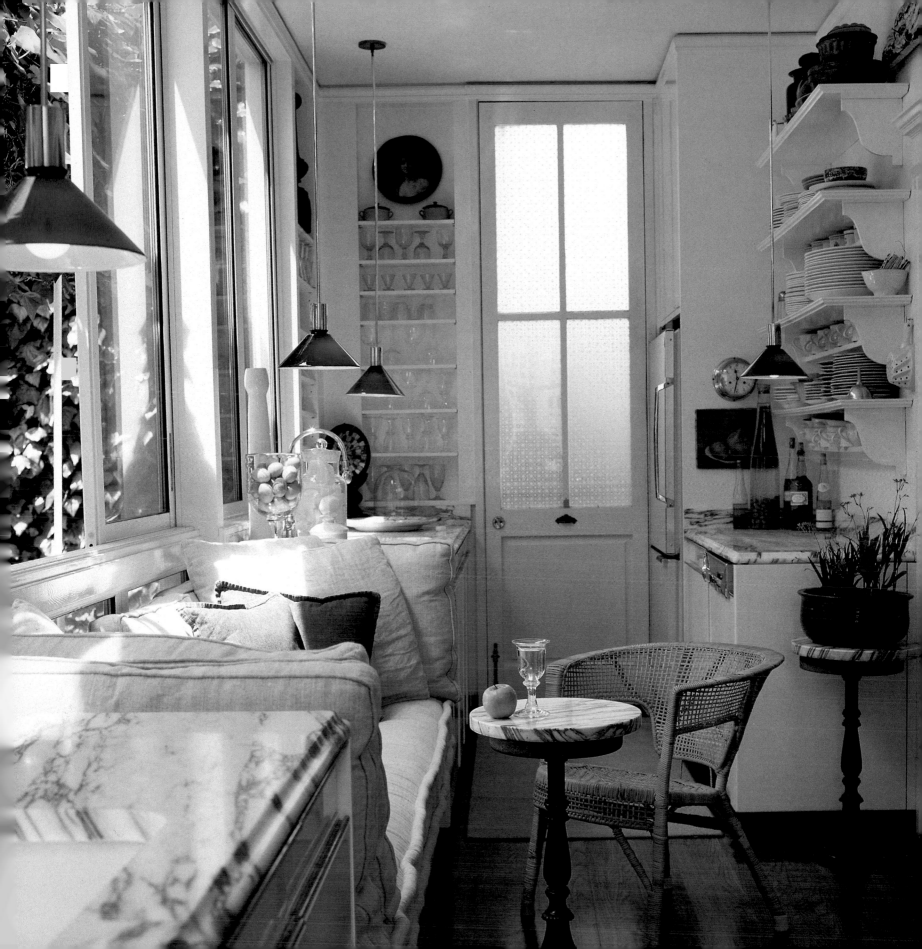

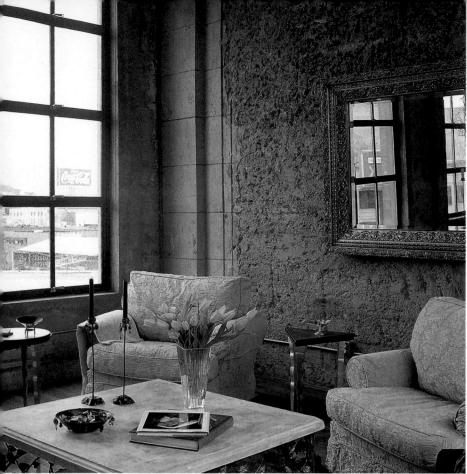

Margie Herron's expansive metal-sash windows overlook the cubist urban landscape, with Twin Peaks, Potrero Hill, and Mt. Davidson on the fog-banked horizon. Shabby Chic damask chairs and a fat ottoman soothe the hard-edged, raw-concrete walls. Herron worked with architect Rita Burgess of David Baker & Associates to make the space as comfortable and livable as possible.

The dining room was defined by raising the hard-wood floor three steps. Stairs with raw-steel balustrades lead to the shoji-screened mezzanine bedroom. Windows, left, draw light from an interior courtyard.

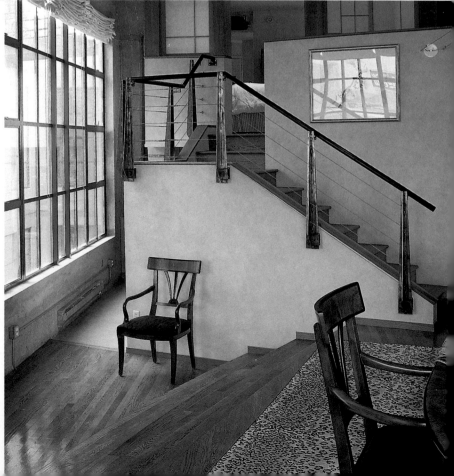

SOUTH OF MARKET CITY LIVING FOR PRINTING COMPANY ACCOUNTS MANAGER MARGIE HERRON MEANS WALKING TO WORK IN THE MORNING AND TAKING HER BICHON FRISÉ, LUCI, FOR EVENING STROLLS ALONG THE EMBARCADERO. WITHIN JUST A FEW BLOCKS OF HER LOFT ARE THE PERFORMING ARTS CENTER, THE NEW MARIO BOTTA-DESIGNED SAN FRANCISCO MUSEUM OF MODERN ART, ART GALLERIES, AND HER FAVORITE RESTAURANTS ON SOUTH PARK. ♦ "MY NEIGHBORHOOD JUST KEEPS GETTING BETTER AND BETTER," SAID HERRON, WHO GREW UP IN NORTHERN MICHIGAN. "FRIENDS WERE CONCERNED ABOUT ME WHEN I FIRST MOVED HERE IN 1990 BECAUSE THIS IS STILL LARGELY AN INDUSTRIAL AREA, BUT IT'S ALL VERY CIVILIZED. ON WEEKENDS, IT'S LOVELY AND QUIET HERE IN THE HEART OF THE CITY." ♦ HERRON WAS ONE OF THE URBAN PIONEERS WHO SNAPPED UP THE FIRST LEGAL RESIDENTIAL/WORK LOFTS IN SAN FRANCISCO. HER 85-UNIT BUILDING, ERECTED IN 1915 FOR THE LIGGETT & MYERS TOBACCO CO., HAD BEEN USED AS A LIQUOR WARE-HOUSE BEFORE IT WAS CONVERTED AND REDESIGNED BY DAVID BAKER & ASSOCIATES. ♦ "WE JOKE THAT THE BUILDING HAS GREAT SPIRIT," SAID HERRON, WHO BOUGHT 1,800 SQUARE FEET OF RAW SPACE WITH 16-FOOT CEILINGS AND VAST 12-FOOT-HIGH BY 16-FOOT-WIDE WINDOWS. OTHER ATTRACTIONS FOR HER WERE FIVE HANDSOME, TREE-LIKE CONCRETE COLUMNS, SOARING BUTTERFLY-WING CEILINGS, CRISSCROSSING EXPOSED PIPES AND WIRES, AND NONSTOP VIEWS OVER CITY ROOFTOPS. ♦ "I WANTED A COMBINATION OF HARD-EDGED, EXPOSED CONCRETE WALLS AND SOMEWHAT BAROQUE FURNISHINGS AND RICH FINISHES," RECALLED HERRON. "I WANTED THE STYLE TO BE ELEGANT AND SENSUAL. I DIDN'T WANT TO FEEL AS IF I WERE LIVING IN A CONCRETE BOX." ♦ ARCHITECT RITA BURGESS DESIGNED A NEW CORE TO ENCLOSE THE KITCHEN, A DOWNSTAIRS GUEST ROOM/OFFICE AND BATHROOM, AND A MEZZANINE BEDROOM AND BATHROOM. ♦ "IT WAS IMPORTANT TO ME THAT THE BEDROOM COULD BE CLOSED OFF," SAID HERRON. "PRIVACY IS AN ISSUE WHEN YOU'RE LIVING IN ONE LARGE OPEN LOFT." ♦ IN THE MEANTIME, MORE SOUTH OF MARKET BUILDINGS HAVE BEEN CONVERTED FROM PRINTING PLANTS AND WAREHOUSES TO LOFT LIVING. FOR MARGIE HERRON, WAKENING TO WEEKDAY CITY SOUNDS AND SUNDAY SILENCE IS STILL A THRILL.

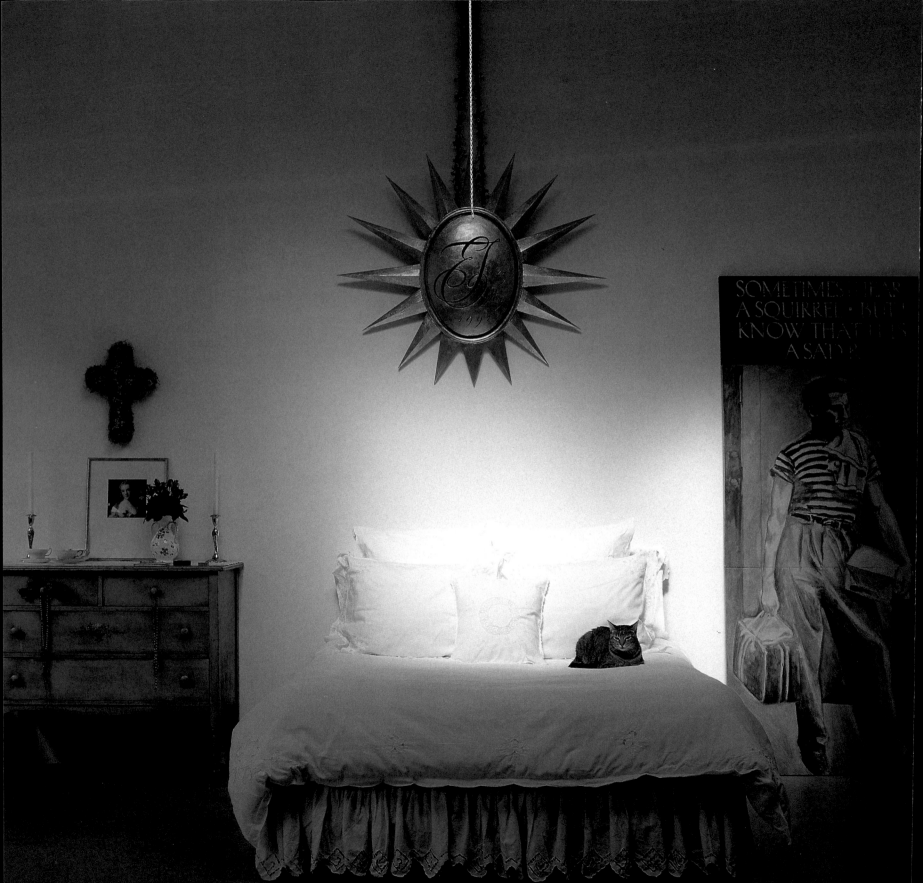

WHEN GRAPHIC DESIGNER ELIZABETH IVES MANWARING AND HER THEN-FIANCÉ, ARCHITECT TIM PERKS, MOVED INTO THEIR SECOND-FLOOR SOUTH OF MARKET LOFT A HANDFUL OF YEARS AGO, THEIR FRIENDS CONSIDERED THE MOVE DARING, PIONEERING, AND PERHAPS A LITTLE DANGEROUS. THAT WAS NOT THE APPEAL FOR THEM. NOR WERE THEY SWAYED BY THE ROMANCE OF LIVING IN A FORMER FURNI-TURE FACTORY. ◆ "WE WERE ABOUT TO BE MARRIED, AND WE SUDDENLY FOUND OUT ABOUT THIS GREAT VACANT LOFT," RECALLED ELIZABETH. "IT WAS A BLANK CANVAS. THERE WAS ONE HUGE OPEN SPACE, PURE WHITE, WITH NO WALLS CLOSING OFF ITS 1,100 SQUARE FEET. NO ONE HAD 'FIXED IT UP' OR FANCIED IT UP. WE TOOK IT IMMEDIATELY AND MOVED RIGHT IN." ◆ PART OF THE APPEAL, TOO, WAS THE FLOOR OF SUBTLE POURED-IN-PLACE PALE-GRAY LINOLEUM. THE WHOLE LOFT WAS FLOODED WITH LIGHT FROM A WALL OF WINDOWS OVERLOOKING AN ALLEY, AND A LARGE CENTRAL SKYLIGHT. ◆ "WE CREATED OUR OWN PRIVATE SANCTUARY IN THE MIDDLE OF URBAN CHAOS," RECALLED ELIZABETH. "THE ARCHITECTURE IS OPEN AND SPACIOUS AND WONDERFULLY SIMPLE. WE'RE BOTH FASTIDIOUS, AND WE LOVE EACH OTHER, SO HAVING NO WALLS IS NOT A PROBLEM FOR US." ◆ PERKS AND MANWARING ARRIVED IN THEIR NEWLYWED BOWER WITH PRETTY, WHITE, EMBROIDERED, AND LACE-TRIMMED LINENS FOR THEIR BED, WITH OLD BOOKS, GENEROUS GIFTS FROM THEIR FAMILIES, GRAPHIC WORKS, IDIOSYNCRATIC FLEA-MARKET FINDS — AND A STYLE ALL THEIR OWN. ◆ "A LOFT DOES NOT HAVE TO BE HARD-EDGE," NOTED ELIZABETH. "IT CAN BE WONDERFULLY ROMANTIC LIVING IN THE HEART OF THE CITY."

Sentiments: A collection of Tim Perks' grandmother's English teacups, lace and sweetheart roses in a hand-painted Italian pitcher offer a charming billet-doux on top of a sidewalk-sale painted dresser.

◆

Getting it white: A tall sketch (a wedding gift) by Elizabeth's father, Michael Manwaring, is a graphic presence in one corner of the white-walled sleeping area. The gold-leafed sunburst monogrammed with TE (for Tim and Elizabeth) is by Dixie and Michael Manwaring.

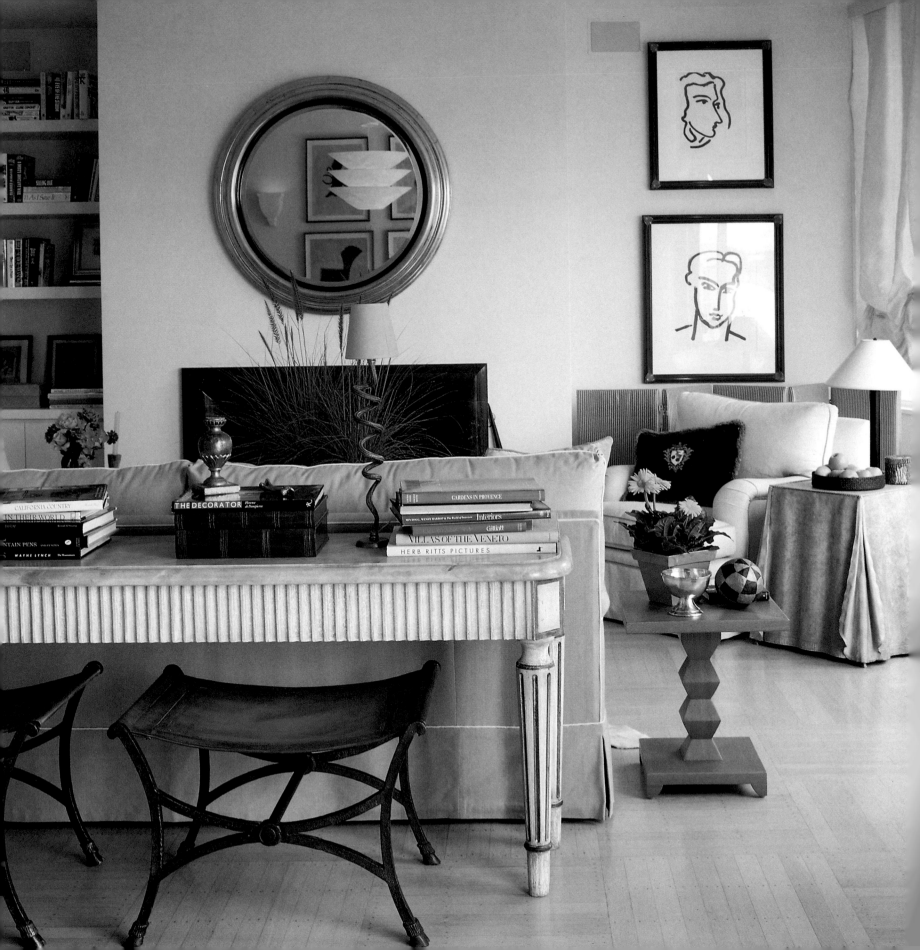

ONE ERA'S AVANT-GARDE MAY BE ANOTHER DECADE'S ANATHEMA. ♦ MODERNIST ARCHITECTURE – SO DARING, SO REFRESHING, SO UNENCUMBERED WITH HISTORY AND EXCESS WHEN IT WAS BUILT IN THE THIRTIES – CAN SEEM LACKING IN ENRICHMENT, FRIENDLY DETAIL, AND CHARACTER IN THE NINETIES. ♦ THAT WAS THE DISCOVERY OF BERKELEY INTERIOR DESIGNER STEPHEN SHUBEL WHEN HE WAS COMMIS-SIONED TO DECORATE THE CLEAN-LINED, STRIPPED-DOWN INTERIORS OF A 1932 HOUSE ON TELEGRAPH HILL. ♦ HIS CLIENTS, BUSINESS EXECUTIVES, LOVED THE SPECTACULAR SETTING AMONG THE TREES BELOW COIT TOWER. ARCHITECT GARDNER DAILEY HAD DESIGNED THE 2,500-SQUARE-FOOT APARTMENT FOR HIM-SELF, AND ITS BEAUTIFULLY LIMNED EXTERIOR SEEMED BARELY TO HAVE DATED IN THE 60-YEAR INTERIM. THE INTERIORS, WERE WELL PROPORTIONED AND SUNNY, BUT THEIR STRINGENT GEOMETRY BESTOWED A RATHER COOL DEMEANOR. ♦ SIMPLICITY IN ROOMS CAN BE POETIC AND SOOTHING. IN THIS CASE, THE APARTMENT LACKED PERSONALITY WHEN SHUBEL UNDERTOOK HIS WORK. ♦ "MY CLIENTS WANTED THIS HOME TO BE WELCOMING AND NOT TOO FORMAL," SAID SHUBEL, WHO HAD DESIGNED THREE HOUSES FOR THE COUPLE. ♦ ON THE FIRST FLOOR, THE CRISPLY DELINEATED LAYOUT INCLUDES A LARGE SITTING ROOM, A DINING ROOM, AND A STUDY. ON THE VERY PRIVATE SECOND FLOOR, A SUN-FILLED BEDROOM HAS DRA-MATIC VIEWS OF THE BAY BRIDGE AND NEARBY COIT TOWER. FROM BROAD ROOF TERRACES, THE OWNERS CAN VIEW THE HIGGLEDY-PIGGELDY ROOFTOPS OF NORTH BEACH AND THE EAST BAY IN THE HAZY DIS-TANCE. ♦ "MY CLIENTS TRAVEL AND THEREFORE SELDOM ENTERTAIN, SO I DESIGNED IT SOLELY FOR THEIR PLEASURE AND COMFORT, " SAID SHUBEL. "MY IMMEDIATE PLAN WAS TO GIVE THE ROOMS CHARM AND TO WARM THEM UP WHILE MAINTAINING THE ARCHITECTURAL PURITY." ♦ SINCE HIS CLIENTS' TASTE DOES NOT VEER TOWARD ANTIQUES, WHICH SHUBEL WOULD HAVE CHOSEN, THE DESIGNER FOCUSED INSTEAD ON

Stephen Shubel's design solution for rather spare, modernist rooms: Richly

textured fabrics, large-scaled furnishings, a bold, gold mirror above the mantel, and cotton

Brighton shades along a wall of windows.

colors he calls "aggressive neutrals" to give the rooms a sunnier disposition. Tobacco-colored silk damask covers a large ottoman in the study. Tan cotton twill covers the living room sofa. The dining room chairs, upholstered in cream leather, are honey-colored Biedermeier reproductions. A cognac-hued chenille sofa piped in silk taffeta gives the study a feeling of ease. An accompanying armchair is in amber taffeta. ♦ "I didn't splash the color around," noted Shubel. "We bleached the hardwood floors, then rubbed in a little ochre for a bit more glow. They had been chocolate brown. The lighter floor really balances out the vanilla-painted walls with more finesse." ♦ Shubel also wanted to keep the scheme rather low-key because the views are so compelling. "I thought it was important to give the rooms a feeling of sunshine. The panoramic views of the Bay and the hillside are all green and blue and very cool," he said. ♦ Clotted-cream-colored cotton drill Brighton shades were designed for the windows of the living room and dining room to soften their lines. ♦ The living room has one corner lopped off to accommodate the hilly site. To counter the asymmetry, Shubel centered his floor plan around the black marble fireplace. A seven-foot sofa and a pair of armchairs upholstered in a textured linen/cotton weave surround a cream gessoed crackle-finish coffee table. ♦ In one corner of the room, the designer planned a vignette with an homage-to-John-Dickinson galvanized table, a down-filled armchair, and a simple metal tube lamp. Matisse prints, framed boldly in black, hang on the adjacent wall. ♦ "Texture and contrast are really important when you use neutrals," said Shubel. "I used no pattern at all, so the lines and layout of the furniture are extremely important. I wanted to soften the edges without getting froufrou."

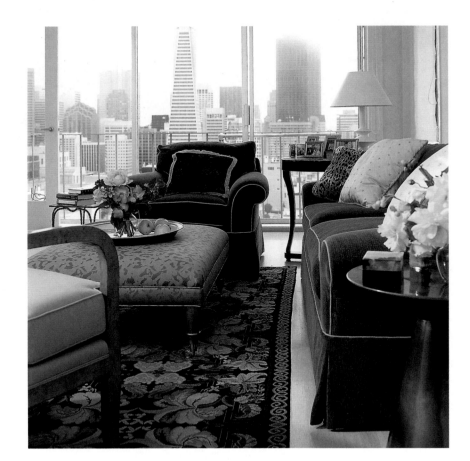

♦

Telegraph Hill has always been a very popular neighborhood because it is within walking distance of downtown San Francisco. From the windows of this apartment, situated on the hillside just beneath Coit Tower, City spires seem within arm's length. To contrast with the rather monochromatic scene, designer Stephen Shubel decorated the study with tobacco-colored damasks and cognac-toned upholstery.

♦

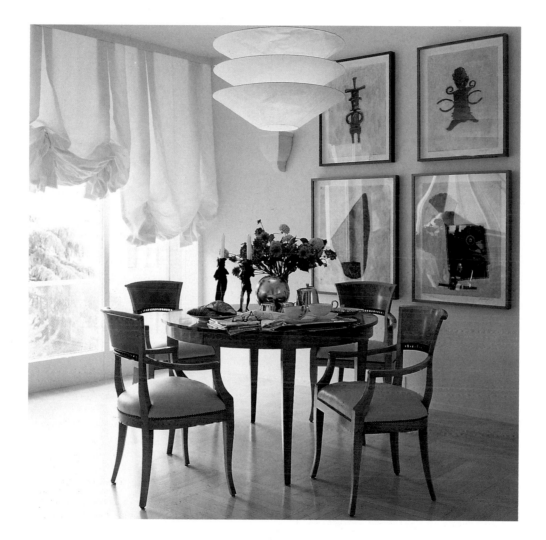

*In the dining room, Biedermeier-style chairs surround the circular table. Above the
table hangs a three-tier paper chandelier by Ingo Maurer from Postmark.
The quartet of paintings is by Sausalito artist Shane Kennedy.*

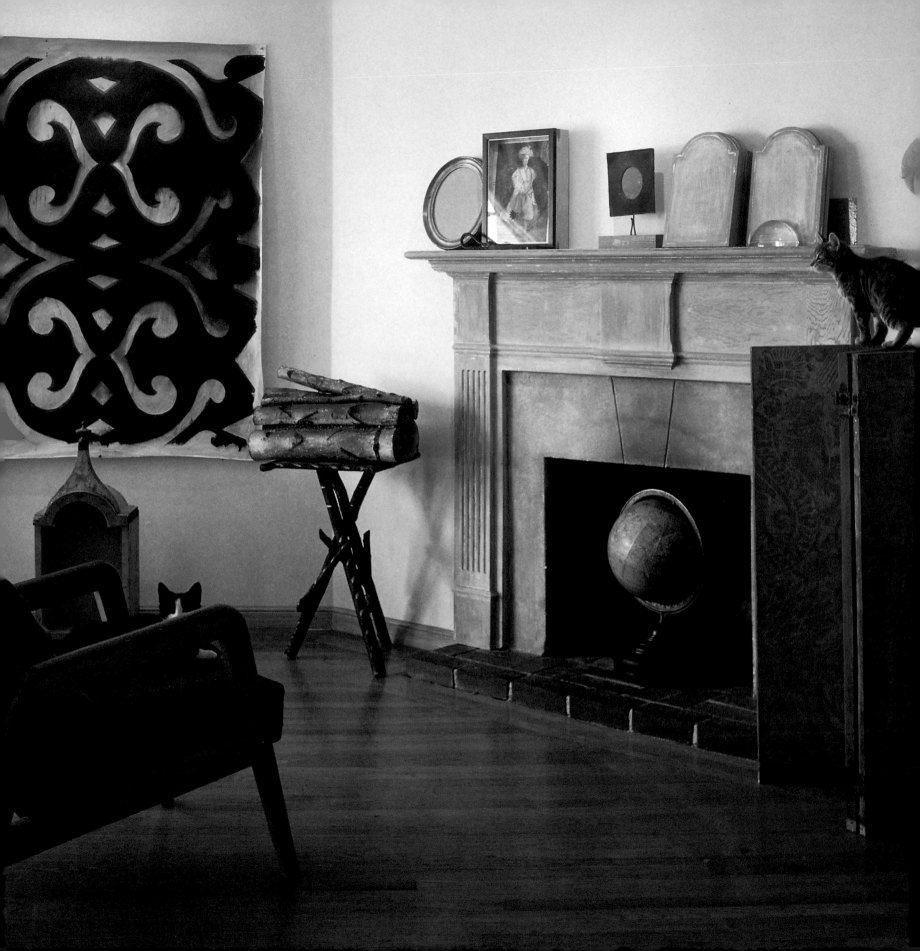

ONE FINE DAY IN 1988, ARTISTS SCOTT WATERMAN AND BRETT LANDENBERGER PILED THEIR BELONG-INGS INTO A RENTED TRUCK AND DROVE CROSS-COUNTRY FROM THEIR ATLANTA HOME OF EIGHT YEARS TO MOVE TO SAN FRANCISCO. THE ADVENTUROUS PAIR HAD VISITED FRIENDS IN CALIFORNIA A FEW MONTHS EARLIER AND DECIDED THAT LIVING WITHIN OZONE-BREATHING DISTANCE OF THE PACIFIC OCEAN WAS THE REFRESHMENT THEY NEEDED. ♦ THE STORY IS A FAMILIAR ONE TO SAN FRANCISCANS WHO EXPECT THAT ONCE A CURIOUS AND IDEALISTIC VISITOR IS STRUCK BY THE CLEAR, WHITE LIGHT THAT REVERBERATES AROUND THE CITY FROM THE BAY AND THE OCEAN, HE OR SHE WILL RETURN TO LIVE AND WORK. ♦ "WE LIVED AMONG DARK TREES EIGHT MILES FROM THE SEA IN GEORGIA, AND THE THOUGHT OF LIGHT POURING THROUGH OUR WINDOWS WAS THRILLING," SAID WATERMAN, A TALENTED DECORATIVE PAINTER WHO BEGAN HIS CAREER WITH TROMPE L'OEIL MURALS AND THE RESTORATION OF HISTORIC BUILDINGS. ♦ THE TWO QUICKLY FOUND A FIVE-ROOM, SECOND-FLOOR APARTMENT IN A 1944 BUILDING IN THE SUNSET, THE WEST-ERN REGION OF THE CITY KNOWN FOR DOELGER BUILDER FLATS, SWEET BUT BLAND HOUSES, AND RELENTLESS SUMMER FOG. ARCHITECTURAL CHARM AND LOCAL COLOR ARE NOT DISTINCTIONS OF THEIR STREET. ♦ "ONE OF THE GREAT REASONS WE CHOSE THIS APARTMENT WAS THAT THE SUNSET IS QUIET AND GRAY AND NOT AT ALL DISTRACTING," SAID LANDENBERGER. "THE SECRET OF OUR NEIGHBORHOOD IS THAT IT'S VERY ACCESSIBLE TO THE BEACH AND TO THE FURTHEST REACHES OF GOLDEN GATE PARK, YET WE'RE 15 MINUTES FROM THE DESIGN CENTER OR DECORATORS' OFFICES. WE TAKE A BIKE TRAIL DOWN THE GREAT

In Waterman's studio, a custom-made lectern modeled after an example in a Renaissance painting displays recent prints and monographs. Brushes are gathered decoratively in a mustard jar and a copper vessel.

♦

Waterman and Landenberger are constantly rearranging the fireplace corner mise èn scene. Sometimes it has a cosy domestic trio of armchairs, other days a workout bench and free weights stand at the ready, like conceptual sculptures. The mantel was stripped of glossy paint and stained to look weathered. On this occasion, kittens Selma (left) and Patti Bouvier cavort on the fifties Scandinavian chair and atop the Waterman-made screen. On the wall, left, is a recent painting by Waterman, one of a series of experiments with enlargements of four-inch paper cutouts.

Highway along the beach to Fort Funston or cycle through the park. It's like being on vacation." ◆ More often, however, the multitalented duo may be working on projects ranging from making paste-paper boxes (a skill Landenberger learned in Cortona, Italy) to painting a flamboyant Spanish baroque bed for a Texas billionaire or framing a watercolor. True to their own ideals of craftsmanship balanced with improvisation, they print, paint, and stencil designs that will translate into fabrics and wallpapers for the design trade. ◆ The distinctive color palette of their work — moody greens, umber, and ochre, smudgy grays, parchment, and antique blues predominate — are inspired by the colors of their surroundings. ◆ "We take our color cues from the City," said Waterman. "The foggy light modulates color. We translate that in our work. Pale hues make prints and objects look vintage. We like that historical look." ◆ Today in their formerly minimalist rooms, no surface is left untouched by Waterman's and Landenberger's extraordinarily prolific hands and their brushes, paints, and paper. Driven to experiment with pattern and papers and prints, each has commandeered a room for making and displaying his art. ◆ Casting aside preconceptions of what an apartment room should look like, and how to decorate, the pair are happy to inhabit an atelier in which the work has overtaken the decor. ◆ "Living and working here, we are always free to exercise our curiosity and concoct new projects," said Waterman. "We have all the books, brushes, inks, fabrics, slides, and projectors we need and a lot to occupy ourselves." ◆ Their focus, he said, is on art and their daily lives rather than on decorating or

◆

In Landenberger's study, the velvet-upholstered daybed made by Mike Elwell provides a cushy nest for Selma the kitten. On the wall shelves, the artists display framed collages, trompe l'oeil paintings, objets trouvés and cutouts. The walls are covered with Landenberger's paste papers. He appreciates the severe simplicity of his stripped pine chest. Above it, a pair of framed sepia-toned prints of Versailles architectural details.

◆

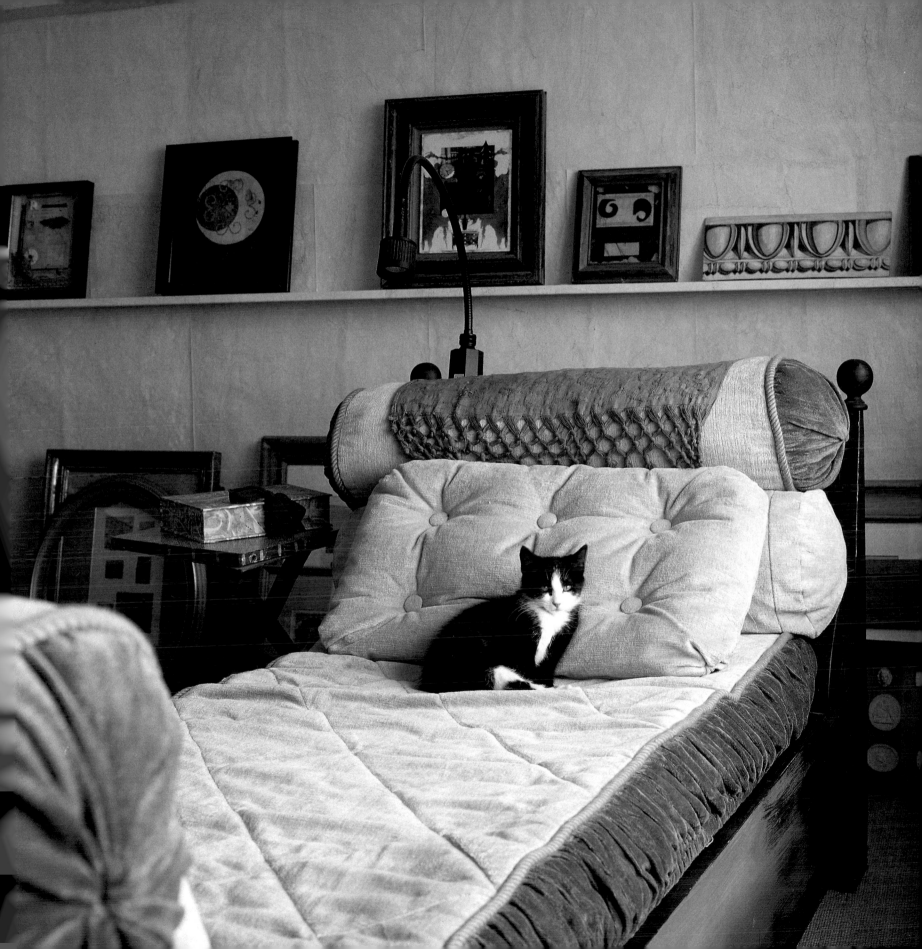

furniture. True to their own ideals of spontaneity, humor, and improvisation, they have crafted rooms of great charm, eccentricity, and originality. Paintings and objects, which would be background in any other dwelling, are foreground here. ♦ "We're content with just enough chairs. We move things around constantly anyway. We don't like these rooms to be static," said Landenberger. "We're not the kind to sit still. Every day there are so many distractions here to keep us busy. Chairs become an issue only when we have guests or family visiting. Then we improvise with the daybed, a flea-market Scandinavian chair, chairs in storage, or a window seat. It all works out just fine." ♦ Waterman noted that the busier they are, the more their work surfaces, art supplies, files, tables, framed works, and samples seemed to be taking over more and more of the apartment. It's beginning to look like the back-room workshops of a museum or the studios of particularly inquisitive French print makers. ♦ "We won't stay in this apartment forever, but while we're here we want it to be as personal and comfortable and inspiring as possible," he said. "Living here, we've learned so much about ourselves. We're happiest making new things. That's how we like to spend our time. Our work gives us such pleasure. We'll take that wherever we go. It will be interesting to see our art in a new light."

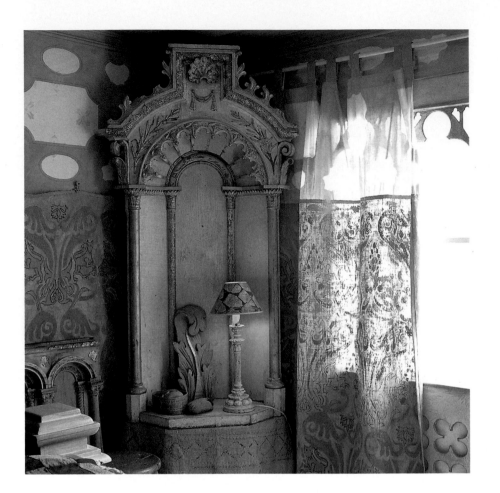

♦

A large, dried Gunnera manicata leaf, captured in a friend's garden,

was hung on the wall of Waterman's and Landenberger's bathroom.

The wall frieze was painted by Waterman.

♦

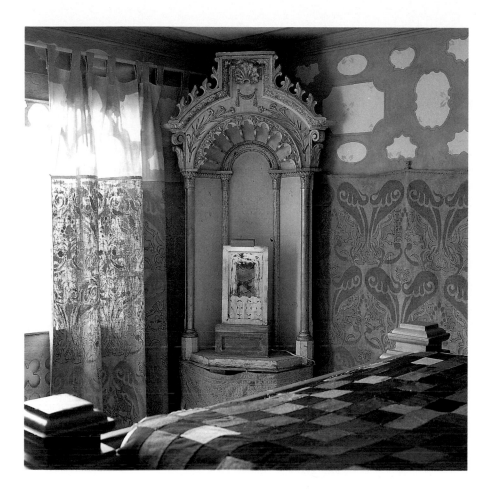

The bedroom is a complete fabrication by Waterman. Challenged by the plain-white-box room and rather prosaic views from the window, he set about creating an escapist fantasy, a refuge where they could read or watch vintage Italian and French videos. ♦ "I wanted to make a comforting and spiritual room," said Waterman. "Since I couldn't paint the walls or make any permanent change to the room, everything here is temporary." ♦ Skirted corner niches from a ruined Montreal church, discovered in Atlanta, are radiant with symbolic flame and flower carvings and sun-faded gilding. Their archetypal images and the golden light suffused through painted draperies give the room an air of benediction. Architecture for the window wall was improvised with wooden fragments from a demolished building, discovered in rural Georgia. ♦ What appear to be elaborately painted bedroom walls are in fact panels of stenciled muslin attached near new crown moldings. Painting the humble fabric the color of the Tuscan earth, Waterman made a rich background for delicate umber-toned traceries. On the lower half of the wall, Waterman hung heavy burlap painted with a repeat pattern of elaborate scrolls and rampant lions taken from a tapestry of Moorish Spain. The rough woven jute was also stenciled, stitched, and gathered to make light-diffusing (and cost-effective) draperies. ♦ The over-scale quarter-tester bed was crafted by their friend Mike Elwell after an Italian Renaissance design. The quilted coverlet was made from vintage suiting fabrics. ♦ "I think this is the final version of this bedroom," said Waterman, rearranging a still-life in one corner niche. "The great advantage of wall draperies is that when we move, they go with us. This loyal burlap will become instant decorating in our next abode."

Unfazed by the landlord's edict for all-white walls, Waterman and Landenberger improvised richly detailed "architecture" for the bedroom with a pair of ornate, carved wooden neo-gothic niches, fabric-draped walls, and wooden "draperies" recovered from a burned-out Montreal church. With stencils of Hispano-Mauresque tapestry scrolls, plus pots of rust, sage, and parchment-colored paint, Waterman metamorphosed plain burlap into the sheer drapery fabric of his dreams.

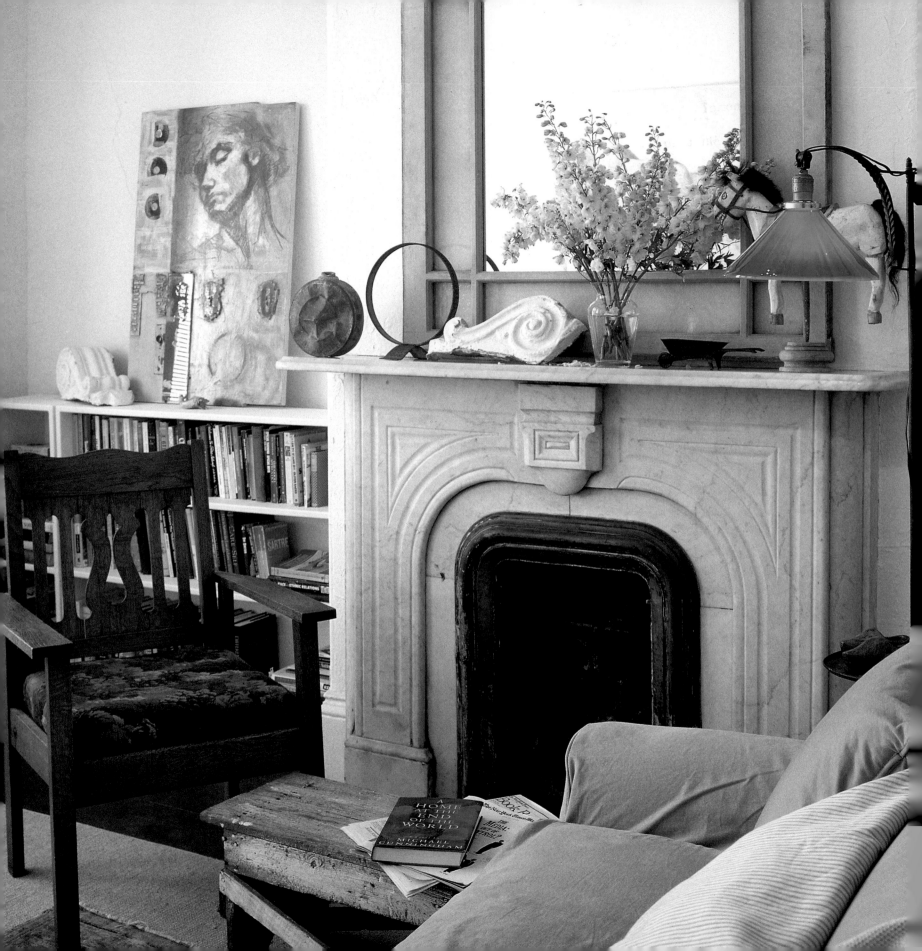

IT'S A LONG WAY FROM SASKATCHEWAN TO SAN FRANCISCO. ASK HAYES VALLEY URBAN PIONEER RUSSELL PRITCHARD, WHO GREW UP IN HIS GRANDPARENTS' FARMHOUSE IN THE WILDS OF CANADA AND NOW LIVES ON HAPPENING HAYES STREET IN THE HEART OF SAN FRANCISCO. HE OPENED A TRENDSETTING VINTAGE FURNITURE SHOP THERE IN 1990, AND NOW LIVES ABOVE THE STORE IN A VICTORIAN APARTMENT. ♦ "GROWING UP IN THE COUNTRY, I COULDN'T WAIT TO LEAVE," PRITCHARD SAID, WHOSE SENSE OF ADVENTURE FIRST TOOK HIM TO NEW YORK, WHERE HE BECAME A STYLIST AND SET DESIGNER. HE LANDED IN SAN FRANCISCO IN 1989 AND SET UP ZONAL TO SELL RUSTY OLD IRON FURNITURE AND ARCHITECTURAL FRAGMENTS. HE SOON BECAME A SALVAGE CHIC TRENDSETTER. ♦ "NOW I SEE THAT MY PASSION FOR ALL THE OLD WOODEN CHAIRS AND PAINT-CHIPPED IRON BEDS AND TWISTED PICTURE FRAMES I SELL AT ZONAL HARKS BACK TO THE LOVINGLY USED FURNITURE OF MY CHILDHOOD," PRITCHARD MUSED. IMAGES OF LONG-GONE ROOMS INFORM HIS EYE. ♦ COOL STUFF THAT IS SO POPULAR IN HIS SHOP – VINTAGE PORCH CHAIRS, SUNFADED PIE CUPBOARDS, AND WONKY OLD TABLES WITH LAYERS OF PAINT WHERE YOU CAN SEE THE YEARS – BRING BACK MEMORIES OF HIS CHILDHOOD, WHEN FURNITURE WAS SIMPLE, HONEST, UNPRETENTIOUS, AND OFTEN WOBBLY. ♦ "NOW I REALLY APPRECIATE TEXTURE AND PATINA ON DUSTY, RUSTY BEDS AND LIGHT FIXTURES. OLD CHIPPED MIRRORS AND DENTED PICTURE FRAMES FEEL RICH WITH HISTORY AND LIFE," SAID PRITCHARD. "CUSTOMERS COME INTO MY STORE ALL THE TIME AND SAY, 'OH, MY AUNT HAD ONE OF THESE' OR 'MY GRANDFATHER'S HOUSE USED TO HAVE A TABLE LIKE THAT,' AND I LOVE THAT FEELING OF TURNING

Living arrangements: In Russell Pritchard's Victorian sitting room, a mirror improvised from a salvaged window hangs above a marble mantel, original to the building. Along the mantel, Pritchard placed architectural fragments, ad-lib sculptures, a rusty vintage flask, and a carved Indonesian horse puppet.

His sofa is covered in practical khaki twill.

♦

In homage to the oil painting by Tom Kalin, Pritchard arranged an allusive still life of rusted miniature chairs, river rocks, and a new lamp made by Jim Misner of vintage hardware and lighting castoffs.

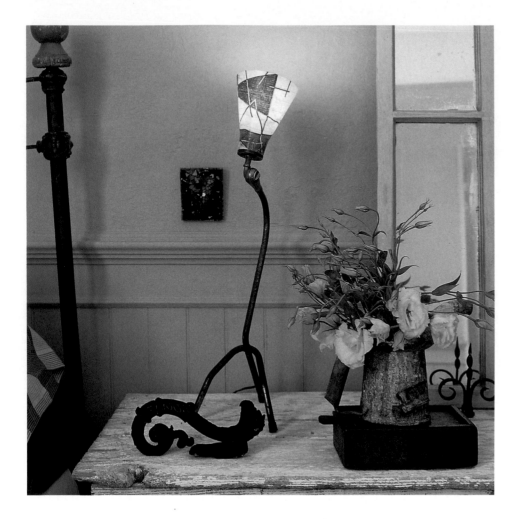

back the pages of their lives." ♦ Pritchard's affection for furniture with a past warms the rooms in his flat, up a steep flight of stairs. There he has created today's version of *la vie bohème* with eccentric found objects and furniture with its own rich history. ♦ "I wanted to live above the store so that I'd have an easy commute," quipped Pritchard, who shares his apartment with his Jack Russell terrier, Nipsy. "I can also keep an eye on things in the street, stay on top of new shipments." ♦ Rooms of the turn-of-the-century flat are filled with light from tall bay windows. ♦ "Architecturally, the flat was great. It just needed cosmetic improvement," said Pritchard. Most of the original moldings, fireplaces, pocket doors, and light fixtures were in good shape. ♦ "I set-to with gallons of white paint," recalled Pritchard. "There isn't an inch of this apartment I didn't paint." ♦ "My vision was to make the rooms pristine and monochromatic while keeping their Victorian formality and grace," Pritchard said. ♦ Of course, he had the store to raid for his choicest furniture. One prize piece, now in the living room, is a sculptural, rusted-metal hospital chair from the thirties. Its sinuous lines add a cartoony touch to the somewhat formal room. "I've only seen three of these chairs, so I snapped it up," Pritchard said. ♦ A sturdy Mission-style chair, which reminds Pritchard of a similar one belonging to his father, contrasts with a ticking-upholstered daybed of rusted iron. Originally a child's hospital bed, it now stands in the full sunlight of the bay window.

The bed, scavenged in Kansas, was repaired but is still bent out of shape and off-kilter. Pritchard reported that for several weeks the troubled spirits of the original owners seemed to hover over his bed. He had tortured dreams every night beneath his down quilt. Finally, after a transcendent dream in which he vanquished the evil spirits, the nightmares ended. Now the bed is as cozy as the beds of his childhood.

♦

The table was an estate-sale find in Minnesota. Pritchard's whimsical lamp is by Jim Misner.

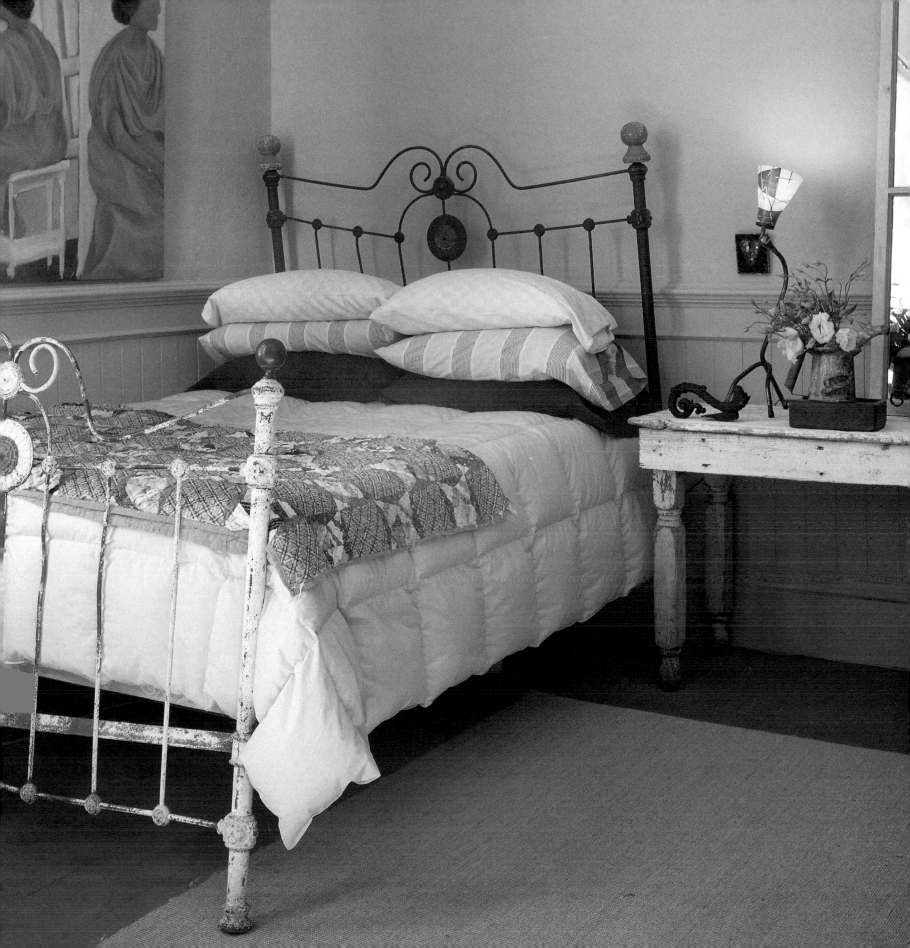

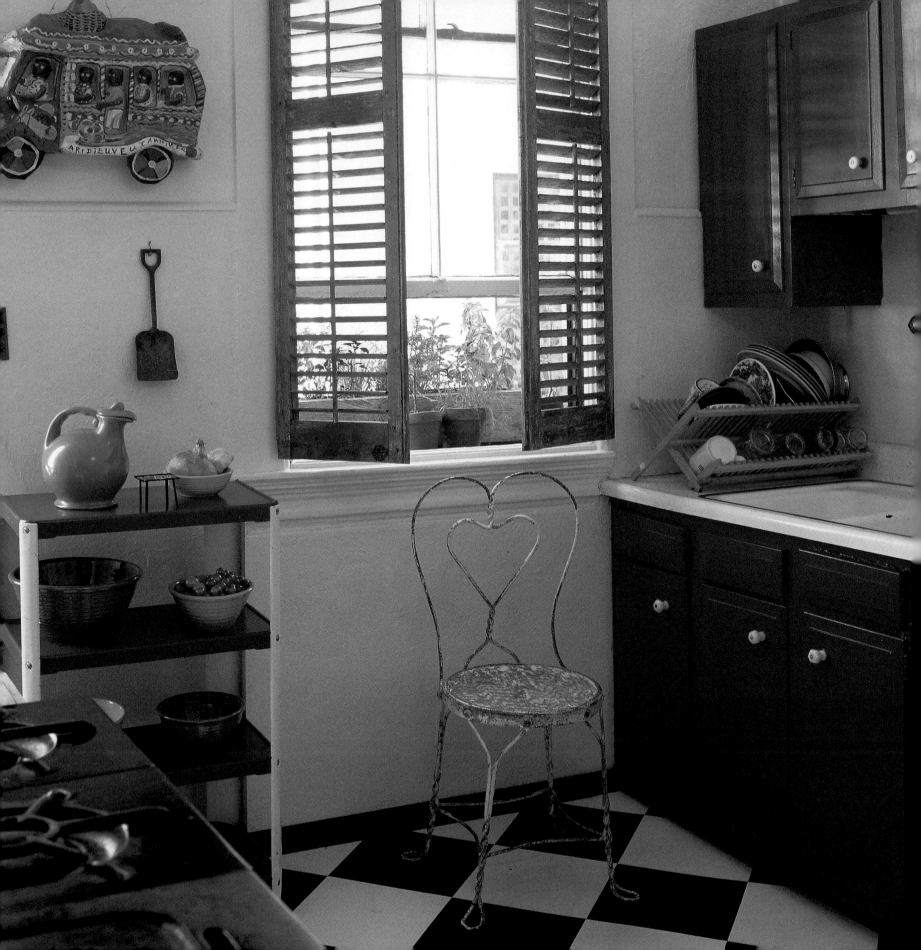

The brightly colored kitchen has the sunstruck air of a house in Mexico or Haiti — without the humidity. ♦ "When I moved in, the kitchen had unfortunately been stripped of all its Victorian cabinets. Fifties renovations were so heartless," said Pritchard. "I immediately painted the indigo walls white and gave the floor some pizazz with black and white tiles. The room still looked rather drab, so I slapped red enamel on all the cabinets. They had been brown, of course. The room instantly came to life." ♦ Vintage farmhouse shutters from the Central Valley were hung at the window. Pritchard grows chives, tomatoes, basil, and thyme in a window box. On the white walls hangs a vivid *papier-mâché* "tap-tap" bus bought from a street vendor in Haiti. ♦ "The great thing about this kitchen is that it has a 12-foot ceiling, tall windows, and a back door that opens onto a sunny landing," Pritchard noted. On a Saturday morning when he dallies over breakfast, the room feels tropical and bright, even though it's in the heart of the City. ♦ Pritchard, one of the pioneers of Hayes Street, has watched the progress of his neighborhood with great interest. ♦ "As more and more artists and stylish shops and galleries are attracted to this street, living here just gets better and better," he said. "Since I first moved here five years ago I've seen Hayes Street go from having vacant and boarded-up storefronts to being a lively destination. Now there are French wine bars, a natural foods store, a great glass gallery, a palm reader/tea salon, a creperie, a German restaurant with polka bands, a framer and gilder, a great design book shop, and excellent art galleries." ♦ Pritchard recently opened a new garden terrace for Zonal, and his store is attracting an international clientele. Meanwhile, he and Nipsy are waiting to see what might be in their next vintage furniture shipment.

Seeing red: Pritchard's bravura choice for kitchen cabinets was a rich, glossy crimson paint. His sleight of hand turned salvage shutters into exotic window coverings.

♦

An ice-cream-parlor chair and a pair of twenties garden chairs provide vintage seating around the thirties farmhouse table. The jolly painting was bought a decade ago in Haiti.

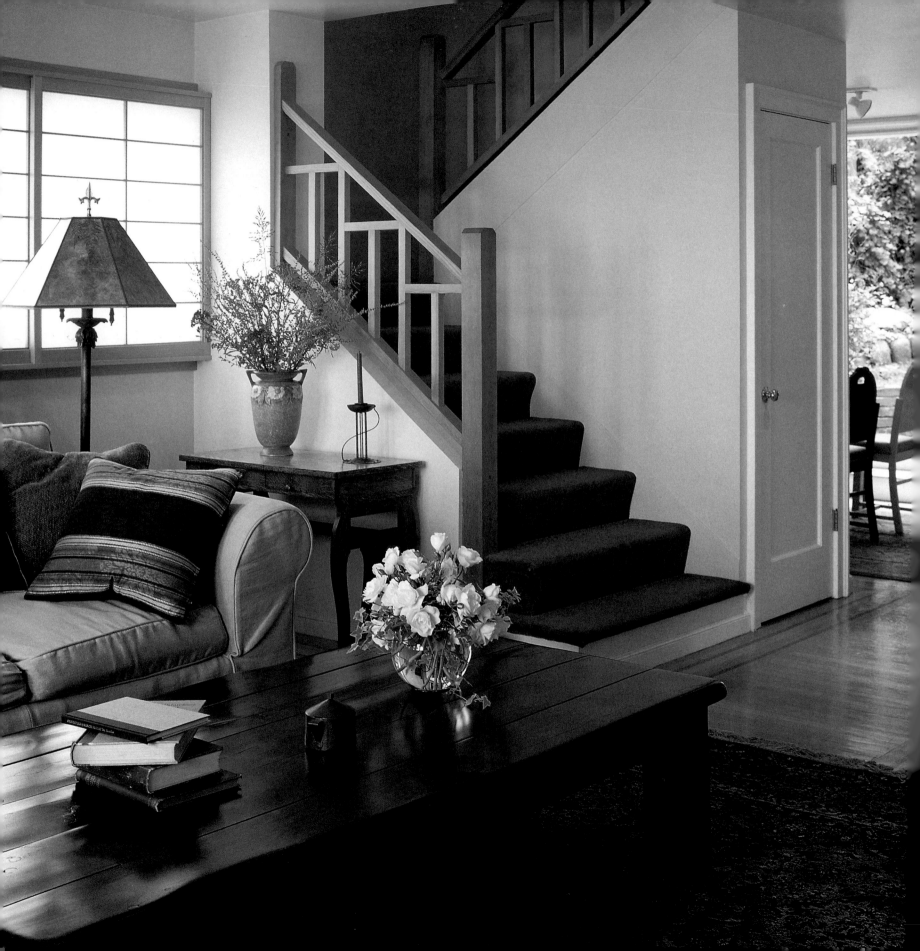

Writer Armistead Maupin's new house in the hills above San Francisco could be called "the house that 'tales' built." The shingled residence, surrounded by a redwood and eucalyptus forest, stands as a tribute to the writer's determination to put down roots in the city, and to his sales of over a million books, in English and French — and now translated into Dutch, Norwegian, Spanish, and German. ♦ Armistead Maupin, who grew up in North Carolina, first became known to San Franciscans in 1976 when his lively serial, "Tales of the City," was published in the *San Francisco Chronicle*. News of Barbary Lane and its cast spread, and the serials were gathered into books. ♦ Maupin's subsequent national and international following made his 1989 book, *Sure of You*, the sixth and final novel in the 'tales' series, a best seller. *Maybe the Moon*, about a 31-inch Hollywood actress, became a best seller in Great Britain in 1992. ♦ *Tales of the City* gained new admirers in 1994 when it was produced as a television series and broadcast in the United States to widespread critical acclaim. Maupin is now working as executive producer on the televised version of his second novel, *More Tales of the City*. He is also writing a new book. ♦ Maupin's move to Parnassus Heights was rather circuitous. In 1990, he and his lover and partner, Terry Anderson, were living in a penthouse in the Mission. In search of peace and privacy, they bought an old farmhouse in Akaroa, a scenic small town on New Zealand's South Island. ♦ "We heard about this wonderful undiscovered place on Banks Peninsula from friends in Sydney," recalled Maupin. "That's how we first got into homeownership and renovation.

In homage to the traditional Arts and Crafts neighborhood and its own architectural lineage, the house makes reference to Mission-style motifs. The handcrafted stair rail and shoji window screens are new additions. Maupin and Anderson found their hefty jarrah wood coffee table in Hampstead, England, and had it shipped home to Parnassus Heights. The hardwood, grown in Western Australia, was transported to South Africa at the turn of the century and used as railroad ties. An enterprising salvager later shipped it to London, where the wood was made into furniture. The pair of sofas, originally a gift from Anderson's aunt, who lives in Georgia, was given new slipcovers of putty-colored cotton twill.

173

Everyone in Akaroa and Christchurch was warm, friendly, and extraordinarily helpful. We remodeled with great enthusiasm." ♦ New Zealand's remoteness (it's as far as you can go southwest from San Francisco without landing in Australia or Antarctica) eventually became a burden for the couple, and they started looking for that same peace and privacy in San Francisco. ♦ "This was the first house we looked at and the only one," recalled Anderson. "We loved the small scale of it, the views of Sutro Forest, and the 500-foot elevation. It was just big enough for both of us to have an office." ♦ Their two-story house had originally been built in 1907 as a weekender for a downtown family. Those were the days when it was an exhausting trip from the stylish Nob Hill out to the wilds and fresh air of Mount Sutro. Today it takes ten minutes by car, perhaps half an hour on the trolley. ♦ Working with Benjamin Shaw, Maupin and Anderson updated the interiors, painted the walls mellow butter yellow, and added an Arts and Crafts air to the living room. ♦ "Renovation is a bit of a grand word for what we did," noted Maupin. "The basic layout was fine but it was too white and bland and architectonic for our tastes. We took out flimsy and dated turquoise post-modern stairway handrails, added shoji screens to the windows, and replaced a wretched prefab fireplace with a custom-made maple cabinet." ♦ The house today is orderly and inviting. "We both get out-of-sorts if the rooms get messy," admitted Maupin. ♦ The small dining room, with French doors opening to a verdant tangle of ivy and old roses, gets its charm from a quartet of Fiestaware-colored chairs and a pair of framed paintings by artist Karen Barbour. ♦ "I love the chairs because they have an art deco look," said Maupin, who used to collect

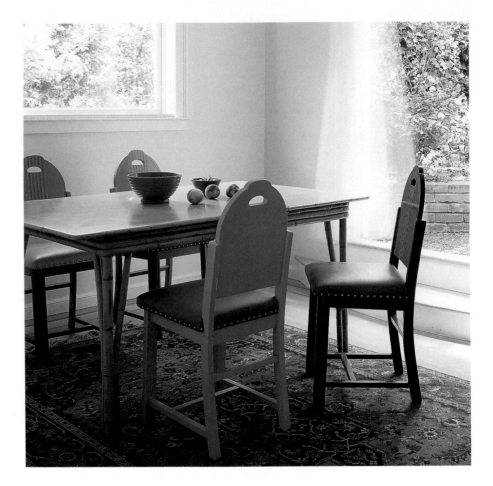

♦

Terry Anderson and Armistead Maupin found their 1930s dining chairs in a junk shop on Valencia Street in San Francisco's Mission District. Simple white muslin draperies blow in the breeze.

♦

♦

The paintings, by their longtime friend Karen Barbour, who lives in Inverness, were executed for the covers of the newest paperback editions of "More Tales of the City" and "Sure of You."

♦

Fiestaware. He found the chairs in a thrift shop in the Mission. Anderson stripped the junk-shop finds of layers of upholstery and gave them their rainbow colors. ♦ For Maupin and Anderson, art imitates life. The fictionalized process of discovering the chairs and giving them new life was chronicled in Maupin's best seller, *Sure of You*, set in San Francisco. In the novel, the protagonists, Michael and Thack, also "scored big" on Valencia Street with dining chairs covered with "cruddy white vinyl but displaying an unmistakable deco silhouette." ♦ In the book, Maupin writes, "They paid an old man ten bucks for the pair and tied them onto the VW, fussing like nuns with a fresh busload of orphans. Back at the house they set to work with hammers and crowbars, ripping away two, three, four layers of plastic and stuffing until the original chairs were revealed. Their peaked backs and oval handholds conveyed a sort of Seven Dwarfish feeling which Michael thought suited the house perfectly." ♦ Michael and Thack also painted their chairs Fiesta colors. ♦ "Of course our lives and our friends find their way into my books," Maupin said. Part of the fun for his readers is playing, "Guess Who?" ♦ "We don't entertain in any formal manner," noted Anderson. "We're more likely to gather around the table in the living room than spend the evening in the dining room. But for breakfast it's great." ♦ They're making plans to improve their garden. "We're working on a new stone terrace and putting in a hot tub," said Maupin. "One of the joys of homeownership is that it makes us feel more secure. We see our adventures in remodeling as a record of our relationship. It's another form of creativity."

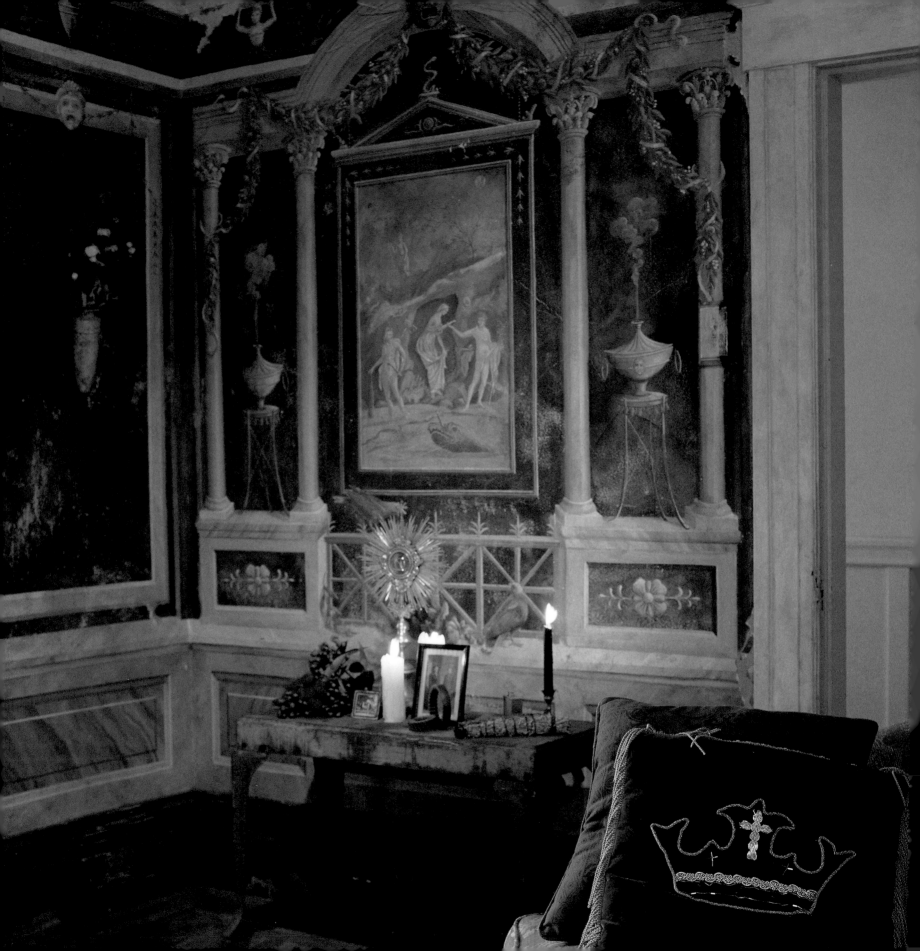

HAYES VALLEY
MICHAEL DUTE'S FLAT

A GUEST WHO VISITS ARTIST MICHAEL DUTÉ'S HAYES VALLEY FLAT AND VIEWS THE SPLENDIDLY ARTIC-ULATED, AUTHENTIC-LOOKING POMPEIIAN MURALS IN HIS LIVING ROOM WOULD FIND IT DIFFICULT TO IMAGINE THAT HE HAS NEVER BEEN TO ITALY. DUTÉ HAS CAPTURED THE STYLE, DISTINCTIVE TIME-WORN COLORS AND ALLEGORICAL FIGURES OF MURALS IN THE HOUSES OF POMPEII, YET HE HAS NOT WANDERED AMONG THE FABLED RUINS OF HERCULANEUM. HE HAS NOT SEEN FIRST-HAND MT. VESUVIUS'S DESTRUCTION, NOR EVEN SEEN THE FRAGMENTS OF POMPEIIAN FRESCOES IN MUSEUMS. ♦ "I SAW SOME BOOKS ON POMPEII AT THE METROPOLITAN MUSEUM IN NEW YORK," SAID DUTÉ, ORIGINALLY FROM PHILADELPHIA. STILL, THIS IS CLEARLY AN ARTIST WHO CAN PICK UP A BRUSH, FIND THE APPROPRIATE PAINTS, AND CREATE WHOLE WORLDS OF THE IMAGINATION. ♦ WHEN DUTÉ SAW MAGAZINE PHOTOGRAPHS OF A PAINTED ROOM IN A HOUSE IN THE HAIGHT-ASHBURY NEIGHBORHOOD OF SAN FRANCISCO, EXECUTED BY MURALIST CARLO MARCHIORI. DUTÉ, WHO HAS NOT STUDIED ART FORMALLY YET HAS DESIGNED FABRICS, TABLEWARE, AND CERAMICS, WENT TO WORK FOR MARCHIORI FOR FIVE MONTHS. ♦ "I CHOSE MY FLAT FOUR YEARS AGO BECAUSE IT HAS WELL-MAINTAINED VICTORIAN DETAILS SUCH AS BEEFY MOLDINGS, EXCELLENT DOOR FRAMES, AND BASE BOARDS," SAID DUTÉ. "FOR A LONG TIME I COULDN'T DECIDE WHAT TO DO WITH THE WALLS. THEN ONE NIGHT I JUMPED OUT OF BED AND STARTED SKETCHING OUTLINES FOR A MURAL WITH A PIECE OF CHALK." ♦ WITH THE FRAMING IN PLACE, DUTÉ PAINTED IN A BLACK BACKGROUND, GOLD EDGING, COLUMNS, A FRIEZE, AND URNS TO CREATE ARCHITECTURE. SPORADICALLY, OVER THE COURSE OF THE NEXT 18 MONTHS, HE WORKED ON THE LIVING ROOM'S FOUR WALLS. ♦ "THIS WAS NOT A COPY OF ANY POMPEIIÁN ROOM BUT MY OWN LOOSE INTERPRETATION OF FRAGMENTS AND IMAGES I HAD SEEN. I WANTED TO EXPLORE POETIC IMAGERY, AND FASHION MYSTERIOUS COLORS THAT LOOKED AS IF THEY'D WEATHERED CEN-TURIES OF HISTORY," SAID THE ARTIST. ♦ "TO ME, THE ROOM FEELS FULL OF LIFE," HE SAID. "THERE ARE MOTIFS, SUCH AS THE URNS, WHICH ALLUDE TO DEATH, BUT I FIND THE AGELESS FIGURES AND TIMELESS SYM-BOLS VERY COMFORTING. THERE ARE OPTIMISTIC SYMBOLS LIKE THE BIRDS AND FLOWERS, AND LOTS OF RED, THE SYMBOL OF LIFE."

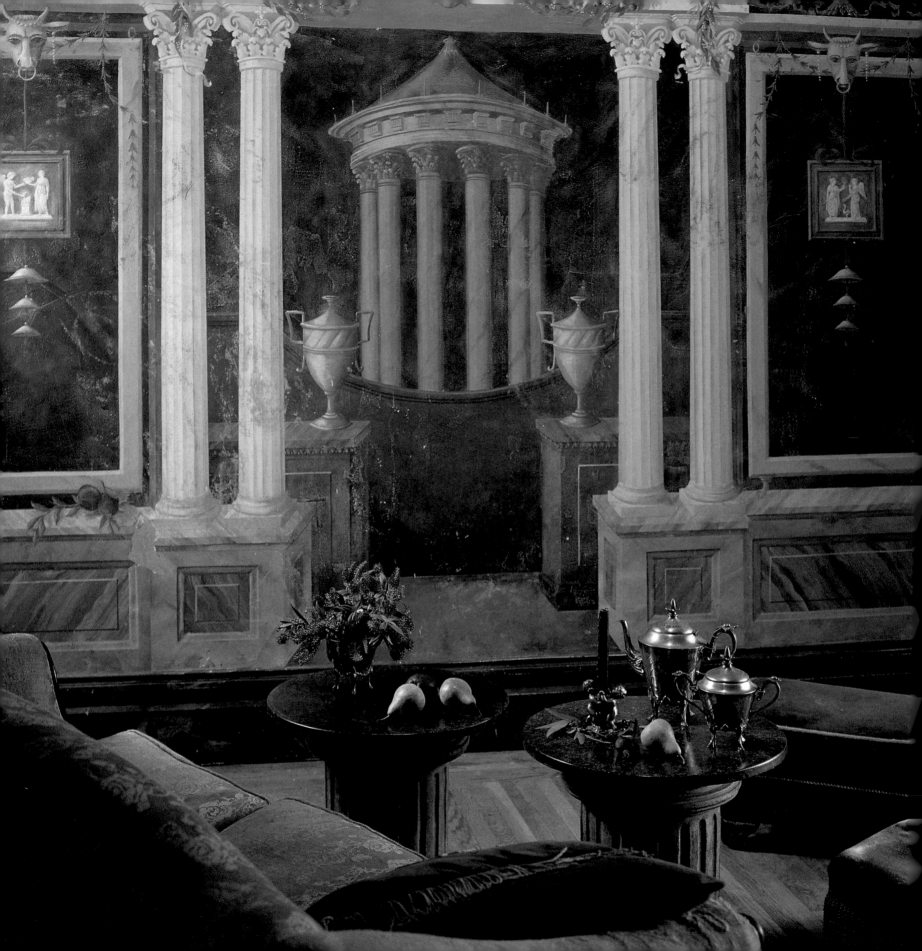

Duté created a vintage vignette on a rusted table from Zonal. His candlelit display
includes a 19th century silver plate monstrance bought at an auction, family photographs,
and bottlebrush flowers.

Michael Duté has the extraordinary talent to capture the dust-faded feeling of ancient
Pompeiian frescoes on his living room walls. He says the highly detailed, formal
depictions are his own interpretation of Pompeiian style, not copies of the original murals,
which he has never seen.

◆

A pair of architectural stone columns is used as coffee tables. Duté made the table
tops from stacking shelves for a pottery kiln. The damask-upholstered sofa was rescued
from its planned sidewalk destiny when two friends left town.

INDIVIDUALISTS

Weekends

In summer, San Franciscans escape the fog by packing their bags and speeding across the Golden Gate Bridge to breathe the warm, wine-scented air of the Napa Valley and the Sonoma Valley. There, just an hour from the cool, gray City, sunshine is certain, and bright days seem to go on forever. As vines flower and grapes ripen, they lie about indolently, weed their gardens, and smile at the sun. ♦ Other perhaps less gregarious or less wine-besotted and food-crazed souls drive north up Highway One to misty bays and quiet coastal towns, there to read old books and gaze out to sea. ♦ The pair of remarkable houses in this chapter was produced and directed by two people with great visions and slightly impractical ideals. Who could ever dream of a Palladian villa in a Calistoga meadow? Who could forebear reinventing and reworking a former winery (and later vinegar factory) into an ode to modernism? ♦ With determination, grit, and the eyes and hands and heart of local talent, these dreams and bold ideals became stone and mortar, timber and glass. ♦ While other artists head to the coast for solitude and the clear, white light, Carlo Marchiori, proud Venetian, has built his dream villa in Calistoga within sight of the Pinnacles and beneath puffs of vapor from the valley's mysterious geysers. ♦ On a quiet street north of St. Helena, a woman of great style and spirit hired a young architectural duo to infuse her residence with light, joy, and a dash of humor. ♦ Both houses are wonderful reasons for heading north one hot day.

Many people who visit the Napa Valley leave with a romantic dream of finding an old country house to renovate. This handsome sandstone residence near St. Helena was created from a former winery-turned-vinegar-factory, first built circa 1880.

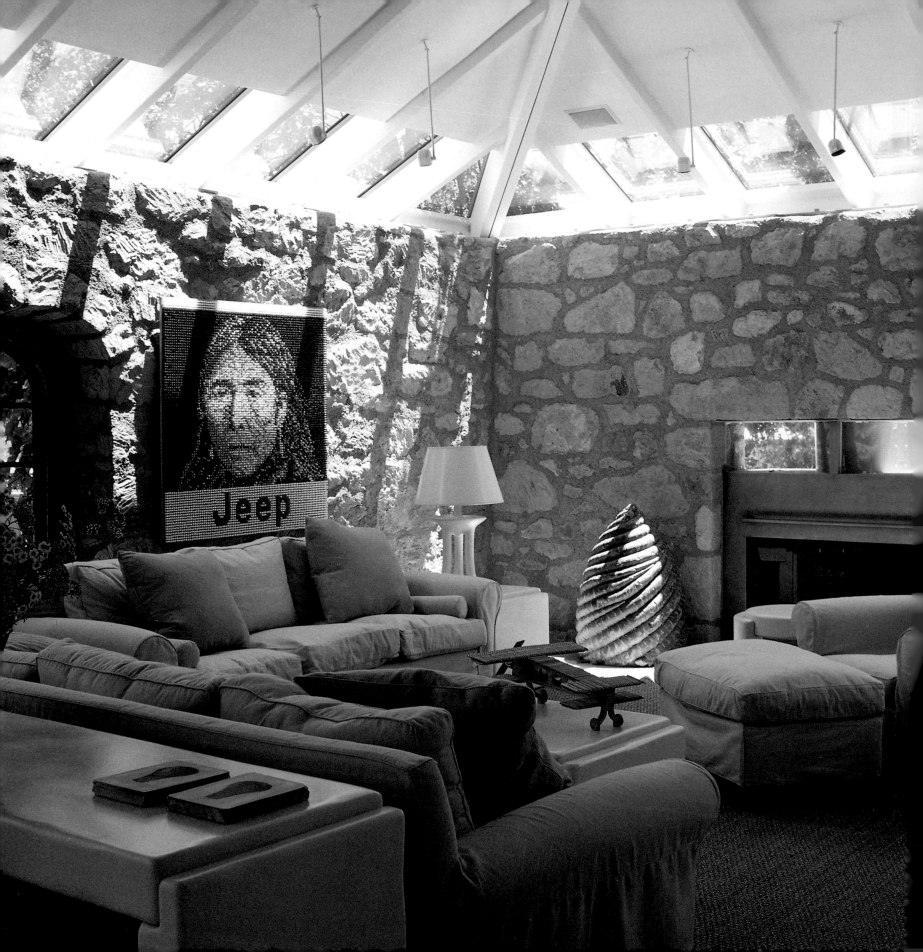

HIDDEN AWAY ON QUIET COUNTRY LANES IN THE NORTHERN REACHES OF THE NAPA VALLEY ARE REMARKABLE PRIVATE HOUSES THAT FEW EXPLORERS EVER ENCOUNTER. SHADED BY GNARLED OLD OAKS, OLEANDER HEDGES, AND TANGLED GARDENS, OFTEN VISIBLE ONLY ACROSS A GREEN MOAT OF GRAPE VINES, THEIR VERY PRIVATE INTERIORS (AND THE LIVES OF THEIR FORTUNATE OWNERS) CAN BUT BE GUESSED AT. ◆ SUCH A RESIDENCE IS THE STRIKING SANDSTONE HOUSE THAT WAS RECENTLY GIVEN A REMARKABLE RENO-VATION BY SAN FRANCISCO ARCHITECTURAL FIRM KUTH RANIERI, WORKING WITH ARCHITECT JIM JENNINGS. ◆ COMPLETELY SCREENED FROM PASSING TRAFFIC, THE IVY-COVERED WALLS OF A CENTURY-OLD WINERY NOW HOUSE A PRIVATE GALLERY AND OFFICE DOWNSTAIRS AND A SUN-FILLED RESIDENCE UPSTAIRS. THE FIVE-ACRE PROPERTY IS ENHANCED BY GARDENS DESIGNED BY RON LUTSKO. ◆ BYRON KUTH AND ELIZABETH RANIERI WERE FIRST COMMISSIONED TO DESIGN FURNITURE FOR A FIRST-FLOOR GALLERY AND TO PLAN SEISMIC UPGRADING FOR THE ENTIRE BUILDING. UPON INVESTIGATING THE ALTERNATIVES, THE ARCHITECTS AND THE OWNER DECIDED THAT THE BEST COURSE OF ACTION WOULD BE TO IMPROVE AND UPDATE THE WHOLE 6,000-FOOT STRUCTURE. ◆ THE COUPLE, WHO BOTH GRADUATED WITH DEGREES IN ARCHITECTURE FROM THE RHODE ISLAND SCHOOL OF DESIGN AND HAD BEEN TEACHING IN BOSTON AND IN SAN FRANCISCO, SEIZED THE OPPORTUNITY TO EXPERIMENT AND REALIZE ARCHITECTURAL IDEAS AND THE-ORIES THEY'D BEEN DEALING WITH IN THEIR TEACHING. ◆ "WHEN WE BEGAN, THE RESIDENCE FLOOR PLAN WAS RATHER DATED, WITH CHOPPED-UP ROOMS AND UNEXCITING MATERIALS," RECALLED BYRON KUTH. ◆ THE TOP FLOOR MEASURED 50 FEET BY 60 FEET, SURROUNDED BY 18-INCH-THICK WALLS. IT WAS SIMPLY LIT WITH FOUR SMALL ARCHED WINDOWS AND FRENCH DOORS. THEY COMPLETELY GUTTED THE INTERIOR.

Walls of the original sandstone building, circa 1880, are evocative of Napa Valley's rich history. Furniture in the upstairs living room was skillfully orchestrated by Los Angeles designer Barbara Barry, who used the owner's John Dickinson-designed furniture from the previous remodel. White lacquer tables and tripod lamps were all designed by John Dickinson. The perimeter custom skylights and steel trusses that anchor them to the roof are all new additions.

"We first projected the work would take about two years, but we buried two years alone on the subtleties of the seismic upgrade," said Elizabeth Ranieri. The owner wanted all of the bracing and support systems to be invisible and to preserve the old local stone walls. ♦ To draw light into the interior, the architects, working closely with Cello and Maudru Construction Company, replaced the old roof and built new skylights around the perimeter flush with the exterior surface of the asphalt shingle roof. Now sunlight casts three-dimensional patterns on the stone walls and slants across the floor. ♦ The architects kept the residence as one open space, with a large central core containing storage closets, a pantry, and an elevator to an upstairs mezzanine. ♦ It's a sure-handed remodel — intelligently planned and executed. In the process, they achieved two fine ideals of the great architect Louis Kahn: silence and light. ♦ The success of the renovation is not simply its large, dramatic gestures but also in the accumulation of endless fine-tuning of luxurious materials. ♦ The architects' attention to detail throughout the house is impressive. "Everything we were going to put in had to have authenticity and integrity," said Ranieri. "It's one thing to design a beautiful interior, but it gains its value by its conncection to and enhancement of everyday life." ♦ New floors for the residence are bleached I 1/2 inch rift-sawn maple. The architects ordered ten percent more than they needed so that they could match the grain and tones of the timber perfectly. Built-in-place storage cabinets of medium-density fiberboard were given four coats of high-quality, metallic-gray auto body

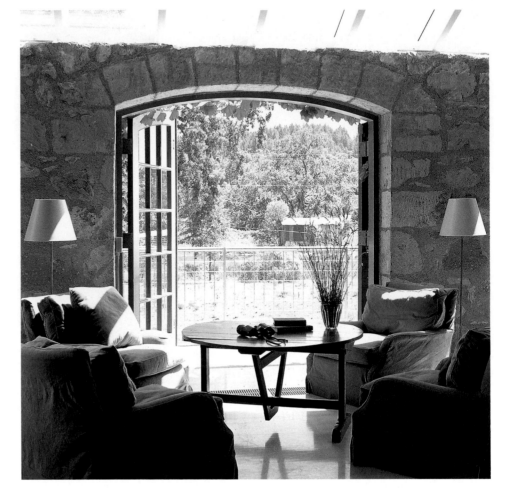

♦

Barbara Barry chose the most comfortable, inviting chairs she could imagine and upholstered them on moss-green slubbed linen.

♦

enamel. Two white-grained black-marble kitchen counters were cut from the same slab so that they would match perfectly. They sit in frames of two-inch sandblasted stainless steel. ♦ "We didn't want to settle for anything ordinary or expected," said Elizabeth Ranieri. "Our plan was to take care of the pragmatic functions of the interior and give them a very high level of consciousness and delight." ♦ The sandstone, so tactile and archetypal, is juxtaposed with 86 glue-laminated rafters, book-match-veneer French sycamore cabinets, and an opinionated collection of contemporary art. ♦ The 50-foot-long living room is bracketed at one end by a six-foot-wide poured in-place concrete stairway, and at the other end by an eight-foot-wide stainless steel fireplace. ♦ "Our client didn't want the rooms to be compartmented or sealed off. The big issue when you're creating an open plan is to define use and 'rooms' within the grand space," said Kuth. "We shaped areas with different wall materials. One corner of the living room was separated from the library with integral-plaster walls. The bedroom, which opens completely to the living room, can be enclosed easily with a series of four fiberglass 'sails,' which seem to disappear when open."

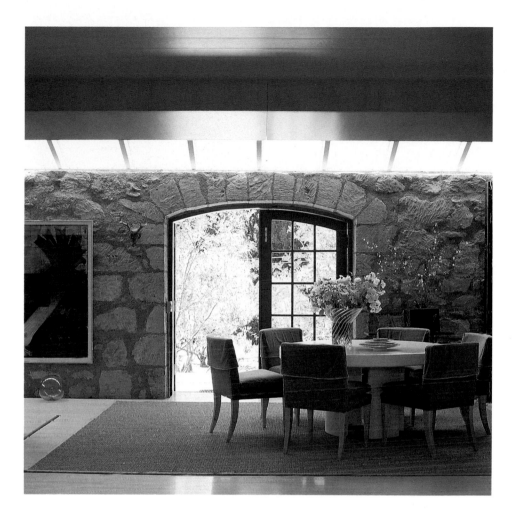

♦

Throughout the renovated residence, the architects planned interiors that were both practical and poetic. Honoring the original simple sandstone building and its wide-open layout, Kuth and Ranieri designed few interior walls. The dining corner and kitchen are set along the west side of the house, with the salon and concrete tower at one end.

♦

*The kitchen is perfectly practical for a country house, with easy-to-clean, honed-marble
countertops, sandblasted stainless-steel cabinets, and fast-access snacks and
drinks for sunbathers. Its dual counters and double sinks suit family gatherings
and informal summer luncheons. Lighting for the residence was
designed by Melinda Morrison.*

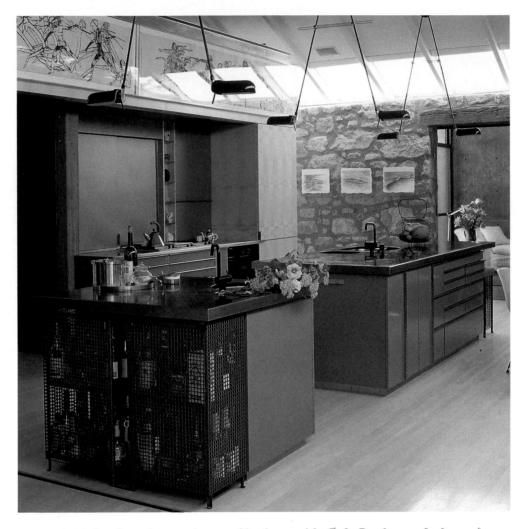

*Behind the "Stonehenge" dining table, designed by John Dickinson, built-in-place
cabinets painted with metallic auto paint, serve as capacious storage and as
a versatile background for paintings and sculpture. Leather topped console table by
Paco Prieto. Bound rugs are classic sisal.*

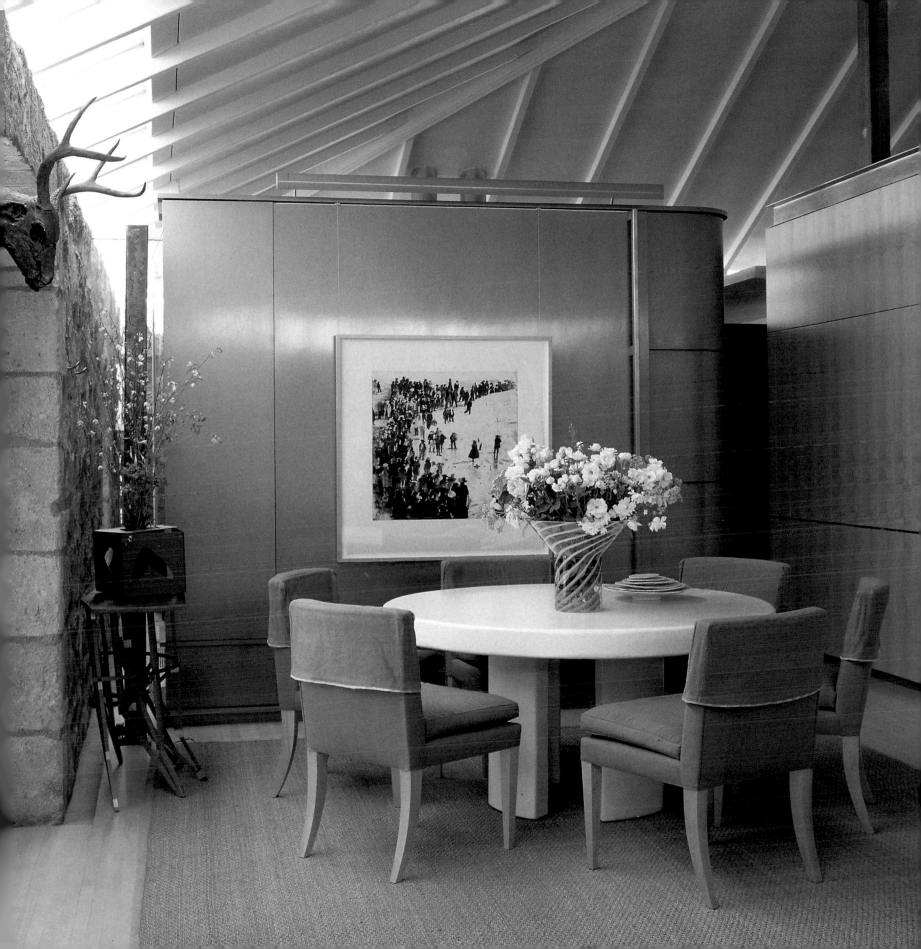

Now that the three-year process is completed, the architects are pleased that the contemporary vocabulary of the renovation has an effortless coexistence with the craggy stone structure. Smooth, rather modernist shapes and sensual contours are perfectly at home with the rough-hewn rocks and the rural site. ♦ "We were so impressed with the quality of workmanship in this house," said Kuth. "We worked with all local craftsmen. They were sixties people who left the City and still had fine values. It was such an honor to work with them." ♦ For Ranieri, putting their beliefs on the line was the ultimate thrill. ♦ "Theory and ideas in architecture are essential, but the actual built artifact is ultimately the true test of an architect," she said. "The pure joy of working on this residence was obsessing about every single detail — the grand concepts, as well as door pulls, window latches, floor finishes, and faucets. In the best architecture, absolutely everything must work to its optimum, as well as give great pleasure."

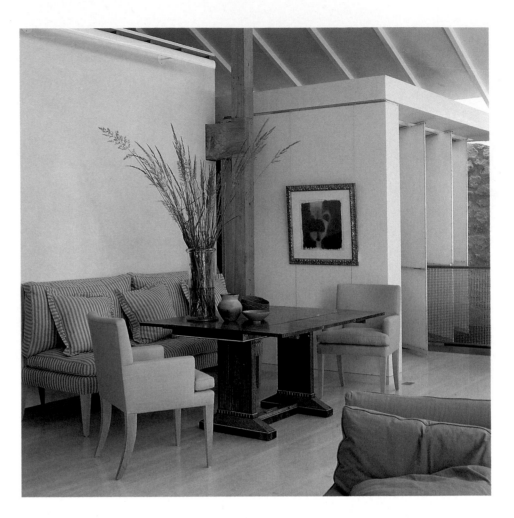

♦

For this rather abstract corner, Los Angeles designer Barbara Barry devised a versatile arrangement of banquette, antique table, and movable chairs. Now the spot may be used for dining, game-playing with grandchildren, reading, travel-planning, or working. Barry's pleasing, neutral linen color palette ranges from taupe and cream to tan, moss green, and sand.

♦

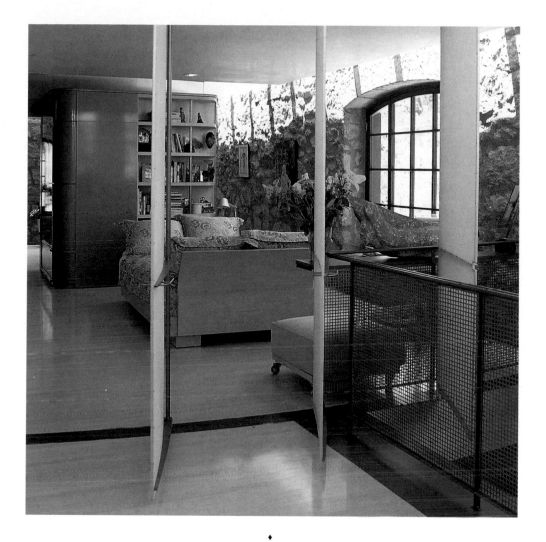

To sleep, perchance to dream: Four diaphanous layered fiberglass screens form a
bedroom wall or open the room to early morning sunshine. They were designed to
signal the passage from consciousness to unconsciousness. The maple-veneer bed is
by Philip Agee. The color palette throughout the house is subdued.
Beyond the bedroom is the stone-walled bathroom.

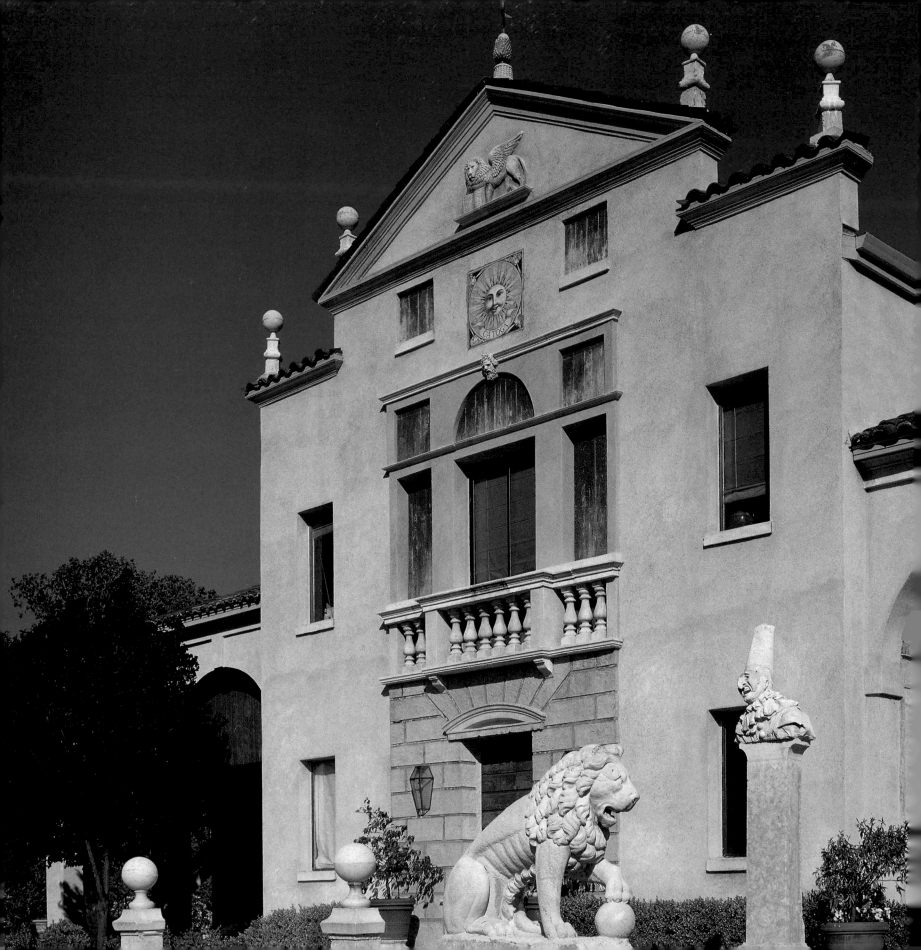

Eight years ago, artist Carlo Marchiori decided he wanted to find a weekend house in the country. He had lived in a Victorian house in San Francisco since 1979 and liked the idea of being closer to the earth. ♦ "Looking toward my old age, I envisioned a house in the sun, with a garden and perhaps a beautiful view," recalled the artist, who was born in Bassano del Grappa, a village near Venice. As a teenager, he studied traditional art techniques like tempera and fresco, and he later worked as an illustrator and mural painter in Japan, Brazil, and Canada before heading for California. ♦ Exploring the far north of the Napa Valley, Marchiori found and purchased five acres north of the town of Calistoga. ♦ "Out of my struggle to build a structure with little money, I came up with the original shell of the house – just a barn, really," said Marchiori, who worked with ARQ Architects. "Little by little, as I had a few dollars, I added the facade, the loggia, bedrooms upstairs, a balcony. On my days off, I decorated all the interior walls with frescoes, my fantasy of Veronese. I knew I was making a kind of stage set and I didn't mind being a bit obvious." ♦ The stucco exterior has wood cornices painted to look like stone. A balcony with balustrades overlooks the garden. His large studio is at the back of the villa. ♦ Marchiori saw the house as suggesting 300 years of life, with layers of construction over time. All of the interior walls are painted with bravura, in the style of those that graced Venetian villas and country houses along the Brenta River at the time of Palladio. ♦ "I'm influenced by Veronese, but I don't try to step into his shoes. That would block my artistic freedom," said Marchiori. "It's my own interpretation. I like the work to look a bit naive. I work completely from my own imagination, never photos." ♦ He used recycled timber for both the interior floors and for exterior construction. "I wanted the villa to have a human touch. Materials that are machine-made lack soul," said Marchiori.

Palladian inspirations: Carlo Marchiori's house is not along the Brenta River, but in a meadow a few miles north of Calistoga in the Napa Valley. After working on his villa for eight years, Marchiori has achieved the sixteenth-century Italian villa of his dreams. Like Villa Barbarigo (circa 1669) near Padua, and other Veneto villas, this has a central section crowned with a pediment surmounted by ornamental vases. Like the rather grander Villa Rinaldi near Treviso, Marchiori's house has a shady loggia and a tall facade that hints at the grandeur of the interior.

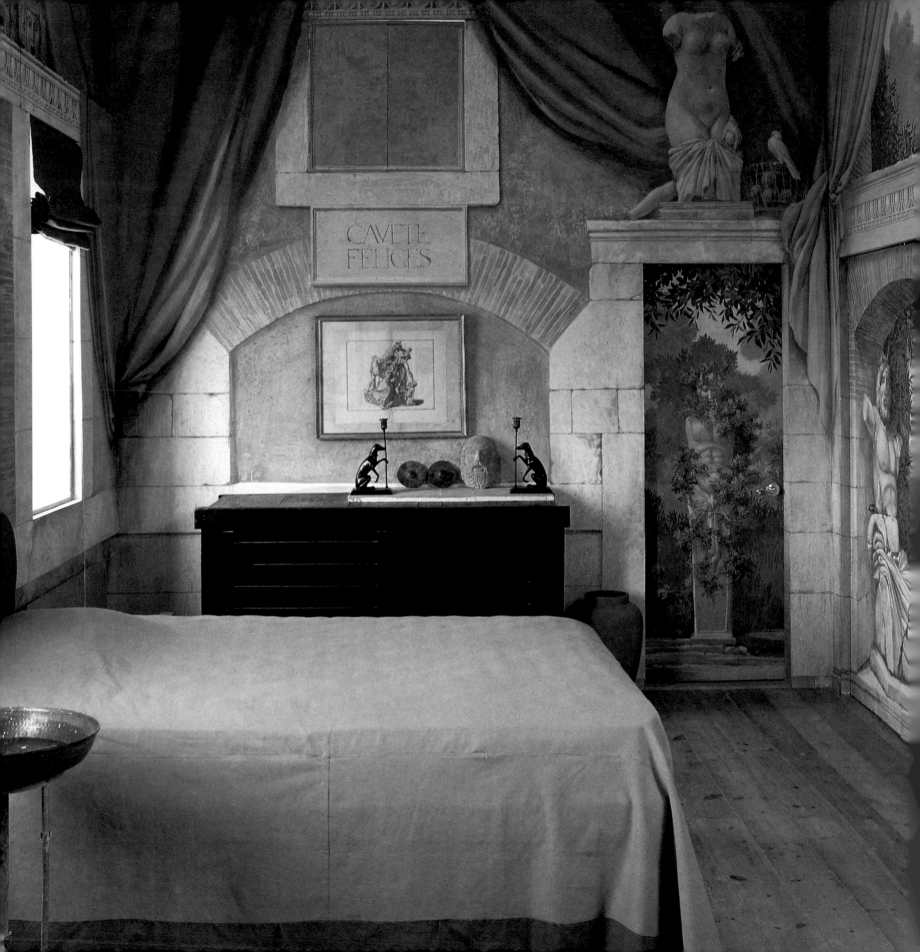

Marchiori calls his guest room the "Greek Myths Room." It has little furniture, but the poetic murals with their bosky dells and noble gods make the lack rather beside the point. Each wall is painted with expressively delineated statues, fragments of Greek gods, and creatures from classic myths. There is Prometheus with a vulture, Icarus falling from the sky, Daedalus' labyrinth with fragments of a statue of a Minotaur. ♦ "I painted the room over three weeks between other projects," the artist recalled. "This manner of somewhat ambiguous painting had to be done quickly and spontaneously. I let it flow out of my hand. In the process, I created a painting that transports me from the everyday." ♦ It's painted with draperies and groves of trees as if viewed from a tent. The mural suggests an archeological site investigating Homer, Trojan conquests, voyages across the Aegean Sea. There is Apollo with a lyre, Janus, Oedipus, Venus, Minerva, Poseidon, and Hercules. ♦ While Marchiori's time-travel frescoes look authentic — as if created with fresh lime-based mortar and traditional mineral- and earth-based paints — he prefers to use an earthy color palette from the local paint store. Today's paints are quicker, need little preparation, and the colors are much more stable. ♦ "I paint only with tones that are natural and very atmospheric, like ochre, sienna, umber, gray, off-white, nothing poster-like," he said. "If Leonardo had had latex paints to paint the Sistine Chapel, I am sure he would have used them. These will last forever." ♦ "I've now almost finished my work on the house, so I'm working on the garden, planting trees and grape vines and a walled kitchen garden," said Marchiori. The nonstop artist has even created a Piscina Romana, a swimming pool disguised with faux ruins, broken statues, and "ancient" columns with Roman inscriptions. ♦ "I have so many plans. I just don't know how to stop," said Marchiori jovially.

♦

Virtuoso visual effects: Like his heroes, classic sixteenth- and seventeenth-century fresco painters such as Veronese, Crosato, or Zelotti, Marchiori paints the walls of his Calistoga villa with light, delicate colors. Unlike them, the artist achieves the great luminosity of the murals for his Calistoga villa using today's house paints. His fantasy depicted here is of an architectural dig somewhere in the Hesperides, the mythical western Mediterranean. Draped cloths suggest a tent; fragments suggest fallen statues of heroes and gods. Marchiori's power of shaping and portrayal is similar to that of a sculptor.

♦

♦

DESIGN & STYLE OF THE CITY & BEYOND

By Diane Dorrans Saeks

San Francisco has always been rich in design stores, museums, historic architecture, wish-I-lived-there houses, art galleries, and welcoming neighborhoods. The City pioneered boutique hotels and now boasts inns and hotels of character in every part of town — including the Embarcadero, the Performing Arts Center, Nob Hill, and Alamo Square. ♦ Even with the cool gray summer fog swirling down city streets, San Francisco offers treasures and surprises for both fortunate residents and passionate, curious travelers. A visitor to San Francisco could, with tips from in-the-know chums and hip-pocket guides like those by Knopf and Access, spend weeks discovering neighborhood shops, wandering through new museums, touring galleries, hiking up brick-paved lanes, sneezing in dusty antique shops, and viewing quirky houses by Julia Morgan, Willis Polk, and today's talented architects. ♦ There is, of course, the pleasure of long pauses for seasonal flavors and companionship at locals' favorite restaurants like Zuni Cafe, Chez Panisse, Stars, Postrio, South Park Cafe, Universal Cafe, the Slow Club, Plumpjack Cafe, at the espresso bars that enliven every block, and at noisy cafes in colorful corners of Chinatown. ♦ In San Francisco, it's possible to tour authentic prim-and-proper Victorian mansions, or take walking tours of Pacific Heights to see beautifully maintained houses, well-appointed apartment buildings, and quiet neighborhood parks where dog-walkers and their polite pets gather in the evenings. ♦ In Golden Gate Park, the M.H. de Young Memorial Museum beckons. At the California Palace of the Legion of Honor (just renovated) out in Lincoln Park, Monet's waterlilies inspire quiet contemplation. The City boasts a Mexican Museum, a Craft and Folk Art Museum, the Museo Italo-Americano, the Asian Art Museum, a Jewish Museum, the Chinese Culture Center, Coit Tower (with its powerful WPA murals), and (of course) the Cable Car Museum. ♦ The City is especially proud of the extraordinary light-filled San Francisco Museum of Modern Art, designed by Mario Botta. The vast rooms Botta limned to show the collections make art viewing pure joy. ♦ Visitors who wander off in search of quiet neighborhoods, old piers of Fort Mason, odd vantage points on hidden leafy stairways on Telegraph Hill, Russian Hill, and North Beach — and those who encounter the Wave Organ at the Marina or frog-filled ponds in Golden Gate Park — will experience some of San Francisco's secret pleasures. ♦ Neighborhoods like Fillmore Street in Pacific Heights, Hayes Street, Chestnut Street, Sacramento Street, Berkeley's Fourth Street, corners of Palo Alto, along with Union Square and redwood-shaded Mill Valley offer the best Bay Area design shopping. ♦ To buy fine furniture usually available to the trade only, make appointments at San Francisco's Galleria Design Center and Showplace Design Center and Showplace West. Visit antiques dealers such as Ed Hardy, Therien & Co (by appointment) in the design center neighborhood. Seek out handsome antique galleries such as Foster-Gwin, Robert Domergue & Company, John Drum & Company, and Marshall Edward, the esteemed W. Graham Arader III rare prints and maps gallery — all of them around Jackson Square. ♦ Check events sections of the *San Francisco Chronicle* for seasonal designer showcase houses (like the San Francisco Decorator Showcase each spring), for walking tours, historic house tours, and special events. And don't forget dusty old book shops, junk shops, and out-of-the-way neighborhoods. They're the only-in-San Francisco treasures that offer the perfect contrast and lightness to the riches of the City.

Art Galleries

A visit to art and craft galleries gives an instant sense of the zeitgeist. Every neighborhood, it seems, is blessed with galleries showing established names, young artists, and undiscovered talent. ◆ In San Francisco, find galleries South of Market, in North Beach, around Grant Avenue, in Pacific Heights, at Fort Mason, and near the Performing Arts Center. ◆ Highly recommended for gallery listings, useful maps, diagrams, drawings, and insider information on architectural gems and house tours, design stores, restaurants: the *Richard Saul Wurman Access San Francisco Guide*, and the new *Knopf Guide, San Francisco*, available at bookstores.

Flea Markets

Another way to see design in action is to go flea-marketing at Northern California antiques and collectibles markets. See newspaper listings for dates of special antiques shows, fairs, and markets. (Insider tip: Go early.)

Museums

M.H. DE YOUNG MEMORIAL MUSEUM
Golden Gate Park
San Francisco
(415) 750-3600

The City's largest art museum, with an emphasis on American art from Colonial times to the twentieth century. Also features arts of Oceania, Africa, and the Americas. Cafe de Young has a pretty garden terrace.

The new Mario Botta-designed San Francisco Museum of Modern Art

PHOTO· RICHARD BARNES

CALIFORNIA PALACE OF THE LEGION OF HONOR
Lincoln Park (34th Ave. & Clement Street)
San Francisco
(415) 750-3600

Paintings, sculpture, and decorative arts by artists from the European schools, superbly displayed in a neo-classical building donated to the City by Alma de Bretteville Spreckels.

ASIAN ART MUSEUM
Golden Gate Park
San Francisco
(415) 668-8921

A superb, beautifully presented collection of the finest Asian historic and contemporary arts.

SAN FRANCISCO MUSEUM OF MODERN ART
151 Third Street
San Francisco
(415) 357-4000

The first museum on the West Coast devoted to twentieth-century art now has a permanent collection of over 13,000 pieces, including painting, sculpture, photography, and media art. Department of Architecture and Design programs and shows include furniture and product design, graphic design, and interior design. New Mario Botta-designed museum building with superb interior. Visit the museum shop, with its special new collections showing the best local design talents.

THE JEWISH COMMUNITY MUSEUM
121 Steuart Street
San Francisco
(415) 543-8880

Explores Jewish art and culture, and traditions throughout the ages. Also focuses on developing and presenting young talent.

JUDAH L. MAGNES MUSEUM
2911 Russell Street
Berkeley
(510) 849-2710

Permanent collection of art and artifacts of Jewish culture. Travelling exhibitions.

MEXICAN MUSEUM
Building D, Fort Mason
San Francisco
(415) 441-0404

Lively shows in all media. Excellent shop selling Mexican arts and crafts.

OAKLAND MUSEUM
1000 Oak Street
Oakland
(510) 273-3401

California art collections – including history and science departments – in a dramatic Kevin Roche-designed building. Public garden and cafe.

UNIVERSITY ART MUSEUM
2626 Bancroft Avenue
Berkeley
(510) 642-1207

University of California at Berkeley museum shows eclectic exhibitions in a bold concrete building designed by San Francisco architect Mario Ciampi. Permanent Asian art collection. Cafe.

SAN FRANCISCO ART INSTITUTE
800 Chestnut Street
San Francisco
(415) 771-7020
Changing shows in an art school's historic building. Be sure to visit the Diego Rivera gallery.

SAN FRANCISCO CRAFT AND FOLK ART MUSEUM
Landmark Building A, Fort Mason
San Francisco
(415) 775-0990
A gem. Imaginative international shows in an historic complex.

Victorians & Gardens to Visit

◆

Visitors can do more than stroll past Victorians and gaze longingly at the windows, hoping to be invited in. Several historic houses have been preserved as museums and may be visited. Filoli in Woodside is noted for its beautifully maintained garden.

HAAS-LILIENTHAL HOUSE
2007 Franklin Street
San Francisco
(415) 441-3004
Built in 1886, the gray house is a classic storybook Victorian. Fully furnished, it was lived in until 1972, when it was donated to the Foundation for San Francisco's Architectural Heritage.

OCTAGON HOUSE
2645 Gough Street
San Francisco
(415) 441-7512
Gray with white trim and quoining, the house was built in 1861 when it was thought that an eight-sided interior would improve the occupants' inner lives. It is now a museum set in a quiet garden. Acquired in 1952 as their headquarters by the California Colonial Dames of America.

DUNSMUIR HOUSE AND GARDENS
2960 Peralta Oaks Court
Oakland
(510) 562-0328
A 37-room Colonial Revival mansion set in 40-acre grounds. Built in 1899, the white house is well maintained and furnished. Special celebrations during the year.

CAMRON-STANFORD HOUSE
1418 Lakeside Drive
Oakland
(510) 836-1796
A graceful Italianate mansion, originally built in 1875. Exhibits describe Victorian techniques of wood graining, cut glass, plaster work, stencilling, and milling.

FILOLI
Filoli Center, Canada Road
Woodside
The 1917 former country estate has gracious furnished rooms (be sure to visit the ballroom, with its Italianate murals) and an extraordinary garden. Docent-led and self-guided tours.

Walking Tours

◆

CITY GUIDES
(415) 557-4266
A favorite institution. Creative, witty and lively tours offering insights into San Francisco history, literature, architecture, roof gardens, the Palace Hotel, the Goldrush City, the Civic Center, the Fire Department Museum, Chinatown, North Beach, Sutro Heights, Coit Tower, the Mission murals, the Marina, the Haight, Pacific Heights mansions. Bring a warm jacket, San Francisco's weather is often "fresh" and summer fogs are cool.

FRIENDS OF THE URBAN FOREST
This group, which encourages and assists tree-planting along the streets of San Francisco, sponsors free guided walking tours. Information: (415) 543-5000.

FRIENDS OF PARKS AND RECREATION
Guided walking tours of Golden Gate Park. Information: (415) 221-1311.

THE SIERRA CLUB
A wide variety of walks. For an activities schedule: (510) 653-6127.

Design & Style Stores

◆

California has always been the trend-setting land of original design. Here on the western edge of the continent, new ideas and styles come to life. ◆ Without the world-weariness, weight, and worry of hundreds of years of history, tradition, and convention to hold them back, San Francisco interior designers, craftspeople, furniture and fabric designers, store owners, artists and architects can dream and create and bring to market breakthrough designs. ◆ The following pages offer a very personal list of highly individual, worth-a-detour stores, museums, galleries, and hotels throughout Northern California. These shops and galleries offer no one look. They are inspiring, ever-changing, and very successful because one or two brilliant, focused owners (backed up with excellent management) have the idiosyncratic vision, passion, and energy to make them work. ◆ New and long-time shops I love — like Bell'occhio, Fioridella, Zonal, Fillamento, Turner Martin, de Vera, The Gardener, Bloomers, Wilkes Home, or Mike

Furniture — are proud one-of-a-kind productions of single-minded owners. Like the best Hollywood productions, they are seductive, original, memorable — and every visit is inspiring. When you walk out of these stores, your day — your life! — feels better.

SAN FRANCISCO

◆

AD/50
Laguna & Hayes streets
Dominic Longacre is a passionate collector and purveyor of mid-century furniture by architects. In addition to chairs, tables, and storage systems by the likes of the Eameses and George Nelson, he also offers the outstanding new modernist furniture designs by Park Furniture, based in San Francisco.

AGRARIA
1051 Howard Street
Maurice Gibson and Stanford Stevenson make the most elegant candles, potpourri, and soaps. A very chic (and wonderfully fragrant) store. Telephone 863-7700 for an appointment or for a catalogue.

ARCH
407 Jackson Street
Architect Susan Colliver's colorful graphic store sells supplies for designers, architects, and artists. Fun place. Excellent ranges of papers, pencils, frames.

BELL'OCCHIO
8 Brady Street

Claudia Schwartz and Toby Hanson offer hand-painted ribbons, French silk flowers, charming tableware, antiques, and wonderfully retro Italian and Parisian treasures.

GORDON BENNETT
2102 Union Street

A wonderful new addition to this street. Stylish tabletop decor, furniture, books, frames, candles, vases, garden supplies, all displayed with great flair. (Be sure to ask the English owners the derivation of their name.)

BLOOMERS
2975 Washington Street

Under Patric Powell's guidance, Bloomers blooms year-round with glorious seasonal cut flowers, orchids, bulbs, vases, French ribbons, and baskets. Phone with confidence to order a thrilling flower arrangement.

VIRGINIA BREIER
3091 Sacramento Street

A fine gallery for viewing contemporary and traditional American crafts, including furniture and tableware.

BRITEX
146 Geary Street

Action-central for fabrics. World-class selections of classic and unusual furnishing textiles. (Don't forget to rummage among the remnants.)

BUILDERS BOOKSOURCE
300 de Haro Street
Also at 1817 Fourth Street, Berkeley

With an accent on the practical, this well-stocked store includes books on interior design, gardens, architecture, and materials. Catalogue.

De Vera Glass, Hayes Valley
PHOTO: ALAN WEINTRAUB

CANDELIER
60 Maiden Lane

Wade Benson's well-modulated ode to the candle. Complete collection of candlesticks and tabletop decor.

CHEZ MAC (or MAC)
1543 Grant Avenue

Store owners Jerry, Chris, and Ben Ospital are San Francisco treasures. First they were leaders in fashion, now they also offer a diverting selection of linens, hand-crafted decorative objects, furniture, and lighting. Pop upstairs to the George boutique on the mezzanine, for at-home essentials like embroidered pillows, charms and cedar beds – especially for dogs. (And be sure to visit the MAC Satellite of Love, 5 Claude Lane, for more housewares and furnishings.)

COLUMBINE DESIGN
1541 Grant Avenue

Kathleen Dooley sells beautiful flowers, dried blossoms (in Victorian and Mexican styles), along with graphic framed butterflies and beetles.

THE COTTAGE TABLE COMPANY
550 18th Street

A designers' favorite. Craftsman Tony Cowan, serious about traditional fine tables, custom-makes heirloom-quality classic hardwood tables. A rare find. Shipping available. Catalogue.

DECORUM
1632 Market Street

Impeccably restored authentic art deco and Moderne furniture in an expansive store opposite the Zuni Cafe.

DE VERA
334 Gough Street

Objets trouvés, fine art, sculpture. Fresh, original and quirky finds by Federico de Vera.

DE VERA GLASS
384 Hayes Street

Federico de Vera has assembled a fine gallery of glass objects by contemporary American artists, along with Venetian and Scandinavian classics.

F. DORIAN
388 Hayes Street

Inspiring collections of contemporary accessories (including those by designer Christopher Pollock) and antiques.

FIORIDELLA
1920 Polk Street

Jean Thompson and Barbara Belloli sell the most luscious flowers in a store full of sensual, fragrant blooms and new ideas. Brilliant selection of decorative and versatile vases. Phone them for deliveries of beautiful arrangements for special occasions.

FILLAMENTO
2185 Fillmore Street

A neighborhood favorite. Owner Iris Fuller orchestrates three floors of well-edited style-conscious furniture, tableware, rugs, toys, and gifts. Iris is always first with new designers' works and supports local talent, including Annieglass and Cyclamen Studio tabletop decor. Frames, lamps, linens, beds, and partyware.

FLAX
1699 Market Street

Vast and tasty selections of design-concious papers, lighting, tabletop accessories, boxes, art books, furnishings. Action-central for art supplies for at-home projects. Catalogue.

STANLEE R. GATTI FLOWERS
Fairmont Hotel, Nob Hill

Beautiful cut flowers, Agraria pot pourri, Zinc Details monkeytail glass vases and candles.

Glass Designs by Annieglass
PHOTO: ROD JOHNSON

GREEN WORLD MERCANTILE
2340 Polk Street

Energetic new owners have carved a niche for themselves selling earth-friendly housewares, clothing, gardening equipment, a pleasing range of decorative accessories.

GUMP'S
135 Post Street

A treasure chest of fine art and Orient-inspired accessories, plus timeless furniture and elegant tableware — since 1861. Recent refurbishing makes the store an essential stop. Be sure to visit the silver departments. Catalogue.

HERMES
212 Stockton Street

Select a scarf or tie, then go upstairs and persue fine china and handsome table decor. Hermes can also outfit you for a wonderful chic picnic.

RICHARD HILKERT BOOKS
333 Hayes Street

Decorators and design book lovers telephone Richard to order out-of-print style books and seek out the newest design books. When you visit Hilkert's store, it's like entering the book-lined living room of a dear bibliophile friend.

DAVID LUKE & ASSOCIATE
773 14th Street

Antique furniture, art, and ornamentation. (David's lovable dog is the associate.)

INDIGO V
1352 Castro Street

Diane's fresh flowers are superbly chosen. A neighborhood favorite.

JAPONESQUE
824 Montgomery Street

Koichi Hara celebrates the Japanese love of harmony, simplicity, refined beauty, humble materials. Graphics, sculpture, glass, furniture. The spirit of his design gallery is entirely timeless and transcendent.

KRIS KELLY
One Union Square

Fine selections of embellished linens.

LIMN
457 Pacific Street & 290 Townsend Street

Contemporary furniture and lighting by over 300 manufacturers. Philippe Starck to Le Corbusier and Andree Putman and Mathieu & Ray, along with Northern California talent.

MACY'S
Union Square

The furniture and decorative accessories floor displays a vast selection of furnishings. The Interior Design Department has designers available to assist with decorating. The Cellar is a lively marketplace offering tableware, kitchenware, and kitchen tools.

MARINA GREEN
2076 Chestnut Street
Also at Embarcadero Center

Charming earth-friendly store (note the counter of recycled materials) selling attractive unbleached bed linens and towels, glasses, and vases of recycled glass, candles, soaps, clothing.

MIKE FURNITURE
Corner of Fillmore & Sacramento streets

With design directed by Mike Moore and his partner, Mike Thackar, this spacious, sunny store sells up-dated classics-with-a-twist. They make forward design very accessible. One-stop shopping for lamps, tables, fabrics, accessories.

NAOMI'S ANTIQUES TO GO
1817 Polk Street

Art pottery to the rafters! Bauer and Fiesta, of course, plus historic studio pottery, American railroad, airline, luxury liner, and bus depot china.

THE OPEN DOOR
548 Union Street

Designer Shawn E. Hall makes furniture from architectural salvage. Serendipitous finds.

PAINT MAGIC
2426 Fillmore Street

Paint enthusiast Sheila Rauch and her energetic partner, Patricia Orlando, have generated great interest and a dedicated following selling Jocasta Innes's innovative Paint Magic paint finishes. They offer paint technique classes, along with materials for gilding, liming, crackle glazing, decoupage, stenciling, and many other decorative finishes.

PAXTON GATE
1204 Stevenson Street

Peter Kline and Sean Quigley's gardening store sells uncommon plants (such as sweetly scented Buddha's Hand citron trees) along with local artists' works, orchids, vases, and hand-forged tools.

Designs by Christopher Pollock

POLANCO
393 Hayes Street

Colorful, superbly presented Mexican arts, photography, and crafts. Museum curator Elsa Cameron says you won't find better in Mexico City.

POTTERY BARN

The San Francisco-based company has stores in Embarcadero Center, on Chestnut Street, and at other locations in Northern California. Great home style at a price. Excellent basics. Ever-changing, accessible, easy to love design. Catalogue.

PURE T
2238 Polk Street

Essentially a tea and ice cream shop, this jewel box, designed by Shawn E. Hall, also percolates with teapots, wall vases, and limited-edition locally designed accessories.

RH
2506 Sacramento Street

Rick Herbert's garden and style store has dramatically displayed tableware, dinnerware by Sebastapol artist Aletha Soule. Inspiring selection of candles, books, cachepots, vases. Topiaries, too.

SATIN MOON FABRICS
32 Clement Street
Twenty-year-old store sells a well-edited collection of decorating linens, chintzes, trims, twills, and other well-priced fabrics.

SCHEUER LINENS
340 Sutter Street
Longtime favorite store for fine-quality bed linens, blankets. This store handles monograms and special custom orders particularly well.

SHABBY CHIC
3075 Sacramento Street
Specializes in chairs and sofas with comfortable airs and loose-fitting slipcovers. Accessories.

SLIPS
1534 Grant Avenue
Sami Rosenzweig's innovative shop sells and custom-makes slip covers for chairs and sofas. Sami has a myriad of ideas for improving furniture with slipcovers — all of them cost-conscious and original.

SUE FISHER KING
3067 Sacramento Street
Sue King's linens and tableware are the finest and prettiest. A must-stop shop for imported and unique accessories and gifts, books, soaps, furniture, and luxurious throws.

TIFFANY & CO.
350 Post Street
Try some diamond rings, then go upstairs to the crystal, silverware, and china department. Of special note: Elsa Peretti's glorious tabletop designs and Tiffany's wonderful, classic dinnerware.

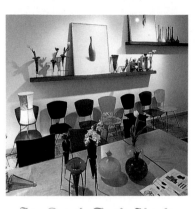

Zinc Details, Pacific Heights

20TH CENTURY FURNISHINGS
1612 Market Street
David Dutra's 30-year-old business has a national and international following. Furniture and accessories since the twenties. Selection ranges from Donald Deskey, Gilbert Rhode, Herman Miller, Knoll, and streamlined furnishings to sixties classics. The shop also offers occasional gems by T.H. Robsjohn-Gibbings and Jean-Michel Frank, currently two of the most admired and copied designers.

WILKES HOME,
WILKES BASHFORD LTD.
375 Sutter Street
Also in Mendocino
Wilkes Bashford's vision shines here with tableware, accessories, furniture, and special *objets d'art* from around the world.

WILLIAMS-SONOMA
150 Post Street
Flagship for the Williams-Sonoma cookware empire. Stores throughout the state, including Corte Madera, Palo Alto, Rodeo Drive, Pasadena. Delicacies. Outstanding basics for serious and dilettante cooks. Catalogue.

WILLIAM STOUT
ARCHITECTURAL BOOKS
804 Montgomery Street
Architect Bill Stout's store specializes in basic and obscure twentieth-century architecture publications, along with new and out-of-print design books. Catalogue.

WORLDWARE
336 Hayes Street
Shari Sant's high-minded and stylish new eco-store sells unbleached sheets and blankets, four lines of clean-lined clothing for men and women, and such delights as patchwork pillows, deluxe soaps. Interiors crafted from recyled materials are very engaging.

YOUR SPACE
868 Post Street
Marion Philpott's housewares shop is small in size, large in inspiration. Pillows, draperies, cachepots, candlesticks, frames, plinths, and other well-chosen accessories.

ZINC DETAILS
1905 Fillmore Street
Architect-designed and handcrafted furniture, lighting. Extraordinary hand-blown glass vases by local artists. Provocative, special domain of friendly partners Wendy Nishimura and Vasilios Kiniris.

ZONAL HOME INTERIORS
568 Hayes Street
Russell Pritchard's pioneering gallery store of one-of-a-kind rustic furniture, most with the patina of rust and the beautiful textures of age. This is Americana at its best.

BERKELEY/ELMWOOD
◆

Much of the design store action is focused on wonderfully revived Fourth Street. We recommend, too, a detour to Café Fanny, the Acme Bread bakery, Chez Panisse, and shops in the Elmwood.

BERKELEY MILLS
1461 Keoncrest Drive
Much-admired custom-crafted furniture. Japanese- and Mission-influenced furniture. Blends the best of old-world craftsmanship with high-tech. All built to order. Catalogue.

BUILDERS BOOKSOURCE
1817 Fourth Street
Excellent design, architecture, gardening, and building book source.

CAMPS AND COTTAGES
2109 Virginia Street
Just a hop and a skip from Chez Panisse and Berkeley's beloved Cheese Board, this spritely and well-stocked little shop sells charming homey furniture and low-key accessories. Owner Molly Hyde English has perfect pitch for the nineties.

CYCLAMEN STUDIO
1825 Eastshore Highway
Julie Sanders' colorful ceramics seconds are available at the factory by appointment. (Her original and very collectible Cyclamen Studio designs are featured at Fillamento, and The Gardner). The hot-off-the-kiln Re-Eco line, new ceramics made of ground-up recycled old ceramics, is especially innovative.

EARTHSAKE
1805 Fourth Street
Also in Palo Alto

One of the pioneers in environmentally safe household goods, this charming store dishes it all up with great panache. It's also a fine place to gain an education in what's good for the planet.

THE GARDENER
1836 Fourth Street

Alta Tingle's brilliant, inspired store sells tools, vases, books, tables, chairs, tableware, paintings, clothing, and food for garden-lovers — whether they have a garden or are just dreaming. Consistently original style.

LIGHTING STUDIO
1808 Fourth Street

Lighting design services. Contemporary lamps.

REGALO
1749 Solano Avenue

Ellen Friedland and Mimi Price have created a magical, romantic store selling antiques, furnishings, tableware, gifts, and draperies. Splendid.

TAIL OF THE YAK
2632 Ashby Avenue

Partners Alice Hoffman Erb and Lauren Adams Allard have created an entrancing store that is always a treat. Absolutely worth the drive to this quiet Elmwood neighborhood. Decorative accessories, Mexican furniture, fabrics, and antique jewelry.

ZIA
1310 Tenth Street

Collin Smith's brilliant, sun-filled gallery-store offers a changing variety of hands-on furniture designs and art. New: Mike Furniture's updated studio collection.

BIG SUR

◆

THE PHOENIX
Highway One

One of my favorite style stores anywhere. Splendid collections of hand-crafted decorative objects, glass, books, sculpture, jewelry, hand-knit sweaters by Kaffe Fassett (who grew up in Big Sur), and toys. Extraordinary coastal views from all windows. Be sure to visit the downstairs boutiques. Crystal, soothing music and handmade objects are on all sides. The sixties never left Big Sur — thank goodness.

BURLINGAME

◆

GARDENHOUSE
1129 Howard Avenue

Topiaries, garden ornaments, beautifully presented decorative accessories.

CARMEL

◆

CARMEL BAY COMPANY
Corner of Ocean & Lincoln

Tableware, books, glassware, furniture, accessories, prints.

LUCIANO ANTIQUES
San Carlos & Fifth streets

Wander through the vast rooms — to view dramatic antiques and handsome reproductions from everywhere, every time period.

Glass designs by Annie Glass
PHOTO: ROD JOHNSON

HEALDSBURG

◆

PALLADIO
324 Healdsburg Avenue

Owner Tom Scheibal worked with architect Andrew Jaszewski to create a spectacular design store. When in Healdsburg, also discover the Raven movie theater, Ravenous restaurant, and Myra Hoefer's design studio.

JIMTOWN STORE
6706 State Highway 128

J. Carrie Brown and John Werner's great country store in the Alexander Valley. Be sure to visit their Mercantile & Exchange. The vintage Americana and quirky antiques are cheerful and very well-priced.

MENDOCINO

◆

THE GOLDEN GOOSE
45094 Main Street

Embellished linens, antiques, tableware, overlooking the ocean. For more than a decade, the most stylish store in Mendocino. ◆ (When in Mendocino, be sure to make a dinner reservation at Cafe Beaujolais.)

MILL VALLEY

◆

ARCHITECTS AND BUILDERS BOOKSTORE
38 Miller Avenue

A broad and imaginative selection of design and architecture books. Excellent selection of nuts and bolts books, as well as interior design and architecture history volumes.

CAPRICORN ANTIQUES & COOKWARE
100 Throckmorton Avenue

This solid, reliable store seems to have been on this corner forever. Excellent, basic cookware, along with antique tables, chests, and cupboards.

PULLMAN & CO
108 Throckmorton Street

Understated but luxurious bed linens (the standouts are those by Ann Gish), along with furniture, frames, tableware, and accessories.

Glass designs by Nikolas Weinstein

35 Corte Madera

First visit the superb nursery (begun under horticulturist Sarah Hammond's superb direction) and then the store. Everything for gardens. Also in Berkeley, Palo Alto, Los Gatos, Santa Rosa. Outstanding catalogue.

SUMMER HOUSE GALLERY
21 Throckmorton Street

Witty handcrafted frames, handcrafted glassware, candlesticks, and colorful accessories. Slipcovered furniture, vases, tables, gifts.

SAN ANSELMO

◆

MODERN I
500 Red Hill Avenue

Steven Cabella is passionate about modernism and time-warp mid-century (1935-65) furnishings. Vintage furnishings, Eames chairs, furniture by architects, objects, and artwork. Located in a restored modernist architects' office building.

SAN RAFAEL

◆

MANDERLEY
1101 E. Francisco Boulevard

Ronnie Welles' antique fabrics and fabric-upholstered furniture emporium will convert you to old fabrics in a second. Outstanding pillows.

PALO ALTO

◆

BELLS BOOKS
536 Emerson Street

An especially fine and thorough selection of new and vintage and rare books on every aspect of gardens and gardening.

HILLARY THATZ
Stanford Shopping Center

A beautiful slice of England, as seen by Cheryl Driver. Accessories, furniture, frames, and beautiful decorative objects. Beautifully presented. Garden.

POLO/RALPH LAUREN
Stanford Shopping Center

A handsome, gracious store. A world through Ralph Lauren's eyes. Outstanding selection of furniture, quality housewares. Catalogue.

TURNER MARTIN
540 Emerson Street

David Turner and John Martin's enchanting one-of-a-kind style-store/gallery. Definitely worth a detour for their displays of frames, lighting, books, tables, photographs by David, vases, chairs (occasionally with grass seats), and witty art.

SONOMA

◆

THE SONOMA COUNTRY STORE
165 West Napa Street

Ann Thornton's empire now includes a new store at 3575 Sacramento Street, San Francisco. Decorative accessories, linens, and housewares.

ST. HELENA

◆

BALE MILL DESIGN
3431 North St. Helena Highway

Tom Scheibal's marvelous roadside store sells furniture, lighting, and accessories that work wonderfully in country and city houses. His look is refined rustic and each piece can be custom ordered. Don't forget to scale the stairs for more tables and chairs.

VANDERBILT & CO
1429 Main Street

Stylish and colorful tableware, bed linens, books, accessories. A favorite in the wine country.

TIBURON

◆

RUTH LIVINGSTON
INTERIOR DESIGN
74 Main Street

An excellent, well-edited design store. Highlight: a very strong collection of arts and furniture by Northern California talents.

┌─────────────────────────────┐
│ *City and Country Hotels* │
└─────────────────────────────┘

◆

In San Francisco, it is essential to stay in distinctive hotels with authentic style and an enhanced sense of place. A view of the City outside your window is a must. Each of the award-winning hotels listed below offers a memorable only-in-California visit. Situated high on spectacular hills, in the heart of the City, overlooking the San Francisco Bay, or in beautifully designed gardens, each hotel offers a cosseted vantage point from which to view the San Francisco Bay or the

Napa Valley. For forays into the Napa Valley and south to Big Sur, we also suggest three hotels with unique points of view.

THE ARCHBISHOP'S MANSION
1000 Fulton Street opposite Alamo Square
San Francisco
(415) 563-7872

This handsome and historic 1904 mansion is a brief drive from City Hall and the Opera House. Each beautifully designed, antiques-filled suite is named for an opera. Discreet, hushed, very private. (Yes, it was once an archbishop's residence.)

AUBERGE DE SOLEIL
180 Rutherford Hill Road
Rutherford
(707) 963-1211

Hotelier and restaurateur Claude Rouas worked with architect Sandy Walker and designer Michael Taylor to create a world-class wine country hotel. Outstanding cuisine, heart-stopping hillside views of the Napa Valley from the restaurant terraces and rooms.

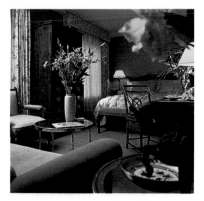

Campton Place Hotel

CAMPTON PLACE HOTEL
340 Stockton Street
(415) 781-5555

A gem close to Union Square (and Wilkes Bashford). The James Northcutt–designed rooms exude comfort. Locals and travelers alike love to meet in the low-key, chic bar. The restaurant specializes in seasonal dishes with spectacular desserts. *(Don't forget to zip upstairs to the discreetly luxurious Bulgari boutique.)*

HUNTINGTON HOTEL
1075 California Street
San Francisco
(415) 474-5400

Standing on the crown of Nob Hill overlooking Huntington Park, this hotel has a handsome presence. For residents and visitors alike, it's a San Francisco treasure. The clanging and clanking sounds of the cable cars are background music in the handsome rooms, most with Bay and City views. For luxurious comfort, we recommend the top-floor suites.

MANDARIN ORIENTAL HOTEL
222 Sansome Street
San Francisco
(415) 885-0999

This beautifully managed Financial District hotel offers some of the world's greatest views...from the bathtubs. From your pampered skyscraper, San Francisco's spires and bay look glamorous and mysterious. A favorite with world travelers.

MEADOWWOOD RESORT
900 Meadowwood Lane
St. Helena
(707) 963-3646

Highly recommended. Like staying on your own leafy estate in the Napa Valley. Well-designed, understated suites among the oak trees. Activities include croquet, hiking, tennis, golf, and reading on a quiet verandah. Within minutes of St. Helena, dozens of wineries, the spectacular valley.

POST RANCH INN
Highway One
Big Sur
(408) 667-2200

Three-year-old, cliff-side, environmentally correct hotel designed by Mickey Muennig. Stands on a ridge on 36 acres. Just 30 rooms. Hiking trails, swimming, and exploring the neighboring national parks are possibilities for the energetic.

PRESCOTT HOTEL
545 Post Street
San Francisco
(415) 563-0303

Gracious interiors designed by San Francisco designer Nan Rosenblatt. Club Level has a concierge, evening refreshments, morning breakfast in a private lounge. Best of all: room service from Wolfgang Puck's Postrio downstairs.

RITZ-CARLTON HOTEL
600 Stockton Street (at California Street)
San Francisco
(415) 296-7464

Glorious views over San Francisco. Like all Ritz-Carlton hotels, this superbly run hotel offers cosseting and comfort. Afternoon tea is served daily in the glamorous lobby lounge. Be sure to visit the spa and glamorous pool – especially in the evening.

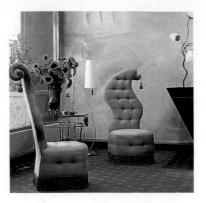

The Hotel Triton

SHERMAN HOUSE
2160 Green Street
San Francisco
(415) 563-3600

A historic Pacific Heights mansion carefully converted into a gracious, stylish small hotel. Rooms were designed by Billy Gaylord. Hollywood stars and business leaders appreciate its privacy, discretion, and attention to detail. Superbly managed. Quiet gardens, fine restaurant. Convenient location a block from Union Street. (Plumpjack Cafe designed by Leavitt/Weaver is just around the corner.)

HOTEL TRITON
342 Grant Avenue
(overlooking the gates of Chinatown)
San Francisco
(415) 394-0500

With witty and worldly interiors designed by San Francisco designer Michael Moore, this hotel is a favorite with cool internationals. (Ask about the new suite designed by boxer shorts mogul Joe Boxer.) Exceptional downtown location.

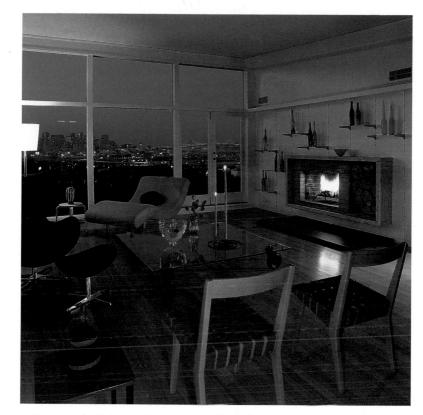

In the twilight beyond Susan Schindler's Potrero Hill windows, the Bay Bridge lights sparkle. Glass bottle from de Vera

PHOTO: ALAN WEINTRAUB.